IMAGES OF MITHRA

VISUAL CONVERSATIONS
IN ART AND ARCHAEOLOGY

General Editor: Jaś Elsner

Visual Conversations is a series designed to foster a new model of comparative inquiry in the histories of ancient art. The aim is to create the spirit of a comparative conversation across the different areas of the art history and archaeology of the pre-modern world—across Eurasia, Africa, Australasia, and the Americas—in ways that are academically and theoretically stimulating. The books serve collectively as a public platform to demonstrate by example the possibilities of a comparative exercise of working with objects across cultures and religions within defined, but broad, historical trajectories.

Forthcoming titles

Word as Image
Nadia Ali, Robert Bracey, Katherine Cross, Jaś Elsner,
Maria Lidova, and Rachel Wood

Altars
Katherine Cross, Dominic Dalglish, Maria Lidova,
and Rachel Wood

Images of Mithra

PHILIPPA ADRYCH,
ROBERT BRACEY,
DOMINIC DALGLISH,
STEFANIE LENK,
and
RACHEL WOOD

OXFORD
UNIVERSITY PRESS

OXFORD
UNIVERSITY PRESS

Great Clarendon Street, Oxford, OX2 6DP,
United Kingdom

Oxford University Press is a department of the University of Oxford.
It furthers the University's objective of excellence in research, scholarship,
and education by publishing worldwide. Oxford is a registered trade mark of
Oxford University Press in the UK and in certain other countries

Published in the United States of America by Oxford University Press
198 Madison Avenue, New York, NY 10016, United States of America

British Library Cataloguing in Publication Data
Data available

Library of Congress Control Number: 2016953559

ISBN 978–0–19–879253–6

Printed in Great Britain by
CPI Group (UK) Ltd, Croydon, CR0 4YY

FOREWORD

Jaś Elsner

Images of Mithra is the first volume of a new and experimental series of multi-authored books published by the Oxford University Press. The series, *Visual Conversations*, brings together groups of scholars with different areas of expertise to work collectively on a single project. The idea is to produce not a conventional edited book where there is one editor and various authors who write more or less related papers, nor the normal scholarly fare of the single-authored monograph. Rather, it is about people working together and bringing together skills and ranges of knowledge greater than any individual can command, but doing so with the coordinated and integrated thrust that is much more characteristic of a single-authored book than a collection.

In the current era, the ancient material cultural disciplines—within art history, archaeology, and ancient history—have a collective identity in engaging with objects via ways that push beyond and at the same time reflect with a different perspective upon the evidence of texts, documents, and literary survivals. One of the real desiderata is a comparative conversation based on shared methodological concerns, that include the archaeological basis of so many of the materials from pre-modern periods and geographical contexts, the complex relations of understanding our objects in reference to the evidence of surviving texts in ancient languages, and the problematic partiality of the surviving evidence—the fact that such a small percentage of what made up the ancient world is known to us. That conversation, in an era of globalization and cross-cultural interest, has a public resonance beyond academia. Even within relatively specific subject fields (e.g. Classical art or pre-Columbian archaeology) a real interest has developed over the last generation in looking at comparative material from other worlds and contexts—Persia, India, Egypt, Ethiopia, China, Mesopotamia, the Americas.... The antiquities that survive from these cultural contexts may not belong in the same place within the same absolute dating system (especially in cultures that had no knowledge of one another—like Mesoamerica and Eurasia, until the Spanish conquest of the former). But their archaeological means of survival, and the fact that they come from a context known to us through the artefacts themselves and a relatively sparse selections of surviving texts, offers us many potential comparisons and conversations based on similar methodological explorations.

The writers of *Images of Mithra* have been working together for several years in the 'Empires of Faith' project funded by the Leverhulme Trust and based between the British Museum and Wolfson College, Oxford. Their areas of

expertise range from ancient India and pre-Islamic Iran to the Roman Empire and the early Christian west, all of them working on material and visual culture in archaeologically embedded contexts, as well as museum collections (notably that of the British Museum). The book arose from a series of conversations and arguments between them and within the group about the nature of ancient religion and the place of visual culture in writing its narratives. This book's energy is thus the energy of a vibrant and still continuing series of discussions, of which this volume is a first stage in a long conversation. As the principal investigator of 'Empires of Faith', it has been a wonderful experience for me to observe the process and the pyrotechnics along the path, not to speak of the way in which the volume has grown from a short collective seminar paper, via a half-day colloquium, and an international conference with external respondents, to a book.

Images of Mithra does two things—first, as a collection of papers that span Asia and Europe within antiquity (in this case a period covering the first century BC to the fourth century AD), the volume challenges what has become the normative scholarly approach to the (now no longer practised) religions associated with Mithra. That normative approach has, in the last half century, been to regard the cults, myths, texts, and images associated with the name 'Mithra' in Asia outside the Roman Empire as an entirely different phenomenon from the cults, myths, texts, and images associated with the name 'Mithras' in the Mediterranean world ruled by the Romans. Given that some of the finest and most thoughtful scholarship in all the history of ancient religion has been devoted to what has been called 'Mithraism', this normative approach has the backing of an extremely powerful and impressive academic constituency. But its starting position, dividing Europe and Asia and assuming the cult should be treated entirely differently in these contexts because it was entirely different in each, at the very least needs some reconsideration. The appeal of a god bearing the name 'Mithra' in both western and Asian religious and visual culture begs the question of whether there are any connections beyond a name; and the increasing impetus in scholarship in the last decade to look comparatively at phenomena on a more global or at least trans-cultural level demands that we be at least open to the possibility for more interconnections than the standard approach to Mithraism has allowed.

One of the particular problems of studying the religions connected with Mithra is that our textual sources—the normative evidential and empirical base for exploring religion—are much more exiguous, fragmentary, and frankly inconclusive than the extremely rich material-cultural, archaeological, and art-historical remains. The use of texts also involves applying literary evidence from one cultural context (for instance, ancient Iran) to archaeology from a different context (for instance, the Roman Empire). This is not only methodologically problematic, but it also represents a theoretical and theological presupposition—not one that is provable—to the effect that Mithra in these different contexts is

in fact the same entity. One of the great challenges facing this book has been to put the material culture first, to find ways to make it speak (sometimes in the absence of texts), to take it across the borders between the Roman world and the empires of Iran and India, and to attempt to make some comparative conclusions on the basis of the visual evidence. In this, the volume attempts to pioneer a new, more material-culturally embedded approach to the study of ancient religion.

But more broadly still, and moving beyond simply the question of Mithra, and indeed beyond issues of ancient deity-worship in the Roman, Parthian, Sasanian, and Kushan Empires, the book broaches the fundamental problem of *what a name may imply about a god*. This is a question in which visual culture confronts epigraphy, in defining iconographic form through naming, and in which material culture confronts literary evidence, raising issues that—at any rate in the history of religions—have ramifications well beyond the ancient world and indeed Eurasia. The volume includes, in the response by Claudia Brittenham, the thoughts of an historian of Aztec art and religion, working with entirely different material in an entirely different cultural context, on this fundamental intellectual issue in the study of religion—which is equally valid and equally problematic in thinking about Mesoamerican deities. The Aztec material, in the context of an entirely different god, Quetzalcoatl, raises precisely analogous problems of the use of texts from different contexts (in this case, some colonial and some from non-Aztec pre-Columbian cultures) to throw light on the material culture, and of visual and archaeological evidence of different kinds and from different places, linked only by the naming of the deity.

As the series editor of *Visual Conversations*, it is my hope that *Images of Mithra* will be a beacon and an inspiration to other groups of scholars who want to try to move beyond the lone expert into a world of collaborative discussion and pooling of intellectual resources to tackle big and complex questions that may be beyond the single researcher. Clearly, such collaborations need not be restricted to material culture, although it is in the arena of comparative art history and archaeology that this particular project began, and clearly they need not be restricted to the ancient or the late antique worlds. This Foreword is thus not only an introduction to a series and to its inaugural volume, but it is also an invitation to readers to approach the series editor with proposals of their own.

ACKNOWLEDGEMENTS

The 'Empires of Faith' research project, of which this book is an outcome, owes its existence to the generous funding of the Leverhulme Trust, and the collaboration between the British Museum and Wolfson College, Oxford. We are also grateful to the ERC-funded research project 'Beyond Boundaries', which allowed Robert Bracey to continue his work on this volume in 2015.

Working collaboratively is never easy, but although the writers of this book have endured seemingly endless meetings, late nights, and drawn-out conversations on the topic of Mithra, the people that have suffered the most are undoubtedly our friends and family who have had to put up with us. Chief amongst the victims are our colleagues on the 'Empires of Faith' project, Nadia Ali, Belinda Crerar, Katherine Cross, Maria Lidova, Georgi Parpulov, and especially our indefatigable leader Jaś Elsner. This book would not have been possible without their support, encouragement, and criticism, and for that we owe them all an enormous debt.

As will be elaborated upon later in the volume, this work is the result of a collaborative process. A collective voice was a target we strove towards and hope to have achieved. Yet, owing to the concomitant need for specialist knowledge in such an endeavour, each chapter is also the work of a primary author. Chapters 1 and 6 were written by Dominic Dalglish, Chapter 2 by Philippa Adrych, Chapter 3 by Stefanie Lenk, Chapter 4 by Rachel Wood, and Chapter 5 by Robert Bracey.

Over the course of 2014 and 2015, the authors gave collaborative presentations on Mithra to four different audiences in four different formats, which helped to shape this final work. In our first outing we were hosted by the Oxford Centre for Late Antiquity, which was followed by a presentation at the British Museum to a public audience. The latter two appearances were international, when we were grilled by colleagues including Hannah Baader and Gerhard Wolf at the Humboldt University in Berlin, and displayed the work in its final incarnation at the 'Empires of Faith' conference, generously hosted by the Divinity School of the University of Chicago. We are deeply indebted to the organizers and funders of these events, and to all of those who attended and offered us their thoughts; they have helped us in innumerable ways. Particular thanks are due to Bruce Lincoln and Claudia Brittenham, both from Chicago, who both independently provided us with exceptional combinations of encouragement and critique. We are especially grateful to Claudia for providing the Epilogue to this book, a contribution that broadens this project's reach considerably and in which we hope the reader finds as much enjoyment as we have.

The thorough feedback and suggestions from our anonymous reviewers was invaluable. Additionally, the individual chapters were read by or discussed with colleagues at The British Museum, Oxford University, and beyond. While we cannot name them all here, we would like to thank in particular Bruno Bijađija, Jelena Bariman, Manfred Clauss, Joe Cribb, Charles Crowther, Vesta Sarkhosh Curtis, Lucinda Dirven, Elizabeth Errington, Ted Kaizer, and Peter Stewart. We thank them for their insightful comments; any remaining errors are our own.

Further thanks go to Charlotte Loveridge and Lisa Eaton at OUP, and all those involved in the production of the final manuscript, particularly Gail Eaton, Tim Beck, and Elizabeth Foley. For granting us permission to use their images, we are grateful to the Trustees of the British Museum, Herman Brijder, Bruno Bijađija, Charles Crowther, Jaś Elsner, Dževad Hadžihasanović, Klearchos Kapoutsis, Akadémiai Kiadó, Miguel Versluys and Engelbert Winter. Richard Kelleher and Fabrice Weexsteen provided assistance with the maps and allowed us to modify and re-use them in this publication.

CONTENTS

LIST OF ILLUSTRATIONS

Several of the illustrations are positioned together in order to aid comparison by the reader. As a result, these images appear non-sequentially from their citations in the text.

LIST OF MAPS

ABBREVIATIONS

ANRW	Aufstieg und Niedergang der römischen Welt
AMIT	Archäologische Mitteilungen aus Iran und Turan
Amm.	Ammianus Marcellinus, *Rerum gestarum*
App. *Mith.*	Appian, *History of Rome: the Mithridatic Wars*
App. *Syr.*	Appian, *History of Rome: the Syrian Wars*
Av.	Avestan
BAI	Bulletin of the Asia Institute
BM	British Museum
BMC	*British Museum Catalogue: Catalogue of Greek coins in the British Museum*, 29 vols (London: Trustees of the British Museum)
CCID	*Corpus cultus Iovis Dolicheni*
CIL	*Corpus inscriptionum Latinarum*
CIMRM	Vermaseren, M. J. (1956–1960), *Corpus inscriptionum et monumentorum religionis Mithriacae*. 2 vols (The Hague: M. Nijhoff)
Comm. *Instr.*	Commodian, *Instructiones*
Curt.	Curtius, *Historiarum Alexandri Magni*
Dio	Cassius Dio, *Roman history*
Diod. Sic.	Diodorus Siculus, *Library of history*
EncIr	*Encyclopaedia Iranica*. Early entries available in print: E. Yarshater, ed. (1982–), *Encyclopaedia Iranica* (London: Routledge and Kegan Paul). All entries available online at <http:www.iranicaonline.org>
EPRO	Études préliminaires aux religions orientales dans l'Empire romain
Firm. Mat. *Err. prof. rel.*	Firmicus Maternus, *On the error of profane religions*
Hdt.	Herodotus, *Histories*
Joseph. *AJ*	Josephus, *Jewish antiquities*
Joseph. *BJ*	Josephus, *The Jewish War*
JRA	Journal of Roman Archaeology
JRS	Journal of Roman Studies
Just. Epit.	Justinus, *Epitome of Trogus*
Just. Mart. *Dial. c. Tryph.*	Justin Martyr, *Dialogue with Trypho*
Mithraic Studies I	Hinnells, J. R. ed. (1975), *Mithraic studies. Proceedings of the First International Congress of Mithraic Studies* (Manchester: Manchester University Press)
MMM	Cumont, F. (1896–1899), *Textes et monuments figurés relatifs aux mystères de Mithra* (Brussels: H. Lamertin)
MP	Middle Persian

MS	Mithraic Studies
Origen *C. Cels.*	Origen, *Contra Celsum*
Oros.	Orosius, *Seven books of history against the pagans*
PAT	Hillers, D. R. and Cussini, E. (1996) *Palmyrene Aramaic texts* (Baltimore: Johns Hopkins University Press)
Plut. *Ant.*	Plutarch, *Life of Antonius*
Plut. *De Is. et Os.*	Plutarch, *On Isis and Osiris*
Plut. *Pomp.*	Plutarch, *Life of Pompeius*
Porph. *De antr. Nymph.*	Porphyry, *De antro nympharum*
SEG	*Supplementum Epigraphicum Graecum*
Stat. *Theb.*	Statius, *Thebaid*
Strabo *Geog.*	Strabo, *Geography*
Suet. *Vesp.*	Suetonius, *Life of Vespasian*
Tert. *De cor. mil.*	Tertullian, *De corona militis*
Tert. *De bapt.*	Tertullian, *De baptismo*
Tert. *De praesc. Haer.*	Tertullian, *De praescriptione haereticorum*
Yt.	Yašt

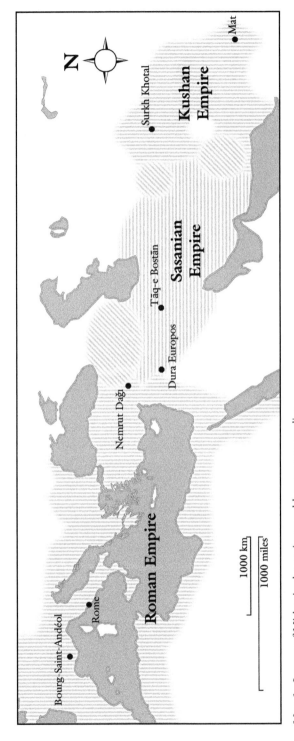

MAP 1. Images of Mithra in the ancient world, some case studies.

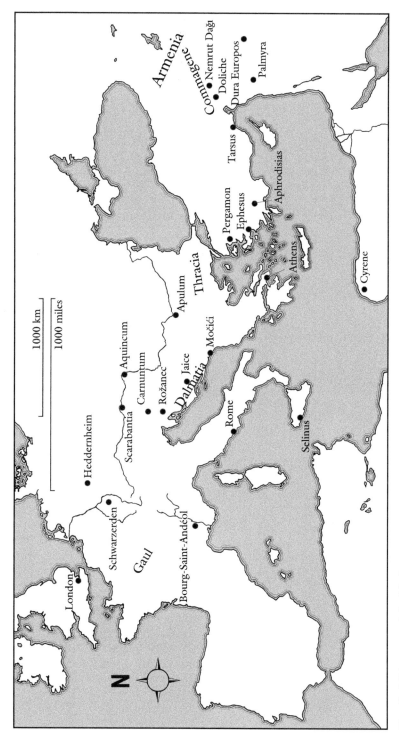

MAP 2. Mithra around the Mediterranean.

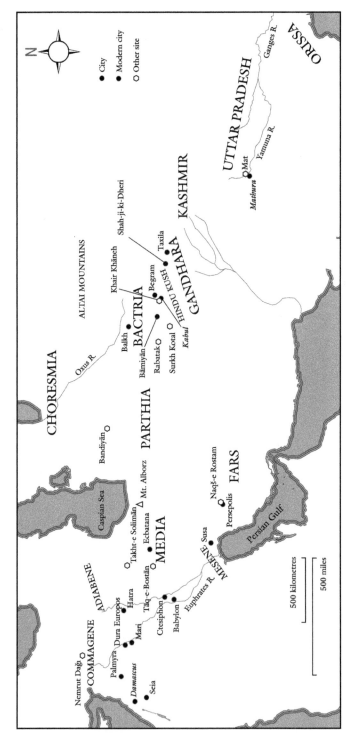

MAP 3. Mithra in Asia.

Introduction

This book is about names and images. Specifically, it is about one name that is widely associated in the early centuries AD with depictions of a divine male figure. In Middle Persian, the name is *Mihr*, in Bactrian *Mioro* or *Miiro*, and in the Latin- or Greek-speaking worlds, *Mithra* or *Mithras*. Although all of these names have a single etymological root, students have long queried to what extent the things that they label are connected.[1] This problem of the relationship between labels and things goes far beyond the scope of Mithraic studies.

In the sixth chapter of *Through the Looking Glass*, Lewis Carroll's Alice enlists the wall-bound ovoid Humpty Dumpty to unravel the meaning of the poem *Jabberwocky*. The conversation turns several times on the question of what a word means, on the relationship between a name and the thing it labels.

> 'When *I* use a word,' Humpty Dumpty said in rather a scornful tone, 'it means just what I choose it to mean—neither more nor less.'
>
> 'The question is,' said Alice, 'whether you CAN make words mean so many different things.'
>
> 'The question is,' said Humpty Dumpty, 'which is to be master—that's all.'

In this part of the exchange, Humpty upholds what we know words are: they are labels that we use; there is no reason that the same label could not be used for two quite different things. Alice, on the other hand, represents how words behave. We often assume that a single word means one thing. We try to avoid using it to mean several different things, and we assume it means the same thing when others use it. Yet we know that is not the sole possibility. It is easy to think of words that mean more than one thing, of words that mean different things to different people, or words that once meant something very different in the past.

Of course, reality lies somewhere between. Words and names clearly are labels, but there must be some consistency if communication is to be possible, and some basic agreement between different users. So if we find the same name

[1] For a discussion of the etymology, see Gordon 2012, 966f. The classic discussion of the problem of labels and the truth of our categorizations is Foucault's 1966 [1970] work, *The Order of Things* (trans.).

labelling a youth slaying a bull as a Roman sculptural group in the British Museum, a divine being greeting a king on a stele in Turkey, and a design on a coin made in Afghanistan, should we assume they depict the same person and relate to the same beliefs?[2]

The name here may function as a basis for comparison. Some comparisons are simpler than others, with much depending on proximity. For evidence close in location, time, function, and form, often what is missing in one instance can be assumed from what is present in another. Similarly, we may witness changes in thought, technological ability, economic well-being, and so on through the comparison of 'close' evidence from the past. This is a fundamental aspect of the historical process: the comparison and interrelation of evidence that we consider to relate directly to the same topic of investigation. With increasing distance it becomes more difficult to relate evidence directly, and comparisons thus become more complex. Often we justify comparison on the basis of commonalities, such as political union—the Roman Empire for example—or geographical concepts. But just how far does political union align to a shared culture? And do geographical distinctions (such as might be born from, for example, topographical peculiarities, established local social norms, or the proximity to an urban or sacred 'centre') have any bearing on religious observances? It is precisely the complexity of comparison that prompts us to ask these questions and reflect on the justifications for it in the first place.

The appearance of 'Mithra' in a variety of places was not coincidental—different peoples did not simply happen upon the same word. The name was a thousand years old or more before it labelled the images that we focus on in this volume; it appears in the very oldest of Indo-European texts, the Rig Veda. Functioning as a noun as well as a name, the word could mean variously 'contract', 'promise', 'oath', 'alliance', 'friend', or more abstractly, a moral obligation.[3] It has continued to appear, more or less frequently, in a variety of places, languages, and media ever since. Yet does continuity in the use of the name Mithra from the second millennium BC through to the present day give us any assurance that the subject it labels remained equally unchanged? Looking at this name alone, a multitude of problems present themselves.

One complication is that of language itself: linguistic translation is rarely simple. Even within Iranian lands, where veneration of Mithra is attested for perhaps over two millennia, the accompanying cultural and political changes during this vast period of time dislodge the comforting illusion of stasis and continuity. In Old Persian, the language of the Achaemenid kings (c.550–331 BC), we see

[2] For an overview of the sites we discuss in this volume, see Map 1.

[3] In contracts written in cuneiform script from 1500 BC, Mithra acts as overseer of the deals. See the extended discussion in Schmidt 2006.

the Avestan 'Mithra' as 'Mitra', written in cuneiform script. In Iran under the rule of the Parthians (*c*.141 BC–AD 224) from the northeast, however, the name is rendered as 'Mihr' in the Aramaic script of the Parthian language, and the same English transliteration is used from the Sasanian Empire's (AD 224–651) language, Middle Persian (Pahlavi). The word lingers in Farsi (modern Persian), bearing similar connotations to the earliest uses: 'mehr' can mean 'seal', 'love', or 'kindness', as well as acting as a synonym for the sun. There is an intrinsic implication of change in such endurance, whereby the name must adapt to the circumstances and demands of the contemporary situation. Names can gather all sorts of associations depending on who ends up using them. Why these people use specific names (in terms of who they wish to communicate with, what they wish to communicate, and how they use them), has the power to change a name through its very use. In Commagene (ch. 6), the name Mithras appears in combination with others to denote what appears to be one figure as 'Apollo-Mithras-Helios-Hermes'.[4] Did the name's association here with the names of three other divine figures modify its meaning?

Putting aside the issue of changes to a name in its iteration across different languages, the spelling—or rather misspelling—of the word within a single language exposes the problem of relying too heavily on any one form of a name in the first place. Coins of Kushan Bactria (ch. 5) bear inscriptions with the name MIIRO and MIORO. We might like to imagine that these two words were closely if not wholly aligned, but as we shall see, the situation was not always so simple. Equally, we might ask how much the names meant at all if people did not require them to be consistent or could not read them. Within the Roman Empire there was no overall uniformity in the name given to Mithras; the god could be described by a number of epithets, of which by far the most common was *invictus*, 'invincible'. These epithets ranged from the specific, such as 'Mithras Oromasdes' and 'Zeus Mithras Helios Cosmocrator', to generic titles applied to many deities, such as the aforementioned *invictus* and the even more ubiquitous *deus*.[5] It is usual to see a string of names and epithets attached to Mithras in inscriptions. The order of these could be changed, or certain elements included or ignored. Further potential for confusion comes with the conflation of Mithras with Sol Invictus, since one of the most popular sequences of names is 'deus Sol Invictus Mithras', the variants of which include 'deus Invictus Sol Mithras', 'Sol Invictus Mithras', and 'deus Invictus Mithras'.[6] There were two important state cults of Sol Invictus in the Roman Empire: that of Sol Invictus Elagabalus, and the Sol Invictus cult promoted by the emperor Aurelian in AD 274. This second cult has often been associated with Mithras worship, although there is little evidence to support such a connection, and indeed it seems mainly to be founded upon the

[4] *CIMRM* 32. [5] *CIMRM* 827, 463. [6] *CIMRM* 53, 422, 803, 890, 1312, 1774.

shared use of the epithets *invictus* and the name (or, in some cases, perhaps an epithet) *Sol*.[7] The confusion and conflation of two apparently separate understandings of a solar god is a salutary lesson; a shared name is not sufficient to create a shared theology.

For this book we use the most relevant formulation of the name according to the particular context in order not to obscure the local variations unnecessarily or to imply a false homogeneity. In other words, we refer to 'Mithras' when talking of sites in the Roman Empire or of scholarship on worship within the *imperium Romanum*, while in the Kushan Empire we refer to 'Miiro' since that is the most common rendering of the name in that region. Geopolitical boundaries, however, are not the only qualifying factor. When referring to the Avestan *yazata* we use the term 'Mithra', yet when talking specifically of the Sasanian context we use the transliteration of the Middle Persian name for the divine being, 'Mihr'. When addressing our topic more broadly, we use the name 'Mithra' not because it is more correct to do so, but because it came out of the hat first.

Such difficulties of comparison do not negate the value of looking at references to Mithra in concert, rather they suggest that certain ways of doing so may be more profitable than others. Invaluable work has been undertaken on the study of Mithra for well over a century, but it is worth remarking on some of the most common pitfalls to which scholarship on Mithra is susceptible, since they have shaped the appearance of our subject.

One would be hard pushed not to be intrigued by the appearance of this name in quite so many places over such a long period, and equally by some of the similarities in how the deity was represented and what his role might have been. This did not escape the attention of historians at the turn of the nineteenth and twentieth centuries, a time when *origins* were very much on the minds of scholars working in diverse fields, many of which were born out of this period. The origins of language were sought by philologists, of society by anthropologists, of the world itself by geologists, and of species by biologists. The burgeoning fields of psychology and sociology similarly sought these traits in all of us and in each community. The search for deep origins was inherently linked to the idea that there could be an initial guiding principle, which, however morphed and shaped by a host of other factors over time, could in some way provide the key to understanding subsequent manifestations of that base phenomenon.

The Belgian scholar Franz Cumont (1868–1947) was the first to study Mithra systematically with the objective of reconstructing a genealogy, a deep history

[7] See also *Historia Augusta vita Aureliani* 5.5, part of a fourth-century fictional collection of imperial biographies, which hints at a similarity between the worship of a solar deity in Rome and Persia.

across cultures and time.[8] Between 1894 and 1899 he published *Textes et monuments figurés relatifs aux mystères de Mithra*, which drew together the texts mentioning Mithra from the Iranian (Avestan), Indian (Vedic) and Greco-Roman worlds, alongside which he placed the first attempt at collecting the vast array of material evidence, predominantly from the Roman Empire. It was a monumental achievement and one that not only founded a discipline (that of Mithraic studies), but that duly placed him at its head for decades to come.

To characterize his work as simply a search for origins would be unjust; Cumont was deeply involved with questions surrounding Mithra's role and place, especially at Rome. But at the core of his scheme runs the thread of a genealogy. It is a method that makes his approach to history somewhat linear; Cumont did not consider his material so distinct as to prevent the sort of comparison that typifies the historical process. He encapsulated his objectives, methodology, and the degree to which he had been influenced by the movements of the time when he declared:

> An analysis of the constituent elements of Mithraism, like a cross-section of a geological formation, shows the stratifications of this composite mass in their regular order of deposition. The basal layer of this religion, its lower and primordial stratum, is the faith of ancient Iran, from which it took its origin.[9]

His argument ran that, over time, the key tenets of the doctrine of 'Mithraism' had developed through the accretion of elements drawn from India, Persia, Babylonia, Armenia, Anatolia, the Hellenistic kingdoms, and finally Rome, which all, ultimately, could be unravelled.[10] So strong did he believe these connections to be that he employed a geological metaphor that not only suggests but necessitates the linear, regular, transmission of Mithra. The argument that resulted from this was that the great spread of the name Mithra represented the movement of *a* god and with him a recognizable religion with distinct doctrines: Mithraism.

In addition to examining this spread of the name Mithra more closely, in particular as it might pertain to the movement of one god, this volume also interrogates the understanding of Mithraic worship as a religion. Not only was there no broad Mithraism, covering the geographic and temporal range of these chapters, from Gaul to Bactria, and from the first century BC to the fourth century AD, but it is highly improbable that there was even a single Roman religion with Mithras at its head. For this reason, we have deliberately avoided the use of the term 'Mithraism' throughout this volume except in quotations or inverted commas. The term gives the suggestion of a unified religious edifice where instead we wish

[8] On Cumont's impact, see in particular Bonnet 2006.
[9] Cumont 1903, 30. [10] Cumont 1903, 31–2.

to raise the possibilities of local variations. This eschewal of the term is in line with a growing movement away from the idea of 'Mithraism' in modern scholarship, although there the tendency is more towards 'Mithraisms' than to a complete avoidance.[11] Where such a term would ordinarily have been used, we have rather inclined towards 'Mithra/s worship'; this is still imperfect, but at least circumvents the dangerous '-ism'.

Which questions one wishes to answer and which methods one uses to attain one's answers are often reciprocal aspects of investigation that tend to reinforce each other, not always to the benefit of our understanding. Cumont did not always allow his evidence to exist in its own context; instead, he removed each instance and placed it within a context of his own devising. In drawing a picture by combining diverse texts, images, and objects, there is a danger that the reconstruction becomes a patchwork of different sources that does not really reflect any of them. Or, if one example is set up as a focus, then there is the possibility of reducing the others to caricatures as we pluck out only the parts that answer specific questions, ignoring the original complexity and context. Such an allegation requires an example. In a discussion of the origins of 'Mithraism', the context and implications of which will become clear over the course of this book, Cumont makes the following statement:

> the vague personifications conceived by the Oriental imagination now assumed the precise forms with which the Greek artists had invested the Olympian gods. Possibly they had never before been represented in the guise of the human form, or if images of them existed in imitation of the Assyrian idols they were doubtless both grotesque and crude. In thus imparting to the Mazdean heroes all the seductiveness of the Hellenic ideal, the conception of their character was necessarily modified; and, pruned of their exotic features, they were rendered more readily acceptable to the Occidental peoples. One of the indispensable conditions for the success of this exotic religion in the Roman world was fulfilled when towards the second century before our era a sculptor of the school of Pergamon composed the pathetic group of Mithra Tauroctonos, to which universal custom thenceforward reserved the place of honor in the apse of the *spelaea*.[12]

Setting aside the question of whether Cumont was correct in his assertions in this passage, we may note some troubling aspects of the way it is argued. Cumont's tone and his choice of such words as 'grotesque' (*bizarres*), perhaps better translated as 'weird' today, and 'crude' (*grossières*), cannot help but suggest his bias and prejudice his readers. More importantly, though, his views on the representations of the gods to whom he is referring are based not on evidence of such objects, but on assumptions and derivations from immensely disparate sources. What this passage amounts to is a comparison of his assumed form of 'Oriental'

[11] See, for example, Gordon 2007a, 394. [12] Cumont 1903, 22–4.

gods, based on an admixture of textual references and a range of representations of divinities that does not, in fact, include Mithra, with a similarly non-existent group of second-century BC sculptures from Asia Minor. This comparison then culminates in their placement in '*spelaea*', a Latin term for 'caves' rarely used in reference to Mithra outside the Italian peninsula and not attested before the second century AD. Thus we leap from Assyria to Rome via the Hellenistic period and Pergamon quite simply because Cumont has assumed that we can, based on his understanding of a Mithraic religion that has gone through these stages of evolution. We must allow evidence to exist in its own context and not enforce what is easy, appealing, or desired.

Cumont's position held sway in Mithraic studies for many decades and was only fully challenged in 1951 when Stig Wikander (1908–1983) published *Études sur les mystères de Mithras*. This was notably followed up by the contributions of John Hinnells (1941–) and Richard Gordon (1943–) at the First International Congress of Mithraic Studies in 1971, and Roger Beck's (1937–) review article, *Mithraism since Franz Cumont* in 1984. Their criticism exposed Cumont's search for origins for what it essentially amounted to, namely a tenuous string of fascinating, but ultimately unsustainable connections. Some of his ideas have remained strong, however, and scholars such as Martin Vermaseren (1918–1985), Robert Turcan (1929–), and A. D. H. Bivar (1926–), whilst not following Cumont to the letter, were certainly heavily influenced by his method and findings.

What this reappraisal began was a trend in the scholarship to try and reconstruct each Mithra on its own cultural and religious terms as an essentially Roman or essentially Iranian phenomenon. Many of the approaches to Mithra in Iranian studies have attempted to identify and elaborate upon an alternative independent and coherent Iranian religious system that held Mithra as a supreme deity, distinct from other Iranian religions; a conceptualization perhaps motivated in response to the challenge presented by the edifice of Roman Mithraism.[13] The few studies that have made use of images and archaeological material for this task have, on occasion, advanced additional features of Mithra's worship by inferring connections between far-flung sources. Paradoxically, perhaps, this could be seen as building on Cumont's legacy of constructing a wide-reaching Mithraic reality.[14] The work of Mary Boyce (1920–2006), perhaps the most influential scholar of Zoroastrianism of the twentieth century, demonstrated that the religious traditions of Iran had been misrepresented in scholarship, often due to the primacy given to notions drawn from ancient Greek and Roman sources.[15] Comparison between evidence relating to separate traditions was thus

[13] Nyberg 1938. For a recent example of this approach, see Pourshariati 2008.
[14] Bivar 1998. [15] See, among others, Boyce 1969.

discouraged, in part, it seems, for the connotations such approaches held of the Cumontian grand narrative.

Criticism of Cumont has not then come without justification, but his approach was perhaps more inclusivist than strictly comparative. As we have said, his study of Mithra involved a simpler form of historical comparison. One might wonder, then, whether a comparative approach to Mithra has ever been taken. In the 1970s, the meetings of the International Congress of Mithraic Studies and the short-lived *Journal of Mithraic Studies* elicited contributions from a variety of scholars working on the breadth of relevant material. At once critical of Cumont's approach but also open to discussion of the topic in a broad academic setting, they went some way to reformulating the grounds on which Mithraic studies could be undertaken. But despite many fine contributions, several of which are referenced over the course of this book, one gets the impression that real comparativism is lacking, not least because the participants did not collaborate. By not taking this potential next step, these books and journals as wholes are less than the sum of their parts.

Our aim in this volume is not to resurrect Cumont's ideal, but rather to engage in a type of comparison that criticism of his model has made somewhat unfashionable, despite the fact that it has never actually been tried. The reasons for this are quite straightforward. As we have noted, there is a general understanding that the Roman Mithras, for example, was very different to the Achaemenid Persian Mitra.[16] To put it simply: these are conceived of as different gods. What is concerning from our point of view is the tendency to assume that even if these two gods were not the same, two gods or two singular conceptions of gods nevertheless existed. It seems to us that modern approaches have gone some way to moving beyond the search for a single, original, and guiding principle. But frequently, we still limit our understanding by seeking to reconstruct a singular deity and thus a singular religion, for the regional and by turns local appearances of gods such as Mithra. We suggest that rather than trying to conceive of gods as being in some sense 'whole', one might think rather of groups of ideas, not bounded, nor absolute, but far more fluid. What our observation of the dispersion of the name Mithra may thus point to is the movement of *ideas* more than anything else.

[16] There remain exceptions. See, for example, Maria Weiss's 1998 attempt to argue that Iranian Mithra should be properly understood as the night sky and in turn that this provided an adequate explanation of the role of Roman Mithras. For a response, see Breyer 2001; and Sick 2004. A. D. H. Bivar (*passim* but esp. 1994; 1998) has argued for a united east/west understanding of Mithra (on Bivar 1998, see Khatibi 2001/2). Roger Beck 1998, has also sought the origins of the Mithras cult in the Roman Empire in Commagene, though he was searching not for the god, but rather the collection of ideas surrounding the sun.

In discussing our work with others, it has been rightly pointed out that to move away from the construction of a 'god' to an 'idea' or even 'ideas', 'can sometimes seem like a facile escape hatch'.[17] These terms can so easily become versions of the very reconstructions they were meant to move us away from; reifying an 'idea' would be no different to having an absolute notion of a divinity. An equally important observation is the danger of conflating our own confusion (the result, in particular, of our fragmented evidence) with the views of people in the past, and thus our reconstructions of ancient religion. This would be as anachronistic as constructions that assume unity based on modern perceptions of religion. Yet these are unavoidable risks. Our focus on 'ideas' and their transmission is simply an heuristic device meant to enable us to grasp our evidence more firmly, to allow for more fruitful forms of comparison, and to develop different types of interpretation through a more flexible approach. The 'ideas' discussed here are meant to replace existing models of 'gods' not to replicate them; whether we have been successful is not for us to judge.

An essential difference between the approach we take here and Cumont's is a sensitivity towards the requirements of the evidence and the need to avoid disproportionate comparisons. It can be all too easy to make comparisons between objects in a utopian space free from the limitations of real-world evidence, a non-place that exists only on the page of an academic book.[18] We have come together as specialists, each with an appreciation of the complexity of our fields, and perhaps most importantly we have focused on objects and images. The latter point is crucial to an investigation of a figure known at certain times predominantly through material culture, some of it accompanied by inscriptions.

In starting with images, we are consciously adopting a method criticized by Roger Beck in one of the most important contributions to the study of Mithra in recent times.[19] His criticism, it must be said, is directed specifically at the study of Mithras in the Roman world, but nevertheless has ramifications for our broader enterprise. His argument is against the adoption of an iconographically centred approach, by which he means taking an evaluation of images as the foundation for subsequent reconstructions. His critique is targeted against the need to provide a meaning for images; a meaning, he claims, that we cannot hope to grasp without recourse to what few literary texts we have and by the contextualization of scenes, such as the Roman tauroctony, within their spaces of worship, namely the Mithraic cave or *mithraeum*.[20] Beck emphasizes the need to get 'inside' the worship of this god in the Roman world, asking not only what images and objects meant, but also how these meanings were communicated.

[17] The insightful opinion of Claudia Brittenham, pers. corr. [18] Foucault 1970, xvi–xxvi.

[19] For criticism of trying to begin with a study of iconography, see Beck 2006, esp. 3–4, 17–23.

[20] For discussion of the tauroctony and Mithraic sacred spaces, see chs 1–3.

The argument he presents as a result is fascinating and we shall reflect on his conclusions in due course.

Beck's critique of approaches that begin with images, however, is more directed against an expected outcome than it is against a methodology per se. He makes it quite clear that the target of his criticism is the Cumontian School: those who, following on from Franz Cumont, placed the decipherment of 'Mithraic doctrine' at the top of their agenda. Today, few scholars are likely to refer to 'doctrine' in their accounts of Mithraic worship. A concept commonly associated with Christianity, the idea that doctrine was a key part of the Mithraic religious experience in the Roman world is nothing more than an assumption, and Beck's criticism in its application is thus quite valid. But the approach of beginning with images is not redundant as a result. Beck's criticism implies that to begin with textual sources rather than images is to avoid constructions based on an assumed doctrine, but in fact the opposite has often been the case; although the word is avoided today, text-based reconstructions of 'Mithraic' worship can seem to be seeking uniformity.

It is time that the surviving images be analysed for the multitude of possible meanings that they carry, rather than trying to ascribe to them a fixed and pre-ordained interpretation. This is not simply a response to the methods used by scholars in the past, but is a base reaction to our evidence. Almost everything that lends itself to a reconstruction of Mithra, his cults, and his worshippers, particularly in the Roman Empire, is material not textual. Before roughly the first century BC, we have very few depictions of figures that we can firmly associate with Mithra.[21] In the following four to five hundred years, depictions of Mithra can be found right across the area under consideration in this volume, as well as specific sites where a figure going by this name was venerated. Whether this change is the accident of survival or the result of something far more profound is not our topic. But what is central to this investigation is the reality of the material evidence in the times and places we address and its centrality to conceptions of Mithra.

Much of what literature we have from the Roman world belongs to the rhetoric of the Church Fathers, who were intent on maligning polytheistic observances rather than representing them in an even-handed manner. The few exceptions to this are not even 'insiders', so to speak, since they do not appear to have been worshippers of the god. No scripture or interpretative manual for the worship of Mithras has come down to us, nor is such a thing as a sacred

[21] For a brief review, see Grenet 2006a.

handbook likely to have existed.[22] Looking eastwards, the Avestan sacred texts are crucial, yet they have a complicated history of transmission. Some elements are thought to date to the beginning of the first millennium BC, after which they were transmitted orally with other parts composed and added at later stages. What we have is the remains of the corpus of hymns and teachings that was not compiled until the fifth or sixth century AD. The Sanskrit Rig Veda also gives us an extraordinary insight into the use of this name and the evolving conception of a figure, but has a similarly convoluted history. Interpretation of material culture is therefore paramount to our understanding of Mithra. It can be all too easy to dismiss what representations we have as manifestations of long-held mental conceptions of the god—to believe that they simply illustrate a deeper truth to be found only in texts—but doing so bypasses all that we might gain from thinking about how images function and the complex roles that objects and images played in religious life.

Bearing all of these caveats and warnings in mind, we present a series of occurrences of the image of Mithras, Mithra, Mihr, or Miiro, in order to explore the question, 'what's in a name?' These are disparate in time and provenance, spanning the first century BC to the fourth century AD, from Western Europe through to Central Asia, though given the long history of the name this is a relatively concentrated period. Each example is allowed the significance of its own contextual background, and the questions that each raises finds resonance with the others. In doing so, we hope to illuminate the range of ideas and the potential for their flexibility and movement in a non-linear sense.

We begin in the first chapter with two marble tauroctony statue groups in the British Museum's collection. Both are thought to be originally from Rome and date roughly between the end of the first and the second century AD. These carefully constructed compositions, painstakingly restored in the seventeenth and eighteenth centuries following damage in the intervening millennium and

[22] Cumont, *MMM* II, collects relevant texts in ancient Greek and Latin up to the end of the first millennium AD. Freely available translations have also been provided by Roger Pearse at www.tertullian. org/rpearse/mithras, where one will also find a number of other useful resources. Of the texts, the neo-Platonist Porphyry's *De antro nympharum* has attracted the most attention. This is in no small part due to his mention [*De abstinentia* 4.16] of histories of Mithras written by Eubulus and Pallas. However much we may long for them, we know that they could neither provide us with a definitive history of Mithras and his worship in the Roman world, nor can they extend such an authority to Porphyry. On Platonic influence, see in particular Turcan 1975. The so-called 'Mithras Liturgy', thought by Albrecht Dietrich to detail a Mithraic ritual for the participant's ascent to heaven, remains a controversial source. Whether we believe the text to be Mithraic or not, it is very much a local, Egyptian work (Betz 1991, 251–2; 2003). See also Brashear 1992. For a very brief summary of the scholarly debate, see Gordon 2003. Aside from textual transmission, others have discussed the possibility of a book of images. See further Downey 1978, 138–9.

a half, simultaneously present us with the characteristic representation of Mithras in the Roman Empire, yet also show the difficulties in reconstructing ancient religion from a fragmented material record.

Our second case study is of two gypsum reliefs from Dura-Europos, a city on the Euphrates in modern Syria. Not only is this a rare example of two carved tauroctony reliefs on more or less equal display in the same *mithraeum*, but each relief respectively shows a unique feature of sacrifice. This is particularly visible on the second relief, where the patron who dedicated it in AD 170/1 chose to have a representation of himself included on the Mithraic scene. This invites the viewer to ask questions about the relationship between Mithraic patrons, wor-shippers, and the god Mithras himself.

The third chapter examines rock-carved tauroctonies in *mithraea* and in particular the monumental tauroctony in Bourg-Saint-Andéol, southeast France. It is noticeable that the carvings are set in different ways within each *mithraeum*, which may suggest differences in the worship of and belief in Mithras between individual communities. The chapter seeks to broaden our ideas of what the tauroctony meant to worshippers by examining the possible impact of the inter-ior setting and exterior surroundings on ancient perceptions of and interactions with the reliefs.

From rock reliefs in the Roman world we move to a late fourth-century rock relief in the Sasanian Persian Empire. At a site in western Iran called Tāq-e Bostān, an unlabelled radiate figure is most frequently identified as the Avestan divine being Mithra. He accompanies two Sasanian kings in a scene commemorating the transition of power from Šāpur II to his successor Ardašir II. This depiction of Mithra—unique among Sasanian rock reliefs—prompts us to explore not only the problem of identification, but also the role of Mithra in the religion that became what we now know as Zoroastrianism and how, if at all, we reconcile images with our far more abundant yet scattered textual sources.

An instance where we do have a labelled image of Mithra, however, prompts further questions concerning the precise character of who is represented and what was understood by such labels and images. This image is the subject of chapter 5 and appears on coins minted in Bactria, part of the Kushan Empire that spanned parts of modern-day Afghanistan, Pakistan, and northern India from the early first century AD to the early third century AD. How does the name 'Miiro' on these coins relate to the religious beliefs of the Bactrian population?

Finally, on the mountain of Nemrut Daği in the kingdom of Commagene, we have a first-century BC stele with a depiction of a king, Antiochus I, grasping the hand of a figure named 'Apollo-Mithras-Helios-Hermes'. This image and others from across the kingdom depicting a god named in this way call upon a variety of iconographic and, through the name, linguistic traditions that raise questions

about the way conceptions of the divine could be selected, rationalized, and propagated. This act of comparing and combining religious traditions, often referred to as 'syncretism', allows us to think about what the use of the name Mithras suggests to us beyond the relatively simple transmission of *a* god.

Despite this being a comparative and joint venture, the core of the book consists of individually authored chapters. This structural separation assuages several methodological concerns. We do not want to give the impression that any of the cases presented is of immediate relevance for the understanding of any of the others. Where we think it is appropriate, we have made direct references to the other chapters. In this way, each case study is allowed the space to speak in its own terms, rather than as a reflection or proxy for any of the others. The question of what significance each chapter holds for the understanding of the others is tackled in the Conclusion.

This book could not have been written by any of us individually. In fact, none of us would have considered writing this book the way it is now without exposure to the often divergent and changing flow of ideas from discussions with each other. We have attempted to be truly collaborative: while each chapter is structurally separated from the others, the texts of each individual author underwent the same process of shaping according to our shared vision of this project as did the Introduction and Conclusion. Each chapter, therefore, is the author's own, but could not have been written without the contributions, criticisms, and challenges brought by all the others.

The epilogue to this book is an indication of how this project has evolved since we began casually discussing appearances of Mithra in our respective fields over lunch. At that stage we could never have imagined that our suggestions might warrant a response from a Mesoamerican art historian, and that our approach might resonate beyond our own particular areas of interest. Claudia Brittenham's short essay, 'Quetzalcoatl and Mithra', is an independent response to this book that reflects on our conclusions in relation to a wholly removed instance of divine representation. This vignette speaks for itself as a fascinating demonstration of the types of comparison that may fruitfully be made, and we believe that the example of Quetzalcoatl inspires more reflection on the topics discussed here.

Our aim has been to illuminate from different angles a range of ideas we want to bring forward about how Mithra was conceptualized—presented and seen— in the ancient world. Since we started with the ambition to argue with one voice, it was necessary to take the time to engage in debate with each other until we could produce this voice. Here lies one of the core ambitions of our collaboration, to address the question of how to approach interdisciplinary research for the most edifying results. It is a problem that has and will continue to attract a great deal of attention. We wish to make a positive contribution to this debate. Overcoming the boundaries of academic disciplines and specialist expertise,

we would argue, needs to be done as a collective, and, whether or not the members decide to speak in one voice, only true exchange and conversation will make cross-fertilization of ideas possible.

It is clear there are many questions and many problems that this book will not answer. Some are intractable and there are others that would require the careful grind of scholarship on a larger scale than we can offer. So instead we present three questions which are a little larger than the many details. They are questions that have driven our research into the problem. First, how might our understanding of each of these objects be furthered by learning about the others that share the same name? The second question is that which attracted us to Mithra in the first place: what does the appearance of a name in such varied contexts mean for our understanding of ancient religion? And the third is, to what extent can material culture tell us anything about religious practice?

ONE

Reconstructions

Mithras in Rome

We begin our investigation not with our earliest image, nor with one found midway between geographical extremes, nor with one from what might be considered an originary point. We start, rather, with what is probably the most famous form of representation of Mithras, an image that is arguably the cause of much of the attention paid to Mithras. Two examples, both rendered as statues and currently housed in the British Museum, are thought to have been made in Rome. They suggest a great deal about which characteristics of Mithras may have been deemed important, and yet they also exemplify the difficulty of reconstructing the past, particularly religion, from fractured remains. It is a challenge that has piqued the interest of scholars from the Renaissance through to the present day. The enduring appeal stems from the numerous possible interpretations of these images, not least because our knowledge of their significance for worshippers in antiquity is appallingly slight, yet nevertheless so tantalizing. Consequently, imaginations have at times been free to roam. As interesting as the products of such thinking may be, there is a real danger of forgetting that our reconstructions of this image's place in the minds of ancient worshippers (however definitive they may seem) exist only as possibilities. Given that this image type is so central to the modern conception of Mithra worship, the problems involved in its assessment seem a fitting place to begin our enquiry.

THE STATUES

The first of our statues is a free-standing sculptural group roughly 130 x 150 cm in a fine, greyish marble, depicting a young man apparently in the moment of killing (perhaps sacrificing) or wounding a bull (Fig. 1.1).[1] The young man's

[1] *CIMRM* 592.

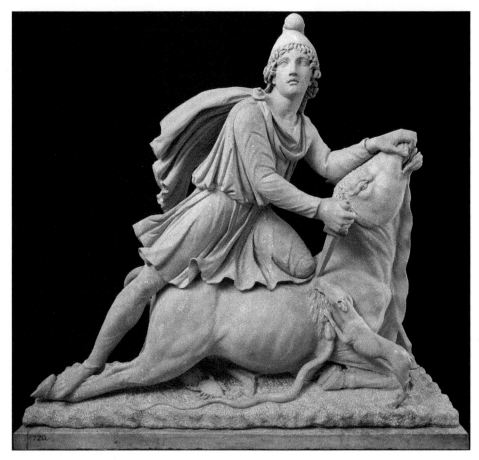

FIG. 1.1. The Standish tauroctony. BM 1825,0613.1.
Trustees of the British Museum.

right foot presses the bull's hind leg to the floor as he pushes its body down with
his left leg. With his left arm, the youth pulls back its head and with his right he
has struck the bull's shoulder with a dagger. He is dressed in a long-sleeved tunic
with thin trousers beneath; he wears a short cape and sports a Phrygian cap
above a head of longish curls. Present at the scene with the young man are a
snake and a dog, both of which clamour at the wound, and a scorpion that
appears to be grasping for the bull's genitals.

The composition is full of muscular tension: we see the dagger still firmly
grasped in the youth's hand with the tip just barely entering the bull's flesh; his
leg is outstretched with effort and his cloak billows as if in motion behind him.
The bull too has muscles taut with exertion, its front legs are constrained awk-
wardly beneath its body, and its face shows signs of the pain and distress it is
suffering. But for all the drama of the scene, the young man's head is turned

away from the bull with an almost unsettlingly placid, even emotionless expression on his face.

There is no inscription on the statue to tell us who this figure is. We have no notion of the piece's archaeological context or even a firm idea of its provenance other than that it was acquired in Rome in 1815 by a Charles Strickland Standish, who subsequently sold the piece to the British Museum in 1825.[2] We do not know when it was made, who made it, or what they made it for. And yet there can be no doubt that this is a depiction of Mithras. This scene is a so-called 'tauroctony' (a modern term), or bull-slaying, and appears about seven hundred times in finds from across the Roman Empire between the first and early fourth centuries AD, on everything from the statue we have here to gems and glass cameos.[3] Enough of these are inscribed with the name Mithras, such as our second statue from the British Museum (Fig. 1.2), for us to be sure that this is a representation of the god.

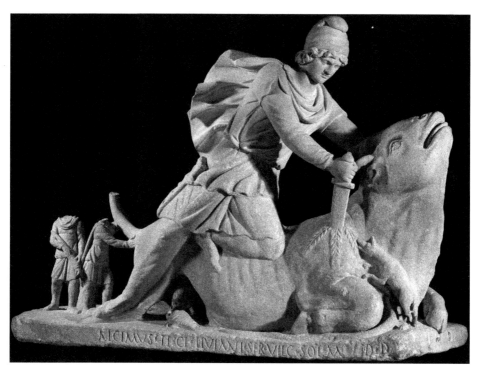

FIG. 1.2. The Townley tauroctony. BM 1805,0703.270.
Trustees of the British Museum.

[2] Ellis 1836, 1.283.

[3] The vast majority of these are found along the northern borders of the empire, particularly modern-day Germany, Austria, and along the Danube, and from the Italian peninsula, particularly Rome and Ostia.

Part of the Townley collection bequeathed to the Museum in 1805, this second statue has never received quite the same position there as its more polished alternative.[4] The inscription, found in slightly different forms on the front of the statue and the back of the bull itself, tells us that a senior slave, a certain Alcimus, dedicated it to 'Sol Mithras'. Richard Gordon has argued convincingly that this is one of our earliest dateable representations of Mithras from Rome (AD 98/99).[5] The statue itself is undoubtedly a depiction of the scene we saw before, but any viewer will immediately notice several features that distinguish it from the former. It is considerably smaller, roughly 80 × 110 cm, and made of a coarser, darker marble. Over on the left of the scene there are two male figures (now without their heads), significantly smaller than Mithras on the bull but apparently dressed in the same garb.[6] These are the torch-bearers Cautes and Cautopates, known from numerous other representations of this scene. Between them and the rump of the bull are the small feet of a bird: presumably all that remains of a raven. At the wound can be found the now familiar dog and snake, and under the bull a scorpion is intent on attacking its genitals once again. Mithras' dress here is the same as on the other statue with little to distinguish the two barring the scabbard on his belt, the extra fold in the lower half of the tunic, and his fine slippers. His position on the bull is different as here we see both of his legs and he is more emphatically at the front of the scene. The bull has a much larger dewlap, perhaps giving the impression of greater age, although we can see in the shortened hind legs and less detailed features of its head a suggestion that the artist was little concerned with a naturalistic representation. This impression is added to by the sheaves of wheat that appear to be stemming from the bull's wound and, of course, the two males presented on a smaller scale who contribute to make the scene distinctly unlike any imitation of reality. And yet one of the most notable differences between our two statues is an element that might make this scene seem more real—namely Mithras' gaze inwards, towards the bull and the action he is taking.

[4] BM no. 1805,0703.270; *CIMRM* 593; the inscription is *CIMRM* 594. Readers may be intrigued by the connection that existed between the Standish and Townley families. It would appear that Charles Townley was the great-uncle of Charles Strickland Standish, both sides having their family homes in Lancashire. I would not wish to speculate on the significance of this beyond noting that it is a pleasant coincidence.

[5] Gordon 1977–1978; *CIL* VI, 30818: 'Alcimus, slave-bailiff of Tiberius Claudius Livianus, gave the gift to the sun-god Mithras in fulfilment of a vow'. Front: *Alcimus Ti(berius) Cl(audi) Liviani ser(vus) vil(i)o Sol(i) M(ithrae) v(otum) s(olvit) d(onum) d(edit)*. Back: *Alcimus T. Cl(audi) Liviani ser(vus) vilic(us) S(oli) M(ithrae) v(otum) s(olvit) d(onum) d(edit)*.

[6] It is unclear when these two figures lost their heads, but Sir Henry Ellis (Ellis 1836, 1.284) refers to only one of them as headless.

RECONSTRUCTIONS

Unfortunately, what is displayed by these statue groups is not entirely ancient. On the first, the bull's muzzle, ears, and horns, the upper half of the dog at the wound, Mithras' left arm, much of his right including the dagger, his cape, and finally his head are all restorations (see Fig. 1.3). The second has been even more heavily restored with the entire top half of Mithras except for a portion of his right arm being reconstructed. This leaves us in a position where neither of these statues can be relied upon as evidence for the original portrayal of the god. For this we have to turn to the hundreds of representations of the scene that have kept their heads, wherein we see that Mithras rarely turns to face the bull, but rather faces out of the scene or towards a bust of Sol.[7] Thus it is highly likely, though by no means definite, that Mithras was turned to face outwards on both of these statues in the ancient past.

Significantly, the problem of the heads is solved by knowing that these are both reconstructions, but it raises the question of why such divergent restorations were made and what impact this might have on the way we understand this scene. Two notable examples of reconstructions where Mithras has been made to face the bull can be found in the Louvre and in the Vatican Museum, both of which are presumed to originate in Rome or nearby. The first (Fig. 1.4) may come from the Capitoline hill at Rome; it was certainly displayed there for a time before being moved to the Villa Borghese collection prior to its 1807 sale to the Louvre, but it is unclear when restoration of this object took place.[8]

The Vatican sculpture's repairs can be more definitely attributed to the celebrated restorer Vincenzo Pacetti, most famous for his restoration of the Barberini Faun prior to its sale to Pope Pius VI in the eighteenth century.[9] From what we know of our second statue, it would appear to have been restored at around the same time. Bought by Charles Townley in 1768, the statue, as far as we know, had been in Rome from at least the seventeenth century as it was spotted by Cittadini (1553–1627) in the collection of Cardinal Farnese on the Via Julia. Townley bought the statue from a sculptor named Giuseppini. Though we cannot be sure of when the initial reconstruction of the head and other pieces were made, it was likely during either this man's possession or that of Cardinal Farnese.[10] Thus, there would seem to be a cluster of such restorations made in

[7] There are exceptions, such as a relief now in the Cincinnati Museum (No. 1968: 112; Gordon 1976, I, Pl. XXV) and a gem now in the Walters Art Museum, Baltimore (No. 42.1342). Some depictions show the god looking forward, though apparently not directly at the action, such as a fractured relief now in the Louvre, once in the Borghese Collection, Rome (*CIMRM* 586), and a bronze plaque now in the Metropolitan Museum of Art, New York (No. 1997.145.3). Other examples are few and far between.

[8] *CIMRM* 415. [9] *CIMRM* 548. [10] Smith 1904, 87–9, no. 1721, fig. 11.

FIG. 1.3. The absence of repairs: the Standish and Townley tauroctonies without reconstructions. Trustees of the British Museum; author's modifications.

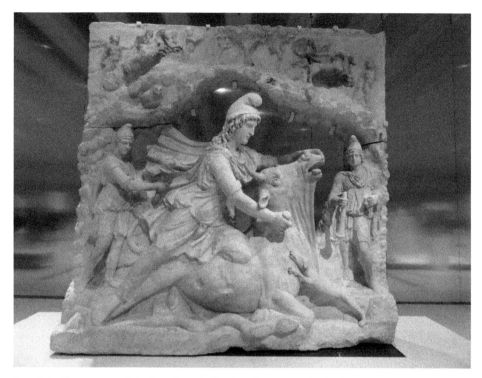

Fɪɢ. 1.4. Tauroctony of the Borghese Collection, Rome, now in the Louvre. Louvre MR 818. Image: Jean-Pol Grandmont. Creative Commons Licence.

Rome between the seventeenth and eighteenth centuries, and there is a distinct possibility that they may have influenced one another.

That the Standish version happened to be restored in a manner more akin to its ancient type than was the Townley is no great historical mystery. On one level, they are simply a result of there being more than one way of repairing the head of Mithras. The restorer of the Standish statue may have simply been more familiar with other un-restored but well-conserved representations than was that of the Townley, or with ones which had been more 'correctly' restored in line with ancient imagery. Or, as we have noted, it might well have been the result of a number of such restorations being made at the same time. Whatever the case may be, this type of reconstruction most plausibly stems from what made most *sense* to those doing the restoration; it is simply more logical for Mithras to be facing the action he is taking than to be looking away. This is particularly so in the depiction of an encounter that otherwise suggests a visceral struggle between the two protagonists rather than an otherworldly contest. We cannot be sure whether this decision was made simply for aesthetic purposes or whether it was believed to be historically accurate, but whatever the intention of the restorers might have been the pieces remain modern interpretations of an ancient drama.

Whilst we know that in the ancient form of this scene Mithras almost always faces out or away from the action, this particular tradition of restoration is somewhat unsettling for it begs the question: are there other restorations that we happily propagate that are based on a similar rationale to this? Given that scholars are aware of the restorations made to these objects, their additions have not been taken as reliable sources of evidence. You might well ask why, if these objects have been so badly damaged, we have chosen them to open this book. It is quite simply because however well any of our objects from the past have survived, they are always fragments of something larger. These statues stand as a cursory reminder of that fact, as something of an allegory of the fallibility of our explanations and assumptions about the past. Our own preconceptions are an issue not only in how we approach discrete objects such as these statues, or how we examine larger and more complex archaeological sites, but also how we conceive of cults, such as that of Mithras, for which we have only the scantest of remains. We noted before that the restoration of the Mithras figures so as to face the bull makes more sense. In reality this is only a half-truth, for the rejection of the logical gaze of Mithras was not unintentional; it would have made sense to the creators of this type and its subsequent ancient viewers, and it could have done so in more ways than one.

THE TAUROCTONY

It is from this position, where we have begun to understand some of the dangers that befall us when we strive to reconstruct the past, that we can tentatively ask what this scene, displayed similarly but not identically in our two statues, can suggest to us. As we noted in the introduction to this volume, scholars in the past have been concerned not only with the origins of Mithraic worship, but also with the decipherment of these origins through 'doctrine' presented in images and texts. Whilst we may be justified in ascertaining certain common understandings between worshippers of Mithras, there is no reason to exclude the wealth of valid interpretations by turning these into doctrinal imperatives.

The tauroctony scene appears to be specific and indeed its elements are clearly positioned to work together to place Mithras at the heart of the action. The god almost always faces out and the dagger is usually depicted at the point of entering the bull's shoulder. With slight differences, Mithras, the bull, scorpion, dog, and snake are almost identically positioned in our two examples, and have parallels in seven hundred or so others. In a scene that appears to be so uniform it is worth reflecting on what impact small differences might have had, a theme we return to later in this volume.[11]

[11] See ch. 2.

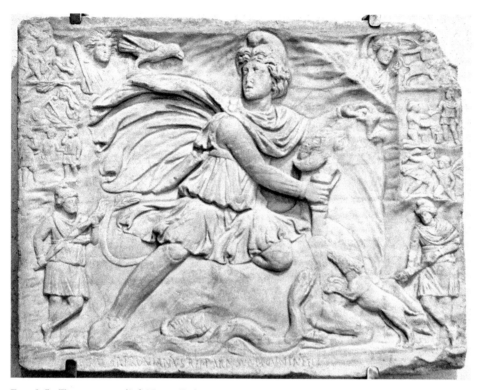

Fig. 1.5. Tauroctony relief, Nesce, Italy.
Image: Marie-Lan Nguyen. Creative Commons Licence.

Beyond our tauroctonies, other depictions of this scene, particularly relief sculptures, bear additional elements that if not archetypal are certainly common (see Fig. 1.5). Cautes and Cautopates, the two small male figures seen on the Townley sculpture, often appear either side of Mithras and the bull, with their torches pointing up and down respectively, and with their legs crossed. The wheat that stems from the bull's wound in the Townley piece can alternatively be found sprouting from the bull's tail. A raven, the feet of which are visible in the Townley, often appears above Mithras or riding upon his cape. On some examples from the Rhine and Danube regions of central Europe, a lion and a cup or crater appear beneath the bull.[12] Representations of the sun (Sol) and moon (Luna) are frequently positioned in the upper left and right corners of the scene respectively, either as busts or in their respective carriages, the four-horse chariot (*quadriga*) of Sol, and the *biga* of Luna drawn by two bulls. This may seem odd; after all, our inscription on the Townley statue refers to 'Sol Mithras'. Anthropomorphic representations of Sol as the sun and Luna as the moon are common in ancient art and need not refer to a god as such. However, in many

[12] A well-known example comes from Nida/Heddernheim, Germany (*CIMRM* 1083).

examples of the scene, Mithras' head is turned not only away from the action, as we have noted, but over his right shoulder in the direction either of the raven on his cape or the figure of Sol.[13] The involvement of Sol in such scenes would seem to suggest a greater role in the drama as a discernible god, but whether this was understood across the expanse of the Roman Empire and whether it remained consistent from the first to the fourth centuries AD we cannot say. As we shall see later, Sol and solar iconography are frequently associated with Mithras worship not only in the Roman world, but right through to northern India. The relative stability of the association with the sun coupled with the ambiguity of the exact relationship between Mithras and the sun remains one of the most intriguing problems surrounding the name.

A crucial part of the way scholars have approached the tauroctony stems from how they have reconstructed the worship of Mithras in the first place. Our earliest evidence for Mithras in the Roman Empire, aside from the Townley tauroctony, comes from places such as Heddernheim in Germania Superior (near Frankfurt), and Carnuntum in Pannonia (eastern Austria) towards the end of the first century AD. Evidence then dramatically increases from the second to the early third century, spread from Britain, through Spain and North Africa, along the Danube, on the Black Sea to the Levant and Syria, and especially in Rome and Ostia. The worship of the god appears to have been particularly strong amongst soldiers. The last traces of Mithras worship from Rome come in the fourth century after the adoption of Christianity as the religion of the empire. A basic structural assumption about Roman Mithras worship is that a closed, hierarchical community of male-only initiates honoured the god in private at each site of worship known as a *mithraeum*. Whilst there is strong evidence for initiatory rites having taken place at specific sites, very little is known about the strength of ties between one community and another. It is sometimes assumed, though, that a more or less unified set of rites was practised, and in turn that a universal understanding of what the tauroctony meant existed amongst the god's worshippers rather than a range of possibilities. The following sections of this book, which look more closely at communities of worshippers and the contexts of Mithra's image respectively, raise some interesting challenges to the assumption of homogeneity between and perhaps also within distinct groups of worshippers, and equally question the extent to which they were closed communities. Suffice it to say that here we may entertain the possibility of a range of meanings being valid.

[13] There are many instances of this, though they are in the minority. Particularly clear examples come from two tauroctonies in the S. Stefano Rotondo, Rome (Lissi-Caronna 1986); the exquisite painted tauroctony of Marino, Italy (Vermaseren 1982, 4–11) and the elaborate relief at Neuenheim, Germany (*CIMRM* 1283).

READING THE TAUROCTONY

Why was this image important? How does it convey information? What does it suggest? And who is this Mithras figure at the heart of it? These are not simple questions and we cannot respond to them fully here, but they serve as an introduction to a vast topic and equally sizeable literature. Since the scholarly investigation of the worship of Mithras began, interpretation of the tauroctony has carried on unabated. Just as important as the overall meaning of this scene, which we will never fully grasp, is the *way* that it means what it does. Over the years, several important propositions have been made about how the tauroctony functioned that explore different aspects of the scene and its relation to the worship of Mithras.

Reading the tauroctony: precedents

One way of thinking about the image is through artistic and religious precedents, which may indicate the depth of its tradition or indeed the extent of its innovation. For all the specificity of this scene it does appear to have forerunners, many of which have long been recognized. The tauroctony possesses a number of stylistic similarities with other Greco-Roman sculptures, in particular statues, plaques, coins, medallions, and engraved gems depicting a winged Victory or Nike in the act of slaughtering a bull (Fig. 1.6).[14] The comparison with the tauroctony is striking, so much so that an example in the British Museum was once referred to as a 'female winged Mythras'.[15] The stances—Victory's knee pressing the animal down while her left hand usually grasps and pulls its head back exposing the neck—are remarkably similar to the Mithraic composition. Other elements are not. Aside from the differing appearance of the two gods, the moment of inflicting the wound or deathblow does not appear crucial in the Victory scenes; sometimes the knife is held aloft while in other instances the goddess has struck.[16] In the Mithras tauroctony, the knife has almost always just entered the bull's flesh. Notably, Victory has also fixed her stare on the action and not outwards. Thus whilst this commonly depicted scene presents parallels and a potential precedent for the tauroctony, there are important differences.

[14] Examples of these objects abound; the British Museum alone has examples spanning antiquity in all of the media mentioned. The comparison has long been made and is still somewhat in vogue, though what to take from it continues to be a matter of debate: Beck 1984a, 2075; Faraone 2013, 108–10.

[15] Charles Townley's first description of BM no. 1805,0703.4 was as: 'A group of a female winged Mythras kneeling upon a bull, and stabbing it with a dagger. The plinth is about four feet long. It was found in 1773 by Mr Gavin Hamilton in the ruins of the villa of Antoninus Pius, in the spot now called Monte Cagnnolo' (TY 12/3, street parlour 9).

[16] As ever there are some exceptions in representations of the Mithraic tauroctony that we should be aware of. See, for example, the statue group in the Terme del Mitra, Ostia, Fig. 2.6.

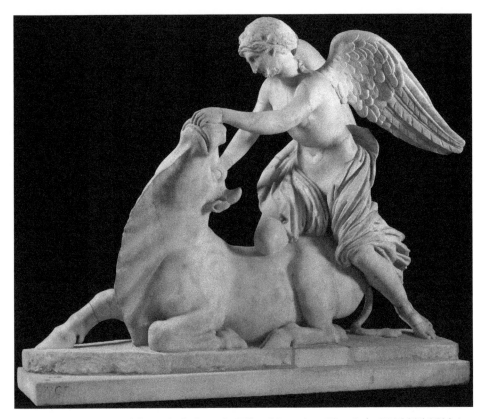

FIG. 1.6. Nike/Victory killing a bull, from the Villa of Antoninus Pius, Italy. BM 1805,0703.4. Trustees of the British Museum.

Are there precedents then for the direction of the god's gaze? As we have noted, the god sometimes stares directly out of the scene, sometimes over his right shoulder towards Sol, but rarely at the bull. Though they are by no means a coherent group and are hardly common, Perseus killing the Medusa, forced by her deathly stare to look away from the scene (Fig. 1.7), Cyrene wrestling the lion, and the figure of Claudius (who looks not out, but away) vanquishing Britannia at Aphrodisias (Fig. 1.8) are some instances that suggest the concept was not novel.[17] It must be said, however, that whilst examples abound of gods and heroes looking 'beyond' the scene, far fewer couple this with a simultaneous action. Even so, the dreamy-eyed, wavy-haired, and beardless heads of ephebic youths common to Hellenistic and Imperial Roman art bear more than a passing

[17] Perseus: Perseus and Medusa sarcophagus from near Aquincum, Hungary; or the Perseus and Medusa metope from the sixth-century BC Temple C at Selinus, Sicily, now in the Museo Archeologico, Palermo. Cyrene: second-century AD inscribed relief from Cyrene, North Africa, BM no. 1861,1127.30. Claudius and Britannia: relief on the so-called 'Sebasteion' at Aphrodisias; see Erim 1982, 279; Smith 2013, 144–7, pl. 61–2.

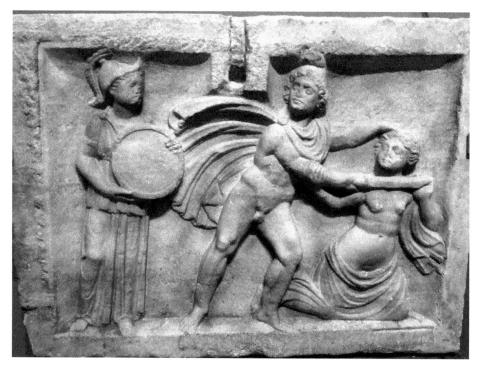

Fɪɢ. 1.7. Perseus and Medusa sarcophagus from Pécs-Aranyhegy, Hungary. Hungarian National Museum 62.84.1.

Author's image.

resemblance to that of Mithras in the tauroctony. Similarly, the god's clothes, in particular his hat, trousers, and cape, are common to stereotypically 'eastern' characters in Roman art, some of whom, like Attis (Fig. 1.9), were also deities.[18] Part of what the tauroctony was, therefore, and perhaps also part of what it *meant* to its viewers was bound up with the stylistic and iconographic traditions of the world in which it was developed.

When the image was formulated may also have a bearing on what it suggests. Many of these image types were near contemporaries of the first tauroctonies for which we have evidence, and indeed they coexisted following its inception. Some do of course have their own long histories: a winged Nike, for example, can be found in the act of killing a bull on the balustrade of the fifth-century BC temple of Athena Nike on the Athenian Acropolis.[19] The figures of youthful men appear

[18] Two good examples, albeit from the second century AD, come from reliefs in the temple to the Deified Hadrian in Rome. The depictions of Parthia and Phrygia in particular adopt a range of 'eastern' elements to make it clear to the viewer what they are looking at. On the creation of a sense of 'otherness', not only in relation to Mithras, see Elsner 2007, 235–46.

[19] Faraone (2013) believes that this was a representation of a *sphagion*, a type of military sacrifice performed by a soldier before battle in the Greek tradition.

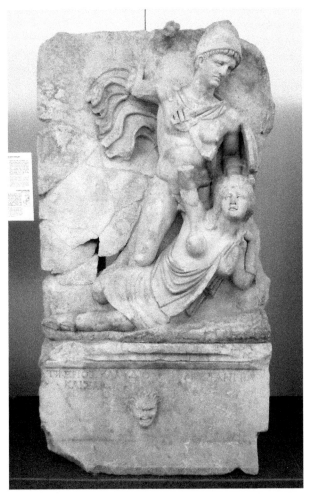

FIG. 1.8. Claudius and Britannia relief from the Sebasteion, Aphrodisias. Aphrodisias Museum. Image courtesy of Rachel Wood.

to have had their zenith in the Hellenistic period, most notably the famous Lysippos 'Alexander type', in vogue following Alexander the Great's endeavours. This led Franz Cumont to suppose that the genesis of the tauroctony occurred much earlier than in the Roman Imperial period, placing it rather at Pergamon in Asia Minor at the beginning of the second century BC.[20] Given what Cumont was attempting to do in connecting the various appearances of Mithra from east to west, it is not surprising that he selected a time and a place that would fit his scheme despite the paucity of evidence for Mithra in this period and place. What Cumont hoped for was the emergence, in the years following his

[20] Cumont 1899, 1.193–4; 1903, 24–5, 210. For specific criticism of the connection with the Alexander-type, see Will 1955, 176–86.

FIG. 1.9. Bronze statuette of Attis, from near
Mount Vesuvius, Italy. BM 1772,0302.166.
Trustees of the British Museum.

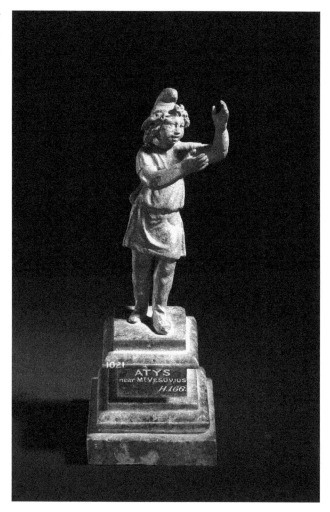

first publications, of a host of Mithraic finds across Turkey and the Near East
from the Hellenistic period onwards. It is a wish that has gone unanswered.[21]
The tauroctony, as far as we know, is a profoundly Roman image.[22] Allusions to
it may be drawn from suggestive depictions, such as the coins of Tarsus (some
five hundred miles to the southeast of Pergamon) that feature a lion pinning a
bull down, its jaws clamped around its neck.[23] A medallion produced there in the

[21] See most importantly Wikander 1951, 5–46. For a further critique of style and the Pergamon con-
nection, see Will 1955, 144–69.

[22] See in particular Gordon 1977–1978.

[23] See, for example, *BMC Greek* (Lycaonia) 52, a silver coin minted between 361–333 BC. See in par-
ticular Bausani 1979, who saw this as a representation of the constellation Leo overcoming Taurus. On
the connection with astrology, see the discussion of Roger Beck's argument (Beck 1994; 2006, ch. 9)
below, pp. 36–7; and this volume, ch. 3, pp. 73–6 and ch. 6, pp. 156–7. Note that a lion pinning a bull

reign of the third-century AD emperor Gordian III actually shows the tauroc-tony.[24] The fact that the image has no record of use there prior to this moment did not stop Cumont from drawing the link, but there is little else to warrant his conclusion beyond these vague approximations and temporally misaligned occurrences. As far as we know the Mithras tauroctony simply did not emerge until the Roman period.

One way of responding to the questions, 'why this image?' and 'how does the tauroctony convey information?' is to refer to its development from precedents featuring specific elements of the scene and indeed from the wider Greco-Roman artistic tradition. It was assembled, in part, for this reason.[25] The image was part of a religious and artistic dialogue that drew upon and developed pre-existing images. One way in which it functioned, therefore, and thus part of its meaning, was bound up with these other images.

It is curious that despite the importance he appeared to place on the origins of the tauroctony, Cumont referred to 'the poverty of the innovations which the Mithraic iconography introduced', i.e. the assemblage of the tauroctony amongst other images, in contrast to 'the importance of the religious movement that provoked them'.[26] A little further on in the same work Cumont stated:

> we should be wrong in exacting from the adepts of Mithraism something which they never made the pretence of offering. The religion which they preached was not a cult of beauty, and love of plastic form would doubtless have appeared to them a vain, if not a condemnable, taste....In spite of the many appropriations which it made from the treasury of types created by Greek sculptors, Mithraic art rested at heart Asiatic, like the Mysteries of which it was the expression. Its predominating idea was not to provoke an aesthetic impression; it aimed not to fascinate, but to tell its mission and to instruct—faithful in this also to the traditions of the ancient Orient. The jumbled mass of personages and groups which are presented on some of the bas-reliefs...show us that a new ideal was born with the new religion.[27]

He was probably right to believe that something else must be on display in these images: as interesting and significant as the pre-existence of artistic tropes may be, they are not entirely satisfactory in explaining the tauroctony, since the changes, additions, and the very combination of elements suggest that other propositions were being made. We shall return to these shortly, but Cumont's argument leaves us in a quandary for two reasons. By stating, 'love of plastic form would doubtless have appeared to [Mithras worshippers] a vain, if not a

in this way is a common motif (see, for example, Achaemenid reliefs in Persepolis) that cannot unequivo-cally be associated with Mithra.

[24] *CIMRM* 27.

[25] On the notion of 'bricolage' more generally for the worship of Mithras in the Roman world, see Gordon 1988.

[26] Cumont 1903, 225–6. [27] Ibid. 226–7.

condemnable, taste' he established a dichotomy between aesthetic appeal and the religiosity of objects. In doing so, he made the assumption that the creation of a definable 'Mithraism' was prior to the formulation of this image.

The first is quite a claim. Our problem is that, if correct, similarities between the tauroctony and some of the other subjects we have seen are irrelevant for the meaning of the tauroctony. So bold was Cumont's proposition, in fact, that it also had the effect of distinguishing the 'new religion' of '*mithraism*' from anything found in the Roman Empire.[28] However, in recent years the 'religiousness of antiquity's religious art' has been dramatically reappraised.[29] What this has done is collapse the distinction between aesthetic appeal and religious meaning that lay at the heart of Cumont's approach, by exploring the complexity and polyvalency of images. This is well represented by the recurrence of the winged Victory and bull motif we have already seen. We have examples of this type as statues, supposedly dug up in the lavish second-century AD villa of Antoninus Pius. The image appears on a medallion issued by the same emperor, and on a first-century BC gold coin of Augustus produced in Pergamon where in both cases its political role is clear. On the temple of Athena Nike, as we have seen, it functions as part of a sacred space, whilst on numerous amuletic gems it served, perhaps, an apotropaic function.[30] The range of material and contextual applications of the image suggests that aesthetic and religious appreciations of the type did not need to conflict, but could be mutually entertained.

Cumont's aesthetic devaluation of the image led him to suppose that his constructed religion was separate and superior to its icon. Thirty years ago, Roger Beck stated explicitly that: 'It cannot be assumed that the development and spread of the icon matches, and is therefore an automatic index of, the development and spread of the cult.'[31] It would indeed be wrong to assume this, but we have good cause to relate them. Whilst the tauroctony may have developed as an attempt to encapsulate existing religious ideas, the act of visual interpretation gave them definition in a very particular manner.[32] What Mithras was to his worshippers in the Roman Empire was very much dependent upon this scene, with all its exploitation of Greco-Roman artistic clichés as much as its content, which we

[28] It is worth noting Cumont's famous statement that, 'Perhaps there never was a religion so cold and prosaic as the Roman' (1903, 28). This type of assessment of Roman religious traditions had a long precedent in eighteenth- and nineteenth-century thought.

[29] Elsner 1996. See further Gordon 1979; Elsner 2007, 1–26; Ando 2008, 21–42; Platt 2010.

[30] The medallion of Antoninus Pius: BM no. 1855,0512.41. Coin of Augustus: BM no. 1864,1128.20. Examples of gems most likely carved in the Roman period: BM no. 1923,0401.636–8. On the tauroctony's function as an apotropaic image, see in particular Faraone 2013, 108–10.

[31] Beck 1984a, 2074.

[32] See Gordon 1977–1978, esp. 154–5, on the unlikelihood of this image evolving over a long period of time. More generally on its development, see Beck 1984a, 2071–8.

have yet to discuss. The culmination of thought that this image represents was a defining moment in what the worship of Mithras in the Roman world meant.[33]

There is no better illustration of this than in the relatively uniform spread of the image type across the empire. This centrality and the very particular depiction of a sacrificial act made this image function almost as part of the ritual of worship itself.[34] In contrast to much other divine iconography in the Roman world it does not appear to mimic a specific cult statue located in a specific place, for example, Jupiter of the Capitoline or Artemis of Ephesus.[35] Furthermore, the god is *doing* something and the act itself is part of what this representation is. It is not a repeated depiction of a sacred prototype (a statue in a particular sanctuary), and thus the scene has a symbolic value that these other statues from the ancient world did not share. These traditional statues were, in a sense, self-referential—their significance came from what they were. By contrast, the tauroctony's significance came from what it represented.

To make these objects work religiously, or rather, for the symbolism of these objects to be effective, its viewers required knowledge. Scholars are generally agreed on this point, but great controversy arises when discussing what knowledge this might be and crucially, whether such knowledge was universally held. A multitude of arguments have been put forward for interpretations, from reading the scene as a primordial hunt to the suggestion that it should be thought of more as 'the formulation of [Mithraic culture's] social principles'.[36] There are different ways of approaching what these meanings might have been, ranging from extensions of the symbols' meanings drawn from wider Greco-Roman society, to astrological interpretations of the tauroctony's configuration, all of which tend to emphasize different aspects.

Reading the tauroctony: the act itself

We have already seen that the references within the images to aspects of Greek and Roman art made the tauroctony work in relation to them. But, as intimated, elements of the scene such as the wheat sprouting from the wound or tail of the bull, the presence of the scorpion, dog, snake, and raven, and the god's gaze outwards suggest that it is also deeply symbolic. The struggle is clearly crucial to the scene. But is this a sacrifice? If so, then it contrasts quite profoundly with other representations of sacrifice in the Roman world where the animals are

[33] For comparable examples and a discussion of religion and art in the Roman period, see Elsner 1996. On the tauroctony in particular, see Elsner 1995, 210–21.

[34] For more detailed discussion of the role of the tauroctony in worship, see ch. 2, pp. 57–60.

[35] For more on this aspect of the tauroctony and its implications, see Elsner 1995, 214–17.

[36] On the hunt: Merkelbach 1984, 4; on social principles: Martin 1994, 221 (= 2015, 25). For a recent summary, see Faraone 2013, 96–9.

almost universally calm and complicit in the action.[37] This does not prevent the tauroctony from being a sacrifice and indeed on some tauroctonies the bull appears to be wearing the dorsal belt, common to Roman sacrificial victims.[38] But the struggle, the contest, and the moment of victory in attaining this act appear to have been paramount to the scene's meaning. The ears of corn sprouting from the bull's wound on the Townley example (see Fig. 1.1), and the common feature of the dog and snake clamouring for its blood, might suggest that the act was in some way life-giving. In the moment of killing the bull, Mithras seems to be providing sustenance; he is the trigger for fertility.[39] That he does so by overcoming adversity has been taken as an act that brings hope out of strife, and through his gaze away from this most momentous event, he might be calling upon something outside of the immediate scene.[40] Such a reading could turn Mithras into a salvific figure, imbuing the scene with a redemptive power beyond the mere provision of a gift.

Whether a broad role as a provider equates to Mithras possessing a salvific quality is debatable, but many have argued for this interpretation. It is questionable because these two aspects are not necessarily synonymous with one another: that a god provided for men did not make him a saviour of men by default.[41] This

[37] See, for example, Trajan's Column, sc. 8; a first- or second-century AD fragmentary relief of a *suovetaurilia* sacrifice now in the Louvre (no. MA 1096; INV. MR 852); and a relief panel of Marcus Aurelius, now in the Capitoline Museum (Inv. Scu 807) with a sacrificial bull so calm that he could almost pass for another Roman. On the notion of the willingness of the victim see, Will 1955, 213–14; 1978, 528–9. On the difference of the tauroctony from Roman sacrifice, see in particular Turcan 1981, 341–80. For further assessments, see Gordon 1988; Prescendi 2006; Elsner 2012; Naiden 2013, 83–99.

[38] Hinnells 1975b, 305. On the comparison between the sacrificial scene here and that of Roman monuments such as the Ara Pacis, particularly as regards the symbolism of the scene, see Elsner 1995, 213–14. Faraone 2013, has recently argued that the bull is not being sacrificed claiming, 'the Mithraic bull . . . usually shows no discomfort at the various attacks against it, despite the blood spurting from its shoulder'. Though the links that he draws between the tauroctony and apotropaic symbols such as the Evil Eye and the Nike and bull are interesting, this is not a strong argument. See further in this volume, ch. 2, pp. 50–2.

[39] See, for example, Clauss 2000, 79–82.

[40] Will 1955, 251, supposed that the gaze was simply a result of 'Oriental frontality', a theme first put forward by Rostovtzeff 1935, in relation to Near Eastern art of the Roman period. However, Mithras' gaze may be away, but as we have seen it was not necessarily directed at the viewer. He is also not looking into our eyes (when looking out), but almost beyond us (Toynbee 1955). It may well be that for some there was no significance to the god's gaze and what they saw was merely a stylistic convention, but other possibilities remain. See, for example, Faraone 2013, 104–7, who claims that Mithras averts his gaze as it would be dangerous to do otherwise, comparing the bull to the 'Evil Eye'.

[41] One of the most recent arguments for a salvific purpose to the Mysteries in general comes from Alvar 2008, returning to arguments made by Cumont 1911, Vermaseren 1963, and Turcan 1988. For criticism of the assumed link between the 'Oriental' religions or mystery cults with salvation, see MacMullen 1981, 55; Burkert 1987, 28; Beard, North, and Price 1998, 1.247. In relation to the worship of Cybele in the Roman world, Sfameni Gasparro 1985, 84–9, noted that 'salvation' appears to have been asked for in terms of the health and well-being of the living as opposed to in the afterlife. See also Bonnet, Rüpke, and Scarpi 2006, *passim*.

is especially true when conceiving of salvation beyond death. Half a century ago, the great successor to Cumont, Martin Vermaseren, with the archaeologist Carel van Essen, suggested a reading of a long poetic, painted inscription (*dipinto*) from the Santa Prisca *mithraeum* in Rome that would pique the interest of scholars working on early Christianity and Mithras alike.[42] Amongst other lines that were taken to be comparable to Christian practices and beliefs was the line rendered, 'and you saved us after having shed the eternal blood'.[43] This aligned clearly with the views of Vermaseren and Cumont, who had both argued that ideas of salvation were central to Mithraic 'doctrine'. Following cleaning of the scene in the 1970s, however, it was made clear that this reading was highly dubious; the only words that appear certain are 'blood' and 'shed', the rest being the result of extrapolation and modern reconstruction. Despite this, the translation has continued to be confidently asserted up until quite recently.[44]

We must be cautious once more not to assume a meaning that makes sense by extension to us, but which may have been lacking amongst worshippers of the god in the ancient past, particularly given the Christian understandings so prevalent in modern conceptions of religion.[45] Some suggestions in inscriptions made by Mithras worshippers that include the phrase *pro salute* in connection with a person ('for the sake / well-being of', or as some will argue, 'for the salvation of'), might also indicate a salvific quality to his worship, as can elements of the iconography.[46] It is beyond the scope of this chapter to discuss these in detail, but I would again sound a note of caution against reconstructing meanings derived from our own preconceptions of what religion should entail. Equally, if such conceptions of the god's purpose existed, as appears very possible, they sat amongst and did not preclude other interpretations.

Reading the tauroctony: mythology and doctrine

So far, these interpretations of sacrifice, of power, and of victory from the scene and the way that they related to worshippers of the god have been drawn primarily

[42] Vermaseren and Van Essen 1965, 187ff. For an example of the response in the scholarly literature for early Christianity, see Hans Dieter Betz 1968, *The Mithras Inscriptions of Santa Prisca and the New Testament*.

[43] Vermaseren and Van Essen 1965, 218, line 14 of the inscription: *Et nos servasti eternali sanguine fuso*.

[44] For the cleaning and subsequent reinterpretation of the inscription, see Panciera 1979, 103–5. Alvar 2008, 134–5, provides examples in recent scholarship of a reliance on this inscription.

[45] The desire to link Christianity to the worship of Mithras has always been strong, notably evident in the work of Franz Cumont and palpable today in the many conspiracy theories one can easily stumble upon with a quick Google search.

[46] Le Glay 1982 provides a discussion of the different ways that *salus* or the Greek, σωτηρία, could be used to refer to the well-being of the empire, emperor, commanders, and armies, as well as private individuals.

from general notions of Greco-Roman religion and the relevance of iconographic traits. By contrast, the argument proposed by Cumont prohibited the *truth* of alternative meanings. For him, the tauroctony had been developed to convey a doctrine of faith drawn from the great bounty of myth and religious thought that was contained within Mazdaism, intermingled with Babylonian science and Greek philosophy on its way to Rome. Beginning with creation, he takes us on a whirlwind tour of Greek and Persian mythology, seeking to situate Mithras as the great life-giver and provider for man, an intermediary between men and the divine, though a divinity himself (like Jesus, one might add).[47] The tauroctony, he argues, is the most important event in the life of Mithras, other parts of which are played out on the walls of several *mithraea* in complementary panel depictions (see, for example, the subsidiary scenes in Fig. 1.5). Mithras appears to be born of a rock; he brings forth water from a stone by shooting it with an arrow; in other scenes he is shown hunting. Some show Mithras struggling with the bull, apparently prior to the final combat in the tauroctony, whilst many others show his apparent rivalry and then friendship with Sol, culminating in a feast where the two appear to share the meat of the bull.[48] There is a uniformity to these depictions that suggests a common myth, though we should be careful not to ignore variations.[49] In any case, the central element is consistently the killing of the bull, at which point Mithras is held to trigger the creative moment that ultimately leads to man's ascendancy.[50]

The deeper significance of the tauroctony, ultimately its salvific meaning, was held by Cumont to be understandable only with reference to Mazdean mythology. It was the interpretation of this mythology that allowed for the decipherment of one true meaning or 'doctrine' of the 'religion', which held the tenets and justification for worship. Whilst this ingenious interpretation of the iconography to render a plausible account of the Mithraic mythological cycle remains important, Cumont's direct attachment of these scenes to Mazdean beliefs was quite fantastic in the literal sense of the word.[51] Though it has been criticized in recent times, not least because Mithras was seemingly held to be a protector, not a sacrificer of cattle within this tradition, the idea that the scene conveys doctrine still lingers in some quarters.[52]

[47] Cumont 1903, 104–49.

[48] Particularly important for Cumont's interpretation were reliefs such as those at Heddernheim (*CIMRM* 1083) and Apulum (*CIMRM* 1935). On the importance of the feast with Sol, see the famous double-sided relief with a tauroctony on one side, and the feast of Sol and Mithras on the other. Cumont 1946, figs 1–2; Louvre no. MA 3441.

[49] For more on the mythography of Mithras in the Roman Empire, see the discussions in chs 2–3.

[50] Cumont 1903, 134–7. [51] See further Beck 1984a, 2003.

[52] For criticism, see in particular Gordon 1976, 215–48 and Hinnells 1975b, 290–312, in the same volume. For more on the role of Mithras in eastern traditions, see chs 4–6. On the continued search for doctrine, see Turcan 1996, 221: 'L'iconographie n'y a…aucune fin esthétique'; 1993, 93–114, is a

What is most troubling about this approach is the emphasis that must perforce be placed on the uniformity of understanding amongst worshippers. If this 'religion' came from Persia to Rome and had managed to maintain its innate character despite the ravages of time, shifts of location, and inclusion of participants from a range of cultural backgrounds, how could its adherents possibly think differently from one another?[53] Thus, the appearance of different elements of the scene or indeed the lack of them, such as whether or not a lion or krater appears, are held to be only minor variants that had little bearing on the overall significance of the imagery. If doctrine is all, then diversity, whether in iconographic or stylistic forms, or indeed in interpretation, is something to be swept away.

A notable example of Cumont doing just that comes in his short preface of a discussion of astrology:

> the tauroctonous group was variously explained with the aid of an astronomical symbolism more ingenious than rational. Yet these sidereal interpretations were nothing more than intellectual diversions designed to amuse the neophytes prior to their receiving the revelation of the esoteric doctrines that constituted the ancient Iranian legend of Mithra.[54]

Earlier on in his account, Cumont had stated explicitly that he considered such astrological dalliances as there were to be nothing more than a veil to the truth:

> the clergy [Mithraic initiates] reserved for the élite exclusively the revelation of the original Mazdean doctrines concerning the origin and destiny of man and the world, whilst the multitude were forced to remain content with the brilliant and superficial symbolism inspired by the speculations of the Chaldæans [Babylonians]. The astronomical allegories concealed from the curiosity of the vulgar the real scope of the hieratic representations, and the promise of complete illumination, long withheld, fed the ardour of faith with the fascinating allurements of mystery.[55]

Reading the tauroctony: astrology

Cumont's dismissal of the importance of astrological interpretations, or 'star-talk', has been challenged by Roger Beck, amongst others.[56] His key proposition

section entitled 'La doctrine'; 93, 'C'est-à-dire sans la révélation d'un mythe ou d'une histoire sainte qui légitime la liturgie en même temps qu'elle fonde une cosmologie, voire une anthropologie, conception de la vie actuelle et posthume, doctrine de salut.'

[53] A telling line from Cumont encapsulates his point of view (1903, 141): 'it would appear certain that the ethics of the Magi of the Occident had made no concession to the license of the Babylonian cults and that it had still preserved the lofty character of the ethics of the ancient Persians.'

[54] Cumont 1903, 130. [55] Ibid. 120.

[56] Beck 1994; 1998; 2004 Introduction; 2006, 190ff. It should be noted that Beck is the most prominent and the most recently vocal of a large group of scholars who have worked on this problem. For reviews of the literature covering the period up to Beck, see the contributions of Ulansey 1991, 15–25

is that the tauroctony exhibits great 'cosmic oppositions' not only expressed in the conflict between Mithras and the bull, but in other elements of the scene and wider iconography.

Like Cumont, Beck traces the movement of these ideas from the east to the west, though not as doctrine.[57] Astrological symbolism is pronounced in Mithraic iconography, evident in the use of the zodiac and the fact that all of the figures common to the tauroctony, such as Mithras (Leo, as Beck argues),[58] the two male figures (Gemini), bull (Taurus), crow (Corvus), snake (Hydra), scorpion (Scorpio), and dog (Canis Major/Minor), could be interpreted as having a celestial equivalent. Beck argues that the positioning of these elements in relation to each other is what provides meaning through reference to the progress of the stars and planets across the sky. He therefore contends that the prevailing message is the victory of the sun over the moon, of light over darkness, summer heat over winter cold, told through the combination of interactions displayed in the tauroctony. Importantly, more than one role may be played by particular figures; this is especially evident with Mithras and the bull. As the constellations of Leo and Taurus respectively, Mithras and the bull are made to be part of a celestial map that the wider tauroctony scene represents, visible in the night sky at precise moments in time. As part of the zodiac Taurus' opposite, Scorpio, is represented grasping for the bull's genitals, supposedly in an act of cosmic humiliation. But Mithras and the bull may also represent the sun and moon respectively, the struggle and victory of the former perhaps suggesting the ultimate triumph of the sun over the moon.[59] Thus he articulates three possible meanings of these symbols astrologically, none of which are mutually exclusive.

THE SIGNIFICANCE OF RECONSTRUCTIONS

Though we may now look upon them as museum objects removed entirely from their former contexts, it is important to remember that our tauroctonies from

and Chapman-Rietschi 1997, 133–4. We should be clear that Cumont 1903, did not deny 'this double system of interpretation' (p. 121), but rather its *truth* and importance for the real content of the Mysteries. Thus, 'it would appear certain that the ethics of the Magi of the Occident [i.e. the Doctrine of Mithraism] had made no concession to the license of the Babylonian cults [i.e. Astrology] and that it had still preserved the lofty character of the ethics of the ancient Persians' (p. 141).

[57] See Beck 1998; 2001. On the question of the movement of these ideas, Commagene is especially important. In ch. 6 of this volume (pp. 156–7) we look in more detail at questions of origin and the place of 'star-talk' in relation to Mithras more broadly.

[58] See Beck 1994; 2006, 214–27.

[59] Beck 2006, 194–6, 198–9. We may note that the inscriptions on the Townley tauroctony explicitly refer to the god as 'Sol Mithras'. On the flexibility of names, see the brief discussion of variations in the Introduction, pp. 3–4.

the British Museum possessed religious dimensions beyond their aesthetic appeal. As the Townley example demonstrates, the reconstruction of these objects as purely aesthetic pieces runs the risk of underplaying if not wholly devaluing their religiosity. What we have in the tauroctony is an idiosyncratic scene with precedents, a sacrifice on behalf of worshippers that may double as a symbol of the cosmic victory of the sun over the moon. The complexity of the image and the meanings that may be drawn from it are, and likely were, part of what made it resonate with worshippers of Mithras in the Roman world.

Reconstructions are powerful tools for examining the past, but this also makes them dangerous. If our two tauroctonies from the British Museum have taught us anything it is the danger of ascribing inflexible and definite meanings to these objects that are at once alike and distinct. Beck's account opens up a raft of potential meanings, not only of particular symbols within the tauroctony, but also for the composition as a whole. In the past, such intricate explanations of iconography might have been held to preclude alternative meanings from being valid. But we are becoming increasingly aware of the greater range of meanings present in such objects. The astrological symbolism of the tauroctony thus stands alongside and does not necessarily overawe the important literal act of Mithras killing the bull and the variety of interpretations that may be taken from it. Equally, we have seen that the development of the scene out of existing traditions in the Greco-Roman world is an important part of how this scene may be read. The tauroctony, which developed and spread in a world laden with representations of gods, is duly a response to this environment seen as much through its maintenance of stylistic traditions as its development of an idiosyncratic iconography.

It is precisely the interplay of the similarities and differences between such objects as well as those relating to Mithras from Britain to Afghanistan which make them so fascinating. In the Roman Empire, the striking dispersal of this image type suggests a high degree of shared knowledge amongst those who worshipped Mithras. Given the possibilities, however, there were many things that viewers of these images, even the initiated, could have taken from them. In the next chapter we look more directly at this community of worshippers and explore the adoption of this central image by distinctive communities. We may do so not only with a greater appreciation of the importance of the tauroctony, but also of the dangers that may befall the inflexible modern viewer.

TWO

Patrons and Viewers

Dura-Europos

From the British Museum, we move to Dura-Europos—a city now in modern Syria but which, in the second century AD, lay on the border between the Roman and Parthian empires (Map 2). The city was not built over after its abandonment in the third century, and the good condition of much of its surviving artwork, as well as its blend of different cultures, led the ancient historian Michael Rostovtzeff to describe it as the 'Syrian Pompeii'.[1] This blend of cultures was mainly derived from Dura's location on an escarpment above the Euphrates, which placed it on one of the principal trade routes of the ancient world, as well as on an important east–west road across the desert. Dura-Europos can therefore be considered as one of the best places to study the phenomenon of the Roman cult of Mithras in the east: as a meeting point between the Roman empire and its eastern neighbours, and between Roman and Durene culture and religion.

Durene culture is, in itself, not easy to define; the city as we see it today is a combination of mainly Hellenistic, Parthian, and Roman architecture.[2] This blend of influences gave Dura-Europos a rich and diverse cultural heritage, in which respect it is typical of many other cities in the 'Fertile Crescent' such as Mari (just downstream from Dura), Susa, and Damascus.[3] It was also affected by its encounters with nearby cities: most pertinently for this chapter, by its interactions with Palmyra. The city's natural defences and location made it an important trading and garrison city, with a population that was often changing, particularly in the Roman period of occupation.[4] The effect of this heritage upon the inhabitants can be traced in the religious art of the city; the Jewish synagogue

[1] Rostovtzeff 1938, 10.

[2] For overviews of Dura-Europos, see Dirven 1999; Millar 1993, chs 4 and 12; Wharton 1995, ch. 2; Brody and Hoffman 2011.

[3] Breasted 1916, 100–1. [4] Welles 1951.

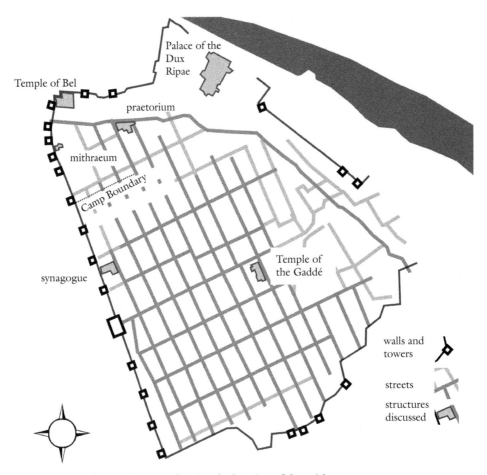

FIG. 2.1. Plan of Dura-Europos, showing the location of the *mithraeum*.
Image by Robert Bracey.

with its frescos is a particularly famous example, but the decoration of the *mith-raeum* tells an equally fascinating story.[5]

The *mithraeum* was situated in the northwest of the city, in the area within the brick wall that marked out the Roman military quarter (see Fig. 2.1). It was found in an excellent state of preservation, no doubt thanks to its location close to the city wall. During the Sasanian siege of Dura-Europos in AD 256, many of the buildings close to this wall were filled in with sand and earth to create a defensive embankment; this protected the interior of the *mithraeum* both from destruction at the hands of the Sasanian army, and from deterioration and

[5] On the synagogue, see Gutmann 1992. The *mithraeum* at Dura has been fairly well-published, featuring in the seventh and eighth excavation reports, although the final report has not been published. The frescoes and graffiti are documented in Hinnells 1975a vol. 2, and Cumont's report features in the same volume.

exposure over the succeeding centuries. It was unearthed in February 1934, and its importance to the corpus of Mithraic evidence quickly became clear: here was a chance to survey a *mithraeum* that was virtually unspoiled, one that contained several unusual forms of decoration, and one that might provide a glimpse into the form of Mithraic worship practised in the eastern half of the Roman Empire. It was an opportunity that Franz Cumont, the great Mithraic scholar, could not ignore; he had been hoping to discover a *mithraeum* in the east that would support his theory of the origins of the Roman Mysteries of Mithras, and he promptly responded to the summons that he received from the archaeological team of Clark Hopkins, Michael Rostovtzeff, and Robert du Mesnil du Buisson.

The discovery of a *mithraeum* in Dura-Europos had opened up potential new avenues for the debate on Mithraic origins; Cumont hoped to find a significant variation in iconography and imagery from the *mithraea* of Rome and Italy, which would reveal a closer affinity between the Roman east and the supposedly Persian origins of Mithraic worship. In fact, there are sufficient differences to allow a strong case for regional variation within the Mithraic Mysteries, but the *mithraeum* of Dura did not fulfil all of Cumont's expectations for finding a missing step in his proposed evolution of the Roman cult. What it does provide, however, is a rare insight into the changing composition of Mithraic patrons and viewers, and their relationship with the god and with the sacred space.[6]

MITHRAIC WORSHIPPERS: PALMYRENES IN DURA-EUROPOS

The worshippers here appear, at least during the early occupation phases of the *mithraeum* in the AD 160s, to have been soldiers of the Palmyrene archer cohort stationed at Dura, who were presumably also members of the wider community of the city. No conclusive proof of Mithraic activity has yet been found in the city of Palmyra itself, which raises the question of where this unit encountered the worship of the god.[7] In appearance, the form of Mithras worship found at Dura-Europos strongly resembles that found across the rest of the Roman Empire; only a few obvious differences may be attributed to a particularly eastern heritage, and most of these will be discussed over the course of this chapter.[8] This

[6] Manfred Clauss has recently emphasized the importance of the unusual insight, provided by the example of Dura, into the composition of a Mithraic community (Clauss 2012, 42–5).

[7] For more on religion in Palmyra, see Kaizer 2002.

[8] Due to spatial restrictions, this chapter can unfortunately go into little detail on the use of frescoes. The only other really comparable *mithraeum* is that at Hawarti in Syria, which also makes extensive use of frescoes to depict Mithraic scenes. See Gawlikowski 2007 on the Hawarti *mithraeum*. The frescoes of the Santa Prisca *mithraeum* in Rome are published in Vermaseren and Van Essen 1965, and those of the Pareti Dipinte *mithraeum* in Ostia in Becatti 1954; neither of these Italian *mithraea*, however, use frescoes to quite the same extent as at Dura and Hawarti.

suggests that the Palmyrene archers had come into contact with a western and Roman idea of Mithras, rather than a native eastern interpretation, either in their home city of Palmyra, or while they were stationed elsewhere in the Roman Empire.

It would perhaps be over-hasty to rule out the future discovery of a *mithraeum* in Palmyra; indeed, this is perhaps the most plausible explanation for how Mithras worship came to be present in Dura. There had been ties between Dura-Europos and Palmyra for over a century before the dedication of the *mithraeum*; the first attestation of a Palmyrene presence in Dura comes from an inscription dated to 33 BC.[9] It records the dedication of a sanctuary to Bel and Yarhibol by two Palmyrenes just outside the city, and was written in their own language. This, therefore, is an early example of a specific Palmyrene community existing in a religious context at Dura, as appears to be the case later in the early *mithraeum*.

The two men who established the sanctuary of Bel and Yarhibol, however, may well have been traders and part of a civilian Palmyrene community at Dura, whereas the worshippers of Mithras were definitely part of a military presence in the city. Little can be said with certainty about the archer cohort that made up the early Mithraists. It is likely that it was attached to the Roman garrison in the city, but that it was not an official part of the army at this point; it is possible that men from this unit were later incorporated into the regular auxiliary cohort, the *cohors XX Palmyrenorum*, that was present in the city in the third century.[10]

An alternative explanation as to how a Palmyrene force came to be worshipping a Roman god is that they encountered Mithras worship while stationed in a province in which it was already well established. Epigraphic evidence indicates that there were Palmyrene archers present in Dacia and Moesia (roughly corresponding to parts of modern Romania and the Balkans) during the AD 120s; some Mithraic finds from the area also date to around this time, leading towards the conclusion that it is possible that Palmyrenes may have come across Mithras while in these provinces.[11] There is, of course, no evidence that the same archers who were in Dacia were then sent on to Dura; indeed the time lapse between the AD 120s and 160s would rather suggest otherwise. This, then, perhaps reinforces the idea that there may have been a *mithraeum* in Palmyra. The archers who had come across Mithras in Dacia could have brought the god back with them to their native city, thus establishing the Palmyrene worship of Mithras.

The preparedness of the Palmyrene soldiers in Dura-Europos to adopt overtly Roman festivals and rites is attested in the famous religious calendar, the *Feriale*

[9] *PAT* no. 1067; Dirven 1999, 32; 199–202; Smith, A. M. 2013, 151.

[10] Welles, Fink, and Gilliam 1959, 26–46; Smith 2013, 153.

[11] For Palmyrenes in Dacia, see *CIL* 837; Mithraic sites have been discovered at Alba Iulia and Apulum. The theory that Palmyrenes encountered Mithras while stationed in Dacia and Moesia is particularly favoured by Lucinda Dirven (Dirven 1999, 185).

Duranum, that was discovered among their documents.[12] It should therefore come as no surprise that the worship of Mithras within Dura was a firm Palmyrene foundation. Although the evidence for this strong Palmyrene association with Mithraic worship in Dura only dates to the AD 160s and 170s, the location of the *mithraeum*, firmly within the wall that delineated the military part of the city, suggests that the worshippers of Mithras continued to be drawn from the military garrison. This wall was constructed under the emperors Septimius Severus and Caracalla (probably in AD 211), and effectively split Dura-Europos into two cities: one civilian and one overtly military. The location of the *mithraeum* on the military, and therefore the clearly Roman-influenced side of the wall, emphasizes the connection between the worship of Mithras within the city and the Roman army.

THE *MITHRAEUM*

The *mithraeum* appears to have undergone three major architectural phases, which saw it transformed from a small shrine to a larger complex with an elaborate niche (Fig. 2.2).[13] Thought to have been built in AD 168 from the evidence of an inscription by a Palmyrene *strategos*, the *mithraeum* underwent two major restorations in 210 and 240.[14] The earliest structure may originally have been a room in a private house that was adapted for Mithraic worship; it probably consisted of a narrow nave, flanked on each side by a bench, from which two columns rose to support the roof. At the entrance, there was a basin for water set into the floors of the nave. This nave then led to a raised platform at the far end of the *mithraeum* that was reached by a short flight of steps. In front of this platform stood the main cult altar, along with two smaller altars at its side, while

[12] For the *Feriale Duranum*, see Fink, Hoey, and Snyder 1940.

[13] See Baur, Rostovtzeff, and Bellinger 1929–1944, for Henry Pearson's full account of the development of the *mithraeum*. He describes the architecture of the early (pp. 64–70), middle (pp. 70–6), and late (pp. 76–82) *mithraeum*, complete with detailed figures outlining the different building phases and their impact upon the sacred space within the sanctuary. See also *CIMRM* 34 for Vermaseren's account, which is based primarily on the Preliminary Report of the Dura excavations.

[14] The date of AD 210 comes from an inscription dedicated by the centurion Antonius Valentinus. See Baur, Rostovtzeff, and Bellinger 1929–1944 vol. 7/8, pp. 85–8. Also *CIMRM* 53: 'On behalf of the health and safety of our Lord Emperors Septimius Severus and Caracalla and Geta, under the Augustan procurator Minucius Martialis, the *templum* of Sol Invictus Mithras was restored by Antonius Valentinus, centurion and *princeps* of the vexillations of the *legio IV Scythica* and the *legion XVI Flavia Firma*' (*Pro sal(ute) et incol(umitate) d(ominorum) / n(ostrorum) imp(eratorum) L. Sep(timi) Severi pii / Pert(inacis) et M. Aurel(i) Aritonini [[et L. Sept(imi) Geta[e]]] / Aug(ustorum) tem/plum dei Solis invicti Mithrae sub Minic(io) Martiali procuratore) / Aug(usti) / rest(itutum) ab Ant(onio) Valentino (centurione) princ(ipe) / pr(aeposito) ve[x(illationum) leg(ionum) III]I Scyt(hicae) / et XVI F(laviae) F(irmae) p(iae) f(idelis))*. For the AD 240 date, see Baur, Rostovtzeff, and Bellinger 1929–1944 vol. 7/8, 76–80.

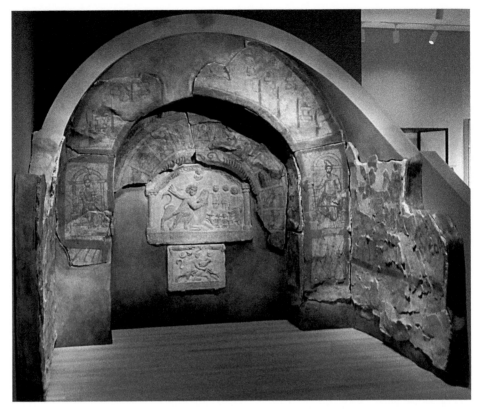

FIG. 2.2. A reconstruction of the arch and niche of the Dura-Europos *mithraeum*. Yale University Art Gallery.

Author's image.

unusually two reliefs of the tauroctony scene were attached to the rear wall. It is these two reliefs that will form the main visual emphasis of this chapter.

During the architectural re-designings of 210 and 240, the space at the end of the nave gained an increased level of importance through the addition of an arched niche and elaborate decoration, which was designed to include the two existing Mithraic reliefs. Around these reliefs runs a series of thirteen frescoes depicting scenes from the mythography of Mithras in trapezoidal frames. Altogether this decoration filled the arch-shaped interior of the niche.

The mythography frescoes show scenes that are familiar from other Mithraic art from around the Roman Empire (Fig. 2.3).[15] They can broadly be split into two groups: the first relates to other gods, who could perhaps be seen as being part of a wider incorporation of extrinsic deities into Mithraic worship, while the second more closely concerns what have been constructed as the life and deeds

[15] For a detailed discussion of these scenes on panelled reliefs, see Gordon 1980.

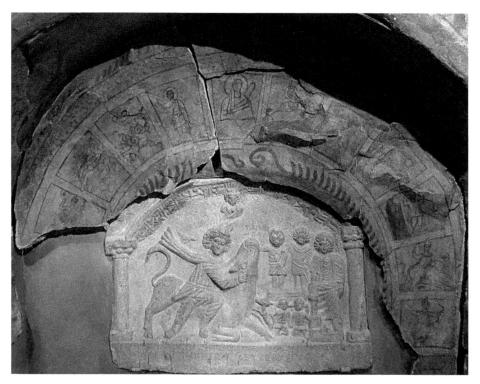

FIG. 2.3. Frescoes from the Dura-Europos *mithraeum* showing the mythography of Mithras.
Yale University Art Gallery.

Author's image.

of Mithras.[16] Such scenes are common to *mithraea*, most often occurring in
reliefs that use them as vignettes surrounding the main motif of the tauroctony.
At Dura-Europos, there are two fresco scenes that are not strictly related to
Mithras himself: a veiled and shrouded figure holding the *harpē* (a type of sickle)
usually associated with Saturn, reclines against a rock; Jupiter hurls his thunder-
bolt at two anguipede giants, one of whom attempts to fight back. The *harpē* is
frequently used as an identifying attribute of Saturn; it is commonly believed to
have this function in a black and white mosaic from the Felicissimus *mithraeum*
in Ostia.[17] Depictions of Saturn with his *harpē* and Jupiter fighting giants also
coincide on a tauroctony relief from Nersae in Italy, where they form two of the
side scenes surrounding Mithras and the bull.[18] Yet representations of Saturn
and of Jupiter battling giants were certainly prolific throughout the Greco-Roman
world, and had no peculiarly Mithraic heritage. The occurrence of such scenes
in *mithraea* suggests that Mithraic worshippers were perfectly comfortable with

[16] On the idea of a Mithraic pantheon, see ch. 3, pp. 79–80.
[17] *CIMRM* 297. For discussion of the symbol, see Chalupa 2008. [18] *CIMRM* 650.

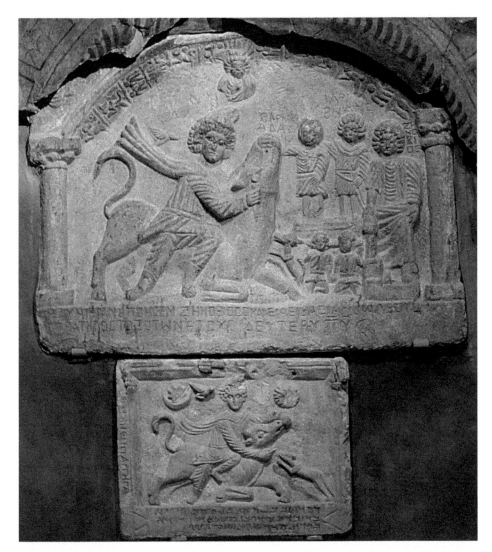

FIG. 2.4. The two tauroctony reliefs from Dura-Europos *mithraeum*. Yale University Art Gallery. Author's image.

associating other gods and other mythic traditions with the mythology of Mithras himself.

There are also two scenes among the frescoes that have been interpreted as relating to the life of Mithras, but that are unconnected with the bull: the first is the birth of Mithras from a rock, while the second is an image of the god shooting an arrow at a rock to produce a stream of water.[19] It is the story of Mithras and the bull, though, that receives the most attention in this series of frescoes.

[19] For greater detail on the rock-birth of Mithras, see ch. 3, p. 75.

Mithras is shown riding the bull, as well as dragging it into the cave for slaughter. In a scene unique to Dura, the Mithraic torchbearers Cautes and Cautopates are shown carrying the bull's carcass on a pole, presumably to prepare it for the feast between Sol and Mithras, which is also shown. This mythography was pieced together by Franz Cumont to make a coherent, though highly creative, whole, but the differences between the mythography in *mithraea* seem to suggest that a symbolic rather than strictly mythological reading may be preferred.[20]

The prominence of scenes relating to the bull in these frescoes frames and highlights the tauroctony reliefs, and it is these two reliefs that contribute to make the Dura-Europos *mithraeum* so unusual (Fig. 2.4). While it is by no means uncommon to find a carved relief accompanying a statue of Mithras, or a relief with a fresco of the bull-slaying scene, the juxtaposition of two stone reliefs is rare.[21] They did not necessarily, however, receive equal status within the daily practice of the cult; one is significantly larger and of better quality than the other, and, indeed, the presence of inset bronze staples in the top corners of the lower, earlier relief suggests that it may originally have been covered by a curtain.[22] If so, then this perhaps raises interesting questions about the function of these reliefs. Might it have been the case that only one relief should be visible at any one time? Could the symbolic power of the image have been affected by duplication? And what do we understand a 'cult' relief to be? In particular, was it an object of veneration in its own right or did it serve to recall a particular event in a visual format for worshippers?

In the absence of widespread examples of concurrent reliefs, and given the general lack of evidence for Mithraic beliefs, it is probably impossible to find an answer to these questions for Mithraic worship. We can, however, ask why might there have been two Mithraic reliefs found in the Dura-Europos *mithraeum*. They show the same scene of Mithras and the bull, with a few differences in the manner of slaughter and the positions of Sol and Luna. They also seem to be strikingly close to one another in date.

There seem to be two possibilities: first, that there were originally two Mithraic foundations in Dura, one established by the *strategos* Ethpeni, and the other by a second *strategos*, Zenobius, both of whose names are attested in inscriptions from the two reliefs. At some point these two *mithraea* were then merged together, perhaps during the Severan alterations to the military quarter of the city, and the two reliefs were placed on the rear wall of the *mithraeum*. If one inclines towards this option, then the lower position of the Ethpeni relief, and the possibility that

[20] Cumont 1903, 130–40. For discussion of the mythography around Mithras, see chs 1 and 3.

[21] Another *mithraeum* that appears to have had two concurrent reliefs is the *Mitreo sotto Santo Stefano Rotondo* in Rome; see Lissi Caronna 1986; Bjornebye 2007, 29–31.

[22] Downey 1977, 23.

it was sometimes covered by a curtain or cloth, perhaps suggests that the Ethpeni foundation was merged into that of Zenobius, and therefore that the Zenobius dedication would take priority. The main problem with this model is that the words of an inscription on the Zenobius relief make little sense without the Ethpeni relief alongside. This inscription dates the relief to 'two years later', and it has been widely assumed that this refers to the date given on the Ethpeni relief above. If this point of reference for the words 'two years later' was not originally in place, then the phrase becomes rather obscure and confusing. It is also possible that the curtain covering the Ethpeni relief was designed not as a means of denoting the inferiority of the lower relief, but rather as a way of heightening its sense of mystery, and giving its unveiling a greater dramatic moment.

This leads us to the second possibility, that there was initially only one *mithraeum*, but one with two rather significant benefactors within a short space of time. The fact that the Zenobius relief did not replace the earlier one could therefore indicate a sense of community among the Palmyrene worshippers of Mithras at Dura; it is likely that they wished to honour both dedicants, although the Zenobius relief took pride of place.

The destruction of many buildings during the Severan period in order to create the military zone makes it doubtful that evidence of another Mithraic community could be found in Dura. It is also unlikely, therefore, that this question about the composition of Mithraic worshippers, and whether they originally formed two separate groups, can ever satisfactorily be answered. Nonetheless, the very fact that there were two reliefs in the *mithraeum* when it was excavated, as well as the unique features of the Zenobius relief with its portrayal of the benefactor, points towards a changing and culturally diverse composition of the Mithraic community at Dura. Let us now examine both reliefs in greater detail.

THE ETHPENI RELIEF

The older, smaller relief is made from white gypsum and measures 42×57 cm (Fig. 2.5).[23] It was originally painted, though the colours have now faded. It has an inscription in Palmyrene in a *tabula ansata* underneath the main panel of the relief that gives the identity of the dedicator and the date of the relief:

> A good memorial; made by Ethpeni the *strategos*, son of Zabde'a, who is in command of the archers who are in Dura. In the month Adar of the year 480 [AD 168].[24]

[23] Baur, Rostovtzeff, and Bellinger 1929–1944 vol. 7/8, 83–4 on the inscription and 92–4 on the relief. See also *CIMRM* 37–9; Downey 1977, 22–5; 218–20.

[24] *CIMRM* 39. The date 480 refers to the Seleucid era dating, which was adopted by most regions that had a Hellenistic heritage and therefore was in use at Dura-Europos.

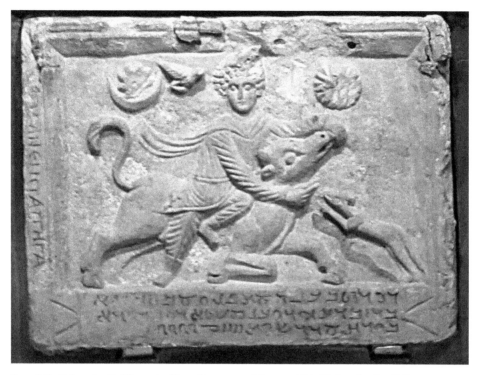

FIG. 2.5. Ethpeni relief from the Dura-Europos *mithraeum*. Yale University Art Gallery. Author's image.

This first inscription is reinforced by a second in Greek (*CIMRM* 38) along the left side of the scene, which simply repeats Ethpeni's name and rank. We must therefore understand from it that the Palmyrene language has been prioritized in this instance; it provides greater information about the dedicator, and perhaps reinforces the impression that the majority of Mithraic worshippers in Dura-Europos at the time of the dedication would have been able to understand this language.

The relief itself shows many of the traditional features of the tauroctony scene, as outlined in chapter 1 (pp. 15–17); Mithras, dressed in Phrygian cap, cloak, tunic, and trousers, is depicted in the act of killing the bull. The dog and snake rise up to lap up the blood from the bull's neck, and the raven is shown in flight, just to the left of the god's head. There are also representations of the sun and moon: to the right of Mithras' head is a sun disc, with the rays carved into the pattern of a star, while to his left is a crescent moon, with a nine-pointed star incised between its horns. The centres of the sun and star have been damaged with tools, perhaps to remove precious stones, and a further drill hole for such a stone can be seen in the peak of Mithras' cap.

There are a few noticeable differences between the features of this relief, and those of western tauroctonies that are frequently considered stereotypical.[25] For example, the scorpion is missing from the usual group of animals that surround the bull, though our lack of understanding of the symbolic purpose of the scorpion prevents us from comprehending what this could potentially mean, if indeed it meant anything at all.[26] Another difference is that while traditionally Sol is represented to the left of the god, and Luna to the right, here the order of the two is reversed. There is no explanation for why the order should have been changed in this relief, nor are there any other astrological symbols shown upon it.

It is Mithras' action in killing the bull, however, which is more worthy of note. In the Ethpeni relief, Mithras is depicted reaching around the bull's neck, either to slit its throat or to plunge the dagger in through its dewlap. In general, the iconography of the cult instead prefers to show the god plunging the dagger into the bull's shoulder.[27] Indeed, Glenn Palmer states that 70 per cent of Mithraic reliefs show the god stabbing the bull in the right shoulder with a short dagger, an action which, he argues, could not possibly hope to succeed in killing the bull. Christopher Faraone, whose article uses much of Palmer's data, raises this figure to 80 per cent.[28] While Palmer accepts that the bull-slaying scene is symbolic and probably not indicative of actual Mithraic practice, Faraone argues that the scene represents merely a 'bull-wounding' rather than actual slaughter.[29] It is therefore unfortunate that Faraone makes no mention of the Ethpeni relief, which, as an anomaly to the general trend of stabbing the bull through the shoulder, presents an obstacle to his argument.

Another variant on this action can be seen in a statue found in the *mithraeum* of the Terme del Mitra in Ostia (Fig. 2.6). There, Mithras is shown as a youthful god, not wearing his traditional eastern costume but instead dressed in a short *tunica* that only covers half of his chest. He pulls back the bull's head with his left hand in the customary way, but his right hand brandishes the dagger in the air. There is no wounding of the bull, and Mithras' gaze is upwards and outwards, over the head of the bull. There is evidence to show that the god's head and arms were reconstructed in antiquity, suggesting that the worshippers in this

[25] Such as the reliefs from the Walbrook *mithraeum* (*CIMRM* 810), from the Circus Maximus *mithraeum* (*CIMRM* 435), and from Mauls (*CIMRM* 1400). These show the full number of Mithraic attendants: the dog, snake, and scorpion around the bull, the raven, the torchbearers Cautes and Cautopates, and representations of Sol and Luna.

[26] On the scorpion in the tauroctony scene, see Beck 1976, 208–9.

[27] Palmer 2009. [28] Faraone 2013.

[29] Palmer 2009, 316; Faraone 2013, 99; cf. Elsner 1995, 214–15. Faraone argues that the wounding of the bull is apotropaic, and that the depiction of the scene on brooches, such as that now in the Ashmolean Museum in Oxford (*CIMRM* 318), was intended to avert evil. The unmistakable scene of bull-slaying shown on the Ethpeni relief does not align with Faraone's argument.

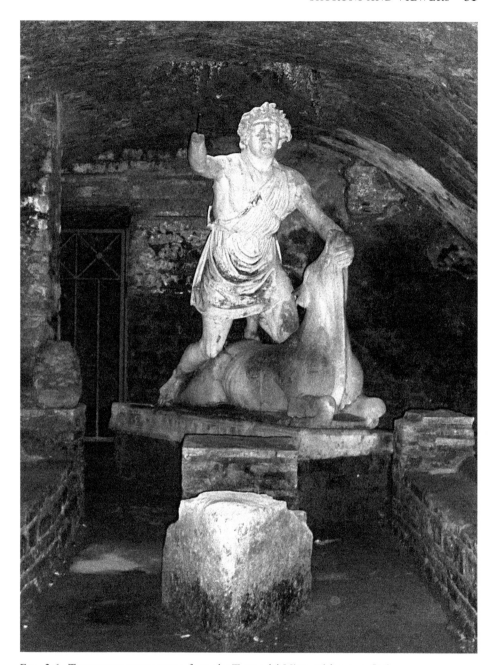

Fig. 2.6. Tauroctony statue group from the Terme del Mitra *mithraeum*, Ostia.
Author's image.

particular *mithraeum* appropriated an existing statue. For them, there seems to
have been no need to see the actual moment in which the bull is wounded.

In the Dura-Europos *mithraeum* at least, however, there was clearly the belief
that Mithras was actively engaged in the killing of the bull, rather than its wounding.

This feature certainly means that the Ethpeni relief is unusual, and in fact it may have originally been even more graphic than it appears today. As Susan Downey points out in her excellent volume on the sculpture of Dura, the excavators' preliminary report on the Ethpeni relief, written before the colours faded, makes mention of a red painted background to the wound, presumably meant to represent the bull's blood.[30] It is this sacrificial action that makes the Ethpeni relief so remarkable.

THE ZENOBIUS RELIEF

The second relief from Dura-Europos (Fig. 2.7) is equally unusual, again particularly in relation to sacrifice, although for different reasons.[31] Like the Ethpeni relief above which it was found, it too is made from gypsum, though it is much larger than the older relief, measuring 0.67 × 1.05 m, and the carving is of

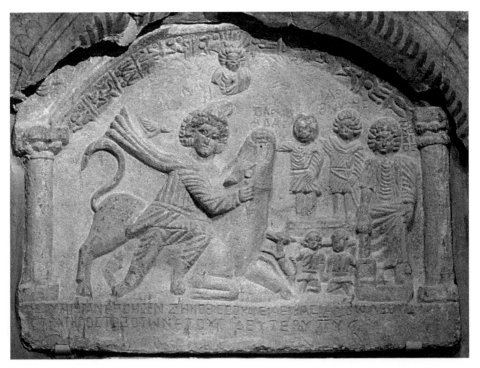

Fig. 2.7. Zenobius relief from the Dura-Europos *mithraeum*. Yale University Art Gallery. Author's image.

[30] Baur, Rostovtzeff, and Bellinger 1929–44 vol. 7/8, 92–4; Downey 1977, 23.
[31] Baur, Rostovtzeff, and Bellinger 1929–44 vol. 7/8, 84 on the inscription, 95–100 on the relief. See also *CIMRM* 40–1; Downey 1977, 25–9; 220–3.

superior quality. Its prominent position within the *mithraeum* suggests that it may have been the main relief for Mithras in the city; it shows not only the traditional tauroctony scene, but also depicts the dedicator himself standing among other figures.[32]

These two scenes, both of Mithras and the bull and of the dedicator Zenobius, are framed by the representation of two round columns with Corinthian capitals, which are slightly asymmetrical. The columns support an arch, which features the signs of the zodiac on the intrados, running from Aries on the far left to Pisces on the far right. This arrangement, of the zodiac on the inside of an arch framing the tauroctony scene, was repeated in the second architectural phase of the *mithraeum*, which dates to after the second relief; in the enlargement of the niche, a physical arch was created to frame the two bas-reliefs, which also had the signs of the zodiac on its intrados.

A Greek inscription below the second relief identifies this patron as Zenobius Eiaeibas, and reads:

> Zenobius, also called Eiaeibas, son of Iariboles, commander of the archers, made this for the god Mithras two years later.

If, as mentioned above, the words 'two years later' refer to the date of AD 168 given on the Ethpeni relief, the Zenobius dedication should therefore be dated to around AD 170. It has been assumed that Zenobius was also a Palmyrene in charge of the auxiliary archer unit from that city, just as Ethpeni had been, though the choice of a Greek rather than Palmyrene inscription may point towards a lessening of an insistence upon a Palmyrene character to the Mithraic community or its leadership at Dura.

It is worth pointing out, however, that the viewer of the Zenobius inscription would need to have been able to read Palmyrene to fully understand the dating reference to the Ethpeni inscription. It would be oversimplifying matters to separate the Palmyrene presence in Dura-Europos from their position in the army; after all, it is probable that the worship of Mithras was as much related to their being archers in the Roman army as it was to their Palmyrene identity.[33] Nonetheless, there is a strong suggestion of a Palmyrene-dominated worship of Mithras during the early years after its foundation in Dura. While the name Zenobius is of Greek origin, his second name, Eiaeibas, is Semitic, indicating that Zenobius was from an eastern (or at least Hellenized) family, and thereby reinforcing the suggestion that he was a Palmyrene commander. The inscriptions

[32] As mentioned above, however, on pp. 47–8, the idea that there was one main relief, and one subordinate, raises more questions than it can answer. It is also perhaps due to a particularly Christian heritage of reading icons and avoiding idolatry (for further reading on this, see Ando 2011).

[33] See Dirven 1999.

from the two reliefs would therefore indicate that worship of Mithras in the city was, at least in the beginning, sponsored by Palmyrene patrons and that many of the initiates would have been drawn from the archer cohort.

The main action of the relief shows Mithras as he prepares to sacrifice the bull, and much of the scene echoes the usual elements of a tauroctony as already described. Mithras is depicted in the act of subduing the bull. Unusually, both of the god's feet touch the ground, allowing him to face the relief's viewers and draw them into the moment of sacrifice. This frontal portrayal is a common element in Parthian painting, and may reveal local influences upon the sculptor of the relief.[34] The god wears his traditional costume of Phrygian cap, tunic, trousers, and cloak swept back over the right shoulder. The Mithraic dog, snake, and raven are depicted in their customary positions: the dog and snake reaching up towards the bull's wound, and the raven hovering above Mithras' outspread cloak. In the field above the head of Mithras there are traces of two missing busts, probably of Luna and Sol. Between these is the bust of a bearded god, possibly Saturn, who is thought, judging from other Mithraic evidence around the Roman Empire, to be associated with the highest grade of initiation.

As mentioned in chapter 1 (p. 24), Mithras worship has traditionally been configured as a male-only cult, with a hierarchical process of initiation. The mosaic set into the aisle of the Felicissimus *mithraeum* in Ostia sets out seven grades of initiation in the shape of a ladder, suggesting that worshippers may have been able to progress through the ranks (Fig. 2.8). The vast majority of scholarship on these initiation grades has been based on this mosaic; it lays out the symbols of each rank, and links them with a planet or astrological deity.[35] As mentioned above, the highest level, that of *pater*, is associated with Saturn through the symbol of a *harpē*. This link between Saturn and the *pater* grade is reinforced by frescoes from the Santa Prisca *mithraeum* in Rome, in which Saturn is invoked as the protector of the grade.[36] The astronomical meanings and associations behind the seven grades have been the subject of much scholarship, especially among those who have wished to see a link between the cosmos and the layout of *mithraea*.[37]

The Felicissimus mosaic does not, however, contain the names of each grade. For that missing information, the *mithraeum* at Dura-Europos has traditionally been seen to be of great importance. Although in the provinces it is more usual only to find single attestations of grade names, with the ranks of *leo* and *pater* being particularly prevalent, graffiti from Dura give the names of six initiatory

[34] See ch. 1, n. 40. [35] See Clauss 1990b; Turcan 1999; Chalupa 2008.

[36] For a detailed explanation of the Santa Prisca frescoes, see Vermaseren and van Essen 1965, chs 17–21.

[37] Selected examples: Gordon 1976; Bianchi 1979, 31–8; Beck 1988; Beck 2006. See also ch. 1, pp. 36–7.

FIG. 2.8. Mosaic pavement from the Felicissimus *mithraeum*, Ostia. Author's image.

grades.[38] Indeed, it is thanks to the evidence from Dura-Europos that the name *nymphus* was discovered and attributed to the second grade. It is perhaps dangerous, though, to be too trusting in this evidence from Dura. Is there any better reason to recreate the series of grades of initiation at Ostia based on graffiti from the Parthian border than to reconstruct a doctrine for a Roman god based on Avestan texts? This question will be reintroduced in chapter 4 (p. 93).

Thus far, the features of the relief have been more or less traditional, despite the absence of the scorpion from the scene once again. This absence of the scorpion could be seen as being a generic feature of a Syrian 'type' of Mithraic relief, an argument that was in fact made by Cumont in his desire to see uniqueness in the East.[39] Other evidence of the Roman cult from Syria, such as the reliefs from

[38] The six grades mentioned at Dura-Europos are: *corax* (*CIMRM* 63); *nymphos* (*CIMRM* 63); *stratiotes* (*CIMRM* 57, 59, 63); *leo* (*CIMRM* 57, 63); *Perses* (*CIMRM* 63); *pater* (*CIMRM* 63). A couple of permutations on the accepted grade names can also be found at Dura; these are: *melloleon* and *antipater* (*CIMRM* 57; 63).

[39] Baur, Rostovtzeff, and Bellinger 1929–1944 vol. 7/8, 101.

Seeia, does contain the scorpion, and therefore its absence is common only to Dura-Europos.

To the right of Mithras and the bull however, there is an exceptional addition to the overall scene: three human figures are shown. The most dominant figure is that of the patron Zenobius, identified by a Greek inscription next to his head. He is depicted in an act of sacrifice, placing incense onto a *thymiaterion* with his right hand, while he gazes out of the scene at the viewer. Accompanying him are two smaller men, identified by Greek inscriptions as Barnaadath and Iariboles respectively. The name 'Iariboles' in particular has strong associations with Palmyra, as we know from a bilingual honorary inscription with this name, dating to AD 138.[40] The evidence of this name should therefore not be over-interpreted; Rostovtzeff, however, argued that these two figures were intended to represent Zenobius' ancestors, drawing on the description of Zenobius in the Palmyrene inscription on the relief as the 'son of Iariboles'.[41] In so doing, he continued the same trend as Franz Cumont, who interpreted the figures as Zenobius' sons, and the kneeling figures beneath them as his grandsons.[42] If the name was common among Palmyrenes though, then there is no concrete reason to assume that Barnaadath and Iariboles were particularly connected to Zenobius.[43]

The figures of Barnaadath and Iariboles stand on a ledge, which appears to be supported by two crouching men. Discussion of their identity has sparked as much debate as that of Barnaadath and Iariboles. As mentioned above, Cumont thought that they were Zenobius' grandsons, but more recent work has moved away from this view. Lucinda Dirven sees them as members of the Mithraic community entirely unrelated to Zenobius, while Susan Downey has interpreted them as caryatids, following on from Rostovtzeff's impression of them as *atlantes*. It is also entirely possible that the two standing figures are statues of gods raised on bases, and that the inscribed names now refer to the two kneeling figures beneath.[44] None of these explanations quite seems to satisfy curiosity about the figures. In particular, is Zenobius' sacrificial action somehow connected to them, in a performance of ancestor cult for example, or is it more overtly connected with the Mithraic scene to the left?

The wealth of possible interpretations of these four figures only complicates our reading of a highly unusual scene. This is a unique portrayal of Mithraic worshippers, and in particular of a patron of the cult, on the main relief; does this suggest that a special relationship between worshipper and the divine was understood in Mithraic practice at Dura?

[40] *SEG* 46 1796. [41] Rostovtzeff 1934, 187. [42] Cumont 1975, 167.
[43] Dirven 1999, 271. [44] Rostovtzeff 1934, 187; Downey 1977; Dirven 1999, 271.

PATRON AND GOD

Traditionally, the sacrifice of the bull by Mithras has been interpreted as being on behalf of the initiates to the Mysteries, and as having some sort of salvific or regenerative function. In part, this understanding has been based on the misreading of the Santa Prisca hexameter graffito described in chapter 1 (p. 34). The belief that the spilling of the bull's blood was a salvific action prompted the drawing out of links between Mithras worship and the more conventional 'mystery' religions in which salvation was key. In this way, it could be more easily compared to the worship of Attis, of Osiris, and even of Jesus.[45] Based on the original reading of the Santa Prisca graffito, Richard Gordon considered 'the saving act of Mithras as bull-slayer' as one of the three characteristics that 'we may select as fundamental to the religious system of the mysteries'.[46]

In other cult reliefs, as we have already seen in the west, the bull's tail often sprouts ears of wheat or grain, suggesting that the sacrifice is connected to a renewal of fertility and life.[47] This idea is also made obvious in the Townley tauroctony discussed earlier, where the blood dripping from the bull's wound turns into ears of wheat.[48] That the god himself performs this sacrificial action is a main way in which the Mithras worship is distinguished from other cults, both civic and private, in which the worshipper is expected to perform an animal sacrifice to the god. Although there is little evidence to show whether animal sacrifice took place as a standard part of Mithraic ritual, the comparatively small size of *mithraea*, which on average would have held between twenty and thirty worshippers, would probably have prevented the slaughter of anything so large as a bull.[49]

If it were indeed the case that the Mithraic worshippers were unlikely to repeat the sacrifice of the bull themselves, then this suggests that Mithras' sacrifice of the bull could be seen as a symbolic act, which places the god at the centre of ritual and performance. The customary position of the tauroctony relief on the back wall of *mithraea* (as will be discussed further in chapter 3, pp. 64, 71) allowed the image of Mithras to dominate the space. The representation of his action, in wounding the bull, thus seems to have been intended as a focal point of Mithraic worship; even in the absence of a carved relief, as is the case with the

[45] As had been done much earlier, in turn of the century scholarship, such as Loisy 1911, 51.

[46] Gordon 1977–1978, 151. [47] For example, *CIMRM* 1083, 1283, and 1400.

[48] *CIMRM* 593. See this volume, ch. 1, pp. 17–18.

[49] Elsner 1995, 212. A large number of animal bones, particularly pig and chicken bones, were found in *mithraea* around the Roman Empire, and these have been the subject of several detailed surveys (see especially Lentacker, Ervynck, and Van Neer 2004, 58–66 on the *mithraeum* at Tienen; de Grossi Mazzorin and Minniti 2004, 179–81 on the Crypta Balbi *mithraeum* in Rome; Bjornebye 2007, 20–3 on 'The cult of Mithras in 4th Century Rome'. This supports the idea that ritual meals were common among Mithraic worshippers, but does not necessarily indicate that animal sacrifice was a part of cult action.

statue from the Terme del Mitra *mithraeum* in Ostia, it is still the image of Mithras *tauroctonus* that commands the attention of the worshipper.[50] The depiction of Zenobius in the Dura relief, engaged in his own sacrificial act of placing incense on the *thymiaterion*, therefore allows the patron to appropriate some of the performative element of sacrifice to himself and away from the god. In so doing, he blurs the boundary between human and divine ritual action.

Nonetheless, Zenobius' act of sacrifice is very obviously different from Mithras' bull-slaying. The presence of Zenobius with a *thymiaterion* on the same relief does not diminish the visual impact of the sacrifice of the bull, though it perhaps breaks down some of the boundaries between viewer and god. Use of incense may have been an important part of some elements of Mithraic ritual, as inferred from lines from a *dipinto* in the Santa Prisca *mithraeum* in Rome that refer to the role of the Mithraic *leo* grade in offering incense.[51] It is therefore possible that, being a common feature of *mithraea*, the depiction of incense gave a greater sense of familiarity to Mithraic worshippers looking at the Zenobius relief.

Was Zenobius assimilating himself to the god by placing himself at the centre of Mithraic activity in Dura, at the heart of the *mithraeum*, on a relief? Zenobius' inclusion not only of his name on the inscription, but also of his representation and name on the relief, ensured that his dedication and his generosity would continue to be remembered by future worshippers within the *mithraeum*. Again, it reinforces the sense that there was a strong Palmyrene identity among the worshippers of Mithras at Dura; that Zenobius was prepared to put himself so prominently on display within the *mithraeum* indicates that he played no small role in the hierarchy of Mithraic worship.

It is by no means unusual to find that the art in *mithraea* employed features deriving from local culture. Zenobius' appearance on the tauroctony relief also reveals the extent to which the artistic traditions of both Dura and Palmyra were capable of influencing Mithraic art, and the way in which a patron of the cult might expect to be portrayed. Pierre Leriche argues that the inclusion of the patron was a common feature of bas-reliefs from a religious context in the art of Dura.[52] He cites the reliefs in the temple of the Gaddé as an example of this, although, as Rostovtzeff had already clarified, since the founder of Dura, Seleucus Nicator, is shown, he should be interpreted more as a heroized and semi-divine figure, rather than as a mortal.[53] More pertinent to Leriche's argument might have been the frescoes from the Temple of Bel, several of which

[50] *CIMRM* 230.

[51] Vermaseren and Van Essen 1965, 224–32 (the under layer of painting on the north wall; column 6, lines 16–17).

[52] Leriche 2001, 199. The inclusion of a patron at an altar is also a frequent motif in Parthian reliefs; see Mathiesen 1992.

[53] Rostovtzeff 1938, 78.

depict sacrifice carried out by members of the Durene community. Perhaps the most famous of these scenes is the Conon fresco, which shows a prominent member of Durene society in the act of placing incense onto a *thymiaterion* with his right hand (Fig. 2.9). Similarly, the Lysias fresco from the same temple shows four men, each sacrificing with incense. In these two frescos, the sacrificants are shown standing slightly apart, within an architectural frame; this could perhaps give a local reason as to why there was an architectural representation of columns and a vault surrounding the action on the Zenobius relief. Parallels to the Mithraic relief can be also be seen in the inscriptions that identify each of the main sacrificants in the frescos, and in their relatively high social status; was the inclusion of the patron therefore a local custom adopted into this example of Mithraic iconography?

It is important to remember the general context in which the tauroctony relief would be seen. After all, Zenobius' image was placed at the centre of the Mithraic worshipper's gaze; his representation would be within the focus of any viewer inside the *mithraeum*. As such, even though the space itself may have been private, his generosity would have been remembered within Mithraic practice at Dura. The relationship between the patron and the viewer becomes more important when seen in this light; is it possible that Zenobius was setting himself up as an intermediary between the initiates and Mithras? Was his act of sacrifice a model for other worshippers to imitate? Or was it supposed to be interpreted

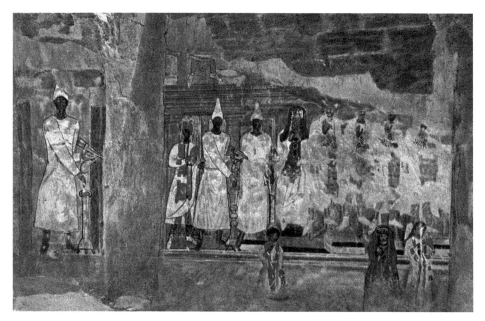

FIG. 2.9. Conon fresco from the Temple of the Gaddé, Dura-Europos. Yale University Art Gallery.
Public domain.

as being on behalf of his fellow worshippers? It is certainly plausible that the image could have been seen in this way later, even if that was not the original intention. Although there are many inscriptions from across the Roman Empire that give a glimpse into the identity of Mithraic patrons, in particular those set up by *patres*, this is a unique case. From nowhere else is there the suggestion that a patron may have acted as an intercessor for the worship of Mithras; to what extent could the modern viewer simply be seeing a local artistic custom in a Mithraic context, or a potential insight into a different understanding of Mithraic practice. It would be unwise to read too much into the appearance of Zenobius on the relief, but it does throw open some tantalizing possibilities for a comprehension of how Mithraic patrons and viewers interacted with one another, and with the god.

Given the private nature of the *mithraeum* at Dura, almost certainly restricted to the Roman military garrison after the construction of the Severan wall, it is unlikely that Zenobius' dedication would have been accessible to different sections of the wider population. His role as a patron may therefore have been limited to within the *mithraeum*; nonetheless, his use of his own image on a tauroctony relief ensured that this role would not be an insignificant one. This raises the question: if the main image of Mithras and the bull had been more open and more visible, would this then have changed other features of a *mithraeum*? Would representations of Mithraic patrons, such as Zenobius, far from being rare, in fact have been commonplace; if their acts of benefaction became more public, would they correspondingly increase in size and scope, including their portraits and images? This subject, of the possible consequences of the greater visibility of the tauroctony scene, will be explored in the next chapter.

THREE

Settings

Bourg-Saint-Andéol

In the previous chapter, we explored the diverse identities of Mithras worshippers and how they perceived themselves with respect to the deity. We saw at Dura-Europos that such perception and self-representation could directly influence the image made of the god. This observation leads us to question what the physical context of images of Mithras can tell us about the communities that installed them and their beliefs. By 'physical context' we mean the position of the image within the *mithraeum*, its relation to other images in that space, its materiality, and the *mithraeum*'s own position in the surrounding landscape.

In attempting to answer this question, we start about two hundred metres west of today's city of Bourg-Saint-Andéol in the Ardèche region of southeast France, the ancient Gallia Narbonensis. Here we find a relief depicting a tauroctony carved into a rock face (Figs 3.1–2). It sits about 2.3 m above ground level on a sloping plateau that is flanked by two springs, Petit Gouffre and Grand Goule, which flow into the nearby river Tourne (Fig. 3.3).[1] The relief measures 2 × 2.08 m and along the base runs a ledge about 25 cm deep.[2] The iconography follows the conventions of Roman tauroctonies, as outlined in chapters 1 and 2. Mithras is depicted as a bull-slayer and is accompanied by the dog, serpent, scorpion, and raven. These figures are encompassed under an arch carved roughly to suggest a natural outcrop over the relief. Above the arch are busts of Sol wearing a radiate crown and Luna. At the base of the relief is a framed inscription that is weathered to such an extent that several attempts at reconstruction have come to very different conclusions, but it is most likely a dedicatory inscription to the *deus Invictus*—the invincible god.[3] This is a typical designation for Mithras in the

[1] On the tauroctony at Bourg-Saint-Andéol, see *CIMRM* 895, *MMM* II 279; Turcan 1972, 7–10; Walters 1974, 70–2; Lavagne 1976. An overview of older literature is given in Walters 1974, 72–3.

[2] These measurements are given in Turcan 1972, 9 and Walters 1974, 70. *CIMRM* 895 records the relief's dimensions as 1.5 × 2 m.

[3] Cf. Lavagne 1976, 223–4. For earlier suggestions, see Walters 1974, 71–2. For a brief discussion of variations in Mithras' names and titles in the Roman Empire, see Introduction, pp. 1–4 this volume.

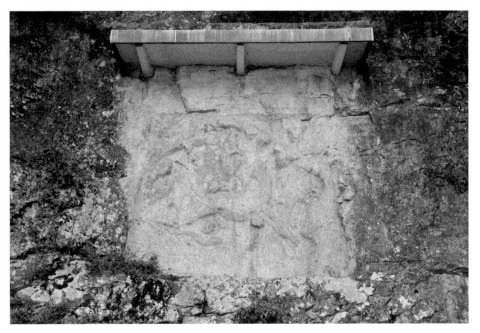

Fig. 3.1. Rock-cut tauroctony relief, Bourg-Saint-Andéol, Ardèche, France.
Image by Carole Raddato. Creative Commons licence.

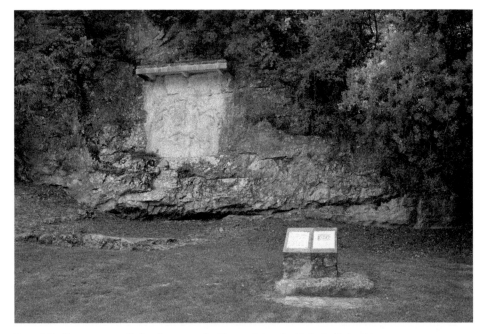

Fig. 3.2. Tauroctony relief and surrounds, Bourg-Saint-Andéol, Ardèche, France.
Image by Carole Raddato. Creative Commons licence.

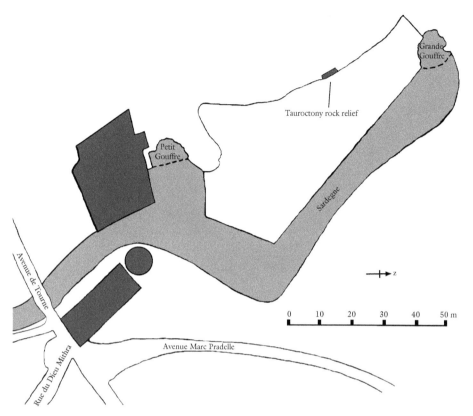

Fɪɢ. 3.3. Plan of Mithraic site at Bourg-Saint-Andéol. R. Wood, after F. Revoil, 1854 in Lavagne 1976, pl.XIV.

Image courtesy of the Archives des Monuments Historiques.

western Roman Empire. A dating of the relief in the second century has been suggested, but is contestable.[4]

The marvellous scenery surrounding the relief today seems like a natural theatre spotlighting its antique protagonist. This theatrical setting, however, is in stark contrast to the conventional idea of the place the tauroctony held within spaces supposedly sacred to Mithras. *Mithraea* have been generally envisioned as 'essentially closed, inward-looking, and somewhat secretive structures with the tauroctony at the heart'.[5] Many excavations throughout the Roman Empire have brought to light a fairly standardized ground plan of *mithraea* that supports this interpretation, a good example of which is the *mithraeum* Budapest II (Fig. 3.4).[6]

[4] The relief was dated by Cumont to before AD 202 on a daring assumption. The *Acts of St. Andéol*, a saint martyred in AD 202, mention a temple of Mars in Bourg-Saint-Andéol. Cumont speculates that the ignorant Medieval author might have mixed up Mithras with Mars. *MMM* II 279. See also Turcan 1972, 9–10.

[5] Beck 1984b, 364.

[6] See Clauss 2000, 42–8 for an overview of *mithraeum* architecture. For Budapest (Aquincum) II, see *CIMRM* 1750.

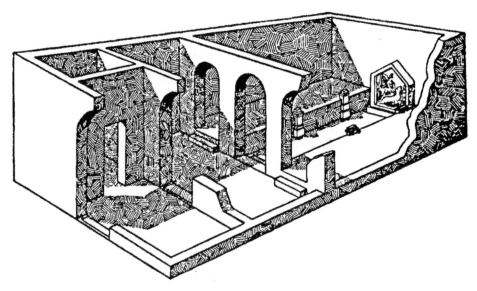

Fig. 3.4. Budapest II *mithraeum* axiometric reconstruction.
Image courtesy of Akadémiai Kiadó.

In the standard model, the tauroctony is shown in relief on a stone slab placed on the back wall of the rectangular room of worship that frequently does not span more than ten metres in each direction and is the last of a suite of small rooms. Many of these complexes were sunken or built underground and were dimly lit. The tauroctony sat in a niche presiding over the cult room that is called in many Mithraic inscriptions a 'temple', whereas in Italy it is usually referred to as *spelaeum* ('cave'). An axial passageway led from the entrance directly to the niche. Both areas to the left and right of this passageway were elevated and perhaps were used as benches, but their exact use is not clear.[7]

This concept of a standardized version, however, can obscure the many diverse manifestations of the scheme that are a crucial part of the material history of Mithras worship. In order to get a more substantial idea about the role the image of the god played, we should therefore look at and not exclude specific examples of this diversity. It is particularly worthwhile examining the rock-carved Mithraic relief of Bourg-Saint-Andéol since it provides information about the setting of the image within its original context, whereas the findspots of the more renowned depictions are typically clouded by insufficient records as to their provenance and setting.[8] The relief of Bourg-Saint-Andéol has several more distinctive features. Besides being carved into the living rock, the tauroctony is characterized by its larger-than-life size and its position well above eye-height, as well as by the proximity to the two springs. Remarkably, the relief shares these features with other rock-cut tauroctonies that are

[7] Clauss 2000, 46. [8] See, for example, the tauroctony statue groups discussed in ch. 1, pp. 15–22.

scattered across the mainland north of the Mediterranean from France to Turkey. This group belongs to a number of *mithraea* that integrated a rocky landscape of some form into the building, be it that a natural cave was used as a *mithraeum* or that a rock face supported a built structure. We currently know of thirty-seven instances of Mithraic spaces set in the landscape spread throughout the Roman Empire, with a core area in Dalmatia and Pannonia.[9]

Among those sites, a group of seven more *mithraea* contain reliefs that share a similar scale and situation as that of Bourg-Saint-Andéol: usually larger-than-life or life-size, and, in five cases, a position at the extreme end of a supposed *mithraeum* (see Fig. 3.5a–b). One relief is in the province of Germania, at Schwarzerden in southwest Germany (Fig. 3.6); two are in Dalmatia, in Jajce in central Bosnia (Fig. 3.7), and in the Croatian village of Močići near Cavtat, ancient Epidaurum (Figs 3.8–9); two more are in Pannonia, near the village of Rožanec in southern Slovenia and in the ancient city of Scarabantia, today near Fertörakos in Hungary; and the last two are in two adjacent, subterranean limestone quarries in Doliche (Fig. 3.10) in Commagene, southeast Turkey, a region to which we will return in chapter 6 (p. 128).[10] Evidently, each of the seven large-scale tauroctonies was part of a *mithraeum*. Beyond these, five more rock-carved tauroctonies are attested that cannot necessarily be attributed to a *mithraeum*.[11]

[9] A good introduction into Mithraic rock sanctuaries as well as a list of all sanctuaries with short bibliographies is provided by Schütte-Maischatz and Winter 2004, 116–22, 127–9, esp. 118. On cave sanctuaries in former Yugoslavia, see Zotović 1973, esp. 153–5.

[10] For Schwarzerden: *CIMRM* 1280 (with bibliography); Vermaseren 1974, 28 fig. 5. At Jajce, the floor level of the *mithraeum* lies 2.8 m below the ground level. Two steps chiselled under the relief can still be seen today. Two triangular niches of 0.11 × 0.08 × 0.07 m, supposedly for lamps, were carved to the left and right of the image. The *mithraeum* is dated to the fourth century based on finds of coins and lamps predominantly from this period. *CIMRM* 1901–5; Sergejevski 1937, 11–18; Basler 1972, 64–5; Zotović 1973, 26–7. For Močići, see *CIMRM* 1882; Evans 1883, 20–1; Rendić-Miočević 1953, 272–5; Zotović 1973, 37–8; Bojanovski 1986, 39–40. More recently Cambi 2006, 207–8; Božić 2008, 348, fig. 4; Sanader 2008, 178; Bijađija 2012, 81–2. Cambi suggests a dating to the late third–fourth century. The *mithraeum* has recently been measured by Bruno Bijađija. It measures 4.5 m in length and 5.6 m in width. The maximum height of the cave is *c*.2.65 m. A date in the late second century of the tauroctony at Rožanec is suggested for typological and historical reasons (Campbell 1954, 41 and Selem 1980, 78–80, esp. 80). See further, *CIMRM* 1481–3; Zotović 1973, 63; Clauss 1990a, 171. On Scarabantia, *CIMRM* 1363. The sites at Doliche are thought to have been used as *mithraea* until the third century. Schütte-Maischatz and Winter 2001; Schütte-Maischatz and Winter 2004, esp. 92 and 101; Gordon 2007b.

[11] In Sveti Juraj, Croatia (Dalmatia), is a carving of 0.5 × 0.8 m in a free-standing rock which potentially was positioned at the back wall of a *mithraeum* of which no traces survive. The relief is now immured in the cellar of the birthplace of Baltazar Bogišić which is managed by the Croatian Academy of Science and Art. I owe this reference to Bruno Bijađija.

(*CIMRM* 1883). In Veliki Vitaly/Arupium, Croatia (Dalmatia), is a natural niche of 1.6 × 1.58 × 0.7 m with a 21.5 cm tall tauroctony carved in the rock 0.8 m above the ground (*CIMRM* 1851; Beck 1984b, 357ff.). A neighbouring site is Prozor/Arupium in Croatia (Dalmatia) with another small tauroctony carved in a natural niche of 1.4 × 1.45 m. Cf. Beck 1984b; *CIMRM* 1852. Near Prilep (Macedonia) is a grotto with a small tauroctony of 0.32 × 0.39 m. Cf. *CIMRM* 2341. For all four tauroctonies, see also the catalogue entries in Zotović 1973.

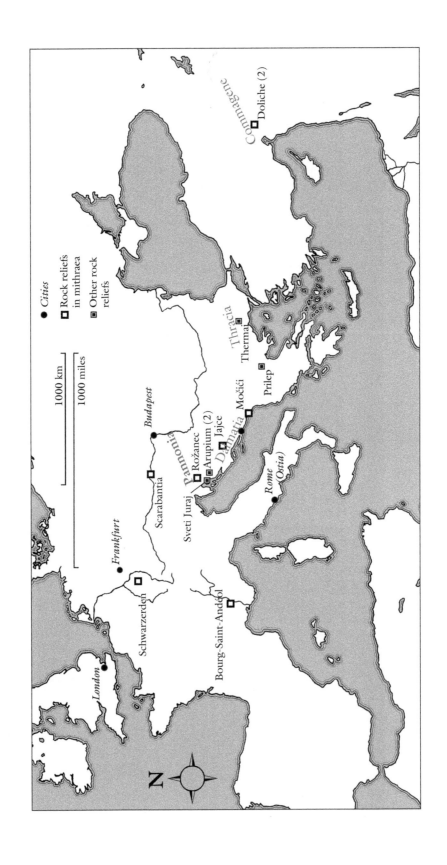

Commagene
Doliche (2)

Thracia
Thermai

Prilep

Dalmatia Močiči
Jajce
Arupium (2)
Rožanec
Pannonia
Sveti Juraj
Budapest

Scarabantia

Rome
(Ostia)

Frankfurt

Bourg-Saint-Andéol

Schwarzerden

London

● Cities
□ Rock reliefs in mithraea
▣ Other rock reliefs

1000 km
1000 miles

N

Location	Dimensions	Setting	Proximity to water
Bourg-Saint-Andéol, southern France (Gallia Narbonensis)	H.2 m; W.2.08 m.	2.30 m above ground level, on a steep rock face that forms the rear wall of a constructed *mithraeum*.	On a plateau surrounded by two springs.
Schwarzerden, southwestern Germany (Germania)	Approx. H.1.50 m; W.2 m.	Sits above sloping ground, on a steep rock face that forms the rear wall of a constructed *mithraeum*.	A brook runs below the *mithraeum*.
Jajce, central Bosnia (Dalmatia)	H.1.65 m.	3.15 m above original ground level, on a steep rock face that forms the rear wall of a constructed *mithraeum*.	Bordered by a stream.
Močiči, southern Croatia(Dalmatia)	H.1 m; W.1.43 m.	1.75 m above ground level, over an arched entrance to a natural cave.	Spring attested next to entrance, later made intoa well.
Fertórakos, northwestern Hungary (Pannonia)	H.1.50 m; W.2.40 m.	Near ground level, on the rear wall of a natural grotto.	Next to a former brook at the point it joined a lake.
Rožanec, southern Slovenia(Pannonia)	H. 1.26 m; W.1.20 m.	70 cm above current ground level (original level unknown), on the wall west of the rear of the *mithraeum*, which is formed of irregular rock faces on its three sides.	Semi-circular basin against the rear wall of the *mithraeum*.
Doliche I, southern Turkey (Commagene)	H.2.10 m; W.1.80 m.	Near ground level, on the rear wall of a subterranean limestone quarry.	Basin hewn out of the uppermost step below the tauroctony.
Doliche II, southern Turkey (Commagene)	H.1.70 m; W.2.40 m.	Near ground level, on the rear wall of an adjacent subterranean limestone quarry.	No relation to water attested.

Fig. 3.5. Distribution map and table of the large rock-cut tauroctonies.

Author's image.

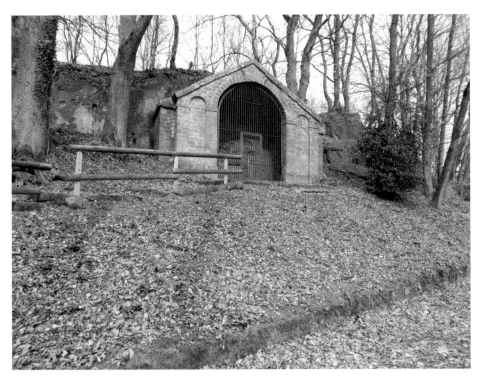

FIG. 3.6. Tauroctony relief, Schwarzerden, Saarland, Germany.
Author's image.

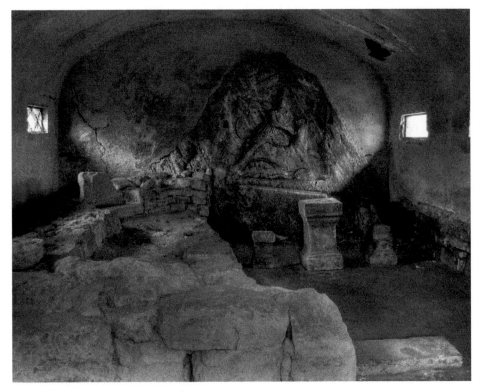

FIG. 3.7. *Mithraeum* of Jajce, Bosnia.
Image courtesy of Dževad Hadžihasanović.

FIG. 3.8. Tauroctony relief above the entrance to a natural cave, Močići, Croatia.
Image courtesy of Bruno Bijađija.

FIG. 3.9. Tauroctony relief, Močići, Croatia.
Image courtesy of Bruno Bijađija.

FIG. 3.10. Tauroctony relief, *Mithraeum I*, Doliche, Turkey.
Image courtesy of Forschungsstelle Asia Minor, Westfälische Wilhelms-Universität Münster.

Four of these are small carvings that are integrated into natural niches in Dalmatia and Macedonia. A geographical exception is the carving at Thermai in the ancient province of Thracia, eastern Greece, of which we know only that it was chiselled into a steep rock-face.[12] In all other *mithraea* placed in natural settings the tauroctony was either not carved into the rock or was not found.

In the case of all these seven, large-scale tauroctonies, the surrounding structures are better preserved than in Bourg-Saint-Andéol. The reliefs were carved in a variety of settings dependent to different degrees on the natural rock structure. It is a worthwhile enterprise to examine further the characteristics that the carving of Bourg-Saint-Andéol shares with this group. This can help not only to reconstruct its setting, but may raise further doubts about established opinions on the place of the image of Mithras. Moreover, it may throw light onto whether the stone-carved images had a specific significance that set them apart from the more widely acknowledged panel reliefs and somewhat glamorous statue groups already discussed in this volume.

THE TAUROCTONY OF BOURG-SAINT-ANDÉOL
A STANDARD MODEL?

The *mithraea* of Schwarzerden (Fig. 3.6) and Jajce (Fig. 3.7) give the best idea of the most likely reconstruction of the Bourg-Saint-Andéol *mithraeum* because their settings are similar. In both cases, the reliefs are placed on a steep

[12] Clauss 1990a, 233, n. 17.

rock face above a sloping approach. Traces of side walls and a roof construction have been preserved at both sites. In Jajce, the relief was evidently set in the centre of the back wall of the *mithraeum* because parts of the constructed side walls can still be seen today. In Schwarzerden, however, a secondary room that also used the rock-face as a back wall was added next to the room containing the tauroctony, and therefore the relief's exact position within the *mithraeum* is less certain.[13] At Bourg-Saint-Andéol, only the supposed back wall of the *mithraeum*, into which the tauroctony is carved, has been preserved. Grooves cut into the rock above the relief, however, suggest that it was sheltered by an artificial roof.[14] Scholars have argued that the tauroctony was placed centrally on the back wall of a *mithraeum*, and hence determined expectations of what a *mithraeum* should look like. But does the group of rock-carved tauroctonies give enough evidence to support this case?

This small group of tauroctonies is far from homogeneous and makes it difficult to assume any standard means of displaying rock-cut tauroctonies at all. In the case of the *mithraeum* near Rožanec, for example, the rock relief is located on the west wall of a *mithraeum* orientated along a north–south axis, with its entrance at the south side.[15] The north side consists of an accumulation of rocks rather than a solid rock face, which appears to have necessitated a reorientation of the rock relief.[16] If, however, the standard location of the central cult image at the back wall was of such immense importance to the practice of worship, as is usually assumed, we might ask why the community here still preferred a rock carving rather than the more flexible option of a slab or statue.

There are two more deviations from the standard location, however, that are not easily explicable by the need for adaptation to the natural environment. Tauroctony I at Doliche (Fig. 3.10), for instance, which sits on the back wall of a subterranean quarry, is placed off-centre although the surface is flat and would not seem to pose any obstacles to a stonemason to place the relief on an axial alignment. The reasoning behind this discrepancy is not clear. Even more astonishing is the position of the Mithraic rock relief in the Croatian village of Močići (Figs 3.8–9). This relief was carved above the entrance of a natural cave of a maximum height of *c.*2.65 m that probably served as the cult room of a *mithraeum*, thus violating the usual convention. The *mithraeum* is composed of the vaulted cave to the west and a larger, open space enclosed within large rocks to the east that is traditionally interpreted as the entrance hall to the *naos*.[17] This particular arrangement allows one to see the rock-carved tauroctony not only from within the *mithraeum*, which is accessible via a staircase in the east, but also

[13] See *CIMRM* 1280.　　[14] Walters 1974, 4.
[15] For a description of the area see Selem 1980, 78–9.　　[16] Selem 1980, 79.
[17] This reconstruction was first suggested by Rendić-Miočević 1953, 272.

from the outside. Due to the lack of any visible structures that could have supported a roof, the irregular shape of the rocks that would not facilitate the necessary vault, and the considerable distance between those rocks, it is doubtful whether the tauroctony was ever protected from the gaze of outsiders.[18] The secret exclusivity of the tauroctony and the *mithraeum* in general, so central to many modern ideas about Mithras worship, seems to be put into question in Močići.

It is generally assumed that the *mithraeum* of Močići was located in the vicinity of a *villa rustica* or perhaps another kind of settlement, yet the cave is reported to be difficult to access.[19] The probability of coming across the *mithraeum* by chance is therefore hard to estimate but seems low. Nevertheless, the example of Močići can be used to question the perseverance with which Mithras worshippers kept their communities secret. There is a similar problem at Ostia, where all in all fourteen *spelaea* have been excavated. Four of them, all from the third century and hence of the latest building period in Ostia, were attached to public spaces.[20] The *mithraea* were placed in two large depots probably run by or under the control of the empire, a public bath, and a collegiate temple built for a guild of Ostia.[21] These locations imply that late Mithras worship functioned well inside the public sphere in Ostia. The examples of Močići and Ostia therefore challenge the established view of the exclusive character of the *mithraeum* and image of Mithras in the Roman west in two different ways: while the accessibility to the sanctuaries was increased in Ostia, the iconography of seclusion was kept alive, whereas in Močići the layout of the *mithraeum* was fundamentally changed in favour of an eye-catching presentation of the central cult image, although access to it may still have been limited. Their privacy led the Christian polemicist Tertullian to describe *mithraea* as *vere castra tenebrarum*, 'veritable camps of darkness', an image that has shaped modern ideas about Mithras worship perhaps disproportionately.[22]

[18] For the measurements of the *mithraeum* see n. 10 in this chapter. An archaeological investigation of the *mithraeum* of Močići was run by Ivica Žile, but unfortunately was never published. The report *Zaštitni radovi na spomenicima kulture* (1998) is now in the Conservation Department of Dubrovnik. I owe this reference to Bruno Bijađija. Very little has been published on the question of the possibility of Mithraic open-air sanctuaries. See the divergent opinions of Zotović 1973, 153–4 and Beck 1984b, 363. See also the certainly romantic account of two lost open-air sanctuaries by Patsch 1924, esp. 137–41.

[19] Rendić-Miočević 1953, 272; Bojanovski 1986, 39–40. Bruno Bijađija, University of Zadar, is currently investigating the supposed *villa rustica*.

[20] The *mithraea* in question are Mitreo della Planta Pedis in a *loggia* adjacent to a *horreum*, c. AD 204–211; Mitreo delle Terme del Mitra in the service corridor beneath the bath, third century; Mitreo dei Fructuosus in a vaulted room beneath the *collegia* sanctuary, from the second half of the third century; Mitreo presso Porta Romana in a part of a *horreum*, second half of the third century.

[21] Schreiber 1967, 39–40. [22] Tert. *De cor. mil.*, 15.

Unexpected locations such as at Rožanec, Doliche I, and Močići document a certain flexibility for Mithraic architecture and ritual in the choice of natural sites used as *mithraea*.[23] In fact, only the *mithraea* of Jajce, Fertőrakos, and Doliche II follow the standard model of where to place the central cult image. In light of this, reconstructing the architectural setting of the relief of Bourg-Saint-Andéol with certainty is perhaps less straightforward than it first appeared. The locations of both the Doliche I and Močići tauroctonies seem to have been deliberately chosen. Just as the Zenobius relief from Dura-Europos (see ch. 2, p. 52) contravenes the convention not to show worshippers next to Mithras' struggle with the bull, so these reliefs present an apparent eccentricity of their own. Even if adaptation to the environment was a crucial factor in placing the images of Doliche I and Močići, as it was at Rožanec, it can still be postulated that the Mithras worshippers preferred an image of Mithras carved into the rock rather than adhering to the supposed conventional arrangement of a *mithraeum*.

THE MATERIAL SYMBOLISM OF THE
ROCK-CARVED TAUROCTONY

Is there any significance in these tauroctonies being engraved in rock instead of being produced as separate reliefs or statues? The major distinction between the two formats is that by cutting an image into a rock that is already part of a *mithraeum*, the image of Mithras is more intertwined with the space than if it were a separate carving. It is conceivable that the rock reliefs were meant to emphasize the affiliation of the god with the place where he was worshipped. So far, however, scholarship has not focused on the place itself, but has taken the carvings into the living rock as a confirmation for *mithraea* having been conceptualized as caves by worshippers.[24] It has been argued many times that *mithraea* were regularly understood in a symbolic way as caves, since the term *spelaeum* ('cave') was used specifically to refer to *mithraea* in Italy.[25] Beyond Italy there are a number of *mithraea* that also suggest an attempt to reference caves, either through their placement in a cave-like structure or in a real cave, as we have seen above. In some cases, where no suitable natural sites were available, pumice or basalt was applied to the ceilings apparently to emulate a cave setting.[26] Apparently in reference to the same idea, many *mithraea*, or at least their central room of worship, were constructed below ground level. Hence, the rock-cut tauroctonies

[23] See also Schütte-Maischatz and Winter 2004, 120–2.
[24] See for instance Clauss 2000, 44.
[25] See Beck 1984b, 364 n. 18; Clauss 2000, 44. Note the response to Beck in Schütte-Maischatz and Winter 2004, 121.
[26] Beck 1984b, 370.

have been taken implicitly as evidence for the conviction that the responsible Mithras worshippers wanted to emphasize the cave-likeness of their *mithraeum*. But can we be sure that this is what was in their mind? There are cases of Mithraic communities, for instance in the Wetterau in Frankfurt (Main), that would have had the opportunity to use a cave, but did not do so.[27] Very few textual sources suggest that outside of Italy Mithraic communities regarded the *mithraeum* as a cave, and the archaeological evidence that we do have is, as this book demonstrates, subject to prevailing popular modern interpretations.

The most precise literary testimony on the topic of the symbolic significance of the *mithraeum* is that of the third-century neoplatonic philosopher Porphyry. For Porphyry *mithraea* symbolize caves, and those caves represent, according to an ancient tradition, earth. Earth, in turn, he says, is a 'symbol of the matter of which the cosmos consists'. According to Porphyry, Mithras worshippers believed the god to be the creator of the cosmos, and in his reasoning the Mithraic cave represents the cosmos:

> The ancients, then, very properly consecrated caves and grottoes to the Cosmos...making earth a symbol of the matter of which the Cosmos consists....They use caves to represent the Cosmos, which was generated from matter; caves, for the most part, are natural and are made of the same substance as the earth is....Similarly, the Persians call the place a cave where they introduce an initiate to the mysteries, revealing to him the path by which souls descend and go back again. For Eubulus tells us that Zoroaster was the first to dedicate a natural cave in honour of Mithras, the creator and father of all; it was located in the mountains near Persia and had flowers and springs. This cave bore for him the image of the cosmos which Mithras had created, and the things which the cave contained, by their proportionate arrangement, provided him with symbols of the elements and climates of the cosmos. After Zoroaster others adopted the custom of performing their rites of initiation in caves and grottoes which were either natural or artificial.[28]

On the basis of Porphyry's interpretation one could suggest that the Mithraic rock-carvings pointed to Mithras' connection with earth and thereby the universe. As they showed the god inseparably connected with the element, they could have signified the mystic relationship between god and cosmos.

However, it is not at all clear how normative the interpretation of the Neoplatonist was for Mithraic communities throughout the Roman Empire. There is no textual evidence to suggest that Mithraic sacred space was uniformly thought of as a cave, especially outside Italy. Nonetheless, it is a recurring theme

[27] Schütte-Maischatz and Winter 2004, 117 n. 195.

[28] Porph. *De antr. nymph.*, 5–6. There is one other textual account of Mithraic practice which suggests that Mithras' sacrifice of the bull and subsequent Mithraic devotion took place in a cave, in Just. Mart. *Dial. c. Tryph.*, ch. 70: 'and when those who record the Mysteries of Mithras say that he was begotten of a rock, and call the place where those who believe in him are initiated a cave (...).'

of Mithraic scholarship, with particular attention being paid to Porphyry's phrase 'image of the cosmos' (*eikona kosmou*). Porphyry has given rise to an entire field of work on astrology and the zodiac in relation to *mithraea*, and to the conception of the perfect Mithraic space.[29] While this kind of in-depth analysis of the orientation and subdivision of space to fit into an astrological frame does seem to work for some *mithraea*, most notably Sette Sfere in Ostia, the idea, largely gained from Porphyry, that this was a constituent part of Mithraic constructions of sacred space around the Roman Empire is less plausible. In the absence of definitive knowledge, it seems wise to refrain from universal claims about how Mithraic communities conceptualized nature. While it is arguable whether the conviction in current scholarship that 'all *mithraea* are "caves" by definition of ideology and symbolism' really reveals anything about the ideology of hundreds of different Mithraic communities spread throughout the Roman Empire, it might reveal something about the ideology of the discipline.[30]

It is doubtlessly possible that the rock-carved tauroctonies relate to the symbolic identity of the *mithraeum* as a cave, but there are alternative options. The sole overarching similarity of which we can be sure is simply that all these tauroctonies are carved into living rock. For all we know, the tauroctonies might well refer to the specific location to which they are attached and mark the particular stone into which they are carved as somehow important. It is further conceivable that they alluded to the location at which Mithras' legendary fight with the bull was thought to have taken place, if we accept the prevalent opinion that it happened in a cave.[31] Modern scholars unequivocally set the bull's fight with Mithras in a cave because of a few textual references that relate caves to Mithras, of which only Statius explicitly mentions a cave as the location of the fight.[32] The arched structures that are often, but not always, found in the iconography of the tauroctony above the pair of God and bull such as at Bourg-Saint-Andéol have in consequence been interpreted as depictions of the cave. In another common depiction of the god Mithras, he is seemingly growing out of a pile of stones or a rock. This iconography is thought to represent the birth of Mithras from a rock, another mythic event documented by only a few textual sources, which furthers the suggestion that he owes his existence to some extent to stone.[33]

[29] For example, Gordon 1976; Beck 1988, 2006; Ulansey 1991.

[30] Beck 1984b, 364 n. 18. [31] Clauss 2000, 44.

[32] Cf. Stat. *Theb.*, 1.717–720: 'You as "rose-red / Titan," in Achaemenian litany, or as "Osiris, / Lord of Harvest," or—thinking how, deep in Persian rock-caves, / He wrangles headstrong bulls—should we invoke You as "Mithras"?' transl. by Joyce 2008. See also Porph. *De antr. nymph.*, 5–6, 9–10; Comm. *Instr.*, 1.13.

[33] See Just. Mart. *Dial. c. Tryph.*, 70 (n. 28 above); also Comm. *Instr.* 1.13. On different interpretations of the genealogy of Mithras, see Weinberg 1986, 147.

Each of these symbolic interpretations, some combination of them, or alternative unidentified options could have been relevant for the communities' decisions for a rock-carved relief. And yet, rock faces could likewise have been favoured by artists and sponsors as their chosen medium because they allowed for monumental depictions without extensive spending on materials and workmanship, they were hard to destroy, and impossible to steal. As it is, there is no way to know how pragmatic or symbolic the reasons for the rock carvings may have been. The unverifiability of the different arguments does not rule out the possibility that the rock-carvings had one or more significances beyond practicalities. Whatever these significances would have been, however, there is no need to assume a uniform conception of the image of Mithras.

THE TAUROCTONY BETWEEN ROCKS AND WATER

The question of how uniform or diverse the presentations of the rock-carved images of Mithras actually were brings us to the little-explored association of *mithraea* with flowing water.[34] Five of the eight large-scale rock-carvings are situated next to a stream. The *mithraea* of Bourg-Saint-Andéol, Schwarzerden, and Jajce all reside over sloping ground bordered by a source of water; the relief of Bourg-Saint-Andéol even sits at a place where two springs join a river.[35] In Močići, a cistern is located in front of the natural cave within the so-called entrance hall.[36] The *mithraeum* near Fertörakos is located at the southwest end of lake Fertö, at which point a small brook (now dry) used to join the lake.[37] Although there is no stream of water close to the *mithraeum* of Rožanec, water is nonetheless highlighted in a particular way. Old photographs attest that a semi-circular basin constructed in brickwork used to stand against the back wall of the *mithraeum* and in front of the rock relief.[38] A similar situation was created in Doliche where a narrow basin was hewn out of the uppermost step below the tauroctony of *mithraeum* I.[39] While water basins occur occasionally in or at the entrance to *mithraea*, they usually do not take over the place of the central Mithraic image at the back wall.[40] Hence, in all seven sites where large-scale rock

[34] A thorough examination of the subject is missing as yet. See notes on sources of water in the vicinity of *mithraea*, for instance in Campbell 1968, 299; Zotović 1973, 153; Walters 1974, 47; Schütte-Maischatz and Winter 2004, 122.

[35] M. Guignes Ribbon, notary of the episcopal court at Bourg-Saint-Andéol in 1422, ascribed miraculous power to the water of this river. He reports that the spring was used for a test of leprosy (Walters 1974, 72).

[36] This has been asserted in Žile 1998. Evans 1883, 20 seems to assume the same; Zotović 1973, 38 speaks of a well.

[37] *CIMRM* 1363. [38] *CIMRM* 1481.

[39] 1.62 m long, 0.32 m wide, 0.14 m deep. Schütte-Maischatz and Winter 2004, 81.

[40] See, for example, Campbell 1968, 299.

carvings were created, a special connection with water existed as well. These data are all the more interesting since, to our knowledge, there are no sources of water attested for the five sites with smaller rock carvings. It seems as if those Mithraic communities who cared for monumental rock carvings also took efforts to integrate water in the place of worship.

There are some textual hints that Mithras worshippers ritualized the use of water in some way, though they are too sparse geographically and temporally too distinct to draw final conclusions from them.[41] The clearest indication comes from the North African Christian writer Tertullian in the early third century. He claimed that Mithraists copied the ceremony of baptism by incorporating ritual ablution into their initiatory rites.[42] The totality of the surviving evidence seems to suggest in any case that a range of Mithraic communities used water as part of their ritual activity. In the *mithraea* of Ptuj II and Budapest II, for instance, dedications to the *fons perennis* (the everlasting source) were found.[43] A source of water is further shown in an iconographic type in which Mithras shoots an arrow into a rock from which spurts water. Two small figures are frequently placed below Mithras: one kneeling in front of him, one drinking from the source. The imagery is thought to be a scene from the life of Mithras. Such scenes have been mainly preserved in the Rhine and Danube region as well as in Rome and in Dura-Europos, where a fresco depicting Mithras shooting with an arrow has been painted in the bottom right scene on the back wall of the *mithraeum* inside the arch (Fig. 2.3, p. 45).[44] An inscription painted on a wall in the *mithraeum* of Santa Prisca in Rome seems to allude to the same scene. It is addressed to a spring enclosed in rock, yet interestingly not of water, but nectar: 'You who have fed the twin brothers with nectar'.[45]

Given that water seems to have been valuable to several Mithraic communities and has a prominent role in all sites of monumental rock-carved tauroctonies, we might ask whether both stream and rock relief were considered suitable furnishings of an exemplary *mithraeum*, if such a thing existed.[46] Porphyry, at least, knew of a Mithraic combination of rock and spring. By

[41] The surviving textual sources are examined in Renaut 2009, 53–9.

[42] Tert. *De bapt.*, 5: 'Even the gentiles, alien to all understanding of spiritual powers, attribute the same effectiveness to their idols; but they deceive themselves with bereft waters, for they become initiates of Isis or Mithra by certain rites of ablution.' See also Tert. *De praesc. haer.*, 40.4: 'It is through a bath (*lavacrum*) that initiates are introduced to mysteries like the one of Isis or Mithras.' On this passage, see Renaut 2009, 55–9.

[43] *CIMRM* 1533, 1753; Walters 1974, 47.

[44] A discussion of the iconography and its ties to Christian iconography as well as a list of objects and several drawings are provided by Renaut 2009, 53 (figs 7–10).

[45] Clauss 2000, 72; Renaut 2009, 53.

[46] On *mithraea* being reproductions of the legendary cave that Porphyry describes, see Gordon 1976, 122.

quoting a lost text on Mithras worship by a certain Eubulus, he states that the legendary first natural cave that Zoroaster had dedicated to Mithras, was 'located in the mountains near Persia and had flowers and springs'.[47] However, the significance of Porphyry for the individual Mithraic community should again not be overstated. Furthermore, the evidence of the seven examples is hardly representative for *mithraea* in general, because of the limited number of examples, and because all of them are exceptional in the degree to which they are integrated in nature. Only more extensive studies of the role of rock and water in Roman *mithraea* could help to clarify how uniform Mithraic approaches to flowing water or rocks really are.

THE TAUROCTONY AMONGST OTHER IMAGES

Our attempt to understand the beliefs of communities worshipping Mithras better by studying the settings in which they created their tauroctonies would not be complete if the tauroctony was considered as isolated in an otherwise empty space. An account of the tauroctony at Bourg-Saint-Andéol by the antiquarian Comte de Caylus in 1759 also documented an altar slab, now lost, 'formed out of the rock' and positioned in front of the carving.[48] Altars and statues have been recorded in large numbers in many *mithraea*. Their subject matter is diverse and not always related to Mithras and his attendants, so it would be impossible to make a plausible guess as to whom the altar at Bourg-Saint-Andéol might have been dedicated. The particularly rich findings of some *mithraea* suggest that a multitude of images could compete with the central tauroctony for the visitor's attention. Their inventories provide a possible explanation for the large size of the tauroctony of Bourg-Saint-Andéol and the like. Besides the presumably distinguished place at the back wall of the *mithraeum*, it would have been mainly the enlarged size, the materiality, and in some instances the elevated position of the rock-carved tauroctony that could have guaranteed an accentuated place among the sheer number of gods and goddesses potentially grouped in the sacred space.

To allow for the possibility that the tauroctony might not have functioned in isolation within the *mithraeum* also raises questions about the coherency of Mithraic communities' beliefs. How important was the image of Mithras, and consequently the god himself, to his worshippers where it was surrounded by images of other gods? And what can we deduce from such a crowded display about the uniformity of Mithraic beliefs? For lack of an appropriate example

[47] Compare n. 28 in this chapter.
[48] Caylus 1759, 343–4.

within the group of *mithraea* that have a rock-carved tauroctony, let us digress to the inventory of the Walbrook *mithraeum* in London.

This *mithraeum* rectifies the erroneous impression that we might unintentionally have given by devoting our undivided attention to the tauroctony.[49] The surviving tauroctony from the site, which is the main reason for the appellation of the structure as a *mithraeum*, is a small marble bas-relief encircled by a zodiac. Besides this, the *mithraeum* counts a multitude of statues and reliefs amongst its inventory, many of which do not have a clear relation to Mithras worship. Among them are a head of Minerva; a head of Serapis; a statuette of Mercury; two fragments that might depict Bacchus; a Bacchic group; a fragment of a water deity; a statue of a Genius; a fragment of a relief of one of the Dioscuri; and a fragment of a roundel that probably shows a Danubian mother goddess attended by two rider gods. In addition, the *mithraeum* also contained another head, possibly belonging to Mithras; an over- sized marble hand perhaps from Mithras fighting the bull; a fragment of a tauroctony relief; the left hand and forearm of arguably another tauroctony; as well as the fragment of a relief of Cautopates.[50]

A universally understood connection between Mithras and these Roman deities is difficult to establish, although it was attempted by Cumont in arguing for the existence of a 'Mithraic pantheon'.[51] Cumont believed that the Mithraic and Roman pantheons had been intermingled by his worshippers, just as Mithras was integrated into the Mazdean pantheon in Persia, through the association of comparable gods in the two different conceptions of the divine world.[52] Thus he associates Minerva with the Persian goddess Anaïtis (Av. Anāhita, MP Anāhid) and Bacchus with Haoma, to take just two figures that we found at Walbrook.[53] As we have seen in the previous two chapters, some gods, in particular Sol, were often represented on tauroctony reliefs and on some occasions in mythographic depictions with Mithras. None of them, however, is present in the Walbrook *mithraeum*. In fact, the appearance of all of these different gods, even those, such as Sol, who appear frequently, are far from uniform. There are quite often a number of depictions of other gods found in *mithraea*, but they are not a coherent collection. Very occasionally, divine figures other than Sol, Luna, and Cautes and Cautopates appear directly in Mithraic imagery; Jupiter and Saturn are the two who are perhaps most likely to appear, as has been posited for the bust in the Zenobius relief (Fig. 2.7, p. 52), which shows a deity underneath the arch.

[49] For the Walbrook *mithraeum*, see Toynbee 1986; Shepherd 1998. For a comparable case, cf. the inventory of the *mithraeum* in Stockstadt am Main in Clauss 2000, 57.

[50] See catalogue in Toynbee 1986. [51] Cumont 1903, 107ff.

[52] See also the discussion of the mythological cycle in chs 1–2. For more on the comparison and equation of gods from different cultural spheres, often referred to as 'syncretism', see ch. 6.

[53] Cumont 1903, 112.

What this suggests more than anything is that a stable pantheon, a notion of which was shared by all worshippers of Mithras, as imagined by Cumont, is highly unlikely. The assemblage of the Walbrook *mithraeum*, found in a space of 18 × 8 m, reveals how pluralistic the religious beliefs of worshippers of the god could be. It also puts into perspective the visual influence that the centrally placed tauroctony could have exerted on worshippers. The actual relevance of these tauroctonies to Mithraic communities is ultimately uncertain.

SETTING MITHRAS IN PLACE

In the course of this attempt to reconstruct the setting of the supposed *mithraeum* of Bourg-Saint-Andéol, a range of similarities and differences between the *mithraea* set in natural environments has become evident. Some of these sites followed the established model of how we imagine *mithraea* to have been arranged and to have functioned, while others did not. The builders of these places took care to create a link between the sanctuary and water, which sets them apart from other groups of *mithraea* which are less consistently associated with water. We discussed moreover the association of the image of Mithras with the rock-face that is a recurrent motif throughout the western Roman Empire, but reaches as far as Turkey. This one particular feature of the image of Mithras, its materiality, might have conveyed to the viewer one or many out of a variety of possible messages about Mithras.

The example of the rock-cut tauroctonies demonstrates that in the west the central image of the god, though it appears—at least at first glance—uniform in its subject matter, is strongly diversified by specific settings within the *mithraeum* and the landscape. Many of these specificities seem to be based on deliberate choices of Mithraic communities that must have followed diverse prerogatives. Variables like the location of the image within the space, its combination with other deities and its accessibility to outsiders made a profound difference to the idea that was presented of Mithras. On the other hand, noticeable similarities, such as the attachment to streams, raise the possibility of a shared vision of what a *mithraeum* should look like beyond the established model that we discussed in the beginning of this chapter. One of the noteworthy exceptions from the rule in Dalmatia was the semi-public display of the tauroctony at Močići. As we go further eastwards in the next chapter, we explore the more public role of Mithra.

Identifications

Mihr in Sasanian Iran

After many allusions in the preceding chapters to the Iranian characteristics of Mithras in the Roman Empire, we now turn to another image of Mithra cut into living rock (Fig. 4.1), but from the heart of the Sasanian Persian Empire (AD 224–651) and which served a very different purpose to our tauroctony rock relief in the preceding chapter. This Sasanian rock relief is the latest of our case studies, carved in the second half of the fourth century AD. It adorns the south face of a low promontory on the southwestern edge of the Kuh-e Paru (a peak of the Zagros Mountains) at Tāq-e Bostān, near the modern city of Kermanshāh in western Iran (Map 3). Our rock relief, Tāq-e Bostān I, appears to show the Zoroastrian divinity Mithra (Middle Persian Mihr) accompanying two Sasanian kings; a visual celebration of divine approval of their rule.[1] Yet, despite the fact that we are seemingly now moving to the geographical home of Mithra, the identification of his image is more problematic than for our other case studies.

Identifications of all the figures in the scene have differed over the centuries, and, in turn, have affected interpretations of the scene's meaning. Identification of the leftmost figure as Mihr bears broader consequences for the interpretation of his role in Sasanian religion and the position of his worship in Sasanian society, particularly since his image is rare in Sasanian art. Due to the relative paucity of images of the divine beings, it is the literary evidence that has shaped understandings of artistic renderings. At the core of interpretations of Mihr in the Sasanian period is this perennial problem of the relationship between the textual and visual evidence extant from the ancient world, whereby we are compelled to make sense of apparent incompatibilities and contradictions. When the textual explanation is deposited on visual evidence, any inconsistencies otherwise presented by the images are shied away from or obscured. A desire for order and

[1] Use of the MP appellation 'Mihr' here refers specifically to the conception of Mithra in the post-Achaemenid and pre-Islamic period (331 BC–AD 651), whereas 'Mithra' refers either specifically to the Avestan representation or to the general term adopted by this volume (see the Introduction, p. 4).

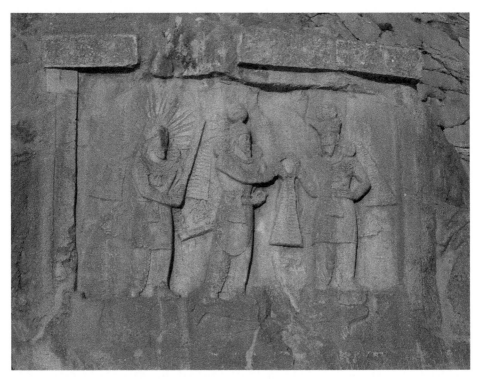

FIG. 4.1. Tāq-e Bostān I, relief of Ardašir II (r. 379–383).
Author's image.

coherence frequently has led to the impression (whether purposefully or accidentally) of a constant idea of Mithra, an Iranian original model, and of a Mithraic worship separate from the Zoroastrian orthodoxy, which this chapter seeks to redress.[2] From this relief we can therefore propose a cautionary tale for our endeavours to reconstruct ancient religion from art, wherein it is not necessary to make the stories we build from images commensurate to those from texts.

THE RELIEF

The relief overlooks ancient artificial lakes formed by natural springs that emerge in plentiful supply at this site. The lakes were most likely created in the Parthian period and perhaps the area around them formed a royal hunting ground or

[2] Past scholarship on an original Iranian construct of Mithra is addressed in the Introduction to this volume, pp. 4–5. See the influential yet controversial volume by H. S. Nyberg (1938) on an early Iranian 'Mithraic' community that rivaled the Zoroastrian 'Gathic' community (the Gathas being the Zoroastrian hymns to Ahura Mazda). On a distinct Mithraic worship during and after the Sasanian period, see Pourshariati 2008 (and below, n. 31) and, *contra*, Frye 1985.

paradeisos.[3] Continued royal attention to this site after the commission of Tāq-e Bostān I is attested by the addition of two deep rock-cut barrel-vaulted *ivāns* (arches) immediately to the west, creating an impressive monumental space.[4] On the rear wall of the closer and smaller of the two *ivāns* is another figural relief (Tāq-e Bostān II) that depicts the *šāhanšāh* (King of Kings) Ardašir II (r. 379– 383) standing next to his predecessor Šāpur II (309–379). This relief, however, was appropriated through the addition of inscriptions to represent Ardašir's successor Šāpur III (r. 383–388) with Šāpur II, his father. Much later, in the early seventh century, was carved the larger and more elaborately decorated *ivān* of Khosro II (r. 591–628) (Tāq-e Bostān III). A small two-arched bridge provided access to the relief from the east.[5]

The main panel of Tāq-e Bostān I measures 4.6 × 3.44 m. It is cut on a vertical plane resulting in deeper relief towards the base of the panel due to the slope of the promontory. The three standing figures are over life-size: including their tall hairstyles, the central and right-hand figures are 2.5 m tall; while that on the left is slightly shorter at 2.25 m. The panel is relatively accessible to the modern viewer since it lies only around one metre above the current ground level, although it is separated from the viewer by a small channel added in recent years (Fig. 4.2).[6] Its accessibility in ancient configurations of the site, however, is unknown. This ambiguity is due to the extensive remodelling of the site under the Qājārs (rulers of Persia from 1785–1925). At the time when two French travellers, the painter Eugène Flandin and architect Pascal Coste, saw and recorded the site in the mid-nineteenth century, one of several springs at the site emerged immediately in front of this relief, and water flowed all around the Sasanian monuments.[7] This area, however, was raised and paved during the construction of a palace to the right of the relief shortly afterwards, built by the Qājār governor of Kermānshāh between 1851 and 1872 (but which was in turn demolished in 1963).[8] The thick concrete lintel is part of conservation attempts in the 1970s, yet apart from mutilation to the faces of the four anthropomorphic figures that were attacked presumably after the Islamic conquest, the relief is otherwise in good condition.[9]

[3] Sarre 1910, 129.

[4] Overlaet 2011, however, argues that Tāq-e Bostān I post-dates Tāq-e Bostān II, which he suggests was carved while Šāpur II was still alive.

[5] Flandin and Coste 1851, pl. 3.

[6] Between 2006 and 2014 (compare fig. 4.2 with Overlaet 2012, fig. 1).

[7] Flandin and Coste 1851, pl. 2–3. See Overlaet 2012, 134–5.

[8] Sarre 1910, pl. XXXVI; Luschey 1979.

[9] Fukai and Horiuchi 1972, pl. LXXIV for an image of the relief in 1965, before the installation of the concrete lintel. Fukai et al. 1983; Fukai et al. 1984.

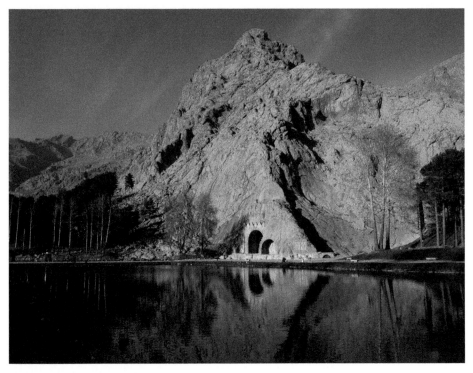

FIG. 4.2. View of Tāq-e Bostān.
Author's image.

In the main field of the relief are three standing bearded male figures on a plain background. Below the left-hand figure, cut into the raised lower border of the main scene in shallower relief, is a lotus flower, and a prostrate male lies to the right under the other two standing figures. Each of the three standing figures wears pearl-drop earrings, long-sleeved rippling tunics belted at the waist over baggy trousers that fall in carefully executed rolls of folds, soft shoes ornamented with buckles, and an elaborate cloak tied in the centre of their chest that flutters behind their backs. The tunics worn by the outer figures finish straight at the knee, while the third ends in a bib-like dip hem. Rather than indicating a realistic breeze, the inconsistent directions of the flowing drapery frames their bodies and suggests inherent dynamism despite their sedate and controlled poses. Their hair falls neatly onto their shoulders in two large bunches of curls tied by diadems across their brows (a signifier of honour and royalty), which fall in long, broadening, corrugated ends behind them. The strong muscular bodies, with broad shoulders, slim hips, and pectoral definition visible through their tunics, are presented frontally in powerful rooted stances, their feet splayed outwards. Their heads are twisted into a three-quarter view (although there is barely any indication of the turn to their torsos) and their gazes draw the viewer's eye to the central figure.

The right-hand figure stands on a slightly raised ground line (suggesting his additional importance), holding up a ribboned wreath in his right hand while his left hand is placed on his hip. He wears a mural crown and a ribboned *corymbus* in addition to the diadem.[10] The central figure faces the former and reaches out to grasp the other side of the ribboned wreath with his right hand. His hair, like the first, is also tied with a ribbon into a *corymbus* on top of his head, while his left hand rests on the hilt of the sword in its scabbard at his left hip, and he wears a heavy pearl necklace. The left-hand figure holds out in both hands a stick corrugated into five strips. This long bundle of rods is the *barsom*, held by Zoroastrian priests during ritual. Around his head is a halo of rays and, as already mentioned, he stands on a lotus flower. The prostrate male presents some markedly different features from the former three: he has straight hair styled in a blunt fringe and squared-off beard and wears a jewelled diadem whose trailing ends are crushed under the feet above. He has a sword at his hip whose scabbard has an elaborate chape, and wears a cloak with a jewelled neck tied at his left shoulder, over a long-sleeved tunic and trousers.

IDENTIFYING THE PLAYERS

Unlike our other case studies in this book, Tāq-e Bostān I has no accompanying inscription to facilitate even our initial identification of the figures in the scene, let alone to help our speculations concerning the wider implications of their depiction. Many identifications for all four characters have been proffered, which cast wildly different shadows upon our understanding of Mihr and Sasanian religion more broadly. The most convincing interpretation of this scene is that Šāpur II is handing the ribboned wreath, symbolizing authority, to his half-brother Ardašir II, who was to act as regent for Šāpur II's young son, the future Šāpur III.[11] We can be fairly certain of the identity of the two kings through comparison with their crowns depicted in coin portraits (Figs 4.3a–c). They stand on the deceased body of the Roman emperor Julian, who died from a wound received while retreating from the unsuccessful siege of Ctesiphon in 363 against the armies of Šāpur II.[12] Behind Ardašir, on the left, stands Mihr.

[10] *Corymbus* is the Latin word for a cluster, usually referring to berries. This term is used in modern parlance to refer to the Sasanian kings' penchant to wear part of their hair in a ball on top of their head, often tied with ribbons and wrapped in material.

[11] Calmeyer 1977; Shahbazi 1985a; Canepa 2009, 108–9; for a detailed discussion of the identifications of these figures, see Overlaet 2012. Ardašir's familial ties are somewhat mysterious: see Azarnoush 1986, who prefers the testimony of Armenian sources that Ardašir was the son of Šāpur II, rather than Arabic sources who name him as a younger half-brother of Šāpur II.

[12] Amm. 25.3.3; Erdmann 1948, 86.

FIG. 4.4. Detail of Mihr, Tāq-e Bostān I.
Author's image.

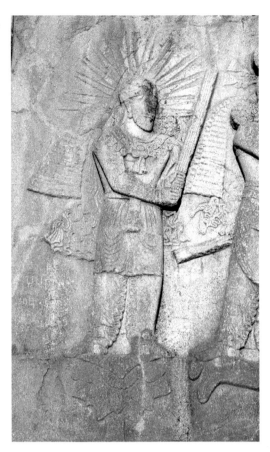

Mihr, Mithra, is one of the Avestan *yazatā* (divine beings, meaning 'worthy of worship'). In Old Persian, the language of the Achaemenid Empire (*c.*550–330 BC), we see the name of a god 'Mitra'; and the divine name 'Mihr' appears in the Middle Iranian languages of the Parthian (*c.*247 BC–AD 224) and Sasanian Empires. Ferdinand Justi first suggested the identification of the left-hand figure in Tāq-e Bostān I (Fig. 4.4) as Mithra in 1904 through comparison with the radiate figure labelled as 'Apollo-Mithras-Helios-Hermes' at Nemrut Dağı in first-century BC Commagene (see ch. 6).[13] The proposition is further supported by the radiate figure of Miiro from Kushan Bactria two hundred years previously, who is the only radiate deity known to us among the Kushan pantheon (and, for the Sasanian Persian context, is prioritized over the other radiate labelled figure on Kushan coinage, the Greek Helios—for further discussion, see ch. 5, pp. 119–121). There are of course notable differences between these examples,

[13] Justi 1904, 157.

and the disparity in date and location should warrant caution, but Mihr remains the most convincingly identifiable radiate divine being of Sasanian religion and, accordingly, the most convincing identification of the radiate figure depicted in Tāq-e Bostān I.

An alternative proposition, however, developed by Ernst Herzfeld and Henry Rawlinson, is that this radiate figure represents Ahura Mazda (lit. 'Lord Wisdom' or 'Wise Lord'), the supreme Zoroastrian divinity.[14] This suggestion is tenable since the defining feature, his halo of rays, refers to light, which, whether from the sun or fire, was associated closely with the presence of Ahura Mazda. He appears in other Sasanian reliefs carrying the *barsom*, such as in Ardašir I's relief at Naqš-e Rostam in Fārs (Fig. 4.5). There is, however, no identifiable representation of him radiate, and possession of the *barsom* is not exclusive to Ahura Mazda or even to deities.[15] It is worth noting, however, that all three of the

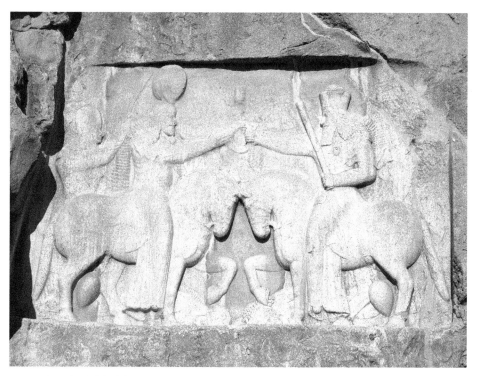

FIG. 4.5. Relief of Ardašir I (r. 224–242), Naqš-e Rostam.
Author's image.

[14] Rawlinson 1876, 64–5; Jackson 1899, 288, 292–3; Herzfeld 1920, 60.

[15] It should also be noted that at Nemrut Dağı in Commagene (see ch. 6), the free-standing sculptures identified as Apollo-Mithras-Helios-Hermes and Zeus-Oromasdes both hold short *barsoms* (and see n. 59, this chapter).

protagonists in Tāq-e Bostān I have at some point been identified as Ahura Mazda, in part because of the ambivalence surrounding his representation, and in part because of the desire for what is expected to be shown in a Zoroastrian context.[16]

Until the early twentieth century, however, the radiate figure in Tāq-e Bostān I was popularly identified as the prophet Zoroaster blessing the investiture of legendary kings, as told in Ferdowsi's tenth-century book of epic tales, the *Šāhnāmeh*. Subsequently this image has been used as the inspiration for modern portraits of Zoroaster (Fig. 4.6).[17] Local Kurdish tradition held yet another identification of the radiate figure drawn from the tales collected in the *Šāhnāmeh*, labelling him as Farhād, who killed himself nearby at Bisitun upon hearing the false information of his beloved's death.[18] This story links Tāq-e Bostān I to the *ivān* of Khosro II (Tāq-e Bostān III) to the west, since in the myth it was Khosro who instructed the false information be given to Farhād, a sculptor who had fallen in love with Khosro's intended wife, Shirin (based on a historical figure, the Armenian Christian queen of Khosro). Other interpretations of the radiate being in Tāq-e Bostān I include Verethragna, *yazata* of victory whose name means 'smasher of obstacles', and Ādur, 'fire'.[19] These multiple examples of the reattribution of the figure throughout the relief's history demonstrate not only the potential flexibility of a divine image but also provide ample warning for us to proceed carefully in our reconstructions of an image's meaning.

MIHR'S ROLE IN TĀQ-E BOSTĀN I

If we take this scene to show from right to left, Šāpur II handing a wreath to Ardašir II while they both stand on the defeated Julian, while Mihr looks on, how should we understand Mihr's role in this composition? The handing over of authority or honour symbolized by the ribboned wreath has a long heritage in Iranian art and is a common motif to Sasanian royal rock reliefs, but the inclusion

[16] See Sarre 1910, 199–200 on 'Šāpur II' as Ahura Mazda; Soudavar 2014, 161 on 'Ardašir II' as Ahura Mazda. This identification usually is drawn from comparison with the representation in Ardašir I's relief at Naqš-e Rostam, and also because he is the largest figure in the scene, and stands on a raised ground line, and therefore must be more important than the radiate figure. After the identification of the prostrate figure as Julian, however, it would then be necessary to identify the central figure as Šāpur II unless we believe Ardašir II was taking extreme historical liberties. See Overlaet 2012, 139 on the possibility of a purposeful ambivalence in the appearance of the Ahura Mazda/Šāpur figure so that Ardašir, as regent, could be seen as legitimized through investiture by Ahura Mazda, and to some extent claiming shared credit in the victory over Julian.

[17] Ker Porter 1822, 193; Flandin 1851, 442–3; Sarre 1910, 199–200.

[18] Luschey 1974, 137–8.

[19] For Verethragna, see Coyajee 1926; for Ādur, see Dhalla 1930.

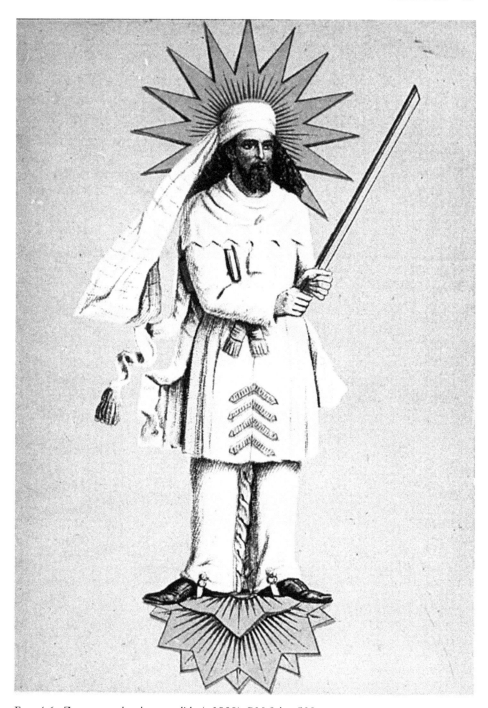

FIG. 4.6. Zoroaster, glass lantern slide (*c*.1900). BM Sykes.508.
Trustees of the British Museum.

of Mihr watching over the transaction is unique.[20] Mithra, however, is the protector of oaths, whose very name means 'contract'.[21] Thus although he does not appear in other Sasanian reliefs, his presence is not untoward given this role: here he is invoked by and sanctioning the covenant between the two kings.[22] This interpretation thus provides a sturdy understanding of the scene based on Iranian religion and culture. The personal connection between the divine being and the Sasanian kings is emphasized by the similarities in their clothing and hair, particularly the dip-hem of Mihr and the deceased Šāpur II. Such conflation between king and god is reiterated on the coins of early Sasanian kings, where Middle Persian legends declare the king 'from the lineage of the gods' (*ke čihr az yazdān*). A tentative alternative proposition to explain Mihr's inclusion in this scene of symbolic investiture could be that Ardašir's coronation took place at *Mihrgān*, Mihr's festival, but this must remain conjecture since there is no historical testimony concerning the details of Ardašir's accession.[23]

Despite this potential for an interpretation derived from Iranian religious conceptions, it has also been argued that the unusual inclusion of Mihr in this scene is directly and exclusively due to the presence of the Roman emperor Julian, a devotee of Helios perhaps aligned with Mithras. Thus the relief would proclaim the true home of the deity despite the efforts of the Roman emperor.[24] This theory suggests that there was a perceived threat or insult to Sasanian religion from Julian's honouring of Mithras/Helios that was important enough to warrant

[20] This motif is also frequently referred to as a diadem, the thin fillet of cloth tied at the nape of the neck, loose ends trailing, which was a signifier of status. In the Hellenistic period the diadem was a signifier of royal status, first seen in representations of Alexander (although it is argued by some, but not universally accepted, that it was not restricted to kings, or that it was based on Achaemenid precedents). Whether the motif featured in Sasanian symbolic investiture scenes in rock reliefs is a diadem or a ribboned wreath is debated among scholars. Figures holding rings or wreaths, or bequeathing them on others, is common in Sasanian art and has earlier Iranian precedents. See, for example, Harper 1978, 74–5, on the pearl rings tied with ribbons held by the flying figures in the spandrels of Tāq-e Bostān III. The motif in this relief should be viewed as symbolizing the bestowal of honour and approval upon Ardašir, rather than literally representing the conferral of royal power, not least since Ardašir already wears both a crown and a diadem.

[21] See Introduction, p. 2.

[22] Calmeyer 1977, 187–8; Frye 1978, 209; Tanabe 1985, 109; Shahbazi 1985a, 184–5. Many further identifications of the three figures are posited from perceived rules of Sasanian art.

[23] See Shahbazi 1993, 278 on *Mihrgān* (in autumn) as the occasional choice for a Sasanian king's coronation, the usual time being the first Nowruz (new year's festival, in spring) after the king's accession.

[24] Julian *Oration* IV (*Hymn to King Helios*), 155. Hollard 2010; Soudavar 2012, 44–5; Canepa 2013, 869. These interpretations of the meaning of Mithra's presence were, of course, only posited subsequent to the identification of the prostrate male as Julian. Other identifications of the fallen enemy included the last Parthian king Artabanus IV, who must therefore be underneath the feet of Ahura Mazda and Ardašir I (Justi 1904, 157), Ahriman (Frye 1978, 207), or an unknown Kushan king (Lukonin 1967, who proposed a similar connection between the defeated foe and 'subjugated' divinity, identifying the radiate god as the Kushan Miiro).

commemoration inside the empire, albeit seemingly converting the Roman image of Mithras to one comprehensible to its Persian audience. But a relief carved into a cliff in Media would hardly have been an effectively communicated retort to the Roman authorities or worshippers of Mithras. The hypothesis has been taken further in a seemingly counterintuitive argument whereby Mihr's inclusion was due to his value as a political tool rather than as an esteemed divinity with his own role: a calculated response, unrelated to the religious requirements of the patron to a tailored propaganda campaign instigated by Julian in order to undermine Sasanian authority prior to his invasion. Thus, Šāpur was 'emphasizing that the supreme deity venerated by his enemy was a mere second in the Persian pantheon, and one who had favoured him over his opponent'.[25] Not only are the foundations of this argument undercut in recent studies that downplay Julian's Mithraic interests, but the implication that Mihr was back 'at heel' as a lesser deity jars as rather hubristic, let alone Romano-centric in attributing the cause of Mihr's presence in this relief to Julian.[26]

How else can we explain the representation in this relief of Julian, an enemy defeated sixteen years prior to the bestowal of power on Ardašir? A trampled foe is an established motif in Iranian art for centuries before this relief was carved, and is a prominent theme in Sasanian rock reliefs.[27] Šāpur II's victory over Julian was highly significant in the balance of Romano-Persian power because not only had the Sasanian Empire been invaded as far as Ctesiphon itself, but because the resulting victory and treaty with the new emperor Jovian regained much of the land previously lost by Narseh to the Romans at the end of the third century. That this relief displayed Sasanian reclamation of Mihr is therefore an unnecessary extra connotation, as well as being loosely grounded, since this portrayal of the new king Ardašir II, honoured by the deceased and admired Šāpur II while sharing in his military glory, promotes the connection between the two men and intimates the continuing success and stability of the empire.[28] Although Ardašir remains a rather mysterious figure before his accession, it seems likely that at the time of Julian's invasion he was not only brother to the King of Kings, but was also king of the Sasanian northwestern province of Adiabene, a border region hotly contested between the Persian and Roman

[25] Soudavar 2014, 161. [26] Smith 1995.

[27] See, for example, the Parthian king Artabanus IV under Ardašir I's horse at Naqš-e Rostam, of the Roman emperor Gordian III under the horse of Šāpur I at Bishapur, and the figure under the equestrian king Bahrām I (later re-attributed by an inscription as Narseh) at Bishapur.

[28] Azarpay 1982 relates Mithra to Julian in another way, by identifying the oath Mithra oversees as the treaty with Jovian in 363/4 that surrendered Roman territories in Armenia and east of the Tigris. Azarnoush 1986, 246, working with the identification of Ardašir II as the older brother of Šāpur III and son of Šāpur II, identifies the defeat of Julian as having a major stake in Ardašir's accession before his brother, hence its visual reference here.

Empires. It is therefore highly likely that Ardašir was closely involved in the campaign against the Romans.[29] It is also notable that Tāq-e Bostān I was the first Sasanian rock relief commissioned outside the region of Fārs, the ancestral dynastic home in southwestern Iran. This is perhaps indicative of a new royal focus on this region of Media, a crucial strategic region both for its location and resources.[30] Tāq-e Bostān lies on the main road between Ecbatana and Babylon (now on the main road between Tehran and Baghdad) and, as such, this sculptural commission was situated in a very prominent location (see Map 1). Such a shift from Fārs to Media would have placed a greater royal emphasis in the centre of the empire, nearer Ardašir's existing support base in Adiabene and the newly secure western border. While Tāq-e Bostān I therefore combines the two most common themes of Sasanian royal rock reliefs (of symbolic investiture with a ribboned wreath, and of military triumph), this relief was highly pertinent to Ardašir's particular situation.[31]

MIHR'S ROLE IN SASANIAN RELIGION

But what (if any) are the implications of our observations drawn from Tāq-e Bostān I for our understanding of Mihr's role in Sasanian religion? How do these observations relate to the testimony of other sources for Mihr in the Sasanian Empire regarding his perceived status and relationship to other divine beings? And does this relief represent an anomalous veneration of an otherwise minor deity? In order to secure our identification of the radiate figure in this relief and to grasp a better sense of the place of Mihr in Sasanian religion, we would naturally hope to have other visual evidence with which to compare this depiction. As mentioned at the beginning of this chapter, while there are very few representations that may be even tentatively identified as Mihr, there are not many certainly identified anthropomorphic representations of any divine beings in Sasanian art.[32] There are, however, far more from the Sasanian period extant than from the earlier Iranian visual record, none of which are confidently identified as Mithra. Consequently, there is no material with which we can compare these Sasanian representations, despite attestations of Mithra's significance to Achaemenid and Parthian religion in inscriptions, where he is given the highest

[29] Calmeyer 1977; Shahbazi 1986. [30] Overlaet 2012, 140.

[31] For introductions to Sasanian rock reliefs, see Vanden Berghe 1983; Herrmann and Curtis 2002; Canepa 2013.

[32] On aniconism in Sasanian religion, see Boyce 1975a and Shenkar 2008. On the problem of identifications of female figures as Anāhita, see Duchesne-Guillemin 1971, 379; Shahbazi 1983. On other Sasanian religious iconography, see Soudavar 2003; Curtis 2008.

honours alongside Ahura Mazda and Anāhita.[33] Despite the scarcity of images of Mihr, therefore, it would be inaccurate to see his worship as extraneous to Sasanian religion or as a hostile competitor to a perceived Zoroastrian orthodoxy in this period, which lay outside the scope of royally sanctioned and imposed religious behaviour.[34]

Reasons for this elusiveness of Sasanian Mihr and the necessity for caution in interpretation of many other aspects of Sasanian religion are based on the problematic nature of the literary sources. Relevant texts are often by necessity drawn from outside of the Sasanian world, either geographically or temporally. The Zoroastrian sacred texts are the *Avesta*, a collection of texts written in its own language and script, and the *Zand*, the texts that constitute its Middle Persian commentary. These present us with a methodological problem in the attempt to reconcile text and image: although the Avestan sources were probably first written down in the late Sasanian period based on an accepted oral tradition, our earliest extant manuscript is from the thirteenth century AD. Despite this, it is not uncommon for these texts to be used as evidence of religious practice and beliefs from the second millennium BC or the sixth century BC (depending on which line of the disputed date of Zoroaster is upheld) through the Sasanian period and to the modern day, due to linguistic analysis as well as current adherents' understandable desire to trace religious continuity and consistency.[35] The contemporary material evidence from the Sasanian Empire is therefore all the more crucial to our understanding. In contrast, the majority of the Greek and Roman sources that refer to Mithra were written during the Parthian period rather than the succeeding Sasanian. Although accounts of Persian religion contemporary with Sasanian rule are found in the texts of Syriac and Armenian Christian martyr narratives, these were written for the purposes of extolling the bravery of the Christians during periods of persecution and thus may vilify characteristics of

[33] Among the British Museum's collection, for example, see the Old Persian inscription of Artaxerxes II (404–358 BC) on a column base from Hamadan that declares, 'by the favour of Ahura Mazda, Anāhita, and Mithra I built this palace. May Ahura Mazda, Anāhita, and Mithra protect me from all evil' (BM 1893,1014.54). See also a first- to third-century AD Parthian terracotta plaque from Uruk that bears a dedication to Mithra, but it is highly unlikely that the accompanying depiction of a reclining male figure represents the *yazata* (BM 1928,0716.76). A seated radiate figure is depicted in a rock relief of the Parthian period on the northeast side of Block II at Tang-e Sarvak in Elymais (Khuzestān). On early images of Mithra, see Shahbazi 1985b, 503–5; cf. Ghirshman 1978; Grenet 1991.

[34] The Sasanian kings, whose religion became what is known as Zoroastrianism, called themselves *mzdyzn*—'Mazda-worshippers'. Pourshariati 2008, 5: 'Pahlavs [Parthians under Sasanian rule] predominantly adhered to Mihr worship, a Mithraic spiritual universe that was distinct from Zoroastrian orthodoxy—whatever the nature of this—that the Sasanians ostensibly tried to impose on the populace living in their territories.'

[35] For attribution to the sixth century BC, see Henning 1951. For the earlier dating to *c*.1200 BC, see Boyce 1992; Gnoli 2000; Boyce 2005, 1. See Christensen 1936, 437 on the repositioning of Mithra in Zoroastrian worship after the Islamic conquest.

Sasanian religion. In one account, for example, we are given a more gruesome description of Zoroastrian practice than that with which we are familiar, wherein Šāpur II threatens to execute certain Christians if they refuse to 'drink blood and worship the sun'.[36] No doubt the Sasanian King of Kings could be merciless to those who opposed him, but casting the Sasanians as bloodthirsty sun-worshippers is more than a little divergent from our normative understandings of their religious beliefs and practices.

Mithra's role over-seeing a transaction or oath as in Tāq-e Bostān I is his main characteristic in the Zoroastrian texts, where he is a judge and the god of contracts. In the *Mihr Yašt* ('Hymn to Mithra', *Yašt* 10), one of twenty-one Avestan hymns to various *yazatā*, Mithra is 'invoked by his own name', which itself meant 'contract' or 'covenant'. His primary role was as enforcer of transactions and promises, upholding truth and smiting those who broke their vows.[37] There are two references in the Classical sources that suggest a link to Mithra's role as god of contracts and oaths: Plutarch (AD 45–120) describes Mithra as a 'mediator' between Ohrmazd and Ahriman (the destructive spirit), while Dio Cassius (*c.* AD 155–235) wrote that the king of Armenia, Tiridates I, in AD 66 addressed the Roman emperor Nero with the words, 'I have come to you, my god, kneeling for you as I also do for Mithra', while pledging his loyalty.[38]

Despite possible ambiguities surrounding his precise role and character, and his rarity in the visual record, there are plenty of references to Mihr that do not suggest an exclusivity to his worship, none of which reject or preclude the veneration of the Ahuras, *yazatā*, or Ameša Spentas, and there are many attestations of the importance of Mihr in the 'mainstream' of Sasanian religion. A fifth-century AD Bactrian letter to *Mihr Yazd* names him 'king of the gods' and calls upon him for help paying taxes, and his name is invoked on two Sasanian stamp-seals in the British Museum collection.[39] The popularity of Mihr is further illustrated by the many theophoric names from the Parthian through to the Sasanian period that derive from his, including by those of the very highest status, such as Mihršāh,

[36] *Acts of Candida* (Brock 1978). See also the *Acts of Simeon*, *Acts of Shahdost*, and the *Chronicle of Seert* (Bedjan 1968).

[37] A further legacy of Mithra is that in the modern Persian language, 'mohr' means seal (MP *mwhr/ muhr*), while 'mehr' means love, kindness, and the sun (reference with thanks to Vesta Sarkosh Curtis). Additionally, *dar-e mehr* (the door/gate of/for Mithra) is the term by which Zoroastrian fire-temples are referred in Iranian dialects and the Parsi community (see Boyce 1969, 27; Callieri 2014, 97–8).

[38] Plut. *De Is. et Os.*, 46–7; Dio 63.5.1.

[39] Stewart 2013, cat. no. 28. See BM 1967,0220.598, a fourth-century agate stamp-seal bearing the inscription 'reliance on Mihr' around a depiction of a griffin (Bivar 1969, 80, pl. 13, EG 3); and BM 1967,0220.478, a chalcedony stamp-seal from the fourth century or later, showing the upper half of a woman holding up her hands in prayer, surrounded by an inscription translated by Gignoux as 'I invoke by (your) name, oh Mihr (and) Nanai, and my hands are held' (Gignoux and Gyselen 1989, 880–1, pl. II, no. 14).

brother of Šāpur I and Lord of Mešun (Mesene/Characene, southern Babylonia), Mihr Narseh, prime minister under Bahrām V (r. 420–438), and a prominent family, the Mihrāns.[40] Mihr's name formed part of the calendar and his festival, *Mihrgān*, was and still is one of the most important of the year, at the autumn equinox and harvest.[41] These many instances reinforce our impression of how integral Mithra was to Iranian religion over many centuries.

IDENTIFYING MIHR'S IMAGE

From the visual evidence of radiate figures in Sasanian art, we can see that Mihr had a clear role in the presentation of royal authority, not only at Tāq-e Bostān, but also on two coin types minted by two kings who ruled roughly a century before Ardašir II. Once again, we see personal interaction between the *yazata* and king, and visual parity in their depiction. The reverse of a coin of Hormizd I (272–273) shows the king reaching to take a ribboned wreath passed over a fire on an altar by a male figure behind whose head emanate rays (Fig. 4.7). Yet this figure is not labelled and his identification as Mihr depends on the identification of all radiate figures in Persia as the same divine being. As in Tāq-e Bostān I, he is dressed similarly to the king although here is armed with a sword. On the obverse of coins of Hormizd I's successor, Bahrām I (273–276), the king's own crown is radiate, encircling his *corymbus* that is wrapped in silk and jewelled (Fig. 4.8). On the reverse, however, we see one figure with a *corymbus* and another figure with a radiate crown and no *corymbus*: perhaps the king and Mihr respectively. Bahrām's lack of a radiate crown here can be explained not only in a prosaic manner of the necessity to distinguish between mortal and divine within the reverse design, but also through a possible narrative connection between the two sides of the coin.[42] Rays of light, while emblematic of solar aspects, are also closely connected with the concept of *farr* (Middle Persian 'glory'; Avestan *khvarneh*), which was bestowed upon the kings by the divine.[43] Thus the reverse shows the act of bestowal of authority and honour in the form of the ribboned wreath, and the obverse displays the king's subsequent possession of the divine glory and personal favour of Mihr. Unlike the Kushan Miiro, however, it does not appear that Mihr's benefaction or worship was restricted to the royal sphere (as discussed in the previous section above, and see further discussion of this theme in ch. 5).

[40] Gyselen 2008, 108.

[41] The sixteenth day and the seventh month of the Zoroastrian calendar (reinstated in Iran in 1925) were named in honour of Mithra (see also ch. 6, p. 141).

[42] See Curtis 2008, 140. [43] *Yt.* 10.127. Duchesne-Guillemin 1962, 203–4.

While the radiate figures on the coins are not labelled, there are two Sasanian seals depicting radiate busts that bear legends relating to Mihr. On one seal, now in Paris, the radiate bust is accompanied by a Middle Persian inscription reading *Mihr Yazd*, 'the god Mihr'.[44] The second seal, once in Berlin but now lost, showed a male bust in a radiate nimbus within the arch of an inscription reading *hu-mihrīh ī pahlom* 'perfect friendship', deriving from 'Mihr'.[45] This seal introduces a further iconographic feature: a chariot drawn by winged horses. Links have been drawn between this and references in the *Mihr Yašt* to Mithra's chariot drawn by four white horses, as well as to iconography further east in the form of a nimbate figure in a chariot painted in the niche behind the head of the 38 m-tall Buddha at Bāmiyān in Bactria (for further discussion, see ch. 5, p. 124).[46]

To this pair of seals, Pierfrancesco Callieri adds two seals without legends that show radiate deities holding spears.[47] Mithra does seem to have also held a war-like aspect: the *Mihr Yašt* is full of elaborations upon how Mithra will come to the aid of those who worship him and those who call upon him in battle, as well as a description of his immense arsenal in the fight against the *daevas* (evil beings).[48] He is called 'the warrior of the white horse, of the sharp spear, the long spear, the quick arrows', who holds a club with one hundred knots and one hundred blades.[49] As patron of pious military victors, his inclusion in a scene with the defeated Julian at Tāq-e Bostān holds another pertinent resonance. In one of these two glyptic depictions, from the late fourth or fifth century and now in the British Museum, the *yazata* appears inside a radiate nimbus over a pile of rocks (Fig. 4.9).[50] To a viewer familiar with Roman Mithras, this might conjure the link with the myth of the god's birth from the rocks (see ch. 3, p. 75), but a Zoroastrian interpretation can be found in the description of Mithra in the *Mihr Yašt* as the first of the gods to rise over Mount Harā (Mount Alborz) every morning, upon which was his home made for him by Ahura Mazda.[51]

Since, despite his association with light, there are no identifiable images of Ahura Mazda/Ohrmazd as radiate, we may proceed with the assumption that, as far as we know, the radiate crown or radiate nimbus was the particular visual

[44] Gignoux 1978, 62; Callieri 1990, 87. [45] Callieri 1990, 86.

[46] Grenet 1993. In *Yt.* 10.125, Mithra drives a gold wagon through the sky drawn by four white horses. See also a cloth probably of Sasanian manufacture but found wrapped around the relics of S. Landrada in Munsterbilsen, Germany, that is decorated with the repeated image of a radiate figure driving a quadriga of white horses (Musees d'Art et d'Histoire, Brussels).

[47] Callieri 1990, 83–6. [48] *Yt.* 10. 8, 9, 11, 128–32.

[49] *Yt.* 10.102. [50] Callieri 1990; BM 1932,0517.1.

[51] *Yt.* 10.13 and 10.50; Grenet 2001.

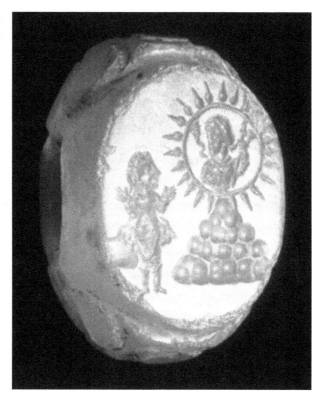

identifier of Mihr in Sasanian art.[52] Mihr had a role in the presentation and blessing of royal authority (in particular the bestowal of divine glory, *khvarneh*). His person was distinguished by rays, but could also have additional attributes such as the spears hinting at his militaristic and retributional character, or his celestial transport, the chariot. We can see that while Mihr's image is rare in the Sasanian material record, it was commissioned not only by kings for rock reliefs and on coins, but also by private individuals on their seals.

MOVING FROM IMAGE TO TEXT

What happens when we go further into the texts in order to contextualize our image? How does, or how can, Tāq-e Bostān I stand next to the more plentiful

[52] Ferdinand Justi, however, suggested that the lotus flower in Tāq-e Bostān I is also an attribute of Mithra's character as a sun god (Justi 1904, 157). See this volume, ch. 5 p. 122, on the lotus flower as an attribute of the Hindu sun god, Surya. For other radiate gods in Iranian art of other periods, see, for example, the seated radiate male figure on the northeastern face of the boulder Tang-e Sarvak II in Elymais from the first to third century AD; the Babylonian goddess Ištar on an Achaemenid seal (Moorey 1979, pl. 1 fig. 4); and the Babylonian sun god Shamash (who also like Mithra, had a role in justice) as depicted in the sculpture of Parthian Hatra.

literary sources? And what do we do with inconsistencies and apparent incompatibilities between them? From the scattered texts, which come from a wide array of sources, cultures, and across many centuries, we can perceive further nuances of, in particular for this study, Mithra's solar aspect and his place in Zoroastrian religion, and question how, if at all, we can hope to reconcile these accounts with his position in the material record. According to the *Mihr Yašt* (*Yt* 10), Mithra is a solar deity, yet frequently distinct from the sun itself. For example, *Yašt* 6 is addressed to the sun, but is composed of only seven verses in contrast to Mithra's 145. *Yašt* 10 continues, describing Mithra as riding in a chariot before the sun in golden array, endowed with his own light, while the blazing fire which is the *khvarneh* ('fortune') go in front of him.[53] His oft-repeated title is 'lord of the wide pastures', he is guardian of cattle (in contrast to the Roman bull-slayer), and is all-knowing, all-seeing, never-sleeping, with one thousand perceptions, one thousand ears, ten thousand eyes, and ten thousand spies. This omnipotence is a feature that one might see as tying together the solar and judicial characteristics.[54]

The overriding impression from the ancient Greek and Latin sources is of Mithra's connection to the sun: he is most frequently identified as equivalent to Helios or Apollo (the latter being a sun god, as Mithra, often associated with truth and guarding herds), sometimes at the head of Persian religion. Yet the translation is not universally consistent: at Seleucia on the Tigris during the Parthian period, only nineteen years before Zenobius' dedication at Dura Europos (see ch. 2, pp. 48–9), Apollo was translated or understood not as Mihr but as equivalent to the Iranian archer god of rainfall and fertility, Tir (Av. Tištrya).[55] This example illustrates yet again the inherent incommensurability in identifying syncretistic processes and interactions between different cultures, languages, and religions (problems which are addressed further in chs 5–6).

Yet Classical authors are inconsistent in their descriptions of Mithra and his place in Persian religion: Strabo (64/63 BC–*c.* AD 24) says that the Persians call the sun 'Mithres', while in Quintus Curtius (mid-first century AD), Darius III invokes 'the sun and Mithra and the sacred and eternal fire', calling upon

[53] *Yt.* 10.13, 142. Translations of this differ crucially in that some prefer 'the blazing Fire *and* the khvarneh' (Gershevitch 1959, 137, 278 n. 127.5).

[54] Boyce 1975b connects Mithra's judicial role to his solar and luminous aspect through the ordeal of fire.

[55] The temple of Tir/Apollo in Seleucia on the Tigris was mentioned in a triumphal Parthian text and its accompanying Greek translation, which record a Parthian military victory of AD 151, inscribed onto the thighs of a bronze statue of Herakles, who is referred to in the Parthian text as Vahrām/Verethragna (Baghdad Museum 100178). On *interpretatio romana*, see Ando 2008, 43.

them together yet as distinct entities.[56] As for the Syriac and Armenian sources, they frequently position Mithra as the most important Sasanian divinity, aligning him with the sun. One narrative of a martyr clearly combines the solar and judicial roles of Mithra when Šāpur II swears by the sun, the judge of the whole earth. A clear alignment is made between Mithra and the sun in another, later, instance of Sasanian attempted proselytism under Yazdegerd II, where the desired object of worship is the sun, who, 'because of his impartial generosity and equal bounty has been called the god Mihr, for in him there is neither guile nor ignorance'.[57] As we have seen from the variety in these sources, the relationship between Mithra and the sun is a complicated one: there was definitely a strong connection, and yet the two are not always synonymous.[58]

As intimated above, there is the potential for confusion in distinguishing in Tāq-e Bostān I between Mithra and Ahura Mazda, deriving from the fact that Ahura Mazda shares the characteristics of light and upholder of truth with Mithra.[59] These two qualities are the most important tenets of Zoroastrianism, where a person is not made good or evil, but can choose the way of either light (truth—*aša*) or darkness (falsehood—*druj*) in their thoughts, words, and actions. To add to the entanglement between the two, Mary Boyce noted how, in some eastern Iranian dialects, the Persian name for Ahura Mazda, Ohrmazd, is used still as the name for the sun.[60]

It has been noted already that the higher position allotted to Mihr in Sasanian religion described in the Armenian, Syriac, and Classical accounts is somewhat at odds with his role in post-Sasanian Zoroastrianism, where he appears in a more supporting role. Taking this to an extreme, one theory explains the inconsistency as a purposeful undermining and replacement of Mithra with Ahura Mazda during the perceived construction of a Zoroastrian orthodoxy during the Sasanian period.[61] Alternatively, we could see any perceived inconsistencies in the textual accounts as suggestive of ongoing evolutions in religious thought and practice, despite the continuity of the name and certain core associated

[56] Strabo 15.3.13; Curt. 4.13.12. See the collection of references in Classical authors in De Jong 1997, 284–96.

[57] Boyce and Grenet 1991, 481. [58] Gershevitch 1959, 35.

[59] Additionally, the *barsoms* held by the free-standing statues at Nemrut Dağı (see above, n. 15) alternatively have been identified as thunderbolts (for example, Boyce 1990, 4), which would suggest a further alignment between Mithra and Ahura Mazda (Oromasdes, Ohrmazd).

[60] Boyce 1984.

[61] See n. 2 above on Nyberg's theory of a conflict between an original 'Mithraic' community and a 'Gathic' community of Zoroaster who worshipped Ahura Mazda; Pourshariati 2008; Soudavar 2014, 9.

attributes.[62] Mithra's role in Zoroastrianism does have a certain ambivalence. In the *Gāthās*, the Avestan hymns of Zoroaster himself, there is no mention of Mithra. Does this mean that he was held to be relatively insignificant? Yet there is also no mention of Anāhita, *khvarneh*, *haoma*, or animal sacrifice, which are all considered crucial elements of Zoroastrianism and are well-attested in the Sasanian period. In other Avestan texts, however, such as the *Yašts*, there is no incompatibility between the worship of Mithra and Ahura Mazda. The *Yašt* to Mithra, one of many hymns to *yazatā*, is 'spoken' by a worshipper who declares himself a follower of Ahura Mazda, and that 'Ahura Mazda created him [Mithra] as worthy of sacrifice, as worthy of prayer as himself'.[63] Their intertwined veneration is also displayed in the design of Hormizd I's coins (Fig. 4.7) that show a radiate figure identified as Mihr, while the accompanying legend proclaims the king a 'Mazda-worshipper' (also the title on coins of Ardašir II, the patron of our anomalous rock relief).

RETURNING FROM TEXT TO IMAGE

In attempting to draw further significance from the iconography of Tāq-e Bostān I for the history of Zoroastrianism, it might be tempting to scour extant texts and attempt to adhere their interpretations to this image. To charge a single image, especially one such as this rock relief that had primary purposes other than as a declaration of faith, as being representative of a consistent religious concept held by all over centuries is clearly problematic. One illustration of the difficulties in ascribing clear religious meaning to iconographic features is demonstrated by the *barsom* carried by Mihr in Tāq-e Bostān I, his distinctive action in this scene. These wooden twigs (in modern-day practice replaced by metal wires) are held by priests in front of the sacred fire and usually scattered during the ritual, so does Mihr in this scene hold an officiant role? As noted above, in some representations of Ahura Mazda in Sasanian rock reliefs he holds the *barsom*, and in antiquity it seems that nobles could also hold the rods.[64] The number

[62] Gershevitch 1959, 35ff. A further indication of development in Iranian religion is found in the earliest Classical description of Herodotus, where Mithra is presented as a more recent addition to Persian worship: Hdt 1.131.2–3: 'they call the whole circuit of heaven Zeus, and to him they sacrifice on the highest peaks of the mountains; they sacrifice also to the sun and moon and earth and fire and water and winds. From the beginning, these are the only gods to whom they have ever sacrificed; they learned later to sacrifice to the heavenly Aphrodite from the Assyrians and Arabians. She is called by the Assyrians Mylitta, by the Arabians Alilat, by the Persians Mitra' (note also the gender change in Herodotus' version).

[63] *Yt.* 10.1.

[64] Boyce and Kotwal 1971. See, for example, the gold votive plaques of the Oxus Treasure (e.g. BM 1897,1231.53).

of rods is important to the particular ritual, as specified by the Middle Persian text *Šayest ne-Šayest* ('Proper and Improper') 14.2, perhaps dating to the late Sasanian period. In Tāq-e Bostān I, Mihr appears to be holding five rods, which is one of the approved numbers for ritual observance.[65] This attention to detail might suggest a particular Zoroastrian ritual is indicated. Yet an ambiguity in Tāq-e Bostān I that would dispel this additional religious meaning is that the shaft of Julian's scabbard is also divided into five ridges, and perhaps Ardašir's also, so it is unclear that Mihr's *barsom* is intentionally representing a specific number of rods.

Another distinctive feature of Mihr's appearance in this relief is that he stands on a lotus flower. The image of Mihr may therefore have visually interacted with the lake in front of the relief. This unique depiction has attracted many theories. Ferdinand Justi compared the lotus flower to Hindu art and suggested it was a further solar attribute of Mithra.[66] A second theory proposed the possibility of Buddhist influence in the formation of this iconography, since the Buddha was commonly depicted seated on a lotus.[67] Another suggestion is that the lotus symbolizes Apąm Napāt (Son of the Waters) rising from the lake (symbolizing Anāhita) in front of the relief, thus presenting a triad of Ahura Mazda. In this identification, the central figure, Mithra (left), and Anāhita/Apąm Napāt (below left) take part in the blessing and investiture of Šāpur II.[68] Yet water was and is a vitally important part of Zoroastrianism more broadly, playing a central role in the *Yasna* (lit. 'offering') ceremony, where offerings are made to the water (the *Āb-zōhr*).[69] *Yašt* 5 is dedicated to Ābān (the Waters), and several sacred texts refer to *khwarneh* residing in water, a concept of particular importance to the Sasanian kings.[70] Recorded as far back as Herodotus, the main noted features of Persian religion were the requirements for fire, water, and a high position.[71] This is corroborated by the many sacred Iranian sites that feature water, such as the

[65] See the number designated in Parsi tradition for the *bāj* (consecration ceremony) of the *pānj tāy* (five wires), a ceremony held before any other main ritual observance (Modi 1922, 340). The *Sraoša Yašt* (*Yasna* 57.5) speaks of the use of three, five, seven, and nine twigs by Sraoša (the *yazata* of obedience or observance) (Modi 1922, 279). See also Kotwal and Kreyenbroek 2009, 39 on the use of five rods as set out by the *Nērangestān*.

[66] Justi 1904, 157.

[67] Carter 1981. Connections between Mithra and the Hindu lotus-carrying personification of the sun, Surya, is discussed in ch. 5, p. 122.

[68] Achaemenid inscriptions, such as of Artaxerxes II (r. 404–358 BC) at Ecbatana and Susa, call upon Ahuramazda, Mithra, and Anāhita together; for more on the development of an 'Ahuric triad', see Boyce 1982, 219; for this identification at Tāq-e Bostān, see Soudavar 2003, 52–4.

[69] Kotwal and Kreyenbroek 2009, 129 n. 503 note that, unlike modern Parsi practice, in the *Nērangestān* the Āb-zōhr seems to be a separate ceremony from the Yasna.

[70] Callieri 2006, 344–6. On *khwarneh* in Iranian art, see Soudavar 2003.

[71] Hdt. 1.131.

most famous Sasanian fire temple at Takht-e Solimān.[72] It should also be noted that proximity to water was a common feature of the majority of ancient Iranian rock reliefs, from the Elamite period through to the Sasanians, perhaps in part due to the additional distinction and aesthetic qualities of such a setting as well as the sacred associations.[73]

MIHR IN SASANIAN ARCHAEOLOGY

By considering these varied accounts of Mihr's place in Sasanian religion, we can therefore hope to avoid (or at least mitigate) the all-too-easy pitfalls either of interpreting one image as representative of a constant religious concept, or, in contrast, viewing the extant material record as a cohesive whole. The latter approach has resulted on occasion in seeing this 'unique' and 'new' depiction of Mihr in a rock relief as indicative of a radical step in Sasanian religion, thereby problematically equating the extant iconography as wholly representative of doctrine or a religious reality where his veneration was isolated from the rest of Sasanian religious practices and beliefs. According to this view, there was an attempted religious upheaval instigated by Ardašir II, who favoured Mihr above all others, striking out against a Zoroastrian orthodoxy. As we have seen, however, images of Mihr are rare, as are, indeed, images of other *yazatā*; it seems therefore that the scarcity is in part the result of an artistic inclination of where, how, and when the images of *yazatā* should be created, rather than a reluctance particular to the depiction of Mihr.

Beyond the image of Mihr himself, identifying 'Mithraic' features in the Sasanian archaeological record is problematic. Motifs that appear unorthodox or even opposed to our understandings of Zoroastrianism, such as scorpions and snakes (animals considered the operatives of Ahriman) that are common to glyptic iconography, are often labelled as 'Mithraic' rather than 'Ahrimanic' or 'apotropaic'. These identifications frequently rest upon borrowings from scholarship on Roman Mithras worship. Among the figures scratched into the outer faces of an *ostadān* (a funerary container for bones) at Bandiyān, Dargez, near the Turkmenistan border, are a wolf attacking a ram bearing a stem of wheat in its

[72] The fire temple at Takht-e Solimān likely housed one of the three most sacred fires, Ādur Gušnasp, and was built on a rocky spur next to a sulphuric lake. The second great fire—Ātaš Bahrām (Victorious Fire)—established somewhere in Parthia, was called Ādur Burzēn-Mihr—'the Fire of Exalted-is-Mihr'. This name is most likely a reference to the personal name of a patron of the fire, just as the names of the other two Ātaš Bahrāms, rather than a direct reference to Mihr. The third great fire was called Ādur Farnbāg and was established somewhere in Fārs.

[73] Callieri 2006, 342 observes that it is likely that thirty-seven of the thirty-eight extant Sasanian rock reliefs were situated near a body of water.

mouth and an unidentifiable symbol on its rump; another hairy fanged creature attacking a cow that has a swastika on its rump; an ass also bearing a swastika on its rump and scorpion on its belly; and a snake biting a cow's udder.[74] While these motifs—the snake, scorpion, and stem of wheat—might be viewed as 'Mithraic' (a reading derived from Roman iconography associated with Mithras), they are part of a complex understanding rather than a clear and isolated Mithraic decorative scheme. They were accompanied by other motifs such as a rider shooting a deer, and a bird with its offspring, while the *ostadān* itself was found in a room adjoining the *atešgāh* (place/room of fire) in a fire temple, the holiest place for a Mazda worshipper.[75] A similar assumption in Iranian archaeology of Mithraic exclusivity is that caves are equated with the worship of Mithra. One such example is the Imamzadeh Ma'sum cave complex at Vardjovi in the Iranian province of West Azerbaijan, whose pre-Islamic function is unknown but which is often referred to as 'Mithraic'.[76] Kreyenbroek, however, has shown that caves played a role in the varied religious practices of wider Sasanian society and were not particular to an exclusive worship of Mihr.[77] It is not possible to identify a distinct archaeology of ritual practices connected with Mithraic worship in the Sasanian Empire because they were part of common religious observance.

THE IMPACT OF IDENTIFICATIONS

Ardašir's relief at Tāq-e Bostān is the most striking remnant of the prominent role that Mihr played in Sasanian religion. It brings to attention how, despite archaeologists and art historians' proclivities for emphasis on image and material evidence, we should of course not only avoid the assumption that our extant evidence is proportionate to the ancient reality, but we should also not align artistic habits and preferences with a reality of religious practices and concepts. This is not to say that images, objects, and the material record cannot play a part in our assessment of religion (quite the contrary), but to take account of the practicalities of artistic conventions and our presumptions about their significance. As many scholars of Zoroastrianism have pointed out, we must endeavour to build an imagining of Mithra in the particular local context (both temporal and

[74] Rahbar 2008, 20, figs 16–25. Rahbar 2008, 20 prefers an interpretation of the saddled horse as a symbol of Mithra, although in *Yt.* 8 the horse is a manifestation of the archer-god and rain-bringer, Tištrya (Tir).

[75] The walls of the main hall of the fire temple were decorated with stucco figures including a Sasanian king fighting foreigners in a battle, a hunt, a fire altar and attendants, a banquet scene, and Anāhita making a libation (Rahbar 2008, 16). See Rahbar 2008, 20 on the presence of the *ostadāns* in a fire temple.

[76] Ball 1979; Azad 2010. [77] Kreyenbroek 2011.

geographical) rather than imposing evidence drawn from disparate sources. Moreover, it is clear that the worship of Mithra was not stagnant over the centuries, but that, even within Iran itself, the ideas associated with the name Mitra, Mihr, or Mithra underwent some degree of adjustment and modification despite the longevity of the name itself and certain key concepts. Mihr held an exalted position in the Sasanian Empire, utilized in the expression of royal power as well as holding a part in wider religious veneration as upholder of truth and light, embodying the two of the most important Zoroastrian concepts.

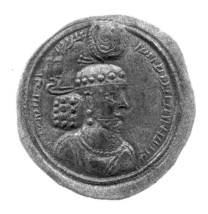

FIG. 4.3a. Obverse of a gold coin of Šāpur II (r. 309–379). BM IOC.435.

Trustees of the British Museum.

FIG. 4.3b. Obverse of a silver coin of Ardašir II (r. 379–383). BM 1862,1004.77.

Trustees of the British Museum.

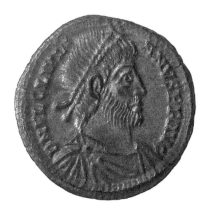

FIG. 4.3c. Obverse of a silver coin of Julian (r. 361–363). BM 1981,0910.47.

Trustees of the British Museum.

FIG. 4.7. Reverse of a silver coin of Hormizd I (r. 272–273). BM 1912,1210.2.

Trustees of the British Museum.

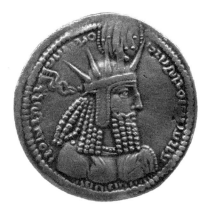

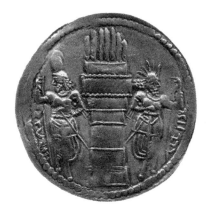

FIG. 4.8. Drachm of Bahrām I (r. 273–276). BM 1894,0506.1313.

Trustees of the British Museum.

FIVE

Interpretations

Miiro in Kushan Bactria

From Iran, our gaze now moves to Central and South Asia, to the Kushan Empire of the first to fourth centuries AD. In the northern province of the empire, Bactria, the name Miiro is the local form of Mithra or Mihr and the god Miiro played a prominent role in the second century AD (Map 3). It was a very public role, displayed on coins of the empire alongside other divinities who supported and blessed the emperors.

Miiro in the Kushan Empire presents both an opportunity and a challenge to imagine another local context, being neither Roman or Sasanian. Bactria's culture was closely related to the Iranian world through a long-shared heritage, but there is little evidence for Zoroastrian practice. The Kushan Empire presents Miiro in a complex iconographic setting, both on its coins and in royal temples. It also gives us an opportunity to compare his image with those of other solar deities, namely the Indian Surya and the Greek Helios, to explore issues of translation, borrowing, and how labels relate to images. The Kushan manifestation is troubling precisely because it invokes the possibility of translation and therefore challenges the notion that finding a label etymologically related to Mithra proves a direct correlation.

Before returning to those questions in more depth, it is necessary to establish the details of our evidence, first the coins and then the temples. One particular coin (Fig. 5.1) was made in the reign of the fourth Kushan emperor, Kanishka (AD 127–150).[1] Weighing 7.93 g and 21 mm in diameter, it is nearly pure gold and the design is loosely based on Greek and Roman gold coins. The die that struck this coin was engraved in the province of Bactria, probably at the capital of Balkh. Ancient Bactria encompassed the northeast of modern Afghanistan and southern regions of Tajikistan and Uzbekistan, comprising a series of fertile river

[1] BM 1894,0506.16 There are at least twenty examples of this type, Gobl 1984 type 68, made from many different dies over a number of years. Coins have featured in Mithraic discussions; *CIMRM* lists six, all drawn from the British Museum catalogue of Gardner 1886. One of these six is the type discussed here and the other five are issues of Kanishka's successor Huvishka, which includes one type depicting a different divinity and the Miiro inscription incorrectly applied, discussed on p. 118.

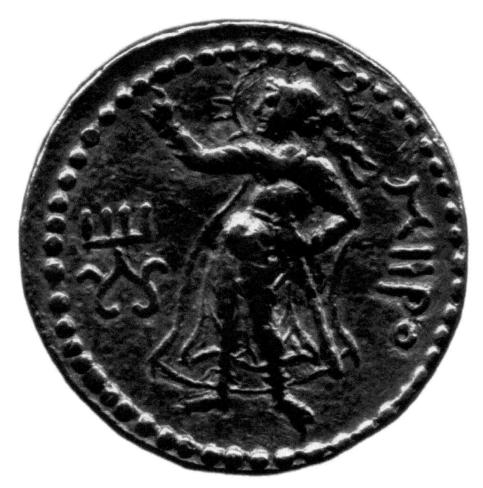

FIG. 5.1. Gold coin of Kanishka showing Miiro (r. 127–150), minted in Balkh. BM 1894,0506.16. Trustees of the British Museum.

valleys and plains between the Hindu Kush mountains to the south and the Altai mountains to the north.

On the reverse of this coin, Miiro stands with his body facing the viewer, while his head is turned to the left following the gesture of his arm. His hair is short and curled, tied by a ribbon (diadem) whose ends flow behind his head. He wears a tight-fitting tunic and trousers typical of depictions of Central Asian nomads, under a cloak fastened with two clasps. A belt at his waist supports a scabbard and he grips the curved hilt of a sword, while his heavy boots point awkwardly in opposite directions. To the left is a *tamga* (symbol) of the Kushan dynasty. Miiro himself is identified twice: first by the radiating halo around his head, the attribute of a sun god, and secondly by an inscription to the right, in Bactrian *Miiro*, cognate for the Mihr, Mithra, and Mithras encountered in previous chapters.

This is an image of curious juxtapositions. Miiro's upper body twists dynamically and the folds of the cloak are modelled in depth across his shoulders, but beneath his waist, garments become only edges and schematic indications of folds superimposed on a stiff frontal depiction. The frontal stance invites the viewer's gaze, but his gesture and turned head redirect it. While on the right the label identifies Miiro, the symbol on the left, to which he turns, is a political badge unrelated to him. And while this figure is viewed in isolation, even demarcated by the border, it was meant to be understood in relation to other images.

This coin is just one example of images of Miiro that were used on Kushan coins, both copper and gold, throughout the second century AD, issued in Afghanistan, Pakistan, and as far south as the city of Mathura in the modern Indian state of Uttar Pradesh (see Figs 5.2–8).[2] The Kushan Empire was defeated by the new Sasanian Empire in AD 230, who established a subordinate kingdom, the *Kushānshahr*, in Bactria. The *Kushānshahr* continued to issue occasional coins featuring Miiro in the third century (Fig. 5.9). That it is a coin necessarily places Miiro's image in a relationship with the image on the other side. That other side depicts Kanishka (Fig. 5.10) standing in the same stiff frontal pose as Miiro, also with his head turned to the left, in which direction he makes an offering at an altar. Kanishka wears a peaked cap, diadem, heavy coat, and a cloak fastened by clasps similar to Miiro over his nomadic jacket, trousers, and the same heavy boots awkwardly turned at ninety degrees from his body. From his belt hangs a sword with a curved pommel in its scabbard and in his left hand he holds a spear.

There are a number of similarities between the images of Miiro and Kanishka, such as the fastening of the cloak, curved pommel of the swords, and the diadem. The most obvious connections, however, are the gaze and the gesture. While the emperor offers at an altar, the god makes a gesture of blessing above the *tamga*. The *tamga* symbolizes both the dynasty and the king. It was used as a seal for official business (such as on the bulla in Figure 5.11) and each of the early kings commissioned a slightly different variation. Both the altar and the *tamga* occupy the same position on the bottom left in the compositions on their respective sides, creating a mutual interdependence of authority that is hard to miss. That interdependence serves a mundane function—to lend authority to the coin.

[2] The principle catalogue of Kushan coins is Göbl 1984, and the various deities represented are discussed in Bracey 2012. Kushan coins have been discussed in regard to Mithraism previously, with MacDowall 1975 and Bivar 1979 both contributing overviews, as well as early contributions on the Kushans more generally by Humbach 1975. Kushan numismatics has moved on considerably since; see, for example, Jongeward and Cribb 2014. As a result, the accounts by MacDowall and Bivar are outdated in important respects.

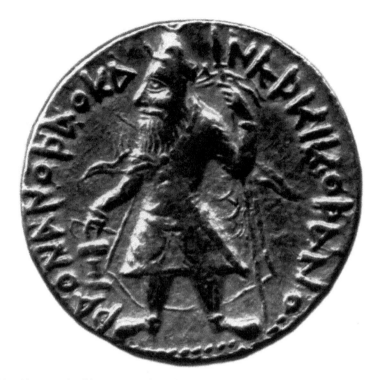

FIG. 5.10. Obverse of gold coin (Fig. 5.1) of Kanishka (r. 127–150), minted at Balkh.
BM 1894,0506.16.

Even users unfamiliar with the script or the religious nuances of the god, and as
we shall see that is a lot of them, could have read this message. The emperor wor-
ships Miiro, Miiro blesses the emperor—trust this money as you would our
worldly and divine power.

This was not an equal relationship. In production, the lower die, the
obverse, is mounted in an anvil and the coin placed on it, while the upper,
reverse, die is struck by a hammer. The reverse die tends to wear out more
quickly, and thus the earliest die-struck coinages were a simple geometric
shape while the complex design was kept for the obverse, in order to preserve
that which took the greatest effort. Even when reverse designs are complex, it
is clear throughout the history of die-struck coinages, in Europe and Asia,
that those who made them associated symbolic value with the obverse and
reverse. The obverse was the principle design, while the reverse was secondary.
In this case, therefore, Miiro is on the reverse indicating his subordinate
position in the relationship. Miiro supports the emperor, the emperor is not
promoting Miiro.

FIG. 5.11. Clay bulla showing the *tamga* of Huvishka (r. 150–190). BM IOLC.2845.
Trustees of the British Museum.

GODS OF THE SUN AND MOON

The relationship of Miiro with the emperor, reminiscent of that depicted in the Tāq-e Bostān relief discussed in chapter 4, is just one relationship that the coins establish. Miiro's position on the back of the coin places it in a relationship to other gods whose images appear on coins. At the time this particular coin was made, the gods Athsho, Mao, Nana, and Wesho were also depicted on coins. The next section of this chapter will discuss this pantheon in relation to the royal temples of the empire. First, however, we will consider an object which juxtaposes Miiro with the moon god, Mao.

Miiro and Mao are depicted together with a Kushan emperor on a casket found at Shah-ji-ki-Dheri near the modern city of Peshawar in Pakistan (Fig. 5.12).[3] The small copper casket comes from the remains of a Buddhist monument (*stupa*), one of the largest of its kind, that was excavated in 1908, and was sent to the Peshawar Museum.

The Kushan emperor depicted prominently on the side of the casket is most likely the same as the ruler depicted on the coin with which we began, Kanishka.

[3] Errington and Cribb 1992, cat. no. 192 gives a brief overview of the casket's study.

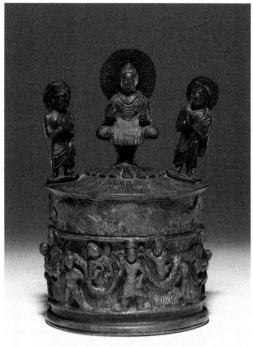

The figure on the casket is similar to that on the coin, wearing the same nomadic dress and feet pointing outwards.[4] Behind Kanishka and around the edge of the casket runs an undulating garland that serves to separate the mortal world at the bottom from the lowest level of the divine world above. Flanking the emperor above the garland are the torsos of two gods. Miiro, just as on the coins, appears with a radiating halo and makes the gesture of blessing. On the opposite side is Mao, dressed in a similar fashion to Miiro but with his own divine attribute, a crescent moon, rising behind his shoulders. He offers the emperor a torque, often used as a substitute for the diadem in official iconography. In Figure 5.4, above, Miiro can be seen extending the torque, this time to the right, above the *tamga*. Miiro's pairing with Mao seems natural as they are respectively personifications of the sun and moon.

In the late 1950s, the casket was sent to the British Museum in order to be cleaned. After the cleaning, an electrotype copy was made for study. A number

[4] That the figure on the casket is clean-shaven yet Kanishka on coins is bearded need not prohibit the identification. On some less-studied coins, Kanishka is shown clean-shaven, as Cribb (forthcoming) demonstrates.

of scholars have used both the cleaned original and the copy in order to read the dedication, which was engraved using a series of small punched dots interspersed across the design. The most recent reading by Stefan Baums runs:

> In the city of Kaniṣkapura, this incense box…is the donation of Mahasena and Saṃgharakṣita, superintendents of construction of the fire chamber in the monastery of the [great] King Kanishka. May it be for the benefit and happiness of all beings. In the possession of the Sarvāstivādin teachers.[5]

The inscription makes clear the container is an 'incense box', not a relic container, which is the use to which it was put in the *stupa*. It probably stood in a monastery on public display before it was repurposed for deposit in the *stupa* as a reliquary. The dedication was added to the casket at a later point than the figural decoration, but, given the correspondence between the iconography and what the inscription says of the royal patronage of the Sarvāstivādin monastery, it is highly likely that the inscription was added within the context of the casket's first use.

The Sarvāstivādin were an important sect of the Buddhist religion in the early centuries AD but though the monastery received royal patronage and royal imagery is present on the casket, the inscription makes clear it was the private gift of two superintendents of work. The figures of Kanishka, Mao, and Miiro resemble the official iconography of the coins, though the context of the casket and the small crystal reliquary, interred within when it was re-purposed as a relic container, are Buddhist. The makers were borrowing the iconography of the Kushan emperors but as will be seen below the emperors were not Buddhists. Both the coins and the Buddhist art discussed above are reflections of beliefs about Miiro rather than expressions of those beliefs. Those who made the coins and the casket did not practice a religion in which Miiro was a significant part. In both cases, Miiro's function is a reflection of the religious activity of the emperor. To better understand that relationship, it is necessary to turn to more overtly religious, though still deeply political, contexts. In the Kushan Empire those are found in royal temples.

THE TEMPLES OF THE KUSHAN EMPIRE

Evidence from royal sanctuaries in the Kushan Empire, also help to put Miiro in the broader context of the pantheon of Kushan gods. A number of royal sanctuar-

[5] Jongeward et al. 2012, 246. Earlier readings are summarized in Errington and Cribb 1992. The initial excavator, D. B. Spooner (Spooner 1908–1909), associated the casket with a story associated with the travels of the Chinese monk Xuanzang, for which see Beal 1911, 63. This was influential and the inscription was initially misread as being a royal gift.

ies have been excavated; these are known as *bagolaggos* in the Bactrian language of Afghanistan and as *devakulas* in the Prakrit language of India. The terms are equivalent and can be translated as 'house of the Lords'. The *bago* or *deva* title is ambiguous. It can mean 'god' but can also be used as a title for a king, and the Kushan emperors are referred to frequently as *devaputra*, 'son of god'. The three best known of the *bagolaggos* are at Surkh Kotal and Rabatak in Afghanistan, and at Mat in India.

Mat is a small village on the opposite bank of the river Yamuna from the holy city of Mathura. Today, Mathura is principally known as a pilgrimage site for Hindus wishing to visit the birthplace of Krishna and features an elaborate twentieth-century temple. In the second century AD, however, Mathura was a centre of Buddhist and Jain art. Near Mat, on a hill called Tokri Tila, a shrine was excavated in 1911 and 1912 that contained statues of Kanishka, his grandfather Wima Takto, and his successor Huvishka. The *bagolaggo* may also have contained images of gods, but the site was destroyed after the end of the Kushan Empire and the ruins were robbed for building materials over the next two thousand years. Some parts of the temple's destruction were clearly deliberate. The statues of the emperors had been decapitated and the principal statue, of Wima Takto, had been dragged from its original position and pushed into a central well.

Surkh Kotal stands on a high rise on the west side of a valley overlooking one of the principal routes south from Bactria towards the province of Gandhāra. Images of Kushan emperors survive from this site, as do several inscriptions recording repair work carried out by a high official called Nokonzok in AD 157. One of these inscriptions, reconstructed by Gershevitch, records how the water supply at the site failed and was later restored. It mentions the removal of the gods, presumably statues, and later their return along with the water, and the importance of water to the site, although it is ambiguous as to whether the water was needed for ritual or pragmatic reasons. So Mat and Surkh Kotal give us a basic outline, that a *bagolaggo* is a temple in which it was appropriate to erect images of both kings and gods, and that water was important for its proper functioning.[6] A curious similarity is that the two sites are both slightly detached from the public gaze. They stand in prominent positions that would have been visible to those travelling north or south, yet are not in urban centres or in locations where they would have been observed closely by many people.

[6] The Mat and Surkh Kotal *bagolaggos* are summarized well by Rosenfield 1967, 138–64 and the inscription at Surkh Kotal was subsequently read by Gershevitch 1979. The various sites which might have been *bagolaggos* are listed in Bracey 2012, 205–9. Canepa 2015, 84–92 gives an overview of these sites in the context of Iranian temples (although note that, contrary to Canepa 2015, 92, the restoration inscription is of Huvishka but the earliest image, and thus the likely founder of the *bagolaggo*s of Wima Takto).

The two sites show many differences as well as similarities. Surkh Kotal is much larger and features a central square hall within a large walled rectangular compound. Mat is an apsidal temple and much smaller by comparison. Both the temples and the sculptures seem to have been made by local craftsmen following local practices. This is most obvious at Mat, where the local red spotted sandstone is particularly distinctive. In all likelihood, the work was carried out by different people who were local functionaries of the empire, but elements of the finished products were dictated by a common conception of the temples' function.

In 1993, an inscription was discovered at the site of Rabatak in Afghanistan. Today the inscription is in the National Museum in Kabul. Rabatak has never been excavated and is a large artificial mound that probably once contained a temple like those at Mat or Surkh Kotal. The inscription is important because it records the foundation of the temple, unlike the inscriptions at Mat and Surkh Kotal that record repair work. The person who carried out the repair work at Surkh Kotal, a man named Nokonzok, is also named in the Rabatak inscription. While Nokonzok's work at Surkh Kotal took place twenty to thirty years later under Huvishka (AD 150–190), the construction work at Rabatak was undertaken at almost the same time that the coin with which we began was issued, in the reign of Kanishka (AD 127–150).

The Rabatak inscription includes Miiro amongst a list of gods: Nana, Umma, Ahura Mazda, Mozdoano, Sroshard, and Narasa. All of these gods likely had images dedicated at the *bagolaggo*, presumably alongside statues of Kanishka and his ancestors, and at different times in the second century all appeared on coins of the empire. The inscription also makes clear what the function of this pantheon was: *May these gods who are inscribed here [keep] the [king] of kings, Kanishka the Kushan, forever healthy, fortunate, [and] victorious.*[7] Miiro is one god amongst this pantheon, whose collective purpose was to maintain the authority and power of the king, and, through the king, the dynasty. The gods had different roles and differed in importance within the pantheon. Miiro was clearly important and some scholars have suggested he might be the chief divinity.[8] Other scholars, by analogy with Zoroastrianism and the Sasanian Empire, have assumed that the Kushans' chief god was Ahura Mazda.[9]

In fact, any part Ahura Mazda fulfilled in the pantheon must only have been minor. Although he is mentioned at Rabatak, the shrine was principally

[7] Sims-Williams 2004, 57.

[8] Various authors have considered whether particular emperors might have been personally devoted to Miiro, associated with the sun, or whether a Mithraic cult might have existed: Rosenfield 1967, 197–8; Kulke and Rothermund 1986, 86; Harmatta et al. 1994, 309.

[9] Authors usually refer to the Kushan religion as 'Mazdean'. Neelis 2011, 139–41 briefly summarizes the discussion.

dedicated to the goddess Nana, and the shrine at Surkh Kotal was dedicated to the goddess of victory, Oanindo. The other *bagolaggos* may have been principally dedicated to a single deity but insufficient evidence survives, and Ahura Mazda is not among the gods mentioned at any of those sites. On Kushan coinage, Ahura Mazda is only depicted once, on an issue produced late in the reign of Huvishka, probably dating to AD 170–190. That particular issue depicts many gods otherwise unattested in Kushan practice and it seems the mint chose temporarily to include a number of minor divinities, of which Ahura Mazda was one.[10]

Of the various gods depicted, the most likely candidate for the position of chief divinity in the Kushan pantheon is Wesho. The exact identification of Wesho, whose iconography resembles that of the Hindu god Śiva, has been a point of dispute, but he appears prominently throughout the history of the dynasty.[11] This marks a dramatic difference between Zoroastrian texts and Kushan practice. Although both religious traditions derive from a common east Iranian heritage, Wesho, who is almost entirely unknown in the Zoroastrian context, takes the place of Ahura Mazda, and Mithra, a divine being principally associated with contracts, becomes in the Kushan Empire a god personifying the sun.

Unfortunately, the bulk of our evidence from the Kushan Empire—temples and coins—while useful for giving Miiro a context and function, does not tell us a great deal about what his image meant. While temples are ambiguous in that they can both display and conceal, coins are always a very public depiction. Anyone who uses a coin can see what is depicted on it, even if most users pay little attention. A gold coin might have been seen only by a small elite, but the Kushan copper coins bear the same imagery of Miiro and were used widely, not only in urban centres within the Kushan Empire but across much of India and Central Asia. Indian traders in cities along the Gangetic Valley as far as the east coast of Bengal and Orissa would have seen the coins. Some would have travelled north and west. In Choresmia, at the far end of the Oxus river, they were marked by local officials and used as currency. Hoards of Kushan coins have been found in the Persian Gulf and even on the east coast of Africa.[12] What did all of these people understand when they saw this solar god depicted?

[10] There is no specific publication on this period of minting, although the data is published in Göbl 1984. See also Bracey 2013.

[11] The most detailed examination is by Cribb 1997, who sees Wesho as an Iranian deity assimilated to the Indian Śiva.

[12] For the Rich parcel, see Jenkins 1964, 93–4; for the Debro Dammo hoard in Eritrea, see Mordini 1967.

UNDERSTANDING THE SUN

Even within the Kushan Empire, it is clear that not everyone understood who or what these images were meant to depict. A little more than fifty years after the coin shown in Figure 5.1 was created, an engraver carved the die that struck the coin in Figure 5.12. The central figure here is the goddess Ardochsho. Instead of the radiating halo, the attribute of a sun god, she holds towards the *tamga* her own divine attribute, the cornucopia, as a symbol of prosperity. However, the label on the left reads *Mioro*. This engraver worked in Gandhāra near the city of Taxila, not at the same mint that engraved the first coin, where the local administrative language was Gandhārī not Bactrian. It is likely that Miiro did not feature in the local mint worker's own religious practices. The bulk of evidence suggests the local population were predominantly Buddhist.

In fact, the images on the coins are often drawn from other religious systems. It seems unlikely there was a tradition of depicting Kushan gods before the first century AD and that the engravers had borrowed or invented iconographies to represent these gods, something for which the eclectic artistic culture of Bactria and Gandhāra was ideally suited.[13]

The basis of this eclectic iconography, an international trade in artistic products, is best illustrated by finds in the ancient city of Kapisi, modern day Begrām in Afghanistan. In 1937, archaeologists opened what they had designated 'Room 10'. The building had been sealed in antiquity, probably to preserve its contents, and never re-opened. Those contents included ivory panels imported from western India, lacquer from China, and glass from Rome. Although it has been described as the treasury of a royal palace, it is far more likely that these items, of variable quality and at various stages of production, comprised a merchant's store.[14] Among the objects were those decorated with a variety of Hellenistic motifs, including divinities. Such material demonstrates that artists in Bactria and Gandhāra could draw on a broad range of iconographies when looking to create images for the first time for the royal pantheon. So the goddess of royal fortune,

[13] As there is no art associated with the Yuezhi, the tribal confederation which Chinese sources take as the Kushan's immediate predecessors, this remains a supposition based on the extent of borrowed and stock images among the pantheon. On artistic precursors for the Kushans, see Srinivasan 2007. Two significant sites are frequently associated with the Yuezhi: the burials at Tillya-Tepe (see Sarianidi 1985 and Cambon 2007a, 153–227) and Khalchayan (see Nehru 2006, who provides a bibliography and agrees with the original excavators in placing the site in the second century BC). Neither site shows any clear evidence of a pre-existing iconography that can be mapped onto the second-century Kushan examples. However, they are of debatable utility in such an argument, since the current author believes both sites to be much later than the dates attributed by their excavators.

[14] The original French excavators had taken the whole complex to be a palace, and so the assumption that the rooms represented a treasury was logical (see Hackin 1939 and 1954). The finds have been recently published in detail by Cambon 2007b, 229–77.

Ardochsho, borrows the dress and cornucopia of the Buddhist ogress Hariti, who is herself based on the Greek goddess Tyche. Meanwhile, the image of the god Wesho combined elements of Poseidon, Herakles, and the Indian god Śiva. In the case of Wesho, the original image thus created was later re-adopted by Śaivite worshippers for early medieval depictions of the god.[15]

The artists were less inventive with Miiro. Just as for a number of other gods on the coins, the artists took a stock image, that of a Kushan prince, and added a divine attribute, the radiating halo. With such an eclectic artistic background and religiously diverse set of sources for the images, and given that many are stock images depicting deities with which the engravers were not familiar, it is unsurprising that they made errors with the labels.

More interesting is that the coin of Huvishka in Figure 5.12 is not the first occasion on which the image and the label do not match. In the first year of the reign of Kanishka, AD 127, the mint at Balkh produced a series of coins that were engraved in Greek rather than Bactrian (Fig. 5.13). Visually they are unremarkable, since the Greek and Bactrian languages were written in the same script and the king's image is unchanged. The Greek title *basileus basileōn* is a translation of the Bactrian *shao nanoshao*, 'King of Kings'. The interesting aspect is on the reverse where the name of the god is given as Helios, rather than Miiro (Fig. 5.14). The image is otherwise identical with the coin in Figure 5.1, and in all likelihood they are the work of the same engraver. We will see another example of a royal context in which the names Helios and Miiro are linked to the same image when the site of Nemrut Dağı in Commagene is discussed in the following chapter. For now, it creates a problem that has several different possible solutions.

When scholars first looked at these coins they privileged the labels—the textual element—over the images. Alexander Cunningham, the first Director General of the Archaeological Survey of India, set the pattern in his various publications on Kushan coins.[16] He divided the depictions on Kushan coins into different pantheons, some Greco-Roman gods, some Zoroastrian, and others Hindu or Buddhist. In this reconstruction, Helios represented a different god from Miiro.

In 1967, John Rosenfield prepared a detailed study of the art associated with Kushan royalty. There were two prevailing theories on the diverse range of gods at the time. The first was that the coins displayed gods familiar in places with which the Kushan Empire traded, including Roman Egypt. The second was that the coins reflected the diversity of beliefs within the Kushan Empire. Rosenfield

[15] The identification of this god has been hotly disputed but this position has received support from some Śaivite specialists, see Sanderson 2013.

[16] Alexander Cunningham published a wide range of articles but particularly developed ideas on the pantheon in a series of articles in 1889, 1892, and 1893. The suggestion of a link to the Roman worship of Mithras was first raised by Prinsep in the 1840s. These early studies are discussed in detail by Cribb 2007 with a full bibliography.

rejected both theories: the first because the coins were rarely used in trade, and the second because major religious communities (such as Jains and worshippers of Nāgas) were ignored by the engravers. Though Kushan coins did move in foreign trade this was mostly copper, not the gold Rosenfield was concerned with, and the coins were mostly found in Central Asia and northern India rather than to the west. A large hoard of gold coins was reported in Eritrea at Debra Dammo but, as only a single find, it does not speak strongly against Rosenfield's assessment. Rosenfield recognized that Helios and Miiro were names for the same deity and attributed this to a 'syncretic attitude' amongst the dynasty.[17]

Subsequent to Rosenfield's account, there has been a noticeable trend in Kushan studies away from syncretic explanations and in favour of seeing the pantheon as a more coherent whole. Franz Grenet has demonstrated in a number of studies that most of the gods have strong parallels in the Zoroastrian tradition, even those which appear at first glance to be Indian.[18] The Kushan pantheon has therefore been assumed to share a common root in Iranian religious beliefs with the texts of the Zoroastrians, though as already mentioned the minor place held by Ahura Mazda marks it apart. So while the Kushan iconography and pantheon may have been made from the same building blocks as forms of religion in ancient Iran, the way in which they were assembled was fundamentally different.

Today the Greek name Helios, like other Greek gods on Kushan coins, is seen simply as an act of translation—the Greek label that comes closest to Miiro. This does not entirely resolve the problem. The name is clearly fluid, able to denote different conceptions at different times and for different viewers. Miiro being a translation of Helios is unlikely, after all his moon god partner is consistently

[17] Rosenfield 1967, 69. [18] Grenet 1984; Grenet 2006b; Bracey 2012.

depicted as male though occasionally labelled by the name of a Greek goddess, Selene. However, this does not mean Miiro is unambiguously Iranian in conception, it is at least possible that Miiro is a Bactrian translation for a traditional Kushan god otherwise unattested in our evidence. Yet if Miiro is simply a label for another god, can we legitimately discuss his relationship with our other examples from the Roman and Sasanian Empires?

MIIRO AND SURYA AFTER THE KUSHANS

In the previous section of this chapter, the relationship between the label and the image was explored. This final section will focus on why this particular image was chosen. What was the relationship between Miiro and the sun? And, given that relationship, why was the particular iconography chosen? Where the previous sections have explored Miiro at a particular moment, this section will range much more broadly, touching on depictions of the sun, whether Miiro or Surya, in the centuries that follow. The fluidity of iconography further undermines our confidence that labels are static or stable in Central Asia at this time.

A solar god is not necessarily the same as a personification of the sun; both Apollo and the Buddha, for example, have solar characteristics but are not considered to be the star itself. Similarly, the Roman Mithras and the Iranian Mihr have solar associations without necessarily being personifications of the sun. Although the Roman god is frequently given the epithet *Sol Invictus Mithras*, as outlined in the introduction to this volume (p. 23), the mythographic scenes associated with Mithraic iconography clearly avoid conflating Mithras and Sol. The sun god in fact appears to play a key role in the mythic story surrounding Mithras and the bull; he is often depicted alongside Mithras, sharing in the feast, and is also sometimes shown kneeling in front of Mithras, in a submissive position.[19] A key distinguishing feature between Mithras and Sol is that the latter is usually portrayed with a radiate crown or sun disc, whereas Mithras is more commonly shown in the Phrygian cap without any markers of solar attributes.

In the Kushan pantheon, Miiro is very likely a personification of the sun, his pairing with the moon god Mao, his conflation with Helios, and the absence of an independent divine figure representing the sun all point in that direction. When the dynasty's artists cut an image for Miiro, they did so for the first time and they did so by picking a stock image with no solar connotations, a god dressed in royal garb offering a diadem, and attaching to it a divine attribute, the radiating halo.

[19] Both of these scenes are shown in the mythography frescoes at Dura-Europos, Fig. 2.3. See also ch. 1, p. 23.

The radiating halo clearly serves to identify Miiro but it is not an attribute that is unique to solar gods in the second century AD. In India, the personification of the sacred fire, Agni, at least one of the Jain *tirthankaras* and, a little later, the Buddha himself, could all be depicted radiate.[20] The engravers did have an alternative to using a stock image. They could have borrowed existing iconography of solar personifications, just as they borrowed the iconography of the Buddhist Hariti to represent the Kushan Ardochsho, or the Greek Athena to represent Rishti.[21] They could even be inventive, such as mentioned above, when they combined elements of the Greek Herakles and Indian Śiva to create their own Wesho. This raises the question, why did they not tap into the iconography of an existing Indian personification of the sun, Surya?

In the modern Hindu pantheon Surya is the personification of the sun and is usually identified by the lotus flowers he holds in each hand (Fig. 5.15). The lotus is a common attribute of divinities in the early first millennium: the Indian goddess Śri sits on one, it is frequently associated with Buddhism, and, as we saw in chapter 4, there is a lotus beneath Mihr's feet in a rock relief at Tāq-e Bostān. What is of particular interest is not this type of depiction but another early Surya iconography in which the god is depicted riding a chariot, or at least accompanied by horses.[22]

In the early first millennium, there were strong affinities between Miiro and Surya. Some texts include 'Mitra' as one of the names of Surya, and describe him as driving a seven-horse chariot. One text, the *Brhatsamita Surya*, prescribes that Surya should appear without multiplication of limbs and dressed in 'northern' garb.[23] What this meant in practice is well-illustrated by a marble sculpture from Khair Khāneh in Afghanistan.[24] Surya squats in the centre of a platform, wearing a decorated tunic and calf-high boots. Two figures flank Surya and beneath is the torso of a much smaller figure, and two horses leaping dramatically backwards and to the sides. The elements, seated figure, driver, and two horses, are the components of a chariot but the representation is a substantial stylization of a much earlier image—a frontal depiction of a chariot like those seen on coins of the Greco-Bactrian king Plato in the second century BC (Fig. 5.16).

[20] It is possible that what was intended with Agni are flames, but the Jain and Buddhist examples are clear, see for example Mosteller 1991, figs 58, 67, 85.

[21] Bracey 2012, 200.

[22] In some cases realistic depictions have been identified as Surya; see, for example, Huntington 1985, fig. 5.27 but most early depictions show a squatting figure with the chariot implied by the presence of two horses, as in the case of the Khair Khaneh statue, see also Huntington 1985, fig. 8.42; and Coomeraswamy 1922, 72.

[23] Banerjea 1956, 137–40. The texts are summarized in Markel 1995 and Nagar 1995. Callieri 1990, particularly pp. 89–93, explores the relationship between Surya and Mithras in India and Afghanistan.

[24] Lee 1967, fig. 7.

Fig. 5.15. Surya relief, sandstone,
H. 21.08 cm, fourth century, Mathura.
BM 1949,1114.1.
Trustees of the British Museum.

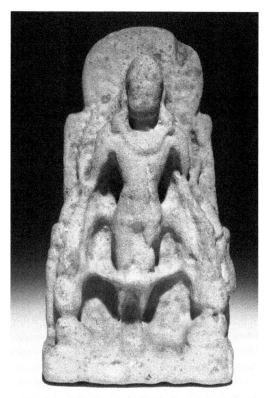

This alternative iconography is intriguing because it existed alongside the iconography of Miiro on Kushan coins and the more 'Indianized' standing figures of Surya holding the lotus. It was also used, but not frequently, on seals in the Kushan period. A seal in the Amun ur Rahman collection depicts three figures in a chariot shown as a small box of crossed lines.[25] The central figure has a halo and either side of the central box two horses leap away. The use of a Kharoshthi inscription dates it roughly to the early centuries AD. The label indicates the owner of the seal, who was named after the hero of the Indian epic poem the *Mahābhārata*, Arjuna. It might be argued that there was therefore a sharp distinction between Surya riding his chariot and Miiro with his radiating halo.

It is important to be careful here. While Surya is usually depicted in a chariot and with no radiate halo, and Mithra/Miiro radiate without chariot, this is not universally true. Two depictions have already been discussed in chapter 4: the lost Berlin seal and a painting in the vaulted ceiling above the larger Buddha at Bāmiyān (p. 96). In both images, a figure is depicted frontally, radiate, and

[25] There are three related seals in Rahman and Falk 2011, 113: Gkc201 (p. 113) bears a standing figure with radiating halo, while Gkc400 and Gkg018 (p. 90), the latter of which is discussed here, are chariot riders without halos.

driving a chariot. In the case of the seal, the Middle Persian inscription *hu-mihrīh ī pahlom* ('perfect friendship') may invoke the Sasanian Mihr, and draws obvious comparisons with Zoroastrian texts that describe Mithra. The context of the Bāmiyān depiction is more ambiguous, though Grenet also read it through the lens of Zoroastrian texts as a depiction of Mihr.[26] Like the incense box discussed at the beginning of this chapter, the image was made by Buddhists, but this time under the rule of Iranian Huns, most likely the Hephthalites, who succeeded the Sasanian-sponsored Kushānshāhs in the late fourth century.[27] The Kushan Empire had ceased to exist by this time, although much of its iconography of rulership had been adopted by successors in India and Central Asia.

In the Bāmiyān depiction, the chariot with its horses leaping sideways clearly derive iconographically from depictions of Surya, or, at least, the early iconography usually attributed to Surya. As pointed out by Tianshu Zhu, in Buddhist art, which incorporated a wide variety of Indian gods, the sun god Surya is commonly depicted in this manner, and Grenet recognizes that images similar to this figure at Bāmiyān occur in India.[28] Though many images of the god in a chariot, so presumably Surya, have halos, most are not radiate; in this, our chariot-driver is the exception rather than the rule, even among the iconography at Bāmiyān.[29]

By at least the eighth century, however, Buddhist translators in China are clear that both of these features, the chariot and radiate halo, are attributes of the sun. In *The Secret Text on Garuda and Other Celestial Beings*, as quoted by Zhu, the image is described almost exactly as we see it at Bāmiyān:

> The sun god is in form [*sic*] of a Heavenly King (*lokāpala*), wearing armour, sitting in the gold chariot with legs crossed. (His chariot) is driven by four horses, two heading left and two heading right. He has black hair and is wearing a jewelled crown. He has both a halo and *mandorla* and is enclosed within the sun disc. The sun disc is red with a pattern like a wheel.[30]

And who is this figure? The Chinese Buddhists are clear that it is the sun whom the inhabitants of Central Asia call *Mi*, the Indians *Anidiye*, respectively Mihr and Aditya/Surya.[31] This brings us back to the fluid nature of labels discussed in the previous section of this chapter. Are all of these instances just translations?

[26] Grenet 1993.

[27] The most recent summary of Iranian Hun numismatics, the principal evidence for this ethno-political group, is summarized in Vondrovec 2014.

[28] Zhu 2003.

[29] Coomeraswamy 1922 notes several examples of Surya with disc behind his head reaching back to the second century BC but these are not radiate or requisite in Surya's iconography. Similar observations are possible of the Panjikent examples in Grenet 1994 and those from Kizil in Zhu 2003.

[30] Zhu 2003.

[31] Zhu offers no explanation for *Yaosenwu*, the name of the sun amongst the Persians, and the difficulties of Chinese rendering of foreign terms prevent us from speculating if they are drawing a distinction between Mihr and Khorshid, the sun itself.

Solar imagery and solar deities remained important throughout northwest India in the first millennium AD. In the eleventh century, the Arabic writer Al-Biruni describes the most celebrated temple of northwest India, in the city of Multan, as dedicated to the sun:

> A famous idol of theirs was that of Multân, dedicated to the sun, and therefore called *Âditya*. It was of wood and covered with red Cordovan leather; in its two eyes were red rubies.[32]

Aditya, as mentioned above is usually a synonym for the Indian divinity Surya, though Al-Biruni had never visited the temple or seen the idol. The temple had been destroyed a few decades before, when a radical Islamic group had seized power in the city from the previous Arab governors. Previous generations of Islamic travellers and the Chinese pilgrim Xuanzang had seen it, however, and left descriptions of the idol.[33] Xuanzang describes it as a golden statue:

> There is a beautifully decorated temple of the sun god. The image of the god is made of gold and adorned with precious ornaments. It has spiritual perception and the power of penetration, and its divine merits protect all secretly.[34]

Xuanzang leaves it ambiguous for us whether the statue represents Surya or some other solar god. The notable disconnect is that he describes the statue as gold rather than wooden and red in appearance. This is undoubtedly the result of the gold having being robbed from the temple by the Arab general Muhammad bin Qasim (in AD 714) between Xuanzang's visit to India (*c.* AD 630) and al-Biruni's report (AD 1030).

The *Chachnama*, a romantic Persian account of Muhammad bin Qasim's campaigns, gives a story of the statue which is particularly interesting. In this Muhammad confuses the idol for a man:

> It is related by the writers of history and narrators of tales on the authority of Alí son of Muhammad (who heard it from Abu Muhammad Hindí), that Muhammad Kásim, accompanied by his companions, chief attendants and private servants, went to the temple. He found an idol made of gold, with two eyes of red rubies in its face. It was so like a living man that Muhammad Kásim mistook it for one, and he drew his sword in order to strike it.

Striking realism is not a characteristic one would associate with the imagery of Surya in his stylised chariot. The sun temple at Multan was founded under a Hunnic dynasty whose kings used names with a solar association only a century

[32] Sachau 1888, 116.

[33] Sachau 1888, 116–17 on the destruction of the temple; Watters 1904 and Li 1996 on Hsuan-Tsang's visit.

[34] Frendunbeg 1910, 192.

or so after the final collapse of Kushan rule. Did its central cult image represent the Kushan Miiro? Certainly an iconography like Miiro, a princely figure in Central Asian dress wearing a sword, would make far more sense in Muhammad's story. Could the image of Miiro have come to be understood as the Indian Surya, or by a Buddhist as a more generic personification of the sun? How did contemporaries perceive the differences in iconography?

This section has ranged broadly in the first millennium over the legacy of solar iconographies left by the Kushan Empire. When Kushan engravers first chose to depict Miiro they repurposed stock images instead of borrowing the contemporary depiction of Surya. There is no way for us to know why they did that, but it is possible for us to understand the interpretive ambiguity this creates. A worshipper of Mihr or Miiro can see him in both a radiating halo and in a figure riding a chariot. At the same time a worshipper of Surya could look at the Kushan Miiro and fail to see a god of the sun at all, since his divine characteristic, the chariot, is entirely missing.

CONCLUSION

This chapter began with a discussion of a Kushan coin, containing an image labelled Miiro. It expanded upon the image by exploring contemporary art and the royal temples of the dynasty which issued the coin. This established the iconographic function that the image served, as divine support to royal power. In the second half of the chapter, the difficulties associated with the label were explored. Coin engravers could translate labels, or be mistaken in their use. Two distinct iconographies for the sun, the figure with radiate halo and the chariot, co-existed in Central and South Asia for most of the first millennium. The degree to which these iconographies demarcated different gods is unclear.

One of the difficulties in interpreting the significance of names and images is that it is very hard to tell what a contemporary understood. Though the image is public, the understanding was often private and individual. What it meant in a royal temple such as at Rabatak, is perhaps very different to what it meant to the engraver of a coin, or to a Bactrian, Gandhāran, or Indian audience. Most people who saw the coins, like us, did not know anything of the religious beliefs of those who had ordered the image engraved.

The fluid nature of names and iconographies in this region makes it almost impossible to proceed by filling in the gaps by reference to a more detailed set of Iranian, or Indian, sources. It is not just that Kushan *bagolaggos* are not Zoroastrian (in the sense that Ahura Mazda is the pre-eminent deity), it is the danger that the Miiro of the Kushan coins might not be related to the other figures named Mithra at all, but might be an entirely unrelated figure labelled

with what amounts to a translation. Perhaps this is too sceptical but the ease with which the iconographies of Helios, Miiro, and Surya could mix and come to represent each other is notable. So, for example, a chariot-riding figure at Bāmiyān in Afghanistan can be confidently identified by Grenet as Mithra, while an image similar to the Kushan Miiro at Multan could be understood by Hindus as Surya. At the same time, a contemporary outsider, such as a Buddhist or a coin engraver, can see all of these labels as translations, different words for the same thing. All of this suggests that 'Miiro' might simply have been a label for a set of practices and perceptions that were more local than they were Iranian. However, this sense of local reinterpretation does not render a comparative approach impossible. Miiro's role as divine patron of the Kushan emperor has clear connections with the focus of the next chapter. The Kushan Empire and the kingdom of Commagene were very different political entities but the iconography used to display the relationship between the divine and royal figures is remarkably similar.

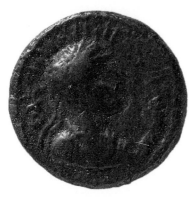

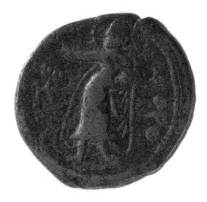

FIG. 5.2. Obverse of copper coin of Wima
Takto (*c*.90–110), minted in Begrām.
BM OR.8946.

Trustees of the British Museum.

FIG. 5.3. Reverse of copper coin of Kanishka
(r. 127–150), minted in Begrām. BM
1894,0506.1436.

Trustees of the British Museum.

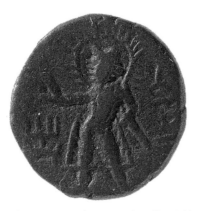

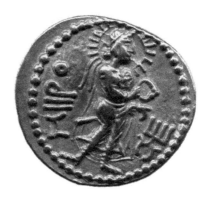

FIG. 5.4. Reverse of copper coin of Kanishka
(r. 127–150), minted in Kashmir. BM
1855,0608.24.

Trustees of the British Museum.

FIG. 5.5 Reverse of gold coin of Huvishka
(r. 150–190), minted in Gandhāra. BM
1879,0501.79.

Trustees of the British Museum.

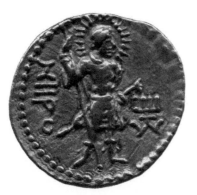

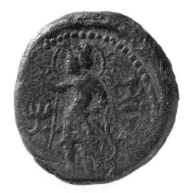

FIG. 5.6. Reverse of gold coin of Huvishka
(r. 150–190), minted in Gandhāra. BM
IOC.313.

Trustees of the British Museum.

FIG. 5.7. Reverse of copper coin of Huvishka
(r. 150–190), minted at Begrām. BM
1894,0506.1528.

Trustees of the British Museum.

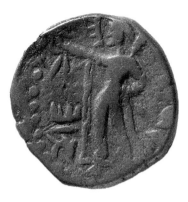
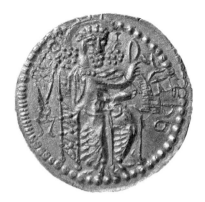

Fig. 5.8. Reverse of copper coin of Huvishka (r. 150–190), minted at Mathura. BM 1847,1201.266.

Trustees of the British Museum.

Fig. 5.9. Reverse of Kushano-Sasanian gold coin of Ardašir I, mid-third century, minted in Bactria. BM 1986,0641.1.

Trustees of the British Museum.

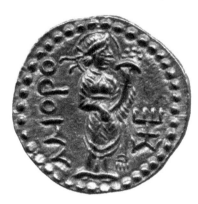

Fig. 5.13. Reverse of gold coin of Huvishka (r. 150–190) showing image of Ardochsho and inscription 'Miiro'. BM 1879,0501.45.

Trustees of the British Museum.

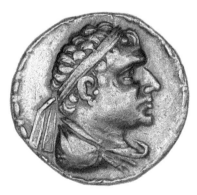
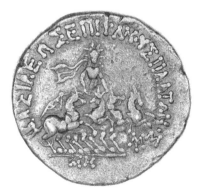

Fig. 5.16. Reverse of tetradrachm of Plato, mid-second century BC. BM 1953,1014.1.

Trustees of the British Museum.

Syncretisms

Apollo-Mithras in Commagene

Finally, we turn to our earliest image of Mithra, from the kingdom of Commagene in the first century BC.[1] It was towards the end of the nineteenth century that the German engineer Karl Sester rediscovered and popularized a series of astonishing remains on the 2,206 m high mountain top of Nemrut Dağı (Fig. 6.1).[2] The giant heads of its once towering statues now litter the front pages of innumerable tourist guides as they continue to evoke a sense of wonder. The site itself consists of three terraces to the north, east, and west built around a 50 m high mound, approached by processional ways leading up the mountain (Fig. 6.2).[3] The remains of stelae, colossal statues, and inscriptions scattered about the complex present a bold religious and political scheme. They are the work of a king, Antiochus I, ruler of Commagene from 69 to around 36 BC, who appears to have built this *hierothesion*, as he calls it, to honour himself after his death. Through this remarkable artistic and epigraphic programme, he positions himself as the descendant of famed kings and as the equal of his favoured gods. But whilst the grandeur and pomp of the place may be immediately intelligible, Nemrut Dağı remains an enigmatic problem for modern scholarship.

Our image from the west terrace appears on a sandstone stele, standing 2.3 m high and 1.5 m across (Fig. 6.3). It features two figures: on the left, Antiochus, and on the right, a god identified as 'Apollo-Mithras-Helios-Hermes' by an inscription in Greek on the reverse, thus combining the name Mithras with three

[1] Aside from the invaluable feedback of my colleagues and numerous reviewers, I would especially like to thank Dr Charles Crowther and Dr Peter Stewart for their comments.

[2] Note that there are variations of the transliteration of the name of the mountain into English such as Nemrud Dagh and Nemrut Dağ. Brijder 2014, 176–312 provides a comprehensive review of past scholarship at the site. Nemrut Dağı was of course known to locals, but it was only in the latter half of the nineteenth century that German and Ottoman interest in particular was piqued.

[3] Brijder 2014, 122ff. and fig. 72 showing the three processional routes leading up the mountain. See also Sanders 1996 1.178–80 for the evidence from the east and west *propylaia*.

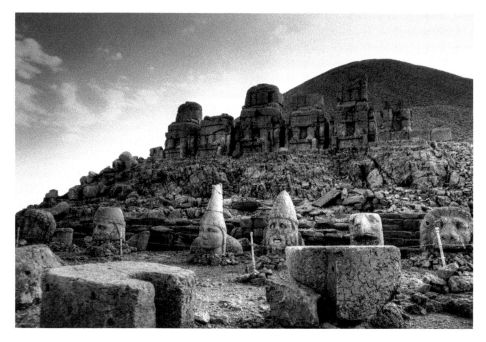

FIG. 6.1. View of the east terrace of Nemrut Dağı, Turkey.
Image: Klearchos Kapoutsis. Creative Commons License.

well-known divine figures in the Greek tradition.[4] Though the central part of the relief has broken away, Antiochus and the god were depicted grasping hands or *dexiosis* (lit. 'accepting the right hand'), an act held to represent the continuing assistance of the god through the struggles in the king's life, but one that also explicitly places them on the same level.[5] The god wears a Persian tiara decorated with several six-pointed stars, unfortunately now barely visible due to weathering.[6] This is sometimes called a Phrygian cap by modern scholars given its resemblance to the headgear frequently worn by Attis, Paris, and most notably Mithras in the west.[7] On his forehead, distinct from the tiara, is a diadem decorated with circles and lozenges. Behind his head emanate rays in front of a disc, identifying him as a sun god. His face is youthful and beardless with large almond shaped eyes. There is a torque coiled twice around his neck that holds a rectangular

[4] *CIMRM* 30; Sanders 1996 1.237–40. The Greek reads: Ἀπόλλωνα Μίθρην Ἥλιον Ι Ἑρμῆν. For brevity we shall refer to these images as those of Apollo-Mithras from henceforth. We have kept the Mithras, rather than having Apollo-Mithra, simply to follow academic convention.

[5] Antiochus himself, in an inscription from a similar monument at Zeugma (ll. 18–23), claims that, 'I set up in sacred stone of a single compass alongside images of the deities the representation of my own form receiving the benevolent right hands of the gods, preserving a proper depiction of the undying concern with which they often extended their heavenly hands to my assistance in my struggles' Crowther and Facella 2003, 46–7.

[6] Sanders 1996 1.157. [7] See, for example, the description by Vermaseren, *CIMRM* 30.

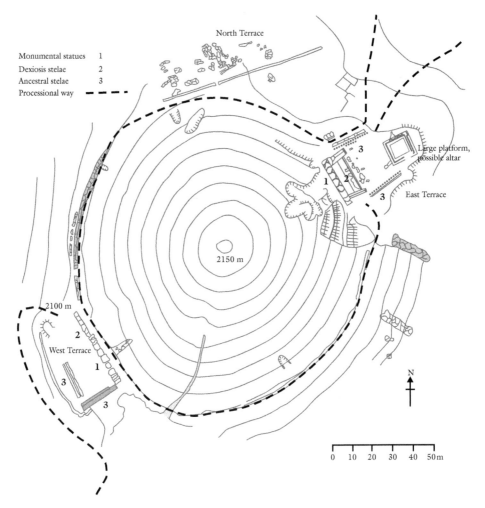

Monumental statues 1
Dexiosis stelae 2
Ancestral stelae 3
Processional way ━ ━ ━

North Terrace

3

Large platform, possible altar

East Terrace

2150 m

2100 m

2

West Terrace

1

3

3

N

0 10 20 30 40 50 m

FIG. 6.2. Plan of the Nemrut Dağı summit.

R. Wood after H. Brokamp, T. Goell, J. Glogasa, and G. R. H. Wright in Goell 1957, figs 6 and 13.

festoon. He wears a simple shirt beneath a cloak fixed at his right shoulder, and close-fitting trousers under a type of skirt. On his feet the god wears Persian boots and finally, in his left hand, he grasps what appears to be a *barsom*, a Zoroastrian ritual instrument such as seen at Tāq-e Bostān, albeit in a considerably stubbier form.[8]

Antiochus' pose and elements of his costume mirror that of Apollo-Mithras. He is beardless and youthful like his opposite. On his head there is an Armenian

[8] The *barsom* has a long and complicated history that is confused, perhaps, by its continued use in Zoroastrian ritual practice. Today the *barsom* is usually a bundle of metal wire, though in ancient times was a bundle of twigs. We may note here that it is significantly smaller than other representations from earlier Achaemenid and later Sasanian art, notably our example at Tāq-e Bostān in ch. 4, p. 82, fig. 4.2 and discussion pp. 100–1.

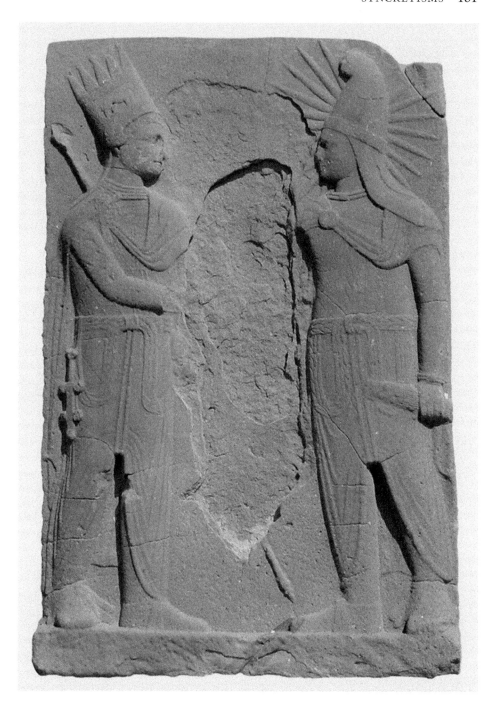

FIG. 6.3. Apollo-Mithras-Helios-Hermes *dexiosis* stele, Nemrut Dağı.
Image courtesy of Miguel John Versluys.

tiara, notable for its five points and the decorated band featuring a lion in profile moving to the right.[9] He wears a short-sleeved leather cuirass under his cloak decorated with a network of lozenges, each enclosing a six-pointed star like those of Apollo-Mithras. Around his neck sits a simple torque coiled four times. He wears the same ensemble of close-fitting trousers and hitched skirt as Apollo-Mithras, the only addition being an ornate dagger and scabbard hanging from his belt. In his left hand he clasps a long sceptre, the top and bottom of which are visible beyond the central fracture.

Despite the importance of this image and this site, it is important to note from the outset that this is not the only depiction of Apollo-Mithras in this pose and that he is not the only god to be depicted in such a manner, on either Nemrut Dağı or in Commagene at large. Across the kingdom are the remnants of similar monuments for what appears to be an ancestral cult, albeit none so high, so remote, or quite as grand as Nemrut Dağı.[10] The latest count has thirteen in total: three *hierothesia*, or tomb-sanctuaries of Antiochus and his immediate family, and ten *temene*, or sanctuaries, often located close to or within urban areas (Map 4).[11] Thus this site would appear to be but the grandest instance of a kingdom-wide scheme, placing Antiochus in a key position with respect to the ruler-cult he appears to have either been founding or greatly embellishing. All told we have confirmed evidence for seven stelae that bear a representation of Apollo-Mithras (or equivalent) and other statues besides, but few which *exactly* match any other. What emerges is a complicated picture of divine representation and understanding, not easily understood with reference to or through the reconstruction of a single deity.

The appearance of Mithra here has aroused a great deal of speculation on its significance for the assumed movement of the god. Commagene's position between Mithra's perceived Persian home and the Roman west where he was so

[9] This tiara was a modification of that worn by Antiochus XII Tigranes of Armenia or Tigranes the Great (for further details see p. 138), featuring a star between two eagles as its central motif, as seen on coins minted at Antioch: Gardner 1878, pl. XXVII, 5–11. Upon becoming king, Antiochus I adopted this motif on his own coins: BMC *Galatia*, 105, 1–2; pl. XIV, 8. The substitution of the lion for the eagle seems to have been a development later in Antiochus' reign, though it does not appear on any extant coins. However, it should be noted that the reverse of these coins shows a lion walking to the right.

[10] Beliefs surrounding the dead in antiquity undoubtedly varied greatly. The Greek word *daimon* is used in the inscriptions, as well as *progonoi* and *heroes*, to refer to dead ancestors and appeal for their support. Ancestor worship was far from limited to the Greek world, and like so many other aspects of Commagenian culture we should consider the influence of other traditions that accorded the spirits of the dead a special status. This issue is not simple as there are numerous discrepancies in the way the term *daimon* (amongst others) is used in the kingdom, often, it seems, referring to gods such as Apollo-Mithras as well as Antiochus' ancestors. See further Facella 2015, for a succinct discussion.

[11] Crowther and Facella 2012; Rose 2013, 220; Brijder 2014, 161–3. Our finds (of inscriptions and of stelae) might not equate exactly with the *temene* sites, but they present a likely pattern of distribution across the kingdom. On the distribution of the sites, see Schütte-Maischatz 2003.

revered makes this a tantalizing point of inquiry, especially given the early date of the site. The mountain-top setting, the god's relation to royalty, his dress, and the association with the sun certainly evoke aspects of those depictions found in northern India and Iran, as well as at Rome. Rationalizing Mithra's appearance here has led many to make Commagene a keystone in the bridge from east to west, leading to arguments that frequently require some leaps of faith to make their schemes work.[12] My approach here is less concerned with the transmission of the god; what interests me is not so much the question of origins, as the complexity of Mithra's appearance in Commagene.[13] Through the example from Nemrut Dağı we have already encountered four names compounded into one, clothing and ritual implements drawn from more than one tradition, and objects that can be construed in more than one way, depending on which tradition a person is or was more familiar with.

Assessing the Nemrut Dağı complex, the context of Antiochus' ruler cult, and the presentation of Apollo-Mithras across Commagene will help us to place this appearance of Mithra in relation to those others we have seen without ignoring the problems that this setting presents. What *is* Mithra here? What function does he serve? These questions lead towards an understanding of what the name Mithra and the variety of depictions of a male deity ultimately represent, both here in Commagene and in those other places we have touched upon in this volume.

THE COMPLEX ON NEMRUT DAĞI

Stepping back from our image, we see that it stands above ground level amongst a row of other stelae looking out onto the west terrace of the mountainside (Fig. 6.4). To the left of this stele stands that of Antiochus with a personification of his kingdom, 'Bountiful Commagene'. To the far right is that of the king and a god called 'Artagnes-Herakles-Ares', whilst to the immediate right is the considerably larger panel featuring 'Zeus-Oromasdes', the combined name of the great gods within the Greek and the Zoroastrian traditions.[14] All of these figures

[12] Cumont 1911, 13–14; Dörner 1978; Duchesne-Guillemin 1978. Most recently Beck 1998; 2001. We hope to have made clear in the Introduction and ch. 1 (pp. 4–8, 28–32) what we consider problematic about Cumont's approach. Roger Beck suggests that the worship of Mithras was in fact transmitted into the Roman world from the court of Commagene that was displaced to Rome after the kingdom was finally annexed in AD 72. As should become clear over the course of this chapter, it is not so much the idea of transmission that is troubling, but what Beck assumes is significant about it.

[13] Similarly, the popularity of Apollo-Mithras, the other gods, or the ruler cult is not the focus of this chapter. For a good recent review of what we know and the trouble with assuming we know more than we do about religion in Commagene, see Blömer 2012; Blömer and Winter 2011.

[14] Both 'Greek' and 'Zoroastrian' are very broad terms that cover many possible ethnic groups, languages and dialects, and, importantly, interpretations of the divine. In turn, the two traditions also had much in common.

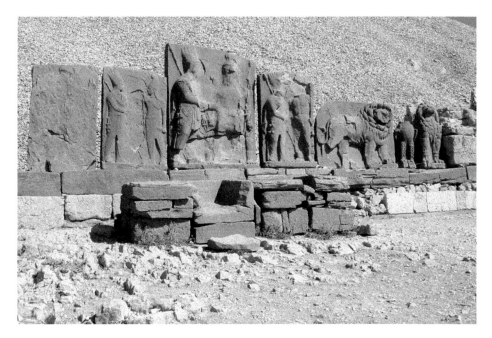

FIG. 6.4. The assembled west terrace *dexiosis* stelae, Nemrut Dağı.
Image courtesy of Herman Brijder.

grasp the hand of the king and thus they are known as the *dexiosis* stelae. Small altars appear to have stood in front of them for incense or libation offerings.[15] Immediately to the right of the Artagnes-Herakles-Ares panel stands the so-called 'Lion Horoscope', an intriguing relief that we shall return to in due course. Already we may note that Apollo-Mithras is neither alone, nor the apparent focus of this line-up.

The *dexiosis* stelae are part of a larger composition. Across from them on the terrace are a number of others depicting various members of Antiochus' close family, along with ancestors of both Greco-Macedonian (seventeen in total, beginning with Alexander the Great) and Persian origin (fifteen, beginning with the Great King Darius I), each with a small altar placed before it. These stelae appear to be in various stages of completeness and not wholly finished. The terrace culminates, however, with the depiction of five enormous statues of enthroned gods flanked by a lion and an eagle both to the right of the group and to the left.[16] Originally between eight and ten metres high, the statues depict the same gods as the *dexiosis* stelae with the notable addition of Antiochus himself. In the middle sits the largest statue, of Zeus-Oromasdes, with Apollo-Mithras to his immediate left. When discovered, all of the statues were separated from their

[15] Sanders 1996 1.108–10, 123–5; Crowther and Facella 2003, 74.

[16] Sanders 1996, 2.83. These were aligned in the same order as can be seen on the east terrace (fig. 6.1).

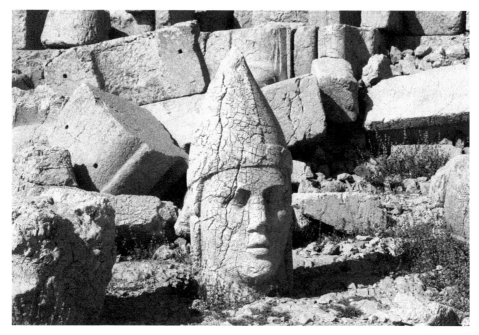

FIG. 6.5. Head of west terrace Apollo-Mithras colossal statue, Nemrut Dağı.
Image: Klearchos Kapoutsis. Creative Commons License.

heads, most likely the result of being in a region subject to earthquakes. The headdress of Apollo-Mithras is the peaked Persian tiara seen in the inscribed *dexiosis* relief, but aside from this feature, few other markers suggest an identification as the god other than the youthful and beardless face (Fig. 6.5). On this statue the god wears a V-necked shirt that can perhaps be linked to an Achaemenid fashion, but it neither hints at a particular god nor relates clearly to the stele depiction.[17] In his hand he again grips the *barsom* as seen on our stele, as does the statue of Zeus-Oromasdes. The lower halves of these statues are fairly cursory and blockish, displaying little of the flourish and attention to detail that the stelae present, but we may note that Apollo-Mithras appears to wear a long gown.

For all the magnificence of these enthroned giants, the most consistently intriguing aspect of the statues (to scholars at least) has been the extremely large and well-preserved inscription that runs along the back of their thrones.[18] Written as if Antiochus himself were speaking, it tells us quite clearly that this *hierothesion* (roughly translated as 'holy place' from the Greek and a word that is unique to Commagene) was built to honour the king, his ancestors, and all the gods after his death. He first explains his position and intentions, including the names of

[17] Sanders 1996, 1.468.
[18] *CIMRM* 32; Sanders 1996, 1.206–17. For a contextual overview of this inscription in relation to Commagene, see Crowther and Facella 2003 and 2011.

the gods present and details of the festivals to be held on the sixteenth of every month and the tenth, commemorating his birthday and the date of his accession respectively. The second section is the *nomos* (law) that details the provisions for ritual taking place around the site. It remains one of the longest epigraphic texts that we have from this period anywhere in the world, but it is by no means unique; in fact, there is an almost identical copy just over a hundred metres away. We are currently on the west terrace of the site, but to the east there is a similar platform with its own set of colossal statues, *dexiosis*, and ancestral stelae, and indeed its own inscription, all featuring the same gods and people (Fig. 6.2). Between these two sites stands an imposing tumulus made from limestone chips added to the natural peak of the mountain. Tumuli had an extremely deep history in the region, as did peak sanctuaries, but the combination of an artificial mound on top of a mountain is not common.[19] Paths winding around the summit pass another man-made terrace on the northern side. This features over fifty stelae seemingly prepared for reliefs that were never executed, either intentionally, as some have argued, or not.[20] If any scheme was planned for this long series we can only guess at what it might have been.[21]

The colossal statues of the east terrace are less well executed than their west terrace counterparts; one commentator has described the Apollo-Mithras of the east terrace as puffy cheeked and as having 'the lips of a fish', perhaps an indication that the statue had yet to receive the final attention of the sculptor.[22] The dress of this statue differs from that of the west terrace example, the V-necked shirt being replaced by a cloak hitched with a brooch at the right shoulder, garb reminiscent of our *dexiosis* stele. Unfortunately, many of the eastern stelae have been badly broken or weathered leaving little to compare to those of the west terrace, including that of Apollo-Mithras.[23] The position of those on the east terrace, however, shows that their layout was quite different, with the colossal statues taking a more central, raised position on the terrace, beneath which we find the appropriate *dexiosis* stelae. These are positioned between two sets of familial stelae that face each other across the terrace. Opposite the colossal statues there also stands a large raised platform, presumed to have held a ritual function of some sort and perhaps to have been an altar.[24]

On both terraces, the *dexiosis* stelae explicitly place Antiochus on a level with the gods. This is an act, as much as anything else, of witnessing: Antiochus is recognized by the gods whilst he in turn acknowledges them. The joining of

[19] Moormann and Versluys 2003, 150–1, provide a brief review of the other evidence from Asia Minor. Burial mounds and the erection of colossal statues had a neo-Hittite and Phrygian precedent; see Andrade 2013, 75.

[20] Sanders 1996, 1.128; Utecht et al. 2003, 104–5, citing Waldmann 1991.

[21] Jacobs 1997, 176–8. [22] Moormann and Versluys 2002, 104.

[23] Sanders 1996, 1.225–6. [24] Jacobs 2000a, 28, abb. 33.

hands, *dexiosis*, does much to collapse the divide between the mortal and divine worlds. In a similar way, the ancestral stelae on the mountain condense time and space by collecting together a host of ancestors drawn from Persia, Macedonia, and Armenia across a span of five centuries.[25] Here on this mountain, gods and men, ancestors and descendants, time and space are concentrated into a religious complex ripe for performance. Watching over this stage on both terraces, bearing witness to whatever acts might have taken place on the mountain, are the ultimate indicators of divine presence, the great colossal statues of the assembled gods. The grandeur of this site thus goes beyond mere bombast and show, to represent a complex attempt to condense the authority of the mortal and divine spheres onto Antiochus, whether alive or dead.[26]

But Nemrut Dağı may never have been used for its intended function: all the indications of unfinished statuary suggest that the site was never completed. The absence of ceramic finds and animal bones in abundance at the site is equally a telling indication of under-use.[27] It is even possible that Antiochus may never have been buried here with all attempts to find his tomb so far coming to nought; as a result, some have suggested it be viewed as more of a cenotaph.[28] Despite this, the site makes a number of stylistic and conceptual propositions that reflect on its intended function if not its actual use. These are particularly interesting in light of the last chapter and *bagolaggos*.[29] Whilst we need not consider a direct connection between them, their means of presenting the relationship between the divine, conceived in terms of a multiplicity of gods, and the ruler, is an interesting instance of cultural coincidence.

POLITICS AND RELIGION: ANTIOCHUS' RULER CULT

As the most prominent site in Commagene, the programme displayed at Nemrut Dağı works independently, but also in relation to others from the kingdom. In the long inscription at the site, Antiochus directs his population, 'to repair by villages and cities to the nearest sanctuaries, whichever is most conveniently located for the festival observance'. This is repeated, though with a number of variations, across the kingdom at a total of fourteen known sites.[30] The establishment of such

[25] On the significance of the ancestral stelae, particularly in relation to the inscriptions and the other monuments of Nemrut Dağı and Commagene at large, see Facella 2015.

[26] For comparable ways of thinking, see Platt 2011, particularly ch. 3, with a focus on Pergamon.

[27] On the (limited) ceramic finds see Moormann and Versluys 2002, 99; Moormann and Versluys 2003, 156–8.

[28] Downey 1997.

[29] See p. 114–15. For a recent discussion of these dynastic monuments, see Canepa 2015.

[30] For a list of the inscription sites and translations of many of the texts, see Crowther and Facella 2003, 41, no. 3; 2011, 364, for a complete list of known inscriptions; Crowther 2013; Rose 2013, 220.

a ruler-cult was not a novel act in this period; indeed, it was almost common for the time and the region.[31] The political situation both within and between the multitude of dominions in the area made strengthening one's position through the advertisement of one's own divine nature just another tactic in the struggle to maintain power.

Wedged between the Euphrates and Mesopotamia to the east, the Taurus Mountains and Cappadocia to the north, Cyrrhestice to the south, and Cilicia to the west, the land-locked kingdom of Commagene had a somewhat tumultuous history.[32] The dynasty was founded in 163 BC by Ptolemaeus I, a Seleucid satrap who rebelled from his overlord Antiochus V Eupator. He was a man of Orontid Armenian descent, a family that traced their line back to the fifth-century BC emperor Darius I, thus claiming both Armenian and Persian Achaemenid origins.[33] The kingdom he established survived until the late first century AD. There were, however, interludes, first with the conquest by Tigranes the Great of Armenia in the early first century BC; then of Roman rule under the emperors Tiberius and Gaius Caligula; the kingdom was finally dissolved and made part of the empire by Vespasian in AD 72.[34] Despite its precarious position, the kingdom's existence appears to owe much to the unsettled environment from which it sprang. By the mid-second century BC, the Seleucid Empire that had previously held sway over a vast area from Iran to Asia Minor was waning, succumbing to numerous aggressors such as Rome, the kingdoms of Pontus and Armenia, the Ptolemies in Egypt, and the Parthian Arsacids in Iran. Aside from these larger authorities, there was a litany of smaller powers that consisted of everything from small kingdoms to brigands based in hard-to-reach mountains. It was from this chaotic tumult that Commagene emerged as but one of a number of newly formed states, albeit with dynasties that claimed far more prestigious pedigrees than the novelty of their kingdoms might suggest.

As precarious as things may sometimes have been, Commagene was not without wealth and resources; the monuments themselves are testament to this. Its position along the Euphrates river, and its mineral-rich hills seem to have furnished the kingdom nicely. But though he was king of Commagene in the first century BC, Antiochus I was in power by the good graces of Rome and to a lesser extent Arsacid Parthia. In 67 BC the Roman general Lucullus had confirmed Antiochus' rule.[35] In 64 BC Pompey the Great did so again, going so far, it seems, as to add the city of Zeugma to his territory, an important strategic crossing

[31] See Canepa 2015, particularly 81–2 for a discussion of Commagene.

[32] Cohen 2006, 30–2.

[33] Diod. Sic. 31, 19a; Sullivan *ANRW* 2:8 1977, 743–8. For the descent, see the ancestral stelae from Nemrut Dağı itself as well as inscriptions from the site.

[34] Joseph. *BJ* 7.7.1; Suet. *Vesp.* 8. [35] Just. *Epit.* 40.2; App. *Syr.* 49; Dio 36.2.5.

into Mesopotamia.[36] And yet in 61 BC, when celebrating his third triumph in Rome, Pompey listed Commagene amongst his subjugated kingdoms.[37] This was not simply propaganda, but is testimony to Rome's role as the ultimate authority in the region at this time. Rome allowed independent states to govern, but owing to its superiority demanded tribute for the privilege. If any ruler should balk at its demands, he was soon sure to be replaced by a more compliant representative. Of course complying with Rome, a state that was itself rife with political rivalries, particularly in the first century BC, was no easy task. In part of his great inscription at Nemrut Dağı, Antiochus refers to the 'great perils' and 'hopeless situations' he had overcome as ruler. It is quite possible that this refers to such events as the siege of his capital, Samosata, by Mark Antony in 38 BC following the involvement of the kingdom in Rome's ongoing civil disputes.[38] As the changing fortune of his descendants over the next century would illustrate, Commagene was very much subject to the machinations of external authorities. In this respect, the kingdom was just one amongst others close by, including Cappadocia, Osrhoene, Sophene, Emesa, Judaea, and Cilicia that were maintained largely on the whim of those in power in either Rome or Iran.

Political stability was undoubtedly a central aim of Antiochus' scheme. At Nemrut Dağı he referred to himself as, 'Great King Antiochus, the god, just, manifest, a friend of the Romans and a friend of the Greeks, the son of King Mithridates the gloriously victorious and of Queen Laodice the goddess, the brother-loving, the daughter of King Antiochus the manifest, mother-loving, the gloriously victorious'.[39] A few lines on, this god among men declared that:

> the kingdom subject to my throne should be the common dwelling place of all the gods in that by means of every kind of art I decorated the representations of their form, as the ancient lore of Persians and of Greeks, the fortunate roots of my ancestry, had handed them down, and honoured them with sacrifices and festivals, as was the primitive rule and the common custom of all mankind.[40]

In these statements he positions himself very deliberately between those to his east and west, doing so not only as friend, but as descendant too. As we have seen, Antiochus traced his line to the Achaemenids of Persia through his father Mithridates, and also to the Seleucids via his mother, Laodice Thea Philadelphus, daughter of the last Seleucid king of note, Antiochus VIII Grypus. He duly

[36] Sometimes referred to as Seleucia-on-Euphrates: Strabo *Geog.* 16.2.3; Braund 1984, 63–4 contra Badian 1968, 78–9; Seager 2002, 54. Facella 2006, 230–6 clarifies that Pompey most likely obtained political submission from Antiochus rather than defeating him militarily.

[37] App. *Mith.* 117; Plut. *Pomp.* 45.

[38] See the brief account in Dio 49.22.1–2 and Plu. *Ant.* 34.5–7, where it is claimed that the king held out. Josephus, *BJ* 1.16.7 (321–2), *AJ* 14.15.9 (445–7), however, and *Oros.* 6.18.23, claims that the king was forced to surrender. See Facella 2006, 244–8.

[39] See Crowther and Facella 2003, 46–7. [40] *CIMRM* 32.

exploited the diversity of his ancestry to position himself not only as an interlocutor between the great powers of the day, but as an embodiment of authority in his own right.[41]

It was in this climate that Antiochus, with the aid, no doubt, of a bevy of advisors, developed a religious programme that called upon a number of traditions to support his rule and that of his family. This was a political act in that it drew his people together to bear witness to his greatness, but it did so through a series of religious propositions. Antiochus presents himself here as receiving the favours of divine figures known the world over (and thus provided with multiple descriptions), and by honouring them in such a way he confirms their support for many a year to come. Apollo-Mithras, like the other gods at Nemrut Dağı, supports the king through the act of *dexiosis* and by being enthroned alongside him. At Tāq-e Bostān we saw Mithra as a special guarantor of royal authority, and the figure labelled Miiro on the coins of the Kushan Empire seems to have done a similar thing.[42] The *bagolaggos* of the Kushan too, appear to have framed a number of gods in relation to royalty in very prominent positions. In these instances, Mithra is just one of several gods. The same was true at Nemrut Dağı where Zeus-Oromasdes presided over the three other gods. The act of confirmation, therefore, is not Apollo-Mithras' prerogative.

APOLLO-MITHRAS AS PATRON

In the Roman west, Mithras would appear to have been one of several deities, but was certainly the focus of attention even if, as the case may have been for some, he was not held to be the greatest divinity.[43] Despite his less than standout, albeit still privileged, position, scholars have frequently argued for a much greater role for Apollo-Mithras in Commagene relative to other gods than he might at first glance appear to have held.[44] At the same time, the Mithra component of the name has often been played up over the other three. But has this been argued on the basis of what would latterly emerge in the Roman Empire?

There is certainly evidence to connect Apollo-Mithras strongly to Antiochus. For a start, we saw that their appearance on the Nemrut Dağı stele draws them together; the recurrence of the six-pointed star motifs on their clothing, the

[41] This was by no means an uncommon act and as with his self-positioning as a deity, there were precedents from neighbouring authorities. See Facella 2005, 88–9.

[42] See chs 4–5.

[43] See further discussion in chs 2–3. Also Beck 2002 for a succinct discussion.

[44] Humann and Puchstein 1890, 324; Cumont 1911, 13–14; Dörner 1978, 123–33; Duchesne-Guillemin 1978, 187–99; Schwertheim 1979; Merkelbach 1984, 50–72; Boyce and Grenet 1991, 309–51; Waldmann 1991, 38–9; Jacobs 2000b, 45–9; Wagner 2000, 11–25.

same combination of trousers and hitched skirt, and the youthful appearance of the pair are but a few examples. In the introduction to this book, we also saw that the word that 'Mithra' derived from could mean 'contract' or 'friendship'; the *dexiosis* scene could not be more apt in this instance. The inscription on the throne-backs at Nemrut Dağı mentions that a festival will be held on the six-teenth of every month to commemorate Antiochus' birthday. Although nothing in this inscription singles Apollo-Mithras out explicitly, the date of Antiochus' birth is a day sacred to Mithra in all twelve months of the Zoroastrian calendar.[45] Much like saints' days within the Christian tradition, it has been assumed that Apollo-Mithras was in some way dearer to Antiochus because of this. The inscrip-tion also refers to Antiochus as *dikaios*, 'just', an epithet held to relate closely to Mithra in the role of a judicial overseer.[46] It is claimed, too, that Antiochus estab-lished a special priesthood for the god. Another inscription from a *hierothesion* dedicated to his father, Mithridates I Kallinikos, at Arsameia on Nymphaios, renders the god's name as 'Mithras-Helios Apollo-Hermes' and refers to a spe-cial priest for the god; some have gone so far as to suggest that a temple to Mithra existed on the site, a proto-*mithraeum* hewn from the rock according to Friedrich Karl Dörner.[47] This is aside from Antiochus' father's theophoric name, Mithridates, meaning 'gift of Mithra'.

Singling Apollo-Mithras out might seem to be justified on the basis of such indications, but in truth they do not suggest a great deal beyond the fact that the king worshipped the god. Though they are not the only indications of possible favouritism, whatever comparison we might wish to draw with the degree to which other gods were revered in Commagene is in danger of relying on *ex silentio* arguments or simply ignoring much of the other evidence around. Several stelae of Artagnes-Herakles-Ares can be found across Commagene and the name appears just as frequently as that of Apollo-Mithras (Fig. 6.6).[48] In these, Antiochus extends the same hand of friendship to the god. Whilst *dikaios* was used by Antiochus himself, the epithet *kallinikos* ('gloriously victorious'), which was frequently applied to Herakles, was not.[49] The term, however, had been used by both his father and his Seleucid grandfather. The connection to Antiochus

[45] For example, Cumont 1903, 126–7. [46] See ch. 4, p. 94.

[47] For the inscription, which is on the back of the smaller stele from Arsameia on Nymphaios, see Dörner and Goell 1963, 93. Note that another inscription (ibid. 59) at the site refers to 'Mithras-Apollo and Helios-Hermes'. Dörner 1978, 125. Duchesne-Guillemin 1978, 199; Schwertheim 1979, 66; Lincoln 1991, 84–5. On the temple, see specifically Dörner 1963, 141ff.; Dörner and von Assaulenko 1967, 133ff.

[48] See Brijder 2014, 159–60. There has been some confusion as to the identity of the king in a *dexiosis* stele at Arsameia on Nymphaios, for example Çevik 2014, 185, who refers to this figure as Antiochus' father Mithridates. However, the Armenian tiara he is wearing almost certainly means this is Antiochus himself.

[49] For the use by Seleucids, see Facella 2005, 89.

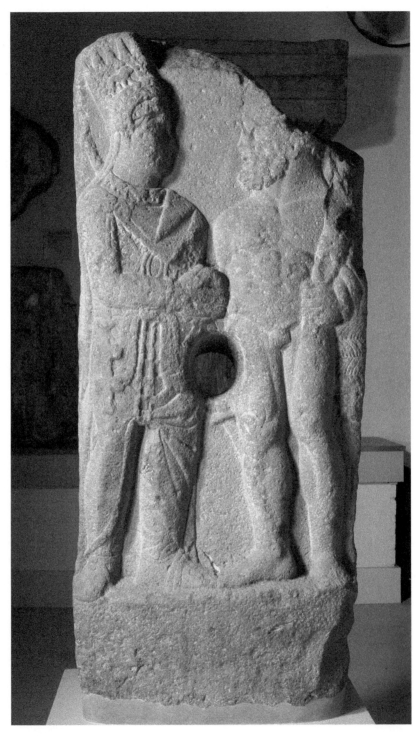

FIG. 6.6. Artagnes-Herakles-Ares stele, Samosata. BM 1927,1214.1.
Trustees of the British Museum.

does appear to be weaker in this case, but at a site where ancestry features so prominently, this figure still held a key role. Thus, though we may not have as much evidence relating to his worship, Artagnes-Herakles-Ares emerges as a prominent figure in his own right. Perhaps most importantly, the considerably larger and centrally positioned stelae and statues of Zeus-Oromasdes at Nemrut Dağı, place this figure at the heart of the complex. The youthful appearance of Apollo-Mithras and Antiochus aside, on the stele with Zeus-Oromasdes the king has also adopted the same dress and shoes as the god, and in place of a lion on Antiochus' tiara is a lightning bolt, a symbol of Zeus.[50] That we have little other evidence of this figure from elsewhere in Commagene may simply be happenstance.

We know, of course, that Apollo-Mithras was a favoured god of the king. Our evidence may even suggest that he was 'extra' special, but the question is whether we are justified in *isolating* him. Doing so risks removing the god from the morass of contextual religious understandings out of which he emerged in the first place. It allows one to assume Apollo-Mithras was separated by people in the ancient past, thus making it a legitimate endeavour for us to engage in too. Scholars of the Roman west and particularly those working on Mithras are almost bound to do so, given their chosen subject. But it is not necessarily the best way forward. In part, the justification for this separation has stemmed from conceptions of Apollo-Mithras that grant him a role beyond guarantor of royal authority. We may simply note that if the god did have a specific reason for being at Nemrut Dağı that he alone possessed, this does not automatically equate to his bearing a role that placed him either above or outside of a religious understanding involving other gods. To get a clearer sense of what this role might have been, we must turn to the portrayal of the god in images and in inscriptions, and assess the ideas associated with him not in isolation, but as part of the wider religious context.

STYLE, CONCEPT, AND THE PROBLEM OF SYNCRETISM

Depending on who you ask, you will receive a very different response to questions about the nature of Apollo-Mithras at Nemrut Dağı and in Commagene. Scholars focused on Rome, the Hellenistic period, Mithraic studies, Zoroastrianism, Armenia, Parthian or Sasanian Iran, and the history of astronomy will tend to emphasize different aspects of the site and Mithra's appearance here.[51] As we have seen already, there is ample evidence to support a variety of claims and the

[50] See Brijder 2014, 94–9. The stele is unfortunately badly weathered, as can be seen in Fig. 6.4, but traces of the clothing in particular are still just visible.
[51] See Petroff 1998.

situation is hardly clarified when one incorporates the larger body of evidence from the rest of the kingdom. But what appears clear is that the combination of a wealth of traditions was precisely what was desired in Commagene, and thus a range of interpretations must inevitably have been valid.

The title given to the god of our stele, Apollo-Mithras-Helios-Hermes, is no chance occurrence. Nor are the depictions of the god which, though not all identical, fundamentally position the god between east and west—in effect, in Commagene.[52] As we have said, there is a tendency in modern scholarship to talk about this god, and indeed the site as a whole, as a combination of elements drawn from what we consider to be recognizable cultures, be they 'Greek', 'Persian', 'Armenian', or what have you.[53] Antiochus' own agenda may seem to legitimize such an approach, presenting himself as the manifest union of Seleucid and Orontid royalty, and describing his gods through the amalgamation of Greek and Persian names. At Nemrut Dağı there are many visual features from which one might extract cultural traits of one culture or another. The *barsom* and the dress of the god point to Persia, but it could be argued that the overall rendering of the image in a 'Greek' manner, with only 'Persian motifs', placed the god more in the Hellenic tradition.[54] The texts too are rendered in Greek and avoid Aramaic or another Semitic language. Similarly, the name Apollo-Mithras-Helios-Hermes uses three Greek gods and only one Persian, perhaps suggesting that the god was 75 per cent Greek and 25 per cent Persian. Or was it rather that Mithra was the god ultimately being described with reference to three Greek gods, even if his name does not appear first?[55] Dissecting the nature of Apollo-Mithras in such a way is patently ridiculous, especially given its flexibility as seen at Arsameia on Nymphaios where we find two different renderings of the name.[56] It does illustrate, however, the problem of focusing solely on the question of cultural influence without allowing for innovation, even if all we consider this to amount to is the combination of cultural phenomena from elsewhere. What we might identify as Greek, Persian, or Armenian elements were in reality what

[52] Andrade 2013, 67–8 has recently observed this problem.

[53] Part of this argument inevitably touches upon the contrived nature of the site and a certain degree of cynicism from scholars in relation to Antiochus' proclaimed devotion; see, for example, Kropp 2013, 357–64. That there was a political function to this site is beyond doubt. It may also have been the case that a great many of Antiochus' subjects were not accustomed to either Greek, Persian, or Armenian traditions and thus found them unfamiliar. These facts do not preclude, however, the reality of the religious proposition, however short-lived and politically motivated it might have been.

[54] On the supposedly Greek nature of the carvings at Nemrut Dağı, see Smith 1988, 103–4, 130–1.

[55] We may note that seeing these three Greek names as amounting to different gods is equally problematic given the frequent identification of Apollo with Helios in the Hellenistic period in particular.

[56] See n. 47. A variation to the long inscription at Arsameia on Nymphaios also states that Mithras is equal to the three Greek deities (l. 252): Dörner 1963; Brijder 2014, 162.

Commagenians thought they were. Thus Apollo-Mithras not only recalls the heritage of Antiochus, but also stands as a Commagenian figure of worship.[57]

It is now common to refer to such acts as syncretistic, though it is debatable what this term can be applied to.[58] In the last section, the use of different names and their combination with different images presented a series of inconsistent products; the way the term syncretism has been used by scholars is similarly wide-ranging. It loosely refers to the analogous description of one religious tradition through that of another as the result of interaction. This might have happened for any number of reasons and could have come about in an enormous range of contextual settings, but at its heart, the act of syncretism is always implicitly comparative. When studying this period and polytheistic religion, the term is frequently used to refer to the comparison of one god with another. This almost always appears to be because they were held to share 'aspects', or dominion over some of the same parts of the natural world or human experience, for example grain, fire, cattle, dreams, or childbirth.[59] In order to be syncretistic, however, the comparison must go so far as actively to conjoin conceptions; to bring together the traditions. As such, each instance of syncretism is an example of the search for, and institution of, alternative approaches to the divine. In this sense they are the product of imperfect knowledge, or rather, they are an illustration of an individual or a community's willingness to change tack. Such modifications as were made, despite their potential novelty for one community, were commonly held to be eternal elements of deities that had only recently come to be understood.

Zeus and Oromasdes, as the supreme deities of their own traditions, were perhaps easier to compare than others; Artagnes, Herakles, and Ares are a case in point as none of these manages fully to describe the other two. But was absolute description or comparison (what might ultimately be seen as conflation) always desired? The range of situations and reasons for thinking of gods syncretistically would suggest not; comparisons might well have been made to demonstrate a characteristic or 'aspect' associated with a deity. As an example, albeit one a

[57] Many have noted the deep history of this region and pointed to the similarities between Hittite conceptions of the divine, in at least name and image, and those we are dealing with here. See Dörner and Dörner 1989, 135ff.; Çevik 2014, 187. Equally, the tumulus in conjunction with colossal representations of gods had a long history in the region: Andrade 2013, 75.

[58] For just the latest use of the term in connection with these images and names, see Blömer 2012, 98–9; Brijder 2014, 162. In some academic disciplines or even when used by scholars working on different periods in time, 'syncretism' is a highly problematic term, a fact I have become acutely aware of by working with and presenting to scholars from outside of my own stable. As with others in this volume, the term is used largely to abbreviate what might otherwise be a long-winded discussion, and to allow for comparison with the work of other scholars.

[59] A good introduction to the notion of 'aspects' of gods, and what is referred to as 'polymorphism' can be found in King 2003.

century and half later, a god of the town Doliche in Commagene would come to be known in many parts of the Roman Empire as 'Jupiter Dolichenus' from the second to third centuries AD whence worship spread rapidly. Did worshippers, by using this specific designation, deny the existence of 'Jupiter'? Did they believe this was a more *correct* form of, or means of addressing, the god Jupiter? Or was this an 'aspect' of the god Jupiter that they especially wished to appeal to? One interpretation might be more likely than another, but we are not in a position to deny that any of these interpretations may have been available to worshippers of Jupiter Dolichenus. Already, the challenge of untangling these comparisons becomes a difficult task.

The problem stems from what it is that we think was being compared. It is perhaps easier to approach if we do not imagine definite, singular divinities; *a* Zeus or *an* Apollo, for example, but rather consider collections of ideas by individuals and communities that ultimately amounted to gods, and indeed, the way they were worshipped (what we might call cult or religion). What Nemrut Dağı illustrates is the ability of people to bring together their notions about the divine, conceived in an array of iconographic and linguistic traditions associated with representing divinity. In effect these creations could be construed as new gods or, conversely, as newly conceived or revealed versions of existing deities, depending on how a person or a community wished to view them. It bears stating plainly that if an individual wished to see a god they 'knew' in the representations at Nemrut Dağı this was perfectly possible. What existed there was not, after all, a radical departure from age-old models of the divine, and Antiochus himself makes several appeals to tradition at the site.

The word 'god' or the names given to deities remain convenient means of referring to the phenomena of clusters of religious ideas; we have used them throughout this work and will do so for the remainder. Telling the difference between their use by scholars to imply either such groupings or distinguishable, singular entities is one of the challenges we face, though we hope we have made it clear what we mean here. Thinking in this way, and allowing for these possibilities is particularly important for ideas that appear to have done as much travelling as that of the name Mithra. What this affects is not the importance of transmission, but our expectations of what we might find where such ideas ended up.

SYNCRETISM IN COMMAGENE: APOLLO-MITHRAS AT LARGE

A fascinating illustration of possibilities at work comes from Commagene itself. Across seven stelae depictions of what appear to be solar deities are three different types of representation, three different names, and at least two different

Location	Depiction Type	Inscription/Site Name	Type of Site	Image/Inscription Date
Nemrut Dağı (West)	'Persian'	*Apollo-Mithras-Helios-Hermes*	*Hierothesion*	Contemporary
Nemrut Dağı (East)	'Persian'	*Apollo-Mithras-Helios-Hermes*	*Hierothesion*	Contemporary
Arsameia on Nymphaios (Large)	Long-gown 'Persian'	*Mithras-Helios-Apollo-Hermes*	*Hierothesion*	Contemporary
Arsameia on Nymphaios (Small)	Long-gown 'Persian'	*Mithras-Helios-Apollo-Hermes*	*Hierothesion*	Contemporary
Samosata	'Greek'	*Apollo-Mithras-Helios-Hermes*	*Temene*	Contemporary
Sofraz Köy	'Greek'	*Apollo Epekoos*	*Temene*	Old inscription/image after
Zeugma	'Greek'	*Apollo-Mithras-Helios-Hermes*	*Temene*	Contemporary

FIG. 6.7. Table of Apollo-Mithras-Helios-Hermes stelae in Commagene. Author's image.

ritual contexts (Fig. 6.7).[60] Nemrut Dağı provides two from the east and west terraces, giving us the name 'Apollo-Mithras-Helios-Hermes' and a type of 'Persian god', to put it simply. Two further stelae from Arsameia on Nymphaios, another *hierothesion*, depict him wearing the Persian tiara, but also a long gown with puffy trousers beneath (Fig. 6.8).[61] The god here, as we know, is referred to as 'Mithras-Helios Apollo-Hermes'.[62] Despite these differences, the presence of the tiara and the fact he wears clothing perhaps aligns this depiction more closely with those of Nemrut Dağı. The closest parallel for the image in fact comes from

[60] See Rose 2013. Rose does not mention the second, smaller stele from Arsameia on Nymphaios (Dörner and Goell 1963, 45ff.); Waldmann 1973, 102–3. See Brijder 2014, 159–60 for an extremely useful size-guide to the stelae. For a map showing the layout of the sites, see Map 4. As well as these stelae, two further fragmentary reliefs from Ancoz and Adıyaman may also depict the god. For Ancoz, see Brijder 2014, 144–7; for Adıyaman, Crowther and Facella 2003, 74–6; Brijder 2014, 139. Only the feet of the two figures remain, the king clothed to the left and another pair of bare feet to the right. It can only be argued it is Apollo-Mithras on the basis that no lion skin can be seen between the bare feet, which would make it a representation of Artagnes-Herakles-Ares, but this is by no means certain.

[61] The first is significantly larger (3.67 m high) showing only Apollo-Mithras: Dörner and Goell 1963, 201, abb. 28; pl. 18, 52 B–C. The second is badly weathered, but clearly depicts a god with Persian tiara, long gown, and as radiate: Dörner and Goell 1963, 209, abb. 30; pl. 52, A.

[62] Dörner and Goell 1963, 97–8, ll. 11–12; abb. 3. See also 59, and the reference in the main cult inscription to 'Mithras-Apollo and Helios-Hermes', though here we concentrate on the stelae.

the enthroned statue of the god on the west terrace.[63] In those from Samosata, Sofraz Köy, and Zeugma, however, the god is hatless, though he wears a laurel, and naked barring the cloak tied at his neck. In his left hand, in place of the *barsom*, he holds a laurel branch (Fig. 6.9). Such iconographic traits are extremely common features of Classical Greek and Hellenistic representations of the very gods whose Greek names appear in our familiar amalgamation. At Samosata and Zeugma, the god is referred to as 'Apollo-Mithras-Helios-Hermes', but at Sofraz Köy he is called 'Apollo Epekoos' or 'Apollo who listens to prayer'.[64]

There is substantial evidence to suggest that Apollo Epekoos was present on some *temene* sites prior to the erection of the *dexiosis* stelae and the advent of Antiochus' ruler cult.[65] The suggestion is that this god was 'reconfigured' and became, later on, Apollo-Mithras. Recent work by Charles Crowther, Margherita Facella, and Brian Rose has determined that the *dexiosis* reliefs on these stelae were all made later in the reign of Antiochus, and that those of Arsameia on Nymphaios, Nemrut Dağı, Samosata, and Zeugma were all contemporary with their inscriptions.[66] This is important because it leaves only Sofraz Köy with a relief from Antiochus' final years, but with the inscription, mentioning Apollo Epekoos, from earlier in the king's reign. This inscription was cut off at the start and the end of each line where the stone was prepared for the re-carving of its front face with the *dexiosis* relief visible today. Thus it seems likely that another depiction, quite possibly featuring Apollo Epekoos, was the subject of the original carving. A degree of transition in conceptions of the divine seems likely here,

[63] The head of a statue of Antiochus, presumed to have once belonged to a colossal statue, has been unearthed at Arsameia on Nymphaios and now resides in the Gaziantep Museum. Though no remnants of statues depicting the other gods have been found, it has been presumed that they did exist at the site and were most likely of a similar style to those at Nemrut Dağı. See Dörner, Goell and Höpfner 1983, 42–9.

[64] Samosata: Crowther and Facella 2003, 56, 68–71, ll. 20–1; Crowther 2013, 200. Sofraz Köy: Crowther and Facella 2003, 71–4, ll. 5–6. Zeugma: Crowther 2013, 199–200, ll. 15–16 of the inscription; Rose 2013, 224–5. Note that at Samosata, the god is referred to on another inscription as 'Apollo-Mithra and Helios-Hermes'. See Waldmann 1973, 28–32; Boyce and Grenet 1991, 334.

[65] We are not without other references to Apollo or Apollo Epekoos from Commagene. A basalt stele at Kilafik Hüyük on the east bank of the Singas invokes Apollo for particular favours: Waldmann 1973, 48–9; Boyce and Grenet 1991, 319–20. There is also a possible *temene* to Apollo and Artemis at Lacotena (Direk Kale), where inscriptions to Apollo Epekoos have been found dating from the second century AD: Wagner 1983, 194–5. The smaller denomination coins of Zeugma in the Roman period also feature a lyre and the head of Apollo: Butcher 2004, 460–5, pl. 29–30. It should be noted that Epekoos was not limited as an epithet to Apollo; two inscriptions, apparently relating to a god of the town of Doliche in Commagene, but not specifically connected with Apollo, also use this term (*CCID* 5 and *SEG* 55, 1541: *Theo Epekoo* and *Theos Epekoos Dolichenus* respectively). This is simply another indication of the fluidity of conceptions around divinity.

[66] Crowther and Facella 2003, 62–5; Crowther 2013, 203; Rose 2013, 225–6. See also Schütte-Maischatz 2003, on the chronological development of Antiochus' cult sites, where she concludes that those in the east of the kingdom (particularly around the capital Samosata) were liable to have been established substantially earlier than those in the west (see Map 4).

where Apollo Epekoos formed part of what became Apollo-Mithras, but the continued presence of the name at Sofraz Köy appears to be somewhat anomalous.

What do the similarities and the differences between these objects suggest? It is interesting to note that the depiction of Antiochus on our stelae remains consistent. Apollo-Mithras is quite the opposite. Laying the inscription of Sofraz Köy to one side, we have a figure performing the same act of *dexiosis* with the same combination of names, but represented in three different ways. The dispersal of the stelae shows their differences coincide with their placement; the Greek-type appear in the *temene*, whilst the Persian-types appear in the *hierothesia* (Fig 6.7 and Map 4).[67] Ultimately, Rose has suggested, 'in the former group he has been invoked as Apollo, and in the latter group as Mithras'. That these images appeal to different traditions does seem likely. What is problematic about this, however, is the implicit assumption that Apollo and Mithra can be identified clearly enough to make this a valid statement in the first place.[68] It may seem a touch pedantic to quibble over terminology, but it is precisely the problem we face in attempting to move away from singular, rounded notions of the divine, which remain pervasive units of understanding. The use of 'god' in this way, far from clarifying matters and keeping things simple, brings with it a host of problems. Why, for example, is the nude god of our stelae to be understood as Apollo and not Helios or Hermes, and why is the clothed god only Mithra? What was the purpose of the combination of names if not to draw the traditions together as opposed to appealing to only one? Another note of caution may be sounded from the remains of a stele at the *temene* site of Ancoz.[69] The fragments of the relief allow us to be sure of very little, but if they feature Apollo-Mithras they appear to represent him in the Persian manner. The strictness of the *temene/hierothesia* divide may not be so secure as once presumed and it should similarly make us question the reality of any Apollo/Mithra, or Greek/Persian division in understandings.

There are other problems apparent when we attempt to distinguish gods too finely. As mentioned above, at Zeugma and Sofraz Köy, Apollo Epekoos appears to have been worshipped prior to the emergence of Apollo-Mithras and his representation in *dexiosis* with Antiochus. Traditions of worship might have remained in these places, but no indication of such an allowance in practices, at least, is contained in the texts of Antiochus' grand proclamation; in fact, he states plainly

[67] Crowther 2003; 2013, 202–3 including no. 76, a response to Jacobs and Rollinger 2005; Rose 2013, 225.

[68] It must be said that this is an interpretation of Rose's meaning. As stated above, the use of a god's name to refer to collective ideas is convenient and this may be what Rose is doing here. However, the surrounding commentary does not suggest that this is the case.

[69] See n. 60, above.

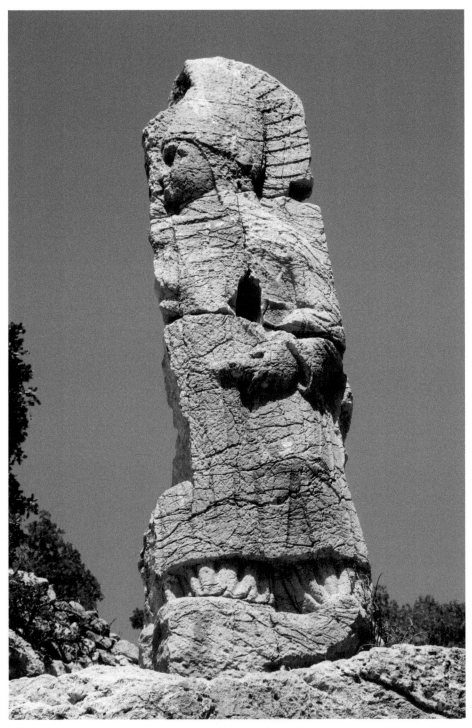

FIG. 6.8. Fragmentary stele of Antiochus and Mithras-Helios, Arsameia on Nymphaios.
Image courtesy of Klearchos Kapoutsis.

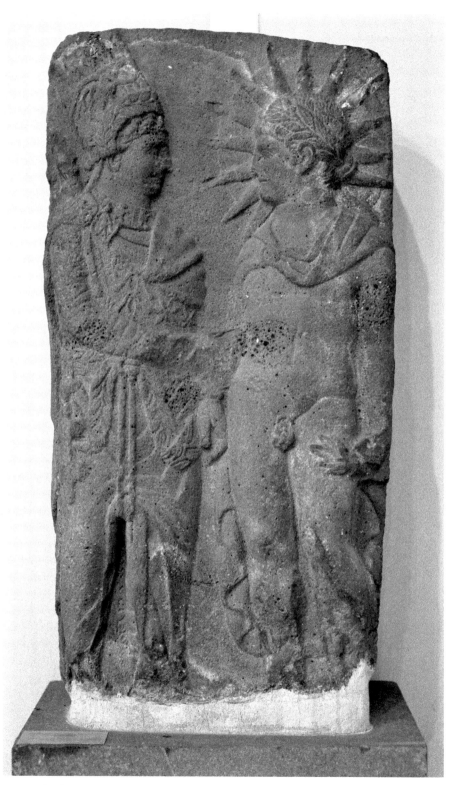

FIG. 6.9. Apollo-Mithras-Helios-Hermes *dexiosis* stele from Sofraz Köy, Gaziantep Museum, Turkey.

Image courtesy of Charles Crowther.

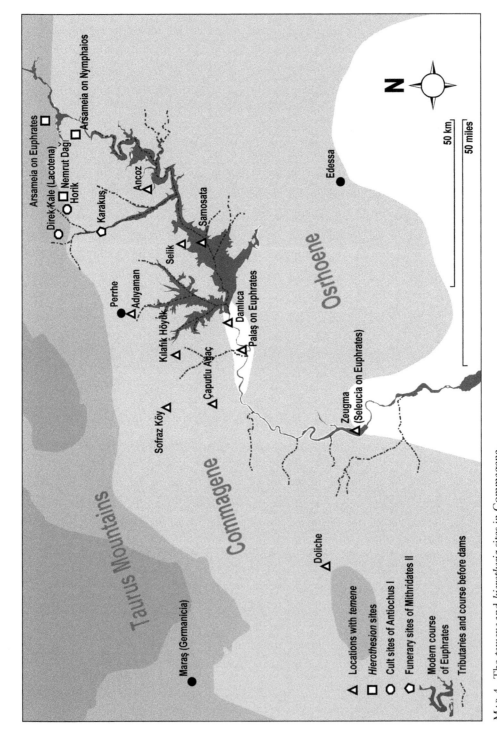

MAP 4. The *temene* and *hierothesia* sites in Commagene.
Image courtesy of Robert Bracey.

at Zeugma, as at Nemrut Dağı, that, 'having selected priests, I appointed them with suitable clothing of Persian character'.[70] The same rituals of burning incense and making offerings were also demanded in both types of sanctuary; they were even required on the same days, and as we saw from the opening of his proclamation at Nemrut Dağı, he held these to be, 'the common custom of all mankind'. Unified worship therefore appears to have been important across all of the invocations at the various sites despite differences in nomenclature and representation.

And yet it could not have been, even if it was hoped for, quite simply because of the positioning of some of these monuments. To compare just two sites, that of Nemrut Dağı and Arsameia on Nymphaios where we have 'Persian' representations of Apollo-Mithras, the positioning of the stelae meant that they cannot have been involved in ritual in the same way. As we know, the stelae at Nemrut Dağı on the west and the east terraces were part of a larger ritual composition and they appear to have had altars in front of them.[71] At Arsameia on Nymphaios by contrast, the stelae were positioned above the path leading to what appears to be the focus of the *hierothesion* and are less likely to have played a part, or certainly not the same part, in any ritual that might have gone on there (Fig. 6.10).[72] What we have, then, is the inscribed request in legalistic terms for cult practice to be carried out in the same way across our various sites, but ritual situations that meant there must have been differences in how this was administered. If the fundamental form of offerings and the dress of those involved were common to all sites, then the way such things were offered and what they were offered to (i.e. what depictions of the gods) certainly were not.

How do we explain instances where the names used to describe this god appear separately? Three inscriptions on the so-called Lion Horoscope (Fig. 6.4) name the planets depicted as, 'The flaming one of Herakles [planet Mars], the shining one of Apollo [planet Mercury], the radiating one of Zeus [planet Jupiter].'[73] Is it significant that only one name pulled from the otherwise amalgamated forms was used? Whether the planet was conceived of as the god, as an aspect of the god, as a possession of the god, or what have you, to apply only one name in a context that otherwise listed four is to imply that separation was possible. The system for naming planets had its own complicated history and association with astrological thought, but we cannot remove this understanding from religious

[70] *CIMRM* 32; Crowther and Facella 2003, 46–8. [71] See n. 15.

[72] The most recent account of the structures and the organization of objects at Arsameia on Nymphaios can be found in Brijder 2014, 238–97, esp. 240, fig. 156.

[73] The Greek reads: Πυρόεις Ἡρακλέους, στίλβων Ἀπόλλωνος, Φαέθων Δίος. Boyce and Grenet 1991, 323. Being a horoscope, the arrangement of stars on the Lion is held to refer to a precise date. On the significance of the relief for the dating of the site and the continuing controversy, compare Belmonte and Gonzalez 2010 to Crijns 2014.

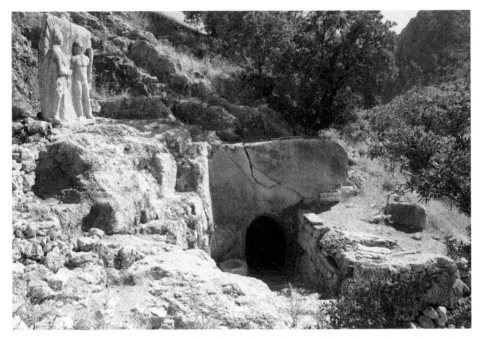

FIG. 6.10. View of the Artagnes-Herakles-Ares stele, pathway, and inscription above the opening in the rock, Arsameia on Nymphaios.

Image courtesy of Charles Crowther.

conceptions, least of all at Nemrut Dağı.[74] Another separation of the names Apollo and Herakles occurs in a different context at Nemrut Dağı, Arsameia on Nymphaios, and at Samosata, as part of a warning to any would-be vandals on the processional routes to the various sites.[75] The inscription on Nemrut Dağı warns that any transgressor will be 'affixed by the unerring shafts of Apollo and Herakles in his evil heart, which is the root of an unjust life, let him endure a bitter pain in his vitals, as one that hates the good'. Does this mean that Apollo could be conceived of as being distinct from Apollo-Mithras? For all the similarities there are as many distinctions. We know that these depictions are different; they so obviously suggest different things. But why and how do we explain the apparent contradictions?

If we understand these as the proposition of ideas and do not search in them for a single, rounded deity, these issues become far less problematic. One notion of Apollo-Mithras did not exist beyond whatever Antiochus wished to create, and even he appears to have been either unable or unwilling to represent his con-

[74] See Cumont 1935, esp. 16. Also Bouché-Leclerq 1963 [1899], 98 n. 4, 100 n. 5.

[75] Nemrut Dağı: Waldmann 1973, 77–8; Sander 1996, 1.94–6, 178–9. Arsameia on Nymphaios: Dörner 1963, 56–9. Note that here Apollo is referenced, but so is 'Zeus-Oromasdes'. Samosata's is a fragmentary text, but appears to feature the same wording: Dörner and Naumann 1939, 31–2.

ception in just one form. It could be argued that different 'aspects' of the divine were being appealed to in different situations, but it is important that we are clear about what we consider these elements to amount to. If we approach them looking to add them together to create a singular 'whole' deity, what emerges is a somewhat contradictory amalgamation. When we talk about 'aspects' of gods, we can sometimes be fooled into thinking that there was a fixed range of possible meanings capable of being associated with a singular deity. In truth, these aspects were just more or less common elements in a much wider pool of ideas that could be brought together; a fact that becomes particularly apparent when we study ideas in transition.

Whether we think of 'ideas' or 'aspects' is not the issue, but rather how we frame these groupings. Most ideas clustered around similar, important traditions. The iconography of the Apollo-Mithras depictions and the four names that they bear make it likely that Antiochus was illustrating ideas built partly around conceptions of the sun. The god's beardless face, solar disc, and rays around his head (common to all the stelae) are parts of solar iconography recognizable throughout the ancient world. The names, except for Hermes, can also readily be linked to the sun.[76] At certain moments, however, it appears to have been advantageous not to combine traditions, such as with the two inscriptions mentioning Apollo above: the association of the planet Mercury to Apollo, as opposed to Helios or Mithras, was strong and thus remained singular; the invocation of Herakles and Apollo could have been something of a literary flourish calling on a tradition unknown to us, but perhaps one that would have become cumbersome with the use of the Apollo-Mithras amalgamation.[77] More importantly the images suggest different ideas were being emphasized. The degree to which factors other than the intended role of the figure affected the manner of depiction, be it the continuation of tradition, an attempt to reach different audiences, the style and training of the artist, or varieties of worship, we cannot say with certainty, but they lend themselves to a similarly diverse range of possible interpretations or at least do not preclude such possibilities.

At the start of this volume, in our discussion of the Roman tauroctony, we suggested that the combination of elements drawn together to express the divinity left the door open, so to speak, to various interpretations.[78] There is good evidence to suggest this was also the case in Commagene given the 'mixed

[76] Notably, Hermes and Apollo in the Hellenistic period were both used to refer to the planet Mercury. See Cumont 1935, 16.

[77] We might note that Mithra, long since regarded as a guardian and judge (and sometimes executioner), was not invoked in this context. See the role of Mithra in the Vedic and Avestan texts, as traced by Schmidt 2006. On the inscription, see the commentary of Waldmann 1973 70, n. 1, 77–8, who sees in the text a comparison of Nemrut Dağı to the equally rocky sanctuary of Delphi.

[78] See ch. 1, pp. 25–37.

signals' incumbent upon representations built from a variety of traditions. As the sun, Apollo-Mithras may have been seen as the overseer and judge of the earth, as a fertility god, and/or as a god of victory and triumph. We know that through the act of *dexiosis* the god was one of a number who confirmed Antiochus and supported him in his rule. This gesture, too, put the king on the level of his chosen gods, placing him amongst the divine. These features are common to all the depictions. But some of the ideas associated with these names and image types can lead us in other directions.

Hermes and Mithras may be construed as psychopomps, leaders of dead souls to the underworld; perhaps some envisaged Apollo-Mithras in such a role.[79] The association of the 'Persian' type with the burial complexes at Nemrut Dağı and Arsameia on Nymphaios is suggestive of this, though given Hermes' name and the 'Greek' type in the *temene* the notion could have been held across Commagene.

An astrological meaning may also be constructed. As with the Roman tauroctony, Roger Beck has argued that Nemrut Dağı is a monument that celebrates the victory of the sun over the moon.[80] His argument is based on the interpretation of the 'Lion Horoscope', an artefact we know only from Nemrut Dağı and which thus may hold a meaning limited to this site, but we are not in a position to say definitively that it was not a more widespread belief. Depending on what these symbols were attached to, the monuments could reflect admiration for these powerful forces and an attempt at appeasing such a colossal power.

And at Nemrut Dağı, we have a depiction that draws Antiochus and Apollo-Mithras together in a way that no other image from Commagene does, whether of the same god or one of the others he so favoured. Their looks, their dress, and symbols such as the stars that adorn both of them might well make Apollo-Mithras the king's most highly favoured god here; we could not blame any viewer for thinking so. Part of what all the gods at Nemrut Dağı were, therefore, but perhaps more so Apollo-Mithras, was Antiochus' gods, and by extension, if only for the brief moment of his lifetime, those of his kingdom.

Given the combination of traditions evident in the god's portrayal, all of these meanings were possible, but still remained clustered around the name Apollo-Mithras. What this illustrates is the potential for those in the ancient past to interconnect notions of divinity; to pick up elements from relatable traditions and incorporate them into larger clusters of ideas and associations that ultimately made up one's own appreciation of the divine. Whether that appears coherent to us or not is irrelevant.

[79] Lincoln 1991. [80] Beck 2006, 230–1.

COMMAGENE IN CONTEXT

Nemrut Dağı and Antiochus' ruler cult were not exceptional. That a monarch should have directed his subjects in such a way was admittedly not an everyday occurrence, but the syncretistic act took place almost whenever different communities came into contact, even if the mechanics of the process and its scale varied dramatically. If anything was unusual in Commagene, it is that the act itself, the deliberate union of different traditions, was seen as grounds for celebration with quite so much aplomb. But unravelling the combined names, particularly our own Apollo-Mithras-Helios-Hermes, each with its own iconographic, mythological, and symbolic possibilities, makes it difficult to see exactly what is going on here, particularly if we are focused on the search for *a* god.

When compared to ideas, gods are cumbersome units. Any notion that we put forward of what a god *was* in antiquity is inherently a modern construction. To that end, scholars frequently draw their understanding of what constituted a god from whatever evidence they can lay their hands on, sometimes with a complete disregard for geographical and temporal distance. The result of this is that gods can be some of the most concertinaed and historically ambiguous concepts that form part of our understanding of the ancient world. It is also one of the reasons why we battle with the seemingly contradictory propositions put forward about gods in the countless images, objects, buildings, and texts from the past. In the first chapter of this book we saw in the physical restoration of objects the danger of forcing reconstructions on the basis of what we believe to make the most sense. Unfortunately, the polished, simple, unitary figures of gods that we create are all too often examples of exactly the same assumptions at work.

As we noted at the start of this chapter, there has been a tendency to frame the appearance of Mithra in Commagene as something of a keystone in a bridge connecting the eastern and western traditions of the deity, or to borrow a phrase from the geologist Charles Lyell, 'the missing link'. That the name appears here is testimony to the extraordinary movement of ideas between places that even today can seem distant. We should not, however, be fooled into framing this as the movement of a god, a religion, or any other phenomenon that we might consider whole or singular. What presents itself to us, both to the east and west, and before and after this moment in Commagene, is the procession of one idea and means of representation amongst many. What this came to be associated with, what lingered from past associations, how it was framed and who came to ponder it are more intrinsic to whatever 'god' may have been constructed from such ideas than any original conception may have been. Whilst scholars say, therefore, a great deal about the combination of cultural elements visible in the figure of Apollo-Mithras, the one that stands to the fore is that of Commagene.

Conclusion

It has not been our aim to construct a seamless argument throughout the different chapters of this book. We have tried to avoid burdening the objects with the need to propose arguments that are derived from distant contexts. What we have attempted to draw out, rather, are questions that seemed to us relevant to a study of Mithra in the ancient world. At the beginning of this volume we asked: how might our understanding of each of these objects be furthered by learning about others that share the same name? What does the appearance of a shared name in such varied contexts mean for our understanding of ancient religion? And to what extent can material culture tell us anything about religious practice?

WHAT CAN WE LEARN BY COMPARING THINGS OF THE SAME NAME?

One matter raised at the start of this volume was whether our understanding of each place and time explored in the last six chapters might be enhanced by studying the others. A common assumption is that similar names demonstrate the presence of similar beliefs. In the Roman and the Kushan Empires, and in Commagene (see chs 1–3, 5, and 6), we have complex iconographies but very few texts. We might therefore try to fill this lacuna by borrowing from the more abundant Zoroastrian textual material (see ch. 4). While it is a natural inclination to do so, and can appear rewarding, there is an inherent danger that in filling gaps in one set of evidence by using information gathered from a very different context, we create a false picture of a unified whole. Each additional inference might seem to broaden our 'understanding', but would in fact build upon unstable foundations.

Tracing links back chronologically so as to identify a common ancestor for the comparanda is another tempting proposition, yet it is one that is likely to overstretch the capabilities of our evidence. The assumption is that we have a goal in sight—that of an identifiable 'whole' that might explain the subsequent

transmission of ideas. For Mithra, this hunt focuses on the borderlands between those supposedly coherent religious systems of the imperial powers of Rome and Parthia (the latter succeeded by the Sasanian Persian empire): Commagene, Syria, Armenia, Asia Minor, and Cilicia. Each of our examples would then be slotted into a timeline of a hypothetical grand narrative, wherein each must account for the abandonment of some characteristics of the earlier evidence and behave as a model for the later examples.[1] The creation of this kind of line of descent can also, equally dangerously, imply a simplistic linear development, coherent and step-by-step, maintaining recognizable features that were consistent from an imagined point of origin.

These were not our aims. By engaging with other examples, we are able to develop an understanding of the movement of ideas—not of tracing these movements, but of exploring the processes and reformulations through which an idea can be rejuvenated and sustained. A further methodologically motivated and rewarding aspect of this venture is that engagement with evidence from outside our fields of research (and outside our comfort zones) helps to shine light on previously unnoticed features within our own areas of interest. It can make the unremarkable stand out, and allow us to look with fresh eyes at the familiar. This aspect is particularly advanced through the collaboration of scholars working in different fields, with different backgrounds, attacking similar questions and problems together. By approaching the questions in this way, we hope that we have challenged some of these assumptions and misconceptions.

Specific to our study, we observed numerous features that retained their attachment to the name of Mithras, Mithra, Mihr, or Miiro in more than one of our test cases. Some of these observations may seem superficial, or are already widely recognized, but even these can prompt new avenues of enquiry.

For example, can Mithra's 'eastern' appearance be seen as a straightforward unifying element across our examples? Does this aspect suggest a consistent link to the east even if the dress across our area is not uniform? Mithras within the Roman Empire wears clothing generally regarded as 'eastern', yet his costume is a stereotypical conflation of clothes worn by other figures ascribed these origins, such as Attis, Sabazios, Paris, Ganymede, and Aeneas. Instead of careful replication of contemporary Parthian or Persian costume, this consists of tight leggings rather than the wide-legged trousers that fall in deep U-folds common to Iranian costume, a loose-fitting tunic rather than a V-necked belted jacket, and a Phrygian cap rather than any type of Parthian or Persian headgear. It is not a representation of a particular eastern dress but a Roman imagining of one. As we have seen in the previous chapters, at Tāq-e Bostān, Nemrut Dağı, and on Kushan coins,

[1] It is worth noting, for Roman Mithras at least, that the explicit search for a grand narrative has been abandoned: 'Grand narratives are perhaps just grand illusions' (Beck 2006, 39).

Mithra and Miiro's appearance is not discordant with presentations of any royal or noble figures in their respective visual cultures apart from his additional divine attributes. It is in making these simple comparative observations of Mithra's costume that we can perceive a constructed eastern character of Mithras in the Roman Empire rather than the indelible stamp of an identifiable eastern origin and retained persona.

In addition to the similar costume of the royal and divine figures in the images from Bactria, Commagene, and Iran, these royal commissions further promote connections between the king and god by showing them physically interacting. The divinity is represented on the same scale as the ruler and is depicted as bestowing his blessing upon the royal figures, whether by raising his hand in a gesture of respect, by being present at the bestowal of honour by the king's predecessor, or by holding the hand of the king in *dexiosis*. Here, we have a remarkably similar positioning of Mithra. Could this therefore suggest a transmission of ideas?[2] As we have seen by considering the ideas in each example's own context, this act of confirmation was certainly common to Mithra but was by no means his domain alone: Ahura Mazda often fulfilled this role in the Sasanian Empire, Zeus-Oromasdes, Artagnes-Herakles-Ares, and 'bountiful Commagene' also did so on Nemrud Dağı, and a number of other gods were featured in similar poses on the coins of the Kushans. Not only is Mithra not alone in these images, but, outside of the Roman Empire, most of our images were royal commissions, which suggests that a relation between royalty and the divine could be seen as a fait accompli. It is possible that the paucity of corresponding non-royal material from these regions might suggest a degree of royal favouritism, but we should not be too hasty to assume the connection was absolute rather than an accident derived from the state of the extant material record.

Another such unifying factor is visible in four of our six main cases. At Dura-Europos, Bourg-Saint-Andéol, Tāq-e Bostān, and the Bactrian sites of Surkh Kotal and Mat, water appears to be used as a liminal device. At each of these sites, the water formed a physical barrier to the sanctuary or image: Mithraic initiates at Dura-Europos had to cross a basin set into the floor of the aisle; worshippers at Bourg-Saint-Andéol and Surkh Kotal had to pass over streams to gain access to the respective sanctuaries; the temple at Mat was separated from the town of Mathura by the river Yamuna; the image of Mithra at Tāq-e Bostān was separated from the viewer by a spring, which may have created the impression of the god's lotus-flower pedestal rising from a lake. In the latter four examples, there is a

[2] According to a Mithraic inscription found in Rome, Mithraists seem to have referred to themselves as *syndexioi*, loosely translated as 'those who clasp hands' (*CIMRM* 423); this is supported by the fourth-century Christian author Firmicus Maternus who, while mocking worshippers of Mithras (Firm. Mat. *Err. prof. rel.* 5.2), also gives them the epithet *syndexioi*.

clear emphasis on living water, where nature has, in effect, been harnessed in order to increase the sacred nature of the sites as well as to delineate sacred space.

The liminal use of water in these spaces therefore seems clear. Moreover, without a comparative approach, the recognition of the commonality of water to each of our contexts might not have occurred. The role of water could easily have been ignored at each site if they had been examined in isolation. Yet it is important that this approach does not go too far in inferring too much and becoming in danger of creating a false reality in which the liminality of water becomes somehow intrinsic or peculiar to Mithra. We might, following this path, attempt to explain the liminal role of water by drawing links between it and the common aspect of the god as a solar deity. We could speculate that crossing water, the element most inimical to fire and heat, was the proper way to delineate sacred space belonging to a solar god.

But what makes a stream liminal and not simply a convenient source of water? It must be remembered that water played a ritual-cleansing role in many different religious practices, it could be an object of veneration in its own right, and it was of course essential to sustained human activity in any location. The need for water at Surkh Kotal, for example, was just as likely to be for practical as much as for ritual reasons, since its high hilltop position meant that wells were a required part of prolonged human use of the site. Nor would any sacred aspect of the water necessarily have been associated solely with Miiro, as the *bagolaggo* was a royal sanctuary and contained both images of Kushan emperors and other gods. Was it the water that was desired most at Bourg-St-Andéol, or the rock face between the streams? Roman Mithras was associated with water in the scene from Mithraic mythology commonly referred to as the 'water-miracle', in which the god shoots an arrow at a rock to produce a stream.[3] Could the siting of the *mithraeum* at Bourg-St-Andéol be, in part, a reference to this element of Mithraic myth, rather than a conscious choice of how to demarcate the site? In the Sasanian Empire, water held divine connotations in itself: it was a crucial element for sacred sites and was integral to the veneration of other *yazatā* such as Anāhita and Apąm Napāt, as well as being, like fire, a conduit of divine glory, *khwarneh*.[4] As a royal commission celebrating the king's accession, dynasty, piety, and military achievements, the presence of water immediately next to the relief may have invoked *khwarneh*—an intrinsic concept to the portrayal of Sasanian dynastic power—and thus the liminal function of water may not have been its most desirable aspect.[5] These additional contextual observations cast far more light on the significance of the springs at Tāq-e Bostān than a focus on Mithra alone allows.

A further possible link is discernible between Mithra and water by looking at the Zoroastrian calendar. At Nemrut Dağı, inscriptions record the commemoration

[3] See ch. 2, p. 46; ch. 3, p. 77. [4] Callieri 2006, 344. [5] Soudavar 2003.

of Antiochus' accession on the tenth day of the month, which was a day sacred to water (Apo) in the Zoroastrian calendar. The only other day decreed to be a festival for Antiochus—his birthday—is the sixteenth day of every month, which is the day in the Zoroastrian calendar dedicated to Mithra. Does this suggest that Antiochus himself was drawing upon an established connection between Mithra and water? Or is this an example of speculating too far? This suggestion gives Mithra particular prominence in the religious life of Commagene, a prominence which may not be deserved. Mithra is only one of many gods celebrated at Nemrut Dağı and in the Zoroastrian calendar more widely; our emphasis on Mithra, and our interest in water, would perhaps here lead us to overlook the context of the appearance of the name.

A potential weakness inherent to comparison thus becomes evident: if our case studies had been compared without regard for their specific contexts, it would have been easy to draw a false conclusion that the presence of water in each was peculiarly Mithraic. Pre-Islamic Iranian rock reliefs from across the centuries, for example, were almost always carved near a body of water. That water performed important functional and symbolic tasks in religious activities, regardless of the particular veneration of Mithra at these sites, seems the most logical explanation, and it is one that we can arrive at only through a comparative exercise sensitive to local context. When one steps back, thinking not only of water but of the wider picture, the connection seems tenuous at best. This discussion of water highlights how, according to our emphasis and our desire to read certain links into the evidence, disparate strands from across different locations and periods can be drawn together to create a more concrete picture. In this way, the example of water highlights both the strengths and the weaknesses of a comparative project.

An unquestionable connection between our various examples is their positioning of Mithra as a solar deity. Mithra's affinities with light are clearly indicated visually in Bactria, Commagene, and Iran through his radiate halo. The connection of Mithras to the sun is more esoteric in Roman depictions, where it is perhaps alluded to through astrological interpretations of his tauroctony, but more clearly stated in the appearance of Sol in representations of Mithraic mythology and in accompanying inscriptions that align Mithras with Helios or Sol. While, therefore, a solar connection seems obvious, comparison allows us to conceive of the potential for modifications and realignments in the role of Mithra and his relationship to the sun. In some places, such as the Kushan Empire, Miiro is the sun, while in others he possesses solar attributes while being distinct from the divine personification of the sun. The comparison does not necessitate that these ideas were unified, but rather suggests how extraordinarily malleable they were.

Mithras' relationship with the sun in the Roman Empire, albeit ambiguous, reminds us that far from being a solitary figure, Mithra appears to have been

positioned as one of many deities across our regions. Likewise, in Iranian and Central Asian depictions, in the context of royal confirmations, Mithra does not appear to have been the primary focus of monuments where his name appears. The situation in scholarship is often the reverse of this. At Commagene, the emphasis frequently placed in the modern era on the presence of Apollo-Mithras-Helios-Hermes, especially the 'Mithras' element, may well stem from our fascination with this name. The appeal of unravelling 'Mithra' has led, time and again, to an imbalanced perspective concerning the prominence of any divinity so named. It is an unblinkered sensitivity to local contexts that can help to temper any such imbalance.

Perhaps the most distinctive iconographic feature of Mithras in the Roman Empire, the killing of the bull, is one that holds an uncomfortable position in comparative studies of Mithra: how to reconcile the Roman bull-thief and bull-slayer with the Iranian guardian of cattle? Should the bull be analogous with Iranian meanings or is it testimony to the Roman reinvention of Mithraic worship?[6] Potential levels of symbolism in this motif (as detailed in chs 1–2) are manifold: is Mithras purposefully portrayed as contradicting his traditional protective role? The iconography of the Mithraic tauroctony has many precursors in Roman and Greek art, such as the same action performed by Victory or Nike, so how particular was this depiction?

An astrological significance of the bull representing either (or both) the moon and the constellation Taurus (and Mithras therefore as either the sun and/or Leo victorious, an interpretation also applied to the motifs of lions attacking bulls among the Achaemenid Persepolis reliefs) is also an option. Roger Beck suggests the tauroctony is a Roman translation of a combination of Iranian myths: both of Ahriman (Av. Angra Mainyu, the Zoroastrian 'destructive spirit') killing the Bull of Heaven (one of many of his destructive acts against the creations of Ahura Mazda) and Saošyant (the future saviour) sacrificing a bull to make the drink of immortality.[7] Attempts to explain conflation or confusion between Roman and Iranian traditions are also drawn to the possible role of Mithra as a demiurge (creator god), as ascribed in Porphyry.[8] For some, this apparent incompatibility attests to the high role allotted to Mithra in early Iranian religion, from which he was later ousted in favour of Ahura Mazda. But it is not necessary to resolve these contradictions into a coherent and logical formula. The bull, just like Mithra himself, is an idea open to reformulation in each locality; it is a concept, though seemingly whole in and of itself, which can have many different additional meanings attached to it. Some of these interpretations may well have been more popular than others, but, as we have seen, traces of variation linger throughout the ancient evidence.

[6] See Beck 1998, 123–4 n. 48. [7] Beck 2002. [8] Porph. *De antr. nymph.* 18.

In addition to the bull, the other generally accepted view of Mithraic worship in the Roman Empire is that any reference or ritual belonging to the deity was highly secluded and only accessible through initiation. The *mithraeum* at Dura-Europos appears to align with this model since it seems likely that access was restricted to a defined community of members. The *mithraea* at Ostia and Močiči, on the other hand, may break away from this trend within the Roman Empire. The Kushan *bagolaggos* and the Sasanian site of Tāq-e Bostān, if the latter was designated as a *paradeisos*, likely both had a restricted royal audience, but neither example was tailored solely to the veneration of Miiro or Mihr. Yet how specific or illuminating are these connections? If anything, these examples may elucidate more about the nature of worshippers' use of divinities in the ancient past than our understanding of Mithra. At the same time, however, by drawing out these comparisons from within the Roman Empire we can observe the discordance in Mithras' settings within a political entity that is all too often treated as a homogeneous cultural sphere.

We have attempted to show how one name is taken, reworked, and renegotiated into its relevant religious landscape, while still being attached to certain distinct sets of iconographic and physical features. A shared name suggests cohesion, yet the bundles of concepts associated with it were more malleable, being redefined and adjusted across temporal and geographical distances. Names have developed precisely to refer to 'things' easily, but we are at pains to suggest that this simplification, though essential, does not necessarily equate to a unified reality. A name, a word, provides a (relatively) simple and recognizable starting point from which the comparative exercise can diverge and spread, but it remains just one piece of evidence amongst others.

WHAT DOES THE APPEARANCE OF A SHARED NAME IN SUCH VARIED CONTEXTS MEAN FOR OUR UNDERSTANDING OF ANCIENT RELIGION?

Our modern, literate, sensibilities incline us to ascribe significance to the choice of a name, particularly when used as a label. As we have seen demonstrated throughout this work, however, the multiple ways in which names could be used may equally denote openness, flexibility, or even accident. Did pre-modern, significantly less literate, societies privilege labels over images in the same way? This issue was made most clear in chapter 5. There, the figure of Miiro possesses a radiate halo, as does Mihr at Tāq-e Bostān and Apollo-Mithras at Nemrut Daǧı, identifying them as solar deities. Yet if the figure we call Miiro had continued to be referred to as Helios, as he initially was, or if he had never been labelled at all, he would have been excluded from this comparison.

We do not want to argue in favour of unlimited onomastic flexibility. The appearance of the name Mithra, or its cognates and derivations, is more than just chance, as is the recurrence of certain characteristics. What this suggests is that the name Mithra was one device among many, including images, that was designed to appeal to groups of ideas. In this respect, it is not surprising that other names were at times also appropriated to communicate similar intentions. The name Mithra was part of an ongoing process of understanding that did not begin or end with its adoption and use by particular communities. Conceptions about the sun, whether understood as a deity or otherwise, undoubtedly pre-dated the introduction of the name Mithra. In Commagene and in Rome, we saw that the name was bound up with others: Apollo-Mithras-Helios-Hermes and Sol Mithras being just two forms, both of which suggest links to, and adaptation of, existing notions of the divine. In Central Asia and India, both Helios and Surya were already current as labels and iconographies when the first image of Miiro was created. At Tāq-e Bostān, the use of an image of which we have little evidence from before this point similarly need not have marked a revolutionary metamorphosis in religious thought.

Nevertheless, we have not included images of solar deities to which the label 'Mithra' is not attached as case-studies, for the very reason that the shared name is interesting. Does this suggest that there was more to the name than just a label for a solar deity? It quite possibly does, for the reasons we have discussed in relation to our first question regarding what we can learn by comparing things of the same name. Elements of the depictions labelled Mithra and the contexts in which we find them, might suggest that more than only the name was travelling. Mithra often appears youthful; is this *who* Mithra was? In many places we find astrological associations to Mithra; did an appreciation of the stars travel with the name? Equally, we have seen texts, particularly from the Roman world, that purport to recount knowledge of the god drawn from the east.

But for all these instances we have seen confusions, contradictions, and coincidences abound in the appearance of the name and the images and contexts with which it is associated. There can be absolutely no doubt that the appearances of the name Mithra are, however tenuously, in some way related: the name was not manifested independently in each of our six examples. The question is how we conceive of this connection. We would suggest that the spread of the name Mithra lends itself to an appreciation of far more fluid systems of religion than we often would perceive or expect. The name Mithra was almost certainly aided in its dissemination through the growth of the Roman Empire both eastward and westward, as it was also by the spread of Iranian influence to Anatolia, Armenia, Afghanistan, and India at various points in time. But the names of other gods were also paired, infused, inferred, or syncretized on a local and regional basis at

various points in time, representing similar (yet not necessarily consistent) manifestations of ancient religious thought.

The connection of images and names complicates the way in which objects and images were viewed. Although differences in conception must have existed across the time and expanse of the Roman Empire, where we find images labelled Mithras, this *image* of the god appears to hold a more central position for worship and its associated rituals than in our other examples.[9] We expect the central act of sacrifice to be performed by the god; what might be seen as the defining moment of Mithras worship in the Roman Empire is fulfilled by Mithras himself. Does this justify reading other figures labelled Mithra in such a way? This is important not only in terms of iconography, but lies at the heart of what we perceive the worship of Mithra in various places to have been concerned with. Because of the nature of the royal dedications at Tāq-e Bostān, in the Kushan Empire, and in Commagene, it would be easy to expect an image labelled as Mithra to depict a god that intercedes on behalf of men; these rulers were harnessing the god's support. We might read these acts of blessing and confirmation within the same frame as the sacrifice shown by the tauroctony. But while a role as interceder must remain a possible aspect of Mithra, as we have seen in all of these contexts this was not peculiar to Mithra, but rather an established aspect of multiple divinities.

The combination of a name and image, or a label and image, is not so straightforward as it might initially appear. Does the name identify the image, or the image the name? What can our objects, all connected by a name, tell us about the worship of Mithra, or how people conceived of labels? More broadly, can we apply our conclusions to our understanding of ancient religion? The names that we have encountered in this volume cannot be separated from the images and objects to which they were attached; to do so would be to disregard the religious power that these images, or names, may have held.[10]

WHAT CAN MATERIAL CULTURE TELL US ABOUT RELIGIOUS PRACTICE?

With or without material culture, religious 'practice' is a difficult thing to grasp, and, while this volume is unashamedly object-focused, we must recognize that

[9] This is certainly not to rule out the involvement of Mithra's image in worship and ritual at Nemrut Daği, Tāq-e Bostān, or in the Bactrian *bagolaggos*.

[10] The 'religiousness' of images is in some ways a new subject, or one that has been frequently neglected in the study of ancient art and religion. In the last twenty years, however, the topic has received an increasing amount of attention, not least as one of the areas of enquiry of the *Empires of Faith* project (see the Foreword, pp. v–viii). See also Elsner 1996; 2007; Platt 2010; 2011.

there were forms of worship that did not position objects and images as centrally as others. In the sacred spaces of Bactria and Commagene, for example, Miiro is one image amongst many, while in Sasanian Persia, images of divine beings were often not the focus of ritual activity (although image shrines did exist), regardless of any perceived divine hierarchy.[11] We have tried to incorporate, where possible, relevant literary and archaeological contexts for our objects. For all of our case studies, the use of literary testimony from which to support, complement, or contradict suggestions drawn from material evidence is highly problematic, whether because it is fragmentary, external, or non-existent. Likewise, the archaeological context of these images of Mithra is frequently incomplete and leaves us with more questions.

Our case studies introduced many different forms of the veneration and use of images of Mithras, Mithra, Mihr, and Miiro, including at sites under royal patronage, in *mithraea*, and on coins. Our objects themselves cannot necessarily provide us with clues to suggest that these images facilitated any aspects of worship, particularly given the diverse range of contexts we have explored in this volume; but no single piece of evidence, whether a coin, a text, an inscription, or a painting ever can, nor should we expect them to. Nonetheless, we can still use them to suggest some ways forward that could temper our approach to different manifestations of the gods and their worship in these disparate locations.

All of our depictions of Mithra are amalgamations and responses to an existing environment. Whether adapting representations of Nike in the Roman Empire or princely figures in the Kushan Empire, there were precedents for much of what we have seen. This is true of all images, which cannot help but contain elements drawn from others, be they in the style, the medium, the iconography, or otherwise. As we have noted at various points, the act of drawing together different ideas is an innovation in its own right. When we think about the spread of the name Mithra, however, even if it is not accompanied by an image, this amalgamation *might* take on a different hue. One could argue that the representations of Mithra from place to place differed in a way that the conception of the god did not: communities only visualized the god in different ways, all the while maintaining a fundamentally universal understanding of the god. We have suggested throughout, and modern scholars are generally agreed, that this is highly unlikely to have been the case.

What can the differences in the way images were viewed tell us not only about Mithra, but about the study of ancient religion? The different ways of positioning images remind us that the reformulations and re-applications of the name took place in different religious, artistic, social, cultural, and political settings,

[11] See Boyce 1975b, 107 on a law report of the sixth century AD concerning the removal of a statue from an image shrine (*uzdēs kadag*).

the impact of which cannot be overlooked. If the way that objects and images were experienced had fundamental differences from place to place, this may have had important ramifications for the conception of the god and the practice of religion.

Comparison between the different ways that communities viewed and used images could prove extremely fruitful. Was there an inherent sacrality to these objects? Were they the recipients of veneration in their own right? Even within the Roman Empire, different conceptions of the tauroctony—whether as a small relief, statue group, or monumental carving—suggest diverse attitudes towards the use of the image. Did the worshippers at the *mithraea* discussed in chapter 3, for example, choose to depict the tauroctony in large rock reliefs to add to the sacred significance of the depiction?

We have attempted to show how our objects and their locations might have played a role in religious ritual and performance. At Nemrut Dağı, the presence of altars in front of the *dexiosis* stelae may suggest that they were venerated, but perhaps their significance lay only in their representations of the gods. And even though the relief at Tāq-e Bostān did not form part of a temple or sanctuary, the site itself is likely to have held some sacred importance that was by extension attached to the relief.[12] These questions are brought to the fore by the comparative endeavour, and that we are left with more questions illustrates the difficulties of trying to interpret religious practice from material culture. It is nevertheless a worthwhile enterprise, in part because it requires that we re-examine our existing understanding of individual objects.

The acts of amalgamation that we have been discussing might also reflect on practice. We have noted how the means of representing the gods referred to as Mithra were drawn from culturally familiar sources: local royal images in the Kushan and Sasanian contexts and an established representation of 'the foreigner' in the Roman. This may equally be the case for the many forms of worship involved. In focusing on the worship of Mithra in each of our regions, it is all too easy to overlook other local and contemporary forms of religious practice. After all, the assortment of customs and traditions that comprise any community's means of worshipping the divine cannot be so far removed from the inconsistencies in their images.

Familiar elements of ritual practice from other contexts could have been applied, whether reconfigured or not, to the worship of Mithra. This is what we see at Dura-Europos, where patrons engaged in a ritual action were frequently

[12] There is evidence of ritual activity taking place immediately in front of other pre-Islamic Iranian rock reliefs, such as the Elymaean relief at Hung-e Aždar in Khuzestan (second century BC–third century AD), but there have not been excavations at Tāq-e Bostān and the extensive modern reworkings of the site make it unlikely any such evidence could be found in the future.

depicted in religious art. The Zenobius relief opens up questions of how incense was used, not only in Mithraic ritual at Dura but around the Roman Empire; nonetheless, it cannot be separated either from its local artistic or from its local religious surroundings. At Tāq-e Bostān we see Mithra bearing the *barsom* (the rods held by priests during Zoroastrian liturgy), which was not particular to the worship of Mithra, and is an inseparable feature of the Sasanian religious context. The open-air *mithraeum* at Močići is the foremost example of a taurochtony in an outdoor, apparently uncovered, and semi-public setting, seemingly contrary to 'normal' practice. Nemrut Dağı provides us not only with a very specific ritual context, but also a demanding code of practice in the form of the *nomos* inscription. Yet despite the repetition of this law throughout Antiochus I's kingdom, worship was almost certainly administered and experienced differently at each site. It is worth noting, however, that the popularization of a formerly esoteric ritual or activity could still have been a marker of 'difference'—either as self-construction, or in the opinion of others.

It is illuminating to see how our understanding of Mithra emerges from gathering together the original contexts of each object. We should constantly re-evaluate our overall impression of Mithraic worship by examining the place of Mithra within other religious traditions, and the place of Mithraic art within local culture. From the far-flung pieces of material evidence that we have pertaining to religious thought and practice concerning one divine name, we can perceive reinterpretations of religious concepts and strands of connection not only between these imagined cultural or religious monoliths (such as 'Roman', 'Persian', or 'Kushan'), but also of flexibility within each 'system', where worship of Mithra was part of a broader religious network.

CONNECTIONS AND POSSIBILITIES

We have suggested that we are not dealing with the same god travelling from western Europe to Central Asia or vice versa. Nor do we believe that the Roman Mithras was a direct transmission and translation of Persian Mithra. It is now common to conceive of the Romans' own assertion that Mithras came from Persia as significant only insofar as it was desired by them.[13] The 'eastern' elements seem to have been constructed, rather than inherited, by these communities of worshippers. Many Roman worshippers of Mithras certainly appear to have maintained that a connection existed between the deity they revered and a Persian god. In addition to the similar nomenclature of the divinity, there are references to Mithras worship in the Roman Empire as 'the mysteries of the

[13] Gordon 1975; Gordon 2007a, 393.

Persians', as well as the fact that his eastern identity was to some extent main-
tained or re-imagined through his dress, as outlined above.[14] Much of the con-
tinuing scholarly arguments about this phenomenon are valid, and what they
cannot deny is the ever-present allure of this name 'Mithra'.

Without the understanding that it is in some way the same god, how, then, do
we understand the appearance of the shared name? However tenuous a connec-
tion might have been, is it really so bad for us to assume that some connection
did exist? The trouble is that if we think about this in terms of the rigid bounds
of 'gods' or 'religions', as they are commonly conceived, then we of course run
into the sorts of difficulties that have befallen the likes of Franz Cumont.

As the first three chapters showed, even within the relatively more confined
sphere of Roman religious belief it is difficult to justify the use of the term
'Mithraism', and the connotations of a unified and uniform religion that this
brings.[15] Even though the tauroctony image itself was instantly recognizable and
remained very similar across the Roman Empire, the diverse approaches of
Mithraic worshippers to such matters as sacrifice, sacred space, and the possible
incorporation of other gods, in addition to all those aspects about which we
know barely anything, should make us extremely cautious about construing
Mithras worship as a unified and consistent religion. We could expect to find
something far more fluid, which was adapted to different social settings and the
different priorities of the worshippers.

Conceiving of Mithra's worship in this manner applies just as much to the reli-
gion of the Sasanian Empire. As Mary Boyce forcibly pointed out over forty years
ago, there is little evidence to support the still-popular theory that Mithra's wor-
ship was a separate or opposing religious community to the veneration of Ahura
Mazda.[16] By appreciating ongoing adaptations and evolutions of Zoroastrianism
within its historical and social contexts, and taking the material evidence into
account, we can make steps towards furthering the study of the worship of
Mithra and, by extension, ancient religion in antiquity.[17]

[14] Porph. *De antr. nymph.*, 5–6; Origen *C. Cels.*, VI.21–2. Neither of these authors, of course, testify
as to how Mithraic initiates would have referred to Mithras worship.

[15] Within the context of a book focused on images, we have tried to avoid a sense of Roman exception-
alism. Of course, this book could be criticized for privileging Roman Mithras; with three chapters on the
significance of the tauroctony in different settings, the charge is not easy to shift. Our aim throughout,
however, has been to demonstrate that the monolith of 'Mithraism' in the Roman Empire is a fallacy and,
as such, is a topic that perhaps necessitates this extra attention.

[16] Boyce 1969.

[17] These calls, firstly to imagine Zoroastrianism 'as a complex network of dynamic ongoing re-creations
that its makers—believers and practitioners—are situated within, continually engaged with, and often
contest' and secondly to include study of the material evidence, are made strongly in Stausberg and
Vevaina 2015, xiii–xiv.

Instead of looking for a god, therefore, we suggest that ideas are a better place to start. Attached to a name is a cluster of ideas that in turn brings with it a host of possibilities. The travel of the name Mithra does not represent the movement of a god, but of iconographic, linguistic, and devotional opportunities associated with this name. These could be, and duly were, adapted for purpose by those that embraced them to construct their own religious understanding. No doubt these communities could compare their Mithra with that of other communities and cultures, and see in them their own god represented and worshipped in different ways. They could equally have chosen to see Mithra reflected in a god whose worshippers would wholly have rejected the identification, whether based on solar affinity, iconography, or factors invisible to us. For those invested in their own reality of the deity, for whom there may have been no question that their god was *the* Mithra, these were important acts of mutual understanding and appropriation. As outsiders witness to a multitude of ancient appearances of Mithra, it is not our role to find the 'true' god but rather to account for the multiplicities.

Conceptualizing a fundamental, single, and definable reality of Mithra's essence, or what it means to be Mithraic, is untenable despite the multiple connections that can be drawn out from images of Mithra. Assessing different contextual occurrences of the name helps to reframe what we think we're looking at in those discrete appearances. If we appreciate that we are not seeing a god move but ideas, then our expectations and preconceptions for the manifestations of Mithra's images must change as a result. In the Roman Empire, we have opened up different ways of looking at the tauroctony, communities of worshippers, and contexts. In the Sasanian Empire, the image is an example not of dramatic change, but of new or unusual ways of representing long-held ideas within the existing religious traditions. The Kushan and Commagenian examples are possibly the clearest illustrations of this bundling of ideas, where we can see an immense fluidity and flexibility that we do not need to try and cram into one mould of understanding, of one god. What *is* in a name? Possibilities.

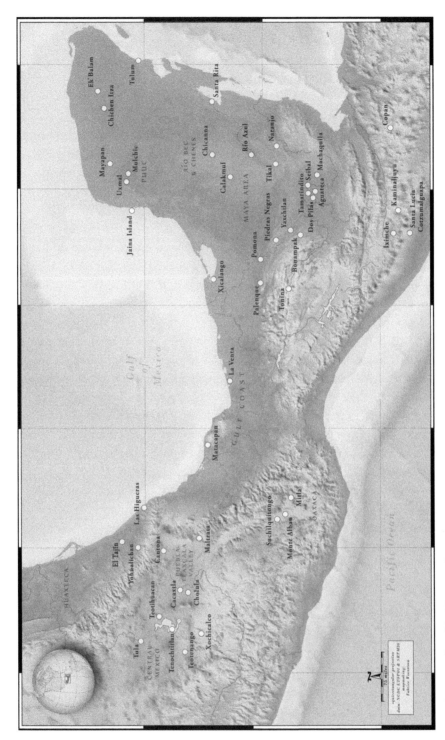

MAP 5. Quetzalcoatl in Mesoamerica.

Epilogue

Quetzalcoatl and Mithra

Claudia Brittenham

The problems so lucidly laid out in this volume are by no means unique to Mithra.[1] They also abound in Mesoamerica, and doubtless in many other parts of the world as well. Consider the figure of Quetzalcoatl, prominent among Aztec deities. The name literally means 'feathered serpent', joining the Nahuatl word for feather, *quetzalli*, with the word *coatl*, or snake. As it happens, there are many stone sculptures of feathered serpents found in Aztec lands, some formally quite different from others (Fig. 7.1). Are these all images of the god? Or, given the very pictorial nature of Aztec writing, are these better understood as hieroglyphs, the name Quetzalcoatl written in three dimensions?

In fact, there is little evidence to support either proposition. Most of the feathered serpent sculptures were found out of context; many were damaged by Spanish iconoclasm. We do not know how—or even *if*—they functioned in religious observance of a god named Quetzalcoatl.[2]

Part of the challenge is that alphabetic texts attest to very different manifestations of a deity with this name. Written after the Spanish conquest of Mexico in 1521, often in aid of Christian evangelization, these texts describe an anthropomorphic deity with no attributes of a feathered serpent. In the list of gods at the beginning of the encyclopaedic Florentine Codex, for example, Quetzalcoatl is shown as a human figure, with ashy grey skin, a red-and-white cap, a shell-trimmed cape, a shield with a cross-section of a conch shell upon it, and a curved

[1] This essay developed out of a response to the 'Ways Forward: Eurasian Mithras' panel at the 'Empires of Faith: Comparativism, Art, and Religion in Late Antiquity' conference at the University of Chicago in October 2015. I am most grateful to the organizers of the conference for inviting me to engage with this stimulating material. Thanks are also due to Kris Driggers for sharing his thoughts on Quetzalcoatl and Ehecatl.

[2] It is worth stressing that two of the few sculptures found *in situ*, a pair of large feathered serpent heads with traces of blue paint, have no clear associations with Quetzalcoatl, and instead formed part of the *coatepantli*, or 'serpent wall' delimiting the principal temple of the Aztec capital of Tenochtitlan, where they were juxtaposed with a number of serpent heads without feathers. See López Luján and López Austin 2011, 64–71. For a survey of the kinds of feathered serpent imagery in the Postclassic period, see Nicholson 2000.

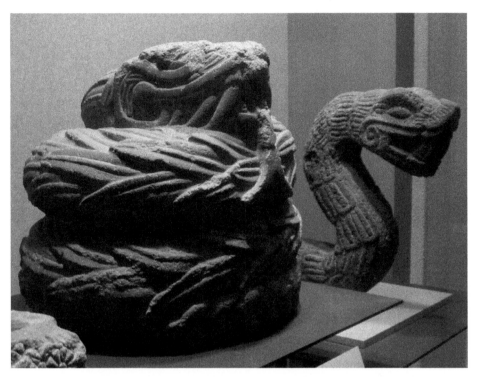

FIG. 7.1. Feathered serpent sculptures, Aztec (*c.*1500). Museo Nacional de Antropolgía, Mexico City. Image by Thelmadatter, licensed under Public Domain via Wikimedia Commons.

sceptre clasped in his left hand (Fig. 7.2).[3] This may be an *ixiptla*, or human god-impersonator, rather than a cult image, but even so, without the textual gloss, it would be difficult to associate such an image with the feathered serpent.

Even more confounding, the god named Quetzalcoatl who was worshipped in Cholula, an independent city-state little over 100 km to the southeast, had a strikingly different appearance than the god of the same name in the Aztec capital, which was described in the previous paragraph. Describing the cult image in Cholula, Fray Diego Durán writes: 'his body was that of a man, and his countenance that of a red-beaked bird.... From the beak to the middle of the face he was painted yellow, and next to the eye was a black stripe which passed below the beak.'[4] This deity wore a conical hat, painted black, white, and yellow; the same colours were repeated on his cape and shield. The *ixiptla*, or human impersonator, of the deity, was dressed in the same way. Only a few elements of costume, such as a curved sceptre or the image of the conch shell in cross section, overlap with the image in Figure 7.2. There was yet another manifestation of Quetzalcoatl

[3] Sahagún 1950–1982, bk 1, ch. 9, 9.

[4] Durán 1971, ch. 6, 130–1. Durán, *Historia de las Indias de Nueva España e islas de la tierra firme*, 1579, fol. 251ᵛ. Image available online at: http://bdh-rd.bne.es/viewer.vm?id=0000169486&page=501.

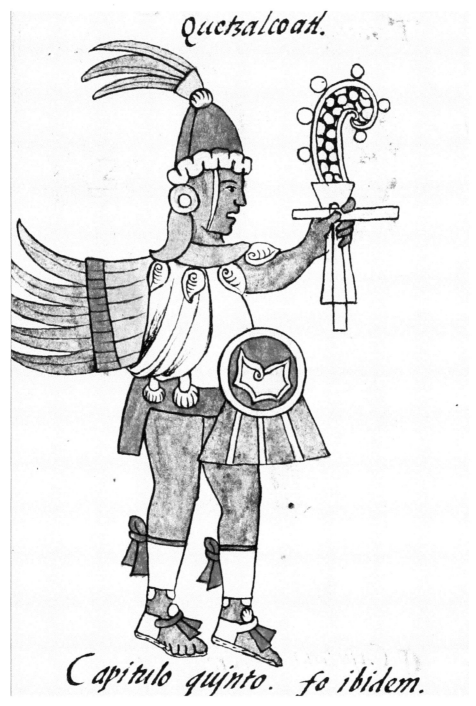

FIG. 7.2. Quetzalcoatl. Bernadino de Sahagún, *Historia general de las cosas de nueva España* (Florentine Codex, *c*.1575–1577), vol. 1, detail of folio 10ᵛ.
Public Domain.

in Cholula, perhaps more important than either the statue of the deity or the human impersonator: a sacred bundle, containing ashes and greenstones, wrapped in a jaguar skin.[5] Again, none of these manifestations is easily identified with the feathered serpent.

Sixteenth-century sources say that Quetzalcoatl was worshipped in round temples.[6] The principal Quetzalcoatl temples of Cholula and Tenochtitlan lie under colonial construction (the convent of San Gabriel and the Metropolitan Cathedral, respectively), but round temple platforms have been found at several Aztec city-state capitals.[7] One such building at the site of Calixtlahuaca yielded a sculpture of a standing male, wearing a red beak-like buccal mask, very similar to the one described on the Quetzalcoatl at Cholula.[8] Another round platform, now at the centre of the Pino Suarez Metro Station in downtown Mexico City, housed the broken pieces of an image of a monkey wearing the same red buccal mask, its body twisted as if dancing (Fig. 7.3).[9]

The domain of the deity was as diverse as his representations. Sources from the Aztec capital refer to Quetzalcoatl principally as a wind god: 'he was the wind; he was the guide, the road-sweeper of the rain gods.'[10] The Quetzalcoatl of Cholula was also described as a 'god of the air', but he was additionally the principal deity of the city, and the patron god of its merchants.[11] Other sources speak of Quetzalcoatl as one of the deities involved in the creation of the earth and/or the creation of humanity.[12] There are associations, too, with the planet Venus as morning and evening star. Quetzalcoatl also appears as a title for Aztec priests and as a kind of poisonous snake which dwelled in lands to the east.[13]

What's more, textual sources also tell us that Quetzalcoatl was the name of the ruler of Tollan, the prototypical Mesoamerican city, a place which existed as much in myth as in memory.[14] The noble and virtuous lord, we are told, introduced

[5] Olivier 1995, 109, 112. [6] The citations are assembled in Pollock 1936, 5–12.

[7] Smith 2008, 103–5.

[8] García Payón 1936, 200; Matos Moctezuma and Solís Olguín 2002, cat. no. 32.

[9] Gussinyer 1969; Matos Moctezuma and Solís Olguín 2002, cat. no. 102.

[10] Sahagún 1950–1982, bk 1, ch. 9, 9.

[11] Durán 1971, ch. 6, 129. By contrast, the patron god of the merchants of the city-state of Tlatelolco seems to have been named Yacatecuhtli: Sahagún 1950–1982, bk 1, ch. 19, 41. On this god, see O'Mack 1991, 1–33.

[12] See, e.g. *La historia de los Mexicanos por sus pinturas*, the *Histoyre du Mechique*, or the *Leyenda de los soles*, in Tena 2011, 25–7, 151–3, 179–81.

[13] Sahagún 1950–1982, bk 3, ch. 9, 69, and bk 11, ch. 5, 85, respectively.

[14] This Quetzalcoatl is sometimes called Ce Acatl Topiltzin Quetzalcoatl, for the date of his birth on 1 Reed (Ce Acatl in Nahuatl); 'Topiltzin' means 'our prince'. Much ink has been spilled about whether to identify Tollan with Teotihuacan or with Tula, Hidalgo; in fact, many Mesoamerican cities claimed to be Tollans, and looking for a single unitary place in which to locate Quetzalcoatl's putatively historical exploits is almost surely the wrong approach. The mentions of Topiltzin Quetzalcoatl are ably summarized, from very different perspectives, in Gillespie 1989, 173–207; Nicholson 2001.

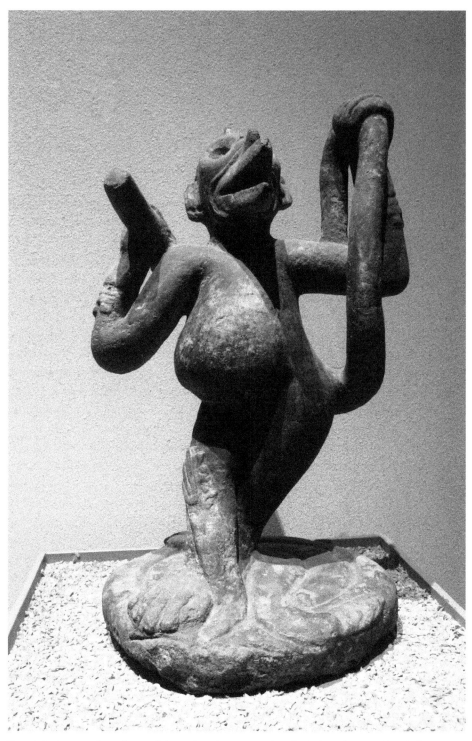

FIG. 7.3. Statue of monkey with buccal mask, commonly called Ehecatl-Quetzalcoatl, found in a round temple during subway excavations in Mexico City. Museo Nacional de Antropología, Mexico City.

Image by Ana Laura Landa, courtesy of Mexicolore.

prayer and fasting before being tempted into sin by the god Tezcatlipoca. Quetzalcoatl fled to the east, where in some accounts, he transformed into the morning star.[15]

Myth-making about Quetzalcoatl has continued past the Spanish conquest. By the end of the sixteenth century, a tradition had emerged claiming that the Aztecs identified the conquistador Hernán Cortés with the returning Quetzalcoatl, even though early accounts of the conquest do not seem to support such a belief.[16] By the eighteenth century, several authors were even suggesting that Quetzalcoatl should be identified with the roving apostle St Thomas.[17]

Many parallels to the Mithra conundrum have emerged: a common name seems to designate many different things, creating connections between phenomena that might otherwise seem unrelated. At the same time, it is difficult to completely separate Quetzalcoatl from other Mesoamerican deities: the red buccal mask appears in other sources as an attribute of Ehecatl, a wind god; while both Tlahuizcalpantecuhtli, a god of Venus as the morning star, and Xolotl, a dog-shaped god of Venus as the evening star, wear the same cut-shell necklace as Quetzalcoatl. Of course, these other entities appear equally unbounded and unstable. The name Ehecatl, for example, simply means 'wind': is it an epithet or a separate deity? We may not fully understand Aztec conceptions of divinity, and err greatly in assuming that they equate with either Judeo-Christian or Greek and Roman notions of godhood—which of course we know principally through a Christian lens.[18]

Finally, the problems of evidence are similar: much of the material evidence lacks archaeological context, and the textual descriptions we have align only partially with the material evidence. None of these texts were written by religious insiders, and we cannot be sure that they accurately represent Quetzalcoatl or his worship. Indeed, text may not have been central in either religious tradition. Instead, much of what mattered in the worship of Quetzalcoatl may have been ephemeral: the deity bundle, the human *ixiptla*, the songs and prayers offered to the deity, the foods eaten at festivals in his honour. In the end, practice is where religious identity is most firmly constituted, but it is exceedingly difficult to access through the archaeological record.

[15] *Anales de Cuahtitlan*, translated in Bierhorst 1992, 28–37. Other versions of the story occur in the *Histoyre du Mechique*, reproduced in Tena 2011, 159–65, and in Sahagún 1950–1982, bk 3, chs 3–14, 12–38.

[16] Gillespie 1989, 179–201; Townsend 2003.

[17] Keen 1971, 238–40, *passim*; Lafaye 1976, 155–206.

[18] For the problem of Roman religion through a Christian lens, see Ando 2010. For recent approaches to the nature of Aztec divinity, see Maffie 2014; Bassett 2015.

Noble attempts have been made to unify these disparate representations.[19] Chains of linked attributes do make it possible to see relationships between the different forms of the Quetzalcoatl: a feathered serpent bears on its back the date 1 Reed, birthdate of the mythical ruler of Tollan; the monkey found in the Mexico City Metro excavations wears the red buccal mask attributed to the god of Cholula, while another statue of a crouching monkey wears the cut-shell ornament found on the shield of the figure in the Florentine Codex.[20] But no single image combines all of the attributes associated with Quetzalcoatl; indeed, no one image could, since some are mutually contradictory. Defining the deity as the union of all possible attributes, whether for Quetzalcoatl or Mithra, creates an agglomeration which never occurred in the ancient world. What's more, it seems to implicitly presume that there *is* one true Quetzalcoatl—a deity with stable, trans-historical characteristics.[21]

Rather than seeking to reconcile these conflicting accounts, what if we instead revelled in the differences? What if, following the authors of this volume, we assume that many different accumulations of ideas might have been grouped together under the name Quetzalcoatl, no one set more 'authentic' or 'true' than the others? Not only did the feathered serpent mean different things in different times and places, but even within a single city people undoubtedly held diverse and conflicting beliefs about the god. Indeed, such contradictions might have been part of the god's power and mystery.

Adopting this approach means that we should not be troubled if the Quetzalcoatl of Cholula looked very different from the god of the same name in Tenochtitlan, or if neither looked very much like a feathered serpent. Our attention shifts from trying to reconcile these images to our own satisfaction to looking at evidence for the processes and institutions which led to such notable variation.

Like worship of Mithra, worship of Quetzalcoatl was likely always diverse and decentralized. We lack any texts composed by devotees of Quetzalcoatl or Mithra and, even more importantly, any indication that doctrinal texts were a central part of the worship of either god. In the religions with which we are most familiar, shared texts provide a common ground for claims of continuity, yet, even so, practice and material culture can still vary tremendously. We should expect even greater variation in a situation where there are no standard written texts, and even more importantly, no institutions which encourage standardization.

[19] See, e.g. Florescano 1999; Nicholson 2001; *Isis y la serpiente emplumada* 2007.

[20] Illustrated in Nicholson 2000, fig. 4.2; Matos Moctezuma and Solís Olguín 2002, cat. nos. 102, 100.

[21] A point made forcefully by Robert Bracey at the 'Empires of Faith' conference, University of Chicago 2015.

In sixteenth-century Mexico, there do not seem to have been political and military institutions invested in enforcing a particular kind of Quetzalcoatl worship. Aztec imperial interests promoted the worship of their patron deity, Huitzilopochtli, alongside other existing gods in newly conquered areas, but otherwise interfered little in local religious practice. Cholula was a powerful commercial centre, and a pilgrimage destination for worshippers of Quetzalcoatl, but beyond its domain, it could only exert the power of suggestion in spreading a Quetzalcoatl cult.[22] Part of what made the idea of Quetzalcoatl, or Mithra, so agile is that it was not bounded by doctrine or institution.

Many ideas, from different times and places, came together in Aztec conceptions of Quetzalcoatl. The feathered serpent's popularity may always have been due to its multivalence, to its power as a symbol onto which many meanings could be mapped. The earliest images of feathered serpents occur in the first millennium BC, over two thousand years before the Aztecs called a god Quetzalcoatl.[23] The feathered serpent can be traced as far afield as the horned serpent which brings rain to the Hopi in the American Southwest.[24] Feathered serpents became especially important in the art of the great city of Teotihuacan during the first half of the first millennium AD (Fig. 7.4), and then spread to cities such as Cacaxtla, Xochicalco, Tula, and Chichen Itza after Teotihuacan's fall, offering many opportunities for reinterpretation.[25] Sixteenth-century sources on the Yucatan Peninsula speak of Kukulcan, whose name is literally a Mayan translation of Quetzalcoatl, 'feathered serpent', and relate him to the ninth- to eleventh-century site of Chichen Itza, where feathered serpents abound.[26] In doing so, do they record an ancient correlation or a sixteenth-century one, which sought to draw Maya elites closer to the centre of Aztec power?

Books written by the Mixtecs of Oaxaca in the centuries before the Spanish conquest feature a bearded deity with a red beak and a stripe down his face. Named '9 Wind', this god plays a role in the creation of the world, like the Aztec Quetzalcoatl. If we are tempted to call 9 Wind 'the Mixtec Quetzalcoatl' or perhaps, to give chronological priority where it is due, Quetzalcoatl 'the Aztec 9 Wind', it is surely because people in the Mesoamerican world had already made these connections.

[22] Durán 1971, ch. 6, 128–39; Rojas 1985, 129–30; McCafferty 2000, 356–8.

[23] The limited contexts of most Mesoamerican writing means that we do not know what these feathered serpents were called in earlier eras. Most scholars now prefer to limit the term 'Quetzalcoatl' to Aztec-period manifestations, and use a more neutral term like 'feathered serpent' to describe earlier images.

[24] Taube 2001.

[25] The Epiclassic manifestations are gathered in Ringle, Gallareta Negrón, and Bey 1998. However, as I've argued elsewhere, the diversity of representations in the Epiclassic seems to argue against the diffusion of a 'feathered serpent cult', see Brittenham 2015, 59–63.

[26] e.g. Landa 1978 [1566], 10–11.

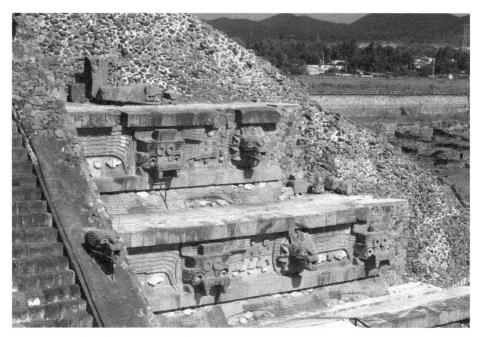

FIG. 7.4. Feathered Serpent Pyramid, Teotihuacan (c.150).
Author's image.

The most important associations for the Aztecs were with the feathered ser-
pents of Teotihuacan and Tula, sites of venerable antiquity not too far from the
Aztec capital, whose visual legacy the Aztecs appropriated as part of their claim
to power and legitimacy.[27] But if there is a historical connection between the two
supernaturals, it is a complex and circuitous one, as elements of belief, practice,
and ritual were transmitted imperfectly from generation to generation during
centuries of loss and upheaval. It is equally possible that the Aztecs re-invented
the tradition of the feathered serpent in ways which Teotihuacanos would have
found unrecognizable. The feathered serpent of Teotihuacan, after all, was a
creature which frequently appeared in multiples, haunting the margins of other
scenes (see Fig. 7.4). If we did not have knowledge of an Aztec god named
Quetzalcoatl, would we see the Teotihuacan feathered serpent as a deity, or
merely as a decorative motif?

The point is that gods do not translate themselves. It requires the work of
people to transmit traditions, to recognize parallels between divine entities, to
borrow elements of costume or practice from one cult to another, to name two
gods in ways which relate them. But processes of transmission and translation are
not always perfect; indeed, misunderstandings may prove especially fruitful.

[27] Umberger 1987, 63–105; López Luján 1989.

The essays in this volume exemplify the rewards of paying close attention to each representation of a god in its own particular context. In doing so, they have demonstrated how the ability to recognize a deity in diverse manifestations was a creative act with political implications.

Upon examination, I would assert, most deities look like Mithra and Quetzalcoatl: multiple in their representations, understood differently in different times and places, always combining with other ideas to respond to local concerns and circumstances. Mithra and Quetzalcoatl let us see more familiar traditions in a different way: they draw our attention to the authorities and institutions necessary to maintain stable practice and iconography. But more importantly, they also highlight the diversity of belief, representation, and practice in any religious tradition. They show us that the continuity of tradition, like so many other things about religion, is a matter of faith.

REFERENCES

Ando, C. (2010), 'Praesentia numinis. Part 1: The invisibility of gods in Roman thought and language', *Asdiwal* 5, 45–73.

Bassett, M. (2015), *The fate of earthly things: Aztec gods and god-bodies* (Austin: University of Texas Press).

Bierhorst, J. (1992), *History and mythology of the Aztecs: the Codex Chimalpopoca* (Tucson: University of Arizona Press).

Brittenham, C. (2015), *The murals of Cacaxtla: the power of painting in ancient Mesoamerica* (Austin: University of Texas Press).

Durán, D. (1971), *Book of the gods and rites and the ancient calendar*, trans. Fernando Horcasitas and Doris Heyden (Norman: University of Oklahoma Press).

Florescano, E. (1999), *The myth of Quetzalcoatl*, trans. Lysa Hochroth (Baltimore: Johns Hopkins University Press).

García Payón, J. (1936), *Zona arqueológica de Tecaxic-Calixtlahuaca y los matlatzincas* (Mexico City: Talleres Gráficos de la Nación).

Gillespie, S. (1989), *The Aztec kings: the construction of rulership in Mexica history* (Tucson: University of Arizona Press).

Gussinyer, J. (1969), 'Una escultura de Ehecatl-Ozomatli', *Boletín del Instituto Nacional de Antropología e Historia*, 37, 29–32.

Keen, B. (1971), *The Aztec image in western thought* (New Brunswick, NJ: Rutgers University Press).

Lafaye, J. (1976), *Quetzalcóatl and Guadalupe: the formation of Mexican national consciousness, 1531–1813* (Chicago: University of Chicago Press).

Landa, D. d. (1978 [1566]), *Yucatan before and after the conquest [Translation of Relación de las cosas de Yucatán]*, trans. William Gates. (New York: Dover Publications, Inc.).

López Luján, L. (1989), *La recuperación mexica del pasado teotihuacano* (México: Instituto Nacional de Antropología e Historia).

LÓPEZ LUJÁN, L. and López Austin, A. (2011), 'El *coatepantli* de Tenochtitlán: Historia de un malentendido', *Arqueología Mexicana*, 19 (111), 64–71.

MAFFIE, J. (2014), *Aztec philosophy: understanding a world in motion* (Boulder: University Press of Colorado).

MATOS MOCTEZUMA, E. and Solís Olguín, F. eds (2002), *Aztecs* (London: Royal Academy of Arts).

McCAFFERTY, G. G. (2000), 'Tollan Chollan and the legacy of legitimacy during the Classic-Postclassic transition', in D. Carrasco and L. Jones (eds), *Mesoamerica's classic heritage: from Teotihuacan to the Aztecs* (Niwot: University of Colorado Press), 341–67.

NICHOLSON, H. B. (2000), 'The iconography of the feathered serpent in Late Postclassic central Mexico', in D. Carrasco and L. Jones (eds), *Mesoamerica's classic heritage: from Teotihuacan to the Aztecs* (Niwot: University of Colorado Press).

NICHOLSON, H. B. (2001), *Topiltzin Quetzalcoatl: the once and future lord of the Toltecs*, 2nd edn (Boulder: University Press of Colorado).

O'MACK, S. (1991), 'Yacateuctli and Ehecatl-Quetzalcoatl: earth-divers in Aztec central Mexico', *Ethnohistory*, 38(1), 1–33.

OLIVIER, G. (1995), 'Les paquets sacrés ou la mémoire cachée des Indiens du Mexique central (Xve–XVIe siècles)', *Journal de la Société des Américanistes*, 81, 105–41.

POLLOCK, H. E. D. (1936), *Round structures of aboriginal Middle America* (Washington, DC: Carnegie Institution of Washington).

RINGLE, W. M., Gallareta Negrón, T., and Bey, G. J. (1998), 'The Return of Quetzalcoatl: evidence for the spread of a world religion during the Epiclassic period' *Ancient Mesoamerica*, 9(2), 181–232.

ROJAS, G. d. (1985), *Descripción de Cholula*, ed. René Acuña. Relaciones geográficas del siglo XVI 5: Tlaxcala tomo segundo (México: Universidad Nacional Autónoma de México).

SAHAGÚN, B. d. (1950–1982), *Florentine codex: general history of the things of New Spain*, trans. Arthur J. O. Anderson and Charles E. Dibble, 13 vols (Santa Fe: School of American Research).

SMITH, M. E. (2008), *Aztec city-state capitals.* (Gainesville: University Press of Florida).

TAUBE, K. A. (2001), 'The breath of life: the symbolism of wind in Mesoamerica and the American Southwest', in V. M. Fields and V. Zamudio-Taylor (eds), *The road to Aztlan: art from a mythic homeland* (Los Angeles: Los Angeles County Museum of Art), 102–23.

TENA, R. (2011), *Mitos e historias de los antiguos nahuas* (Mexico City: Cien de México).

TOWNSEND, C. (2003), 'Burying the white gods: new perspectives on the conquest of Mexico', *American Historical Review*, 108(3), 659–87.

UMBERGER, E. (1987), 'Antiques, revivals, and references to the past in Aztec art', *Res*, 13, 63–105.

GLOSSARY

We are aware of the potential irony of including a glossary in a book that stresses the ambiguity of names. Nonetheless, what we also hope to have emphasized throughout the volume is the importance of a collaborative model, wherein people with different areas of specialism have contributed and shared their knowledge. When this project began, even the authors were not familiar with all of the terms listed here; we therefore considered it unfair to demand such expertise from the general reader.

GLOSSARY OF TERMS

apotropaic A term denoting the power to avert bad luck or malign influences.

atlantes A Greek architectural term describing a column or pilaster formed in the shape of a man.

Avestan An Iranian language of the Zoroastrian sacred texts, the **Avesta**, the distinctive script of which was likely later invented in the Sasanian period.

Bactrian A language of the **Kushan Empire**, used in Bactria (modern-day Afghanistan) that was written using a modified Greek script.

bagolaggo A royal sanctuary of the **Kushan Empire**.

barsom A ritual implement, comprised of a long bundle of rods and used by Zoroastrian priests.

bašlyk Turkish for a soft helmet or hood.

biga A two-horse chariot.

Buddhism A religion that originated in India based upon the teachings of the Buddha.

chape The metal tip of a scabbard or sheath.

Christianity A religion based around the teachings of Jesus, believed by Christians to be the son of God.

corymbus The hair-style of a large globe of curls, usually covered with a cloth and tied with ribbons, favoured by Sasanian kings.

dewlap The fold of loose skin on an animal's neck.

die A coin die is a piece of metal bearing an inverted design to be impressed on a flan (metal disc) in order to make a coin.

epigraphic A term referring to the evidence gained from inscriptions and graffiti.

demiurge The creator of the universe.

dexiosis A term derived from Greek that refers to the joining of right hands in a formal handshake.

farr The Middle Persian word for divine fortune or glory, Av. *khvarneh*.

Farsi The Modern Persian language.

fire temple A Zoroastrian place of worship.

glyptic Denoting carving or engraving, particularly referring to engraved designs on small precious objects such as gemstones.

haoma Av. name of a plant and its divinity, the divine sacrificer. The plant was crushed to form a drink with hallucinogenic effects prepared and drunk by priests during the most important Zoroastrian ceremonies. MP *hōm*.

harpē A type of sword or sickle.

hierothesion A Greek word for the royal burial sanctuaries of Commagene.

Hinduism A multi-denominational religious tradition and way of life that is particularly dominant in South Asia.

ivān A monumental arched space or recess, a feature of Sasanian architecture.

intrados An architectural term for the inner curve of an arch.

Islam A religion following the teachings of the prophet Mohammed as the messenger of God.

Jainism A religion that originated in India roughly contemporaneously to Buddhism.

khvarneh The **Avestan** word for divine fortune or glory. MP *farr*.

Mazdaism A term constructed in the nineteenth century to refer to **Zoroastrianism**, formed by taking part of the name of **Ahura Mazda**.

Middle Persian A western Iranian language that particularly came to prominence under the **Sasanian Empire**.

mithraeum A modern term to describe the sacred space of Roman Mithras worship.

Mithraism Scholarly shorthand for the collective worship of Mithras in the Roman Empire.

Mystery cult and/or religion A term used to describe a variety of ancient religious practices and beliefs that are thought to have been kept deliberately secret from outsiders or the uninitiated.

naos From the Greek for 'temple'; the inner room of a shrine in classical architecture.

numismatic Relating to (the evidence gained from) coins and tokens.

obverse and reverse The front and back of a coin.

Old Persian The language of the rulers of the Achaemenid Persian Empire (550–330 BC), written in cuneiform script.

Palmyrene A form of Middle Aramaic used as a written language in Palmyra.

Parthian A Middle Iranian language written in Aramaic script.

paradeisos Greek term deriving from **Old Persian** *pairidaida*, signifying a cultivated enclosure that functioned as a park and/or hunting ground for royalty and the elite.

propylaia A monumental gateway.

quadriga A Roman four-horse chariot.

spelaeum The Latin word for cave; one of two terms used by Roman worshippers of Mithras to describe their sacred space.

star-talk A term used to explain the astrological and astronomical understandings of Roman Mithraic iconography.

stele A stone or wooden slab, used as a monument, often for commemorative purposes.

stratēgos The Greek word for a military general; later expanded to also refer to military governors.

stupa A solid structure with a domed top resembling a mound. Stupas are central to Buddhist worship and often contain Buddhist relics.

Syriac A form of Middle Aramaic used extensively across the **Fertile Crescent**.

tabula ansata A shape resembling a rectangle with dove-tail handles. It was popular for votive dedications.

tamga An emblem or symbol to represent a family, particularly favoured by Central Asian nomadic tribes.

tauroctony A modern term used to describe the most common scene in the Roman worship of Mithras: the bull-wounding, or bull-killing.

temenos A Greek word designating a piece of land dedicated to a particular god or as a sanctuary.

templum A Latin word for a sanctuary or consecrated site; the other of the two terms used by Roman Mithras worshippers to describe their sacred space.

tirthankara In **Jainism**, a teacher who has conquered *saṃsāra* (the cycle of death and rebirth), literally meaning 'who makes a ford' across the cycle for others to follow.

thymiaterion An incense-burner.

Vedic Sanskrit An Indo-Aryan language related to **Avestan**, and the language in which the Vedas are written.

Yašt One of the twenty-one hymns in the **Avesta** to a specific deity, or *yazatā*.

Yasna Av. name of the most important Zoroastrian ceremony and the texts recited during its performance.

yazata A Zoroastrian divine being. Av. 'worthy of worship', pl. *yazatā*.

Zoroastrianism A religion following the teachings of the prophet **Zoroaster**.

GLOSSARY OF NAMES AND PLACES

Ādur Av. 'fire'. Zoroastrian *yazata* of fire. MP *Ātaš*.

Agni Vedic divinity of fire.

Ahriman MP name of the spirit of destruction. Av. Angra Mainyu.

Ahura Mazda The supreme Zoroastrian divinity, whose name means 'Wise Lord' or 'Lord Wisdom'.

Ameša Spentas Av. 'Bounteous Immortals'. The first and greatest six emanations or aspects of Ahura Mazda.

Anāhita Av. name of a female divinity associated with water, healing, fertility, and wisdom. MP Anāhid, Greek Anaïtis.

Apąm Napāt Av. name of the 'Son of the Waters'.

Apollo A divine name in the Greek and Roman tradition associated with numerous characteristics including the sun, music, healing, law, protecting cattle, and the planet Mercury.

Ardochsho Kushan goddess of plenty, with the typical attribute of a cornucopia.

Avesta A collection of Zoroastrian sacred texts, written in its own language and script.

Cautes and Cautopates The two torchbearers associated with Roman Mithras. They are usually shown with crossed legs, and seem to be connected with Mithraic mythology. Cautes holds an upturned torch, Cautopates a downturned torch.

Fertile Crescent A crescent-shaped area of fertile land in the Middle East and Western Asia, and along the river Nile.

Gaddé The Gaddé are representations of the fortune and prosperity of cities. In this way they are similar to the Greek **Tyche**.

Gathas Seventeen **Avestan** hymns believed to have been composed by **Zoroaster**.

Kushan Empire An empire formed in the early first century AD that encompassed modern Afghanistan, Pakistan, and substantial parts of northern India.

Kushānshāh 'King of the Kushans', Sasanian client king of Bactria.

Kushānshahr MP 'land of the Kushans'. A satrapy of the **Sasanian Empire** located in modern-day Pakistan and the surrounding area.

Mao The **Avestan** and Bactrian word both for the moon and its presiding deity.

Ohrmazd MP name for **Ahura Mazda**.

Nāgas A group of serpent deities found in **Hinduism**, **Buddhism**, and **Jainism**.

Parthian Empire The ruling dynasty of the Parthians, the Arsacids, established their kingdom *c.*247 BC in Parthia (now northeastern Iran and part of Turkmenistan) before expanding their empire westwards to the Euphrates in *c.*141 BC until their fall to the Sasanians in AD 224.

Qājārs Rulers of the Persian Empire from 1785–1925.

Rig Veda An ancient Indian collection of sacred hymns. It is one of the four canonical Hindu texts known as the Vedas.

Roman Empire Referring to both the geographic space and the temporal period of **Roman** power.

Saošyant The future saviour figure in **Zoroastrianism**.

Sasanian Empire Empire ruled by the Persian house of Sasan, AD 244–651.

Šāhanšāh MP 'King of Kings', title of the Sasanian king.

Shāhnāmeh A tenth-century epic poem written in early Modern Persian by Ferdowsi, which details the mythic history of Persia.

Seleucid Empire An empire of 311–63 BC founded by Seleucus I Nicator, a general of Alexander the Great, at one point spanning from Asia Minor to Bactria.

Śiva The Sanskrit word for 'the Auspicious One'; one of the three principal deities of **Hinduism**.

Surya The personification of the Sun in **Hinduism**.

Tyche The Greek and Roman representation of the fortune and prosperity of a city.

Verethragna A Zoroastrian *yazata* associated with victory, whose name in Avestan means 'smasher of obstacles'. MP 'Vahram'.

Wesho A divinity in the **Kushan** pantheon who is often associated with the Hindu god **Śiva**.

Zand MP commentary on the **Avesta**.

Zeus The supreme deity in the Greek tradition and language.

Zoroaster The prophet and founding figure of **Zoroastrianism**.

BIBLIOGRAPHY

ALVAR, J. E. (2008), *Romanising Oriental gods: myth, salvation and ethics in the cults of Cybele, Isis and Mithras*, trans. R. L. Gordon (Leiden: Brill).

ANDO, C. (2008), *The matter of the gods: religion and the Roman empire* (London: University of California Press).

ANDO, C. (2011), '*Praesentia numinis*. Part 2: objects in Roman cult', *Asdiwal* 6, 57–69.

ANDRADE, N. J. (2013), *Syrian identity in the Greco-Roman world* (Cambridge: Cambridge University Press).

ASIA SOCIETY (2011), *The Buddhist heritage of Pakistan: art of Gandhāra* (Bonn: Kunst- und Ausstellungshalle der Bundesrepublik).

AZAD, A. (2010), 'Three rock-cut cave sites and their Ilkhanid Buddhist aspects reconsidered', in A. Akasoy, C. Burnett, and R. Yoeli-Tlalim (eds), *Islam and Tibet: interactions along the musk routes* (Farnham: Ashgate), 209–30.

AZARNOUSH, M. (1986), 'Šāpur II, Ardašīr II, and Šāpur III: another perspective', *AMIT* 19, 219–47.

AZARPAY, G. (1982), 'The role of Mithra in the investiture and triumph of Šāpur II', *Iranica Antiqua* XVII, 181–7.

BADIAN, E. (1968), *Roman imperialism in the Late Republic*, 2nd edn (Ithaca: Cornell University Press).

BALL, W. (1979), 'The Imamzadeh Ma'sum at Vardjovi: a rock-cut Il-Khanid complex near Marghageh', *AMIT*, 12, 329–40.

BANERJEA, J. N. (1956), *The development of Hindu iconography* (Calcutta: University of Calcutta).

BASLER, Đ. (1972), *Arhitektura kasnoantičkog doba u Bosni i Hercegovini* (Sarajevo: Veselin Masleša).

BAUR, P., Rostovtzeff, M., and Bellinger, A. (1929–1944), *Excavations at Dura-Europos: preliminary report of [1st to 9th] season of work* (London: H. Milford; Oxford University Press).

BAUSANI, A. (1979), 'Note sulla preistoria astronomica del mito di Mithra', in U. Bianchi (ed.), *Mysteria Mithrae: Atti del Seminario Internazionale su 'La specificatà storico-religiosa dei Misteri di Mithra, con particolare riferimento alle fonti documentarie di Roma e Ostia', Roma e Ostia 28–31 Marzo 1978* (Leiden: Brill).

BEAL, S. (1911), *The life of Hiuen-Tsiang by the shaman Hwui Li* (London: Kegan Paul, Trench, Trübner).

BEARD, M., North, J., and Price, S. (1998), *Religions of Rome*, Vol. 1 (Cambridge: Cambridge University Press).

BECATTI, G. (1954), *Scavi di Ostia II. I Mitrei* (Roma: Libreria dello Stato).

BECK, R. (1976), 'A note on the scorpion in the tauroctony', *Journal of Mithraic Studies*, 1, 208–9.

BECK, R. (1984a), 'Mithraism since Franz Cumont', *Aufstieg und Niedergang der römischen Welt*, II.17.4, 2002–115.

BECK, R. (1984b), 'The rock-cut mithraea of Arupium (Dalmatia)', *Phoenix*, 38.4, 356–71.

BECK, R. (1988), *Planetary gods and planetary orders in the mysteries of Mithras* (Leiden: Brill).

BECK, R. (1994), 'In the place of the lion: Mithras in the Tauroctony', in J. R. Hinnells (ed.), *Studies in Mithraism: papers associated with the Mithraic Panel organized on the occasion of the XVIth Congress of the International Association for the History of Religions, Rome 1990* (Roma: 'L'Erma' di Bretschneider), 29–50.

BECK, R. (1998), 'The mysteries of Mithras: a new account of their genesis', *JRS*, 88, 115–28.

BECK, R. (2001), 'New thoughts on the genesis of the mysteries of Mithras', *Topoi*, 11, 59–76.

BECK, R. (2002), 'Mithraism', *EncIr* [accessed online: www.iranicaonline.org/articles/mithraism, March 2016].

BECK, R. (2004), *Beck on Mithraism: collected works with new essays* (Aldershot: Ashgate).

BECK, R. (2006), *The religion of the Mithras cult in the Roman empire: mysteries of the unconquered sun* (Oxford: Oxford University Press).

BEDJAN, P. (1968), *Acta Martyrum et Sanctorum 1–7* (Hildesheim: G. Olms).

BELMONTE, J. A. and Gonzalez Garcia, A. C. (2010), 'Antiochos' hierothesion at Nemrud Dag re-visited: adjusting the date in the light of new astronomical evidence', *Journal for the History of Astronomy*, 41.4, 469–81.

BETZ, H. D. (1991), 'Magic and Mystery in the Greek magical Papyri', in C. A. Faraone and D. Obbink (eds), *Magika Hiera: ancient Greek magic and religion* (Oxford: Oxford University Press) 244–59.

BETZ, H. D. (2003), *The 'Mithras liturgy': text, translation, and commentary* (Tübingen: Siebeck).

BIANCHI, U. (1979), *Mysteria Mithrae: Atti del Seminario Internazionale su 'La specificatà storico-religiosa dei Misteri di Mithra, con particolare riferimento alle fonti documentarie di Roma e Ostia', Roma e Ostia 28–31 Marzo 1978* (Leiden: Brill).

BIJAĐIJA, B. (2012), 'Roman religions and cults in Epidaurum', *Archaeologia Adriatica*, 6.1, 67–86.

BIVAR, A. D. H. (1969), *Stamp seals ii: the Sassanian dynasty* (London: Trustees of the British Museum).

BIVAR, A. D. H. (1975), 'Mithra and Mesopotamia', *Mithraic Studies*, II, 275–89.

BIVAR, A. D. H. (1979), 'Mithraic images of Bactria: are they related to Roman Mithraism?', in U. Bianchi (ed.), *Mysteria Mithrae: Atti del Seminario Internazionale su 'La specificatà storico-religiosa dei Misteri di Mithra, con particolare riferimento alle fonti documentarie di Roma e Ostia', Roma e Ostia 28–31 Marzo 1978* (Leiden: Brill), 741–52.

BIVAR, A. D. H. (1994), 'Towards an integrated picture of ancient Mithraism', in J. R. Hinnells (ed.), *Studies in Mithraism: papers associated with the Mithraic Panel organized on the occasion of the XVIth Congress of the International Association for the History of Religions, Rome 1990* (Roma: 'L'Erma' di Bretschneider), 60–73.

BIVAR, A. D. H. (1998), *The personalities of Mithra in archaeology and literature* (New York: Bibliotheca Persica Press).

BJORNEBYE, J. (2007), *Hic locus est felix, sanctus piusque benignus* (Bergen: University of Bergen).

BLÖMER, M. (2012), 'Religious life of Commagene in the late Hellenistic and early Roman period', in A. Merz and T. Tieleman (eds), *The letter of Mara bar Sarapion in context: proceedings of the symposium held at Utrecht University, 10–12 December 2009* (Leiden: Brill), 95–128.

BLÖMER, M. and Winter, E. (2011), *Commagene: the land of gods between the Taurus and the Euphrates* (Istanbul: Homer).

BOJANOVSKI, I. (1986), 'Epidauritana Archaeologia 1., O rimskoj cesti Epitauro—Resinum (Tab. Peut)', *Dubrovački horizonti* 26, 36–45.

BONNET, C. (2006), 'Les «Religions Orientales» au Laboratoire de L'Hellénisme. 2: Franz Cumont', *Archiv der Religionsgeschichte*, 8, 181–205.

BONNET, C., Rüpke, J., and Scarpi, P. (2006), *Religions orientales—culti misterici: neue Perspektive = nouvelles perspectives = prospettive nuove; im Rahmen des trilateralen Projektes 'Les religions orientales dans le monde gréco-romain'* (Stuttgart: Franz Steiner).

BOUCHÉ-LECLERQ, A. (1963), *L'astrologie grecque* (Brussels: Culture et Civilisation).

BOYCE, M. (1969), 'On Mithra's part in Zoroastrianism', *Bulletin of the School of Oriental and African Studies*, 32, 10–34.

BOYCE, M. (1975a), 'Iconoclasm among the Zoroastrians', in J. Neusner (ed.), *Christianity, Judaism, and other Greco-Roman cults: studies for Morton Smith at sixty* (Leiden: Brill), 93–111.

BOYCE, M. (1975b), 'On Mithra, lord of fire', in J. Duchesne-Guillemin (ed.), *Monumentum H. S. Nyberg*, Acta Iranica, 4, 69–76.

BOYCE, M. (1982), *A history of Zoroastrianism*, Vol. 2: *Under the Achaemenians* (Leiden: Brill).

BOYCE, M. (1984), 'Ahura Mazdā', *EncIr* [accessed online: www.iranicaonline.org/articles/ahura-mazda, March 2016].

BOYCE, M. (1990), 'Mithra Khšathrapati and his brother Ahura', *BAI*, 4, 3–10.

BOYCE, M. (1992), *Zoroastrianism: its antiquity and constant vigour*, Columbia Lectures on Iranian Studies 7 (Costa Mesa: Mazda).

BOYCE, M. (2005), 'Further on the calendar of Zoroastrian feasts', *Iran* 53, 138.

BOYCE, M. and Grenet, F. (1991), *A history of Zoroastrianism*, Vol. 3: *Zoroastrianism under Macedonian and Roman rule* (Leiden: Brill).

BOYCE, M. and Kotwal, F. M. P. (1971), 'Zoroastrian *bāj* and *drōn* II', *Bulletin of the School of Oriental and African Studies*, 34, 298–302.

BOŽIĆ, V. (2008), 'Sve´Cenici O Špiljama U Hrvatskoj', *The Review of Senj* 35.1, 345–64.

BRACEY, R. (2012), 'Policy, patronage and the shrinking pantheon of the Kushans', in V. Jayaswal (ed.), *Glory of the Kushans: recent discoveries and interpretations* (New Delhi: Aryan Books), 197–217.

BRACEY, R. (2013), 'E.G1-v Huvishka's Late Phase V gold mint: procedures and practice. What do we know? Should anyone care?', presentation to the Oriental Numismatic Society <http://tinyurl.com/zo2a72m>.

BRASHEAR, W. M. (1992), *A Mithraic catechism from Egypt: (P. Berol. 21196)* (Vienna: Wien: Verlag Adolf Holzhausens Nfg).

BRAUND, D. (1984), *Rome and the friendly king: the character of the client kingship* (London: Croom Helm).

BREASTED, J. H. (1916), *Ancient times, a history of the early world* (Boston: Ginn and Company).

BREYER, R. (2001), 'Mithras—der Nachthimmel? Auseinandersetzung mit Maria Weiss', *Klio* 83, 213–18.

BRIJDER, H. A. G. (2014), *Nemrud Dağı: recent archaeological research and conservation activities in the tomb sanctuary on Mount Nemrud* (Berlin: Walter de Gruyter).

BROCK, S. (1978), 'A martyr at the Sasanian court under Vahrām II: Candida', *Analecta Bollandiana*, 96, 167–81.

BRODY, L. R. and Hoffman, G. L. (2011), *Dura Europos: crossroads of antiquity* (Chestnut Hill, MA: McMullen Museum of Art, Boston College).

BURKERT, W. (1987), *Ancient mystery cults* (Cambridge: Harvard University Press).

BUTCHER, K. (2004), *Coinage in Roman Syria. Northern Syria, 64 BC–AD 253* (London: Royal Numismatic Society).

CALLIERI, P. (1990), 'On the diffusion of Mithra images in Sasanian Iran. New evidence from a seal in the British Museum', *East and West*, 40, 79–98.

CALLIERI, P. (2006), 'Water in the art and architecture of the Sasanians', in A. Panaino and A. Pirasi (eds), *Proceedings of the 5th conference of the Societas Iranologica Europaea held in Ravenna, 6–11 October 2003. Vol. 1: Ancient and Middle Iranian Studies* (Milan: Mimesis), 339–49.

CALLIERI, P. (2014), *Architecture et représentations dans l'Iran sassanide*, Studia Iranica Cahier 50 (Paris: Association pour l'avancement des études iraniennes).

CALMEYER, P. (1977), 'Vom Reisehut zur Kaiserkrone: B. Stand der archäologischen Forschung zu den iranischen Kronen', *AMI*, 10, 168–90.

CAMBI, N. (2006), 'Antički Epidaur', *Dubrovnik, časopis za književnost i znanost* 3.17, 185–217.

CAMBON, P. (2007a), 'Tillya Tepe', in P. Cambon and J-F. Jarrige (eds), *Afghanistan: hidden treasures from the National Museum, Kabul* (Amsterdam: De Nieuwe Kerk), 153–227.

CAMBON, P. (2007b), 'Begrām', in P. Cambon and J-F. Jarrige (eds), *Afghanistan: hidden treasures from the National Museum, Kabul* (Amsterdam: De Nieuwe Kerk), 229–77.

CAMPBELL, L. (1954), *Typology of Mithraic tauroctonies*. Berytus 11 (Copenhagen: The Museum of Archaeology of the American University of Beirut).

CAMPBELL, L. (1968), *Mithraic iconography and ideology* (Leiden: Brill).

CANEPA, M. P. (2009), *Two eyes of the earth: competition and exchange in the art and ritual of kingship between Rome and Sasanian Iran* (Berkeley: University of California Press).

CANEPA, M. P. (2013), 'Sasanian rock reliefs', in D. T. Potts (ed.), *Oxford handbook of Ancient Iran* (Oxford: Oxford University Press), 856–77.

CANEPA, M. P. (2015), 'Dynastic sanctuaries and the transformation of Iranian kingship between Alexander and Islam', in S. Babaie and T. Grigor (eds), *Persian kingship and*

architecture: strategies of power in Iran from the Achaemenids to the Pahlavis (London: I. B. Tauris), 65–118.

CARTER, M. L. (1981), 'Mithra on the lotus', *Acta Iranica*, 21, 74–98.

CAYLUS, A. C. P. Comte de (1759), *Recueil d'antiquités égyptiennes, étrusques, grecques, romaines et gauloises* 3 (Paris: Chez Desaint and Saillant).

ÇEVIK, N. (2014), 'Nemrud Dağ of Commagene: *dexiosis* of east and west', in P. Leriche (ed.), *Art et civilisations de l'Orient Hellénisé: rencontres et échanges culturels d'Alexandre aux Sassanides. Hommage à Daniel Schlumberger* (Paris: Picard), 185–90.

CHALUPA, A. (2008), 'Seven Mithraic grades: an initiatory or priestly hierarchy?', *Religio*, XVI.2, 177–201.

CHAPMAN-RIETSCHI, P. A. L. (1997), 'Astronomical conceptions in Mithraic iconography', *Journal of the Royal Astronomical Society of Canada*, 91, 133–4.

CHRISTENSEN, A. (1936), *L'Iran sous les Sassanides* (Copenhagen: Levin and Munksgaard).

CLAUSS, M. (1990a), *Cultores Mithrae. Die Anhängerschaft des Mithras-Kultes.* Heidelberger Althistorische Beiträge Und Epigraphische Studien 10 (Stuttgart: Franz Steiner).

CLAUSS, M. (1990b), 'Die sieben Grade des Mithras-Kultes', *Zeitschrift für Papyrologie und Epigraphik*, 82, 183–94.

CLAUSS, M. (2000), *The Roman cult of Mithras: the god and his mysteries*, translated by Richard Gordon (Edinburgh: Edinburgh University Press).

CLAUSS, M. (2012), *Mithras: Kult und Mysterium* (Darmstadt/Mainz: Philipp von Zabern).

COHEN, G. M. (2006), *The Hellenistic settlements in Syria, the Red Sea basin, and north Africa* (Berkeley: University of California Press).

COOMERASWAMY, A. (1922), 'Recent acquisitions of the Department of Art', *Museum of Fine Arts Bulletin*, 20.122, 69–73.

COYAJEE, J. G. (1926), 'The supposed sculpture of Zoroaster at Tak-i Bostan', *Journal and Proceedings of the Asiatic Society of Bengal*, 22.6, 391–409.

CRIBB, J. (1997), 'Shiva images on Kushan and Kushano-Sasanian coins', in K. Tanabe, J. Cribb, H. Wang (eds), *Studies in Silk Road coins and culture, papers in honour of Professor Ikuo Hirayama on his 65th birthday* (Kamakura: Institute of Silk Road Studies), 11–66.

CRIBB, J. (2007), 'Rediscovering the Kushans', in E. Errington and V. S. Curtis (eds), *From Persepolis to Punjab: exploring ancient Iran, Afghanistan and Pakistan* (London: British Museum), 179–210.

CRIJNS, M. (2014), 'Astro-religion in Commagene', in H. A. G. Brijder. (ed.), *Nemrud Dağı: recent archaeological research and conservation activities in the tomb sanctuary on Mount Nemrud* (Berlin: Walter de Gruyter), 563–99.

CROWTHER, C. (2003), 'Inscriptions of Antiochus I of Commagene and other epigraphical finds', in J. H. Humphrey (ed.), *Zeugma: interim reports.* JRA Supplement 51 (Portsmouth: Journal of Roman Archaeology), 57–67.

CROWTHER, C. (2013), 'Inscriptions on stone', in W. Aylward (ed.), *Excavations at Zeugma.* Vol. 1 (Los Altos: The Packard Humanities Institute), 192–219.

CROWTHER, C. and Facella, M. (2003), 'New evidence for the ruler cult of Antiochus of Commagene from Zeugma', in G. Heedemann and E. Winter (eds), *Neue Forschungen*

zur Religionsgeschichte Kleinasiens: E. Schwertheim zum 60. Geburtstag gewidmet. Asia Minor Studien 49 (Bonn: Rudolf Habelt), 41–80.

CROWTHER, C. and Facella, M. (2011), 'A new Commagenian nomos text from Samosata', in E. Winter (ed.), *Von Kummuḥnach Telouch. Historische und archäologische Untersuchungen in Kommagene*. Asia Minor Studien 64 (Bonn: Rudolf Habelt), 355–66.

CROWTHER, C. and Facella, M. (2012), 'Die Heiligtümer des Antiochos I. im Spiegel neuer epigraphischer Funde', in J. Wagner (ed.), *Gottkönige am Euphrat: neue Ausgrabungen und Forschungen in Kommagene* (Darmstadt/Mainz: Philipp von Zabern), 71–6.

CUMONT, F. (1896–1899), *Textes et monuments figurés relatifs aux mystères de Mithra* (Brussels: H. Lamertin).

CUMONT, F. (1903), *The mysteries of Mithra* (London: Kegan Paul, Trench, Trübner).

CUMONT, F. (1911), *The Oriental religions in Roman paganism*, trans. G. Showerman (Chicago: The Open Court Publishing Company).

CUMONT, F. (1935), 'Les noms des planètes et l'astrolatrie chez les Grecs', *L'Antiquité Classique*, 4, 5–43.

CUMONT, F. (1946), 'Un bas-relief mithriaque du Louvre', *Revue Archéologique*, 25, 183–95.

CUMONT, F. (1975), 'The Dura Mithraeum', *Mithraic Studies*, I, 151–214.

CUNNINGHAM, A. (1893), 'Later Indo-Scythians', *Numismatic Chronicle*, 13, 93–128.

CURTIS, V. S. (2008), 'Royal and religious symbols on early Sasanian coins', in D. Kennet and P. Luft (eds), *Current research in Sasanian archaeology, art and history. Proceedings of a conference held at Durham University, November 3rd and 4th, 2001 organized by the Centre for Iranian Studies, IMEIS and the Department of Archaeology of Durham University* (Oxford: BAR International Series 1810, Archaeopress), 137–47.

DE GROSSI MAZZORIN, J. and Minniti, C. (2004), 'Lo studio dei resti animali', in N. Parmegiani and A. Pronti (eds), *S. Cecilia in Trastevere nouvi scavi e ricerche* (Città del Vaticano: Pontificio istituto di archeologia cristiana).

DE JONG, A. (1997), *Traditions of the Magi* (Leiden: Brill).

DHALLA, M. N. (1930), 'The nimbus-crowned figure at Tak-i Bostan', in D. P. Sanjana (ed.), *Dr. Modi memorial volume: papers on Indo-Iranian and other subjects* (Bombay: Fort Printing Press), 62–7.

DIETER BETZ, H. (1968), 'The Mithras inscriptions of Santa Prisca and the New Testament', *Novum Testamentum*, 10, 62–80.

DIRVEN, L. (1999), *The Palmyrenes of Dura-Europos: a study of religious interaction in Roman Syria* (Leiden: Brill).

DÖRNER, F. K. (1963), 'Kultinschrift von Antiochus I von Kommagene für das Hierothesion des Mithradates Kallinikos in Arsameia am Nymphaios', in F. K. Dörner and T. Goell (eds) *Arsameia am Nymphaios: die Ausgrabungen im Hierothesion des Mithradates Kallinikos von 1953–1956* (Berlin: Gebr. Mann), 36–92.

DÖRNER, F. K. (1978), 'Mithras in Kommagene', in J. Duchesne-Guillemin (ed.), *Études Mithriaques. Actes du 2e congrès international, Téhéran, du 1er au 8 septembre 1975*, Acta Iranica 1 (Leiden: Brill), 123–33.

DÖRNER, F. K. and Dörner, E. (1989), *Von Pergamon zum Nemrud Daǧ: die archäologischen Entdeckungen Carl Humanns* (Darmstadt/Mainz: Philipp von Zabern).

DÖRNER, F. K. and Goell, T. (1963), *Arsameia am Nymphaios: die Ausgrabungen im Hierothesion des Mithradates Kallinikos von 1953–1956* (Berlin: Gebr. Mann).

DÖRNER, F. K., Goell, T., and Höpfner, W. (1983), *Arsameia am Nymphaios* (Tübingen: E. Wasmuth).

DÖRNER, F. K. and Naumann, R. (1939), *Forschungen in Kommangene* (Berlin: Deutsches Archäologisches Institut).

DÖRNER, F. K. and von Assaulenko, A. (1967), *Kommagene: ein wiederentdecktes Königreich* (Böblingen: Codex-Verlag).

DOWNEY, S. (1977), *The excavations at Dura Europos: the stone and plaster sculpture* (Los Angeles, CA: Institute of Archaeology, University of California).

DOWNEY, S. (1978), 'Syrian images of Mithras Tauroctonos', in J. Duchesne-Guillemin (ed.), *Études Mithriaques. Actes du 2e congrès international, Téhéran, du 1er au 8 septembre 1975,* Acta Iranica 1 (Leiden: Brill), 135–50.

DOWNEY, S. (1997), 'Nemrud Daği: the hierothesion of Antiochus I of Commagene (Book Review)', *Bulletin of the American Schools of Oriental Research*, 307, 94–5.

DUCHESNE-GUILLEMIN, J. (1962), *La religion de l'Iran ancien* (Paris: Presses universitaires de France).

DUCHESNE-GUILLEMIN, J. (1971), 'Art et religion sous les Sassanides', *Atti del Convegno internazionale sul tema: La Persia nel Medioevo. (Roma, 31 marzo–5 aprile 1970)* (Rome: Accademia Nazionale dei Lincei), 377–88.

DUCHESNE-GUILLEMIN, J. (1978), 'Iran and Greece in Commagene', in J. Duchesne-Guillemin (ed.), *Études Mithriaques. Actes du 2e congrès international, Téhéran, du 1er au 8 septembre 1975*, Acta Iranica 1 (Leiden: Brill), 187–204.

ELLIS, H. (1836), *The British Museum: the Townley gallery*, 2 vols (London: W. Clowes and Sons).

ELSNER, J. (1995), *Art and the Roman viewer* (Cambridge: Cambridge University Press).

ELSNER, J. (1996), 'Image and ritual: reflections on the religious appreciation of Classical art', *Classical Quarterly*, 46, 515–31.

ELSNER, J. (2007), *Roman eyes: visuality and subjectivity in art and text* (Princeton: Princeton University Press).

ELSNER, J. (2012), 'Sacrifice in Late Roman art', in C. Faraone and F. Naiden (eds), *Greek and Roman animal sacrifice: ancient victims, modern observers* (Cambridge: Cambridge University Press), 120–66.

ERDMANN, K. (1948), 'Sasanidische Felsreliefs—Römische Historienreliefs', *Antike und Abendland*, 3, 75–87.

ERIM, K. T. (1982), 'A new relief showing Claudius and Britannia from Aphrodisias', *Britannia*, 13, 277–81.

ERRINGTON, E. and Cribb, J. (1992), *The crossroads of Asia: transformation in image and symbol in the art of ancient Afghanistan and Pakistan* (Cambridge: The Ancient India and Iran Trust).

EVANS, A. J. (1883), *Antiquarian researches in Illyricum: I Epitaurum, Canali and Risinium* (Westminster: Society of Antiquaries of London).

FACELLA, M. (2005), 'Philorōmaios kaì philéllēn: Roman perception of Commagenian royalty', in O. Hekster (ed.), *Imaginary kings: royal images in the Ancient Near East, Greece and Rome* (Stuttgart: Franz Steiner), 87–104.

FACELLA, M. (2006), *La dinastia degli Orontidi nella Commagene ellenistico-romana* (Pisa: Gardini).

FACELLA, M. (2015), 'Defining new gods: The daimones of Antiochus', in M. Blömer, A. Lichtenberger, and R. Raja (eds), *Religious identities in the Levant from Alexander to Muhammed: continuity and change* (Turnhout: Brepols), 169–84.

FARAONE, C. (2013), 'The amuletic design of the Mithraic bull-wounding scene', *JRS*, 103, 96–116.

FINK, R. O., Hoey, A. S., and Snyder, W. F. (1940), *The Feriale Duranum* (New Haven: Yale University Press).

FLANDIN, E. N. (1851), *Voyage en Perse de mm. E. Flandin et P. Coste, 1840 et 1841. Relation du voyage, par E. Flandin* (Paris: Gide et Jule Bardry).

FLANDIN, E. N. and Coste, P. (1851), *Voyage en Perse de MM. Eugène Flandin, peintre, et Pascal Coste, architecte attachés a l'ambassade de France en Perse pendant les années 1840 et 1841* (Paris: Gide et Jule Bardry).

FOUCAULT, M. (1970), *The order of things: an archaeology of the human sciences* (London: Tavistock).

FREDUNBEG, M. K. (1900), *The Chachnamah: an ancient history of Sind: giving the Hindu period down to the Arab conquest* (Karachi: Commissioner's Press).

FRYE, R. N. (1978), 'Mithra in Iranian archaeology', in J. Duchesne-Guillemin (ed.), *Études Mithraiques. Actes du 2e congrès international, Téhéran, du 1er au 8 septembre 1975*, Acta Iranica 1 (Leiden: Brill), 205–11.

FUKAI, S. and Horiuchi, K. (1972), *Taq-i-Bustan II—Plates*, the Tokyo University Iraq-Iran Archaeological Expedition, Report 13 (Tokyo: Institute of Oriental Culture, University of Tokyo).

FUKAI, S., Horiuchi, K., Tanabe, K., and Domyo, M., (1984), *Taq-i-Bustan: IV—Text*, the Tokyo University Iraq-Iran Archaeological Expedition, Report 19 (Tokyo: Institute of Oriental Culture, University of Tokyo).

FUKAI, S. and Sugiyama, J., Kimata, K., and Tanabe K. (1983), 'Taq-i-Bustan: III— Photogrammetric elevations', the Tokyo University Iraq-Iran Archaeological Expedition, Report 19 (Tokyo: Institute of Oriental Culture, University of Tokyo).

GARDNER, P. (1878), *Catalogue of Greek coins: the Seleucid kings of Syria* (London: Trustees of the British Museum).

GARDNER, P. (1886), *Catalogue of Indian coins in the British Museum: Greek and Scythic kings of Bactria and India* (London: Trustees of the British Museum).

GAWLIKOWSKI, M. (2007), 'The mithraeum at Hawarti and its paintings', *JRA*, 20, 337–61.

GOELL, T. (1957), 'The excavation of the "hierothesion" of Antiochus I of Commagene on Nemrud Dagh (1953–1956)', *Bulletin of the American Schools of Oriental Research*, 147, 4–22.

GERSHEVITCH, I. (1959), *The Avestan hymn to Mithra* (Cambridge: Cambridge University Press).

GERSHEVITCH, I. (1979), 'Nokonzok's well', *Afghan Studies*, 2, 54–73.

GHIRSHMAN, R. (1978), 'The cult of Mithra in Iran', in J. Duchesne-Guillemin (ed.), *Études Mithriaques. Actes du 2e congrès international, Téhéran, du 1er au 8 septembre 1975*, Acta Iranica 1 (Leiden: Brill), 213.

GIGNOUX, P. (1978), *Catalogue des sceaux, camées et bulles sasanides de la Bibliothèque nationale et du Musée du Louvre* (Paris: Bibliothèque nationale).

GIGNOUX, P. and Gyselen, R. (1989), 'Sceaux de femmes à l'époque sassanide', in L. de Meyer and E. Haerinck (eds), *Archaeologia Iranica et Orientalis: miscellanea in honorem Louis vanden Berghe* (Gent: Peeters), 877–96.

GNOLI, G. (2000), *Zoroaster in history* (New York: Bibliotheca Persica Press).

GÖBL, R. (1984), *System und der Chronologie der Münzpgrägung des Kušanreiches* (Vienna: Österreichische Akademie der Wissenschaften).

GORDON, R. L. (1975), 'Franz Cumont and the doctrines of Mithraism', *Mithraic Studies*, I, 215–48.

GORDON, R. L. (1976), 'The sacred geography of a *mithraeum*: the example of Sette Sfere', *Journal of Mithraic Studies*, 1, 119–65.

GORDON, R. L. (1977–1978), 'The date and significance of *CIMRM* 593', *Journal of Mithraic Studies*, 2, 148–74.

GORDON, R. L. (1979), 'The real and the imaginary: production and religion in the Graeco-Roman world', *Art History*, 2, 5–34.

GORDON, R. L. (1980), 'Panelled complications', *Journal of Mithraic Studies*, 3, 200–27.

GORDON, R. L. (1988), 'Authority, salvation and mystery in the mysteries of Mithras', in J. Huskinson, M. Beard, and J. Reynolds (eds), *Image and mystery in the Roman world* (Cambridge: Cambridge University Press), 45–80.

GORDON, R. L. (2003), 'Review: probably not Mithras (reviewed work: The "Mithras Liturgy". Text, Translation, and Commentary by H. D. Betz)', *The Classical Review*, 55, 99–100.

GORDON, R. L. (2007a), 'Institutionalized religious options: Mithraism', in J. Rüpke (ed.), *A companion to Roman religion* (Oxford: Blackwell).

GORDON, R. L. (2007b), 'Mithras in Dolichê. Issues of date and origin, review of "Doliche. eine Kommagenische Stadt und ihre Götter. Mithras und Iupiter Dolichenus,"' *JRA*, 20, 602–10.

GORDON, R. L. (2012), 'Mithras', *Reallexikon für Antike und Christentum* XXIV (Stuttgart: Hersemann), 964–1009.

GRENET, F. (1984), 'Notes sur le panthéon iranien des Kouchans', *Studia Iranica*, 14.2, 253–62.

GRENET, F. (1991), 'Mithra au temple principal d'Ai Khanoum?', in F. Grenet and P. Bernard (eds), *Histoire et cultes de l'Asie centrale preislamique. Sources écrites et documents archéologiques: actes du Colloque internationale du CNRS (Paris, 22–28 novembre 1988)* (Paris: Éditions du CNRS), 147–52.

GRENET, F. (1993), 'Bamiyan and the Mihr Yasht', *BAI*, 7, 87–94.

GRENET, F. (2001), 'Mithra, dieu iranien: nouvelles données', *Topoi*, 11, 35–58.

GRENET, F. (2006), 'Mithra ii. Iconography in Iran and central Asia', *EncIr* [accessed online www.iranicaonline.org/articles/mithra-2-iconography-in-iran-and-central-asia, March 2016].

GUTMANN, J. (1992), *The Dura-Europos synagogue: a re-evaluation (1932–1992)* (Atlanta, GA: Scholars Press).

GYSELEN, R. (2008), 'The great families in the Sasanian empire: some sigillographic evidence', in D. Kennet and P. Luft (eds), *Current research in Sasanian archaeology, art and history. Proceedings of a conference held at Durham University, November 3rd and 4th, 2001 organized by the Centre for Iranian Studies, IMEIS and the Department of Archaeology of Durham University* (Oxford: BAR International Series 1810, Archaeopress), 107–10.

HACKIN, J. (1939), *Recherches archéologiques à Begrām*, Mémoires de la Délégation Archéologique Française eń Afghanistan 9 (Paris: Les Éditions d'art et d'histoire).

HACKIN, J. (1954), *Nouvelles recherches archéologiques à Begrām*, Mémoires de la Délégation Archéologique Française en Afghanistan 11 (Paris: Impr. nationale).

HARMATTA, J., Puri, B. N., Lelekov, L., Humayn, S., and Sircar, D. C. (1994), 'Religions in the Kushan Empire', in J. Harmatta (ed.), *History of civilizations of central Asia II: the development of sedentary and nomadic civilizations: 700 B.C. to A.D. 250* (Paris: Unesco), 305–22.

HARPER, P. O. (1978), *The royal hunter: art of the Sasanian empire* (New York: Asia Society).

HENNING, W. B. (1951), *Zoroaster: politician or witch-doctor? Ratanbai Katrak lectures 1949* (London: Oxford University Press).

HERRMANN, G. and Curtis, V. S. (2002), 'Sasanian rock reliefs', *EncIr* [accessed online: www.iranicaonline.org/articles/sasanian-rock-reliefs, March 2016].

HERZFELD, E. (1920), *Am Tor von Asien* (Berlin: D. Reimer).

HILLERS, D. R. and Cussini, E. (1996), *Palmyrene Aramaic texts (PAT)* (Baltimore: Johns Hopkins University Press).

HINNELLS, J. R. (1975a), *Mithraic studies: proceedings of the First International Congress of Mithraic Studies*, 2 vols (Manchester: Manchester University Press).

HINNELLS, J. R. (1975b), 'Reflections on the bull-slaying scene', *Mithraic Studies*, 1, 290–312.

HÖRIG, M. and Schwertheim, E. (1987), *Corpus Cultus Iovis Dolicheni (CCID)*, Études préliminaires aux religions orientales dans l'Empire romain 106 (Leiden: Brill).

HUMANN, K. and Puchstein, O. (1890), *Reisen in Kleinasien und Nordsyrien: ausgeführt im Auftrage der Kgl. preussischen Akademie der Wissenschaften* (Berlin: Reimer).

HUMBACH, M. (1975), 'Mithra in the Kuṣāna period', *Mithraic Studies*, 1, 135–41.

HUNTINGTON, S. L. (1985), *The art of ancient India* (Weatherhill: New York).

JACKSON, A. V. W. (1899), *Zoroaster, the prophet of ancient Iran* (New York: Columbia University Press).

JACOBS, B. (1997), 'Beobachtungen zu den Tuffitskulpturen vom Nemrud Dağı', *Istanbuler Mitteilungen* 47, 171–8.

JACOBS, B. (2000a), 'Das Heiligtum auf dem Nemrud Dağı: zue Baupolitik des Antiochos I. von Kommagene und seines Sohnes Mithradates II', in J. Wagner (ed.), *Gottkönige*

am Euphrat, Sonderbände der Antiken Welt—Zaberns Bildbände zur Archäologie (Mainz: Philipp von Zabern), 27–36.

JACOBS, B. (2000b), 'Die Religionspolitik des Antiochus I. von Kommagene', in J. Wagner (ed.), *Gottkönige am Euphrat*, Sonderbände der Antiken Welt—Zaberns Bildbände zur Archäologie (Mainz: Philipp von Zabern), 45–9.

JACOBS, B. and Rollinger, R. (2005), 'Die "himmlischen Hände" der Götter—Zu zwei neuen Datierungsvorschlägen für die kommagenischen Reliefstelen', *Parthica*, 7, 137–54.

JENKINS, G. K. (1964), 'Coins from the collection of C. J. Rich', *British Museum Quarterly*, 28, 88–94.

JONGEWARD, D., Errington, E., Salmon, R., and Baums, S. (2012), *Gandhāran Buddhist reliquaries*, Early Buddhist Manuscripts Project (Seattle: University of Washington Press).

JONGEWARD, D. and Cribb, J. (2014), *Kushan, Kushano-Sasanian, and Kidarite coins: a catalogue of coins from the American Numismatic Society* (New York: The American Numismatic Society).

JOYCE, J. W. (2008), *Thebaid: a song of Thebes* (Ithaca: Cornell University Press).

JUSTI, F. (1904), 'The life and legend of Zarathustra', *Avesta, Pahlavi and ancient Persian studies in honour of Dastur P B Sanjana* (London: Williams and Norgate), 117–58.

KAIZER, T. (2002), *The religious life of Palmyra* (Stuttgart: Franz Steiner).

KER PORTER, R. (1822), *Travels in Georgia, Persia, Armenia, ancient Babylonia, &c. &c. during the years 1817, 1818, 1819, and 1820*, II (London: Longman).

KHATIBI, A. (2001–2002), 'Donyā-ye Por-ramz o Rāz-e Mehr "The mysterious world of Mithra"—review in Farsi of A. D. H. Bivar, "The personalities of Mithra in archaeology and literature"', *Iranica Antiqua* 18, 177–8', *Nāme-ye Irān-e Bāstān* 1.2, 41–54.

KING, C. (2003), 'The organization of Roman religious beliefs', *Classical Antiquity*, 22, 275–312.

KOTWAL, F. M. P. and Kreyenbroek, P. G. (2009), *The Hērbedestān and Nērangestān*, Vol. 4: *Nerangestan, fragard 3*, Studia Iranica 38 (Paris: Association pour l'avancement des études iraniennes).

KREYENBROEK, P. (2011), 'Some remarks on water and caves in pre-Islamic Iranian religions', *AMIT*, 43, 157–64.

KROPP, A. J. M. (2013), *Images and monuments of Near Eastern dynasts, 100 BC–AD 100* (Oxford: Oxford University Press).

KULKE, H. and Rothermund, D. A. (1986), *A history of India* (London: Croon Helm).

LAVAGNE, H. (1976), 'Éléments nouveaux au dossier iconographique du mithraeum de Bourg-Saint-Andéol (Ardèche)', *Journal of Mithraic Studies*, 1, 222–4.

LE GLAY, M. (1982), 'Remarques sur la notion de Salus dans la religion romaine', in U. Bianchi and M. J. Vermaseren (eds), *La soteriologia dei culti orientali nell' imperio romano: atti del Colloquio internazionale su la soteriologia dei culti orientali nell'Impero romano, Roma, 24–28 settembre 1979: pubblicati*, Études préliminaires aux religions orientales dans l'empire romain 92 (Leiden: Brill), 427–44.

LEE, S. E. (1967), 'Clothed in the sun: a Buddha and a Surya from Kashmir', *The Bulletin of the Cleveland Museum of Art*, 54.2, 42–63.

Lentacker, W., Ervynck, A., and Van Neer, A. (2004), 'The symbolic meaning of the cock. The animal remains from the mithraeum at Tienen (Belgium)', in M. Martens and G. de Boe (eds), *Roman Mithraism: the evidence of the small finds* (Brussels: Museum Het Toreke).

Leriche, P. (2001), 'Observations sur le mithraeum de Doura-Europos', *Topoi*, 11.1, 195–203.

Li Rongxi (1996), *The great Tang dynasty record of the western regions* (Hamburg: Numata Center for Buddhist Translation and Research).

Lincoln, B. (1991), 'Mithras as sun and savior', in B. Lincoln (ed.), *Death, war, and sacrifice: studies in ideology and practice* (Chicago: Chicago University Press), 6–95.

Lissi-Caronna, E. (1986), *Il Mitreo dei 'Castra Peregrinorum' (S. Stephano Rotondo)*, Études préliminaires aux religions orientales dans l'empire romain 104 (Leiden: Brill).

Loisy, A. (1911), *Á propos d'histoire des religions* (Paris: Nourry).

Lukonin, V. G. (1967), 'Kushano-sasanidskie monety', *Epigrafika Vostoka*, 18, 16–33.

Luschey, H. (1974), 'Bisutun, Geschichte und Forschungsgeschichte', *Archäologischer Anzeiger* 89, 114–49.

Luschey, H. (1979), 'Das Qadjarische Palais am Taq-i Bostan', *AMI*, 12, 395–414.

MacDowall, D. W. (1975), 'The role of Mithra among the deities of the Kuṣāna coinage', *Mithraic Studies*, 1, 142–50.

Macmullen, R. (1981), *Paganism in the Roman empire* (New Haven: Yale University Press).

Markel, S. (1995), *Origins of the Indian planetary deities* (Lampeter: Edwin Mallen Press).

Martin, L. (1994), 'Reflections on the Mithraic tauroctony as a cult scene', in J. R. Hinnells (ed.), *Studies in Mithraism: papers associated with the Mithraic Panel organized on the occasion of the XVIth Congress of the International Association for the History of Religions, Rome 1990* (Roma: 'L'Erma' di Bretschneider), 217–24.

Martin, L. (2015), *The mind of Mithraists: historical and cognitive studies in the Roman cult of Mithras* (London: Bloomsbury Academics).

Mathiesen, H. E. (1992), *Sculpture in the Parthian empire: a study in chronology* (Aarhus: Aarhus University Press).

Merkelbach, R. (1984), *Mithras* (Königstein/Ts: Hain).

Millar, F. (1993), *The Roman Near East, 31 BC–AD 337* (Cambridge, MA; London: Harvard University Press).

Modi, J. J. (1922), *The religious ceremonies and customs of the Parsees* (Bombay: British India Press).

Mordini, A. (1967), 'Gold Kushana coins in the convent of Dabra Dammo', *Journal Numismatic Society of India*, 29.2, 19–26.

Moorey, P. R. S. (1979), 'Aspects of worship and rituals on Achaemenid seals', *AMIT*, 6, 218–26.

Moormann, E. M. and Versluys, M. J. (2002), 'The Nemrud Dag Project: first interim report', *Bulletin Antieke Beschaving: Annual Papers on Mediterranean Archaeology*, 77, 73–111.

Moormann, E. M. and Versluys, M. J. (2003), 'The Nemrud Dag Project: second interim report', *Bulletin Antieke Beschaving: Annual Papers on Mediterranean Archaeology*, 78, 141–66.

MOORMANN, E. M. and Versluys, M. J. (2005), 'The Nemrud Dag Project: third interim report', *Bulletin Antieke Beschaving: Annual Papers on Mediterranean Archaeology*, 80, 125–43.

MOSTELLER, J. F. (1991), *The Measure of form* (New Delhi: Abhinav Publications).

NAGAR, S. L. (1995), *Sūrya and sun cult: in Indian art, culture, literature, and thought* (New Delhi: Aryan Books International).

NAIDEN, F. S. (2013), *Smoke signals for the gods: ancient Greek sacrifice from the Archaic through Roman periods* (Oxford: Oxford University Press).

NEELIS, J. (2011), *Early Buddhist transmission and trade networks: mobility and exchange within and beyond the northwestern borderlands of south Asia* (Leiden: Brill).

NEHRU, L. (2006), 'Khalchayan', *EncIr* [accessed online: www.iranicaonline.org/articles/khalchayan, March 2016].

NYBERG, H. S. (1938), *Die religionen des Altes Iran* (Leipzig: J. C. Hinrichs Verlag).

OVERLAET, B. (2011), 'Ardašir II or Šāpur III? Reflections on the identity of a king in the smaller grotto at Taq-i Bustan', *Iranica Antiqua*, 46, 235–50.

OVERLAET, B. (2012), 'Ahura Mazda and Šāpur II? A note on Taq-i Bustan I, the investiture of Ardašir II (379–383)', *Iranica Antiqua*, 47, 133–51.

PALMER, G. (2009), 'Why the shoulder? A study of the placement of the wound in the Mithraic tauroctony', in G. Casadio and P. A. Johnston (eds), *Mystic cults in Magna Graecia* (Austin, TX: University of Texas Press).

PANCIERA, S. (1979), 'Il materiale epigrafico dallo scavo del mitreo di S. Stefano Rotondo (con un addendum sul verso terminante sanguine fuso)', in U. Bianchi (ed.), *Mysteria Mithrae: Atti del Seminario Internazionale su 'La specificatà storico-religiosa dei Misteri di Mithra, con particolare riferimento alle fonti documentarie di Roma e Ostia', Roma e Ostia 28–31 Marzo 1978*, Études préliminaires aux religions orientales dans l'empire romain 80 (Leiden: Brill), 87–126.

PATSCH, C. (1924), 'Drei Bosnische Kultstätten. 1. Mithras-Waldandacht', *Wiener Zeitschrift für die Kunde des Morgenlandes*, 31.1, 137–41.

PETROFF, P. (1998), 'Die griechisch-persische Tradition in Kultordnung und Herrscherrepräsentation des Antiochos I. von Kommagene', *Mainzer Althistorische Forschungen*, 1, 21–97.

PLATT, V. (2010), 'Art history in the temple', *Arethusa*, 43, 197–213.

PLATT, V. (2011), *Facing the gods: epiphany and representation in Graeco-Roman art, literature and religion* (Cambridge: Cambridge University Press).

PRESCENDI, F. (2006), 'Riflessioni e ipotesi sulla tauroctonia mitriaca e il sacrificio romano', in C. Bonnet, J. Rüpke, and P. Scarpi (eds), *Religions orientales—culti misterici: neue Perspektive = nouvelles perspectives = prospettive nuove; im Rahmen des trilateralen Projektes 'Les religions orientales dans le monde grèco-romain'* (Stuttgart: Franz Steiner), 112–22.

POURSHARIATI, P. (2008), *Decline and fall of the Sasanian empire: the Sasanian-Parthian confederacy and the Arab conquest of Iran* (London: I. B. Tauris).

RAHBAR, M. (2008), 'The discovery of a Sasanian period fire temple at Bandiyan, Dargaz', in D. Kennet and P. Luft (eds), *Current research in Sasanian archaeology, art and history. Proceedings of a conference held at Durham University, November 3rd and 4th, 2001 organized by the Centre for Iranian Studies, IMEIS and the Department*

of Archaeology of Durham University (Oxford: BAR International Series 1810, Archaeopress), 15–40.

RAHMAN, A. ur and Falk. H. (2011), *Seals, sealings and tokens from Gandhāra* (Wiesbaden: Reichert Verlag).

RAWLINSON, H. (1876), *The seventh great oriental monarchy, or the geography, history, and antiquities of the Sassanian or new Persian empire* (London: Longmans, Green).

RENAUT, L. (2009), 'Moise, Pierre et Mithra, despensateurs d'eau: figures et contre-figures du baptême dans l'art et la littérature des quatre premiers siècles', in I. Foletti and S. Romano (eds), *Fons vitae* (Rome: Viella), 39–64.

RENDIĆ-MIOČEVIĆ, D. (1953), 'Da li je spelaeum u Močićima služio samo mitrijačkom kultu', *Glasnik Zemaljskog muzeja u Sarajevu (=Vestnik Muzeïa Bosny i Gertsegovniny v Saraeve)* 8, 271–6.

ROSE, C. B. (2013), 'A new relief of Antiochus I of Commagene and other stone sculpture from Zeugma', in W. Aylward (ed.), *Excavations at Zeugma*, Vol. 1 (Los Altos: The Packard Humanities Institute), 220–31.

ROSENFIELD, J. (1967), *The dynastic art of Kushans* (Berkeley: University of California Press).

ROSTOVTZEFF, M. (1934), 'Das Mithraeum von Dura', *Mitteilungen des Deutschen Archäologischen Instituts, Römische Abteilung* 49, 180–207.

ROSTOVTZEFF, M. (1935), 'Dura and the problem of Parthian art', *Yale Classical Studies*, 5, 155–304.

ROSTOVTZEFF, M. (1938), *Dura-Europos and its art* (Oxford: Clarendon Press).

SACHAU, E., trans. (1888), *Alberuni's India. An account of the religion, philosophy, literature, geography, chronology, astronomy, customs, laws and astrology of India about A.D. 1030* (London: K. Paul).

SANADER, M. (2008), 'On the cults of antiquity in Croatia', *Vjesnik*, 101, 157–86.

SANDERS, D. H., ed. (1996), *Nemrud Daği: the hierothesion of Antiochus I of Commagene: results of the American excavations directed by Theresa B. Goell*. Vols 1 and 2 (Winona Lake, IN: Eisenbrauns).

SANDERSON, A. (2013), 'The impact of inscriptions on the interpretation of early Śaiva literature', *Indo-Iranian Journal*, 56, 211–44.

SARIANIDI, V. I. (1985), *Bactrian gold* (Aurora: Leningrad).

SARRE, F. (1910), *Iranische Felsreliefs: Aufnahmen und Untersuchungen von Denkmälern aus alt- und mittelpersischer Zeit (mit E. Herzfeld)* (Berlin: E. Wasmuth).

SCHMIDT, H. P. (2006), 'Mithra i. Mitra in Old Indian and Mithra in Old Persian', *EncIr* [accessed online: www.iranicaonline.org/articles/mithra-i, March 2016].

SCHREIBER, J. (1967), 'The environment of Ostian Mithraism', in S. Laeuchli (ed.), *Mithraism in Ostia* (Evanston, IL: Northwestern University Press), 22–45.

SCHÜTTE-MAISCHATZ, A. (2003), 'Götter und Kulte Kommagenes. Religions-geographische Aspekte einer antiken Landschaft', in E. Schwertheim and E. Winter (eds), *Religion und Region: Götter und Kulte aus dem östlichen Mittelmeerraum*, Asia Minor Studien 45 (Bonn: Rudolf Habelt), 103–13.

SCHÜTTE-MAISCHATZ, A. and Winter, E. (2001), 'Die Mithräen von Doliche. Überlegungen zu den ersten Kultstätten der Mithras-Mysterien in der Kommagene', *Topoi. Orient-Occident*, 11.1, 149–73.

SCHÜTTE-MAISCHATZ, A. and Winter, E. (2004), *Doliche—eine Kommagenische Stadt und ihre Götter. Mithras und Jupiter Dolichenus.* Asia Minor Studien 52 (Bonn: Rudolf Habelt).

SCHWERTHEIM, E. (1979), *Mithras: seine Denkmäler und sein Kult. Antike Welt* 10 (Feldmeilen: Raggi-Verlag).

SEAGER, R. (2002), *Pompey the Great* (Oxford: Blackwell).

SELEM, P. (1980), *Les Religions orientales dans la Pannonie Romaine. Partie en Yougoslavie*, Études préliminaires aux religions orientales dans l'Empire romain 85 (Leiden: Brill).

SERGEJEVSKI, D. (1937), 'Das Mithräum von Jajce', *Journal of the National Museum*, XLIX, 11–18.

SFAMENI GASPARRO, G. (1985), *Soteriology and mystic aspects in the cult of Cybele and Attis*, Études préliminaires aux religions orientales dans l'Empire romain 103 (Leiden: Brill).

SHAHBAZI, A. S. (1983), 'Studies in Sasanian prosopography I. Narse's relief at Naqsh-i Rustam', *AMIT*, 16, 255–68.

SHAHBAZI, A. S. (1985a), 'Studies in Sasanian prosopography II. The relief of Ardašēr II at Taq-i Bustan', *AMIT*, 18, 181–6.

SHAHBAZI, A. S. (1985b), 'Iranian notes 1–6', *Papers in honour of Professor Mary Boyce*, Acta Iranica 10–11 (Leiden: E. J. Brill), 500–10.

SHAHBAZI, A. S. (1986), 'Ardašīr II', *EncIr* [accessed online: www.iranicaonline.org/ articles/ardasir-ii-sasanian-king-of-kings-a, March 2016].

SHAHBAZI, A. S. (1993), 'Coronation', *EncIr* [accessed online: www.iranicaonline/ articles/coronation-pers, March 2016].

SHENKAR, M. (2008), 'Aniconism in the religious art of pre-Islamic Iran and central Asia', *BAI*, 22, 239–56.

SHEPHERD, J. D. (1998), *The temple of Mithras, London. Excavations by W. F. Grimes and A. Williams at the Walbrook* (London: English Heritage).

SHERMAN, E. L. (1967), 'Clothed in the sun: a Buddha and a Surya from Kashmir author(s)', The Bulletin of the Cleveland Museum of Art, 54.2, 42–63.

SICK, D. H. (2004), 'Mit(h)ra(s) and the myths of the sun', *Numen* 51, 432–67.

SIMS-WILLIAMS, N. (2004), 'The Bactrian inscription of Rabatak', *BAI*, 18, 53–68.

SIMS-WILLIAMS, N. and De Blois, F. (2006), 'The Bactrian calendar: new material and new suggestions', in D. Weber and D. MacKenzie (eds), *Languages of Iran: past and present. Iranian studies in memoriam David Neil MacKenzie* (Wiesbaden: Harrassowitz), 185–96.

SMITH, A. H. (1904), *A catalogue of sculpture in the Department of Greek and Roman Antiquities, British Museum*, Vol. 3 (London: British Museum).

SMITH, A. M. (2013), *Roman Palmyra: identity, community and state formation* (New York: Oxford University Press).

SMITH, R. (1995), *Julian's gods: religion and philosophy in the thought and action of Julian the Apostate* (London: Routledge).

SMITH, R. R. R. (1988), *Hellenistic royal portraits* (Oxford: Clarendon Press).

SMITH, R. R. R. (2013), *The marble reliefs from the Julio-Claudian Sebasteion* (Darmstadt/ Mainz: Philipp von Zabern).

SOUDAVAR, A. (2003), *The aura of kingship: legitimacy and divine sanction in Iranian kingship* (Costa Mesa: Mazda).

SOUDAVAR, A. (2012), 'Looking through The Two Eyes of the Earth: a reassessment of Sasanian rock reliefs', *Iranian Studies*, 45.1, 29–58.

SOUDAVAR, A. (2014), *Mithraic societies: from brotherhood ideal to religion's adversary* (Houston: Soudavar).

SPOONER, D. B. (1908–1909), 'Excavations at Shāh-ji-Dherī', *Archaeological Survey of India Annual Report* 1908–1909, 49.

SRINIVASAN, D. M. (2007), *On the cusp of an era: art in the pre-Kuṣāna world* (Leiden: Brill).

STAUSBERG, M. and Vevaina, Y. (2015), *The Wiley-Blackwell Companion to Zoroastrianism* (Oxford: Wiley Blackwell).

STEWART, S., ed. (2013), *The everlasting flame: Zoroastrianism in history and imagination* (London: Tauris).

SULLIVAN, R. D. (1977), 'The dynasty of Commagene', *Aufstieg und Niedergang der römischen Welt*, 2.8, 732–98.

TANABE, K. (1985), 'Date and significance of the so-called Investiture of Ardašir II and the images of Šāpur II and III at Taq-i Bustan', *Orient*, XXI, 102–21.

TOYNBEE, J. M. C. (1955), 'Le relief culturel gréco-romain: contribution à l'histoire de l'art de l'empire romain (book review)', *JRS*, 47, 262–4.

TOYNBEE, J. M. C. (1986), *The Roman art treasures from the temple of Mithras* (London: London and Middlesex Archaeological Society).

TURCAN, R. (1972), *Les religions de l'Asie dans la vallée du Rhône*, Études préliminaires aux religions orientales dans l'Empire romain 30 (Leiden: Brill).

TURCAN, R. (1975), *Mithras Platonicus: recherches sur l'hellénisation philosophique de Mithra*, Études préliminaires aux religions orientales dans l'Empire romain 47 (Leiden: Brill).

TURCAN, R. (1981), 'Le sacrifice mithriaque: innovations de sens et de modalités' in J.-P. Vernant et. al. (eds), *Le sacrifice dans l'Antiquité: huit exposés suivis de discussions: Vandœuvres-Genève, 25–30 août 1980,* Entretiens sur l'Antiquité classique 17 (Geneva: Fondations Hardt), 341–80.

TURCAN, R. (1988), *Religion romaine*, 2 vols (Leiden: Brill).

TURCAN, R. (1989), *Les cultes orientaux dans le monde romain* (Paris: Belles Lettres).

TURCAN, R. (1993), *Mithra et le mithriacisme* (Paris: Les Belles Lettres).

TURCAN, R. (1999), 'Hiérarchie sacerdotale et astrologie dans les mystères de Mithra', *La science des cieux: sages, mages astrologues*, Res orientales 12. Bures sur-Yvette: Groupe pour l'étude decivilisation du Moyen-Orient (GECMO), 249–61.

ULANSEY, D. (1989), *The origins of the Mithraic mysteries: cosmology and salvation in the ancient world* (Oxford: Oxford University Press).

UTECHT, T., Schulz-Rincke, V., and Grothkopf, A. (2003), 'Warum kein rechter Winkel? Zur Architektur des Hierothesion von Antiochos I. auf dem Nemrud Daġı', in G. Heedemann and E. Winter (eds), *Neue Forschungen zur Religionsgeschichte Kleinasiens: E. Schwertheim zum 60. Geburtstag gewidmet*, Asia Minor Studien 49 (Bonn: Rudolf Habelt), 97–114.

VANDEN BERGHE, L. (1983), *Reliefs rupestres de l'Iran ancien: Bruxelles, Musées royaux d'art et d'histoire, 26 octobre 1983–29 janvier 1984* (Brussels: Les Musées).

VERMASEREN, M. J. (1956–1960), *Corpus Inscriptionum Et Monumentorum Religionis Mithriacae (CIMRM)*, 2 vols (The Hague: M. Nijhoff).

VERMASEREN, M. J. (1963), *Mithras, the secret god* (London: Chatto and Windus).

VERMASEREN, M. J. (1974), *Der Kult des Mithras im Römischen Germanien* (Stuttgart: Ges. f. Vor- u. Frühgeschichte in Württemberg u. Hohenzollern).

VERMASEREN, M. J. (1982), *Mithriaca III: the Mithraeum at Marino*, Études préliminaires aux religions orientales dans l'Empire romain 16 (Leiden: Brill).

VERMASEREN, M. J. and Van Essen, C. C. (1965), *The excavations in the mithraeum of the church of Santa Prisca in Rome* (Leiden: Brill).

VONDROVEC, K. (2014), *Coinage of the Iranian Huns and their successors from Bactria to Gandhāra* (Vienna: Austrian Academy).

WAGNER, J. (1983), 'Dynastie und Herrscherkult in Kommagene—Forschungsgeschichte und neuere Funde', *Istanbuler Mitteilungen*, 33, 177–224.

WAGNER, J., ed. (2000), *Gottkönige am Euphrat, Sonderbände der Antiken Welt—Zaberns Bildbände zur Archäologie* (Darmstadt/Mainz: Philipp von Zabern).

WALDMANN, H. (1973), *Die Kommagenischen Kultreformen unter König Mithradates I. Kallinikos und seinem Sohne Antiochos I* (Leiden: Brill).

WALDMANN, H. (1991), *Der Kommagenische Mazdaismus*, Istanbuler Mitteilungen 37 (Tübingen: Wasmuth).

WALTERS, V. J. (1974), *The cult of Mithras in the Roman provinces of Gaul* (Leiden: Brill).

WATTERS, T. (1904), *On Yuan Chwang's travels in India (A.D. 629–645)* (Delhi: Munshi Ram Manohar Lal).

WEINBERG, F. M. (1986), *The cave. The evolution of a metaphoric field from Homer to Ariosto* (New York: Peter Land).

WEISS, M. (1998), 'Mithras, der Nachthimmel: Eine Dekodierung der römischen Mithras Kultbilder mit Hilfe des Awesta', *Traditio* 53, 1–36.

WELLES, C. B. (1951), 'The population of Roman Dura', in P. R. Coleman-Norton and A. C. Johnson (eds), *Studies in Roman economic and social history in honor of Allan Chester Johnson* (Princeton: Princeton University Press), 251–74.

WELLES, C. B., Fink, R., and Gilliam, J. (1959), *The excavations at Dura-Europos. Final report V.1: the parchments and papyri* (New Haven: Yale University Press).

WHARTON, A. J. (1995), *Refiguring the post classical city: Dura Europos, Jerash, Jerusalem and Ravenna* (Cambridge: Cambridge University Press).

WIKANDER, S. (1951), *Études sur les mystères de Mithras* (Lund: C. W. Gleerup).

WILL, E. (1955), *Le relief cultuel gréco-romain: contribution à l'histoire de l'art de l'empire romain* (Paris: E. De Boccard).

WILL, E. (1978), 'Origine et nature du mithriacisme', in J. Duchesne-Guillemin (ed.), *Études Mithriaques. Actes du 2e congrès international, Téhéran, du 1er au 8 septembre 1975*, Acta Iranica 4 (Leiden: Brill), 527–36.

WROTH, W. W. (1899), *Catalogue of the Greek coins of Galatia, Cappadocia, and Syria* (London: Trustees of the British Museum).

ZHU, T. (2003), 'The sun god and the wind deity at Kizil', in *Ērān ud Anērān. Webfestschrift Marshak* [accessed online: http://www.transoxiana.org/Eran/Articles/tianshu.html, March 2016].

ŽILE, I. (1998), *Zaštitni radovi na spomenicima kulture* (Unpublished. Department of Conservation Dubrovnik).

ZOTOVIĆ, L. (1973), *Mitraizam Na Tlu Jugoslavije (Le Mithraïsme sur le territoire de la Yougoslavie)*, Institut Archéologique Monographies 11 (Belgrade: Arheološki institut).

INDEX OF PEOPLE AND PLACES

Page numbers in bold refer to figures and maps

INDEX OF SELECTED SITES

INDEX OF SUBJECTS